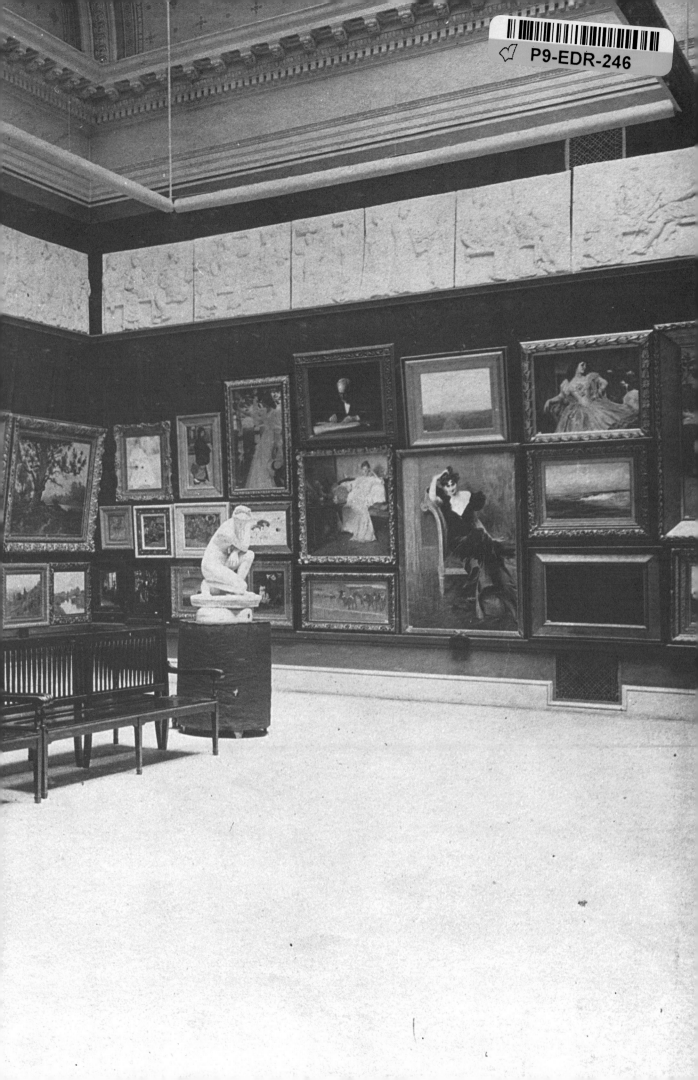

Carnegie International 1995

by Richard Armstrong
Curator

with the assistance of
Paola Morsiani

The Carnegie Museum of Art
Pittsburgh Pennsylvania

Guillermo Kuitca

Moshe Kupferman

Thomas Locher

Agnes Martin

Beatriz Milhazes

Joan Mitchell

Tomoharu Murakami

Tony Oursler

Sigmar Polke

Doris Salcedo

Cindy Sherman

Robert Therrien

Rirkrit Tiravanija

Richard Tuttle

Franz West

Rachel Whiteread

Rémy Zaugg

Chantal Akerman

Nobuyoshi Araki

Richard Artschwager

Mirosław Bałka

Stephan Balkenhol

Georg Baselitz

Rob Birza

Chuck Close

Stan Douglas

Leonardo Drew

Marlene Dumas

Louise Fishman

Robert Gober

Angela Grauerholz

Gary Hill

Craigie Horsfield

Cristina Iglesias

Committee and Jury **Carnegie International 1995**

Advisory Committee

Bice Curiger

Phillip M. Johnston

Mark Rosenthal

Vicente Todolí

1995 Carnegie Prize Jury of Award

Bice Curiger, Zurich

Milton Fine, Pittsburgh

Mark Rosenthal, Washington, D.C.

Juliet Lea Hillman Simonds, Pittsburgh

Vicente Todolí, Valencia

Carnegie International 1995
November 5, 1995 — February 18, 1996

Major corporate support for the *Carnegie International*
exhibition and catalogue is provided by PNC Bank Corp.

Additional funding is provided by income from the
A.W. Mellon Educational and Charitable Trust Endowment
Fund for the Pittsburgh International Exhibition
and the Beal Publications Fund and by
the National Endowment for the Arts, the Pennsylvania
Council on the Arts, and the Howard Heinz Endowment.

Grants have also been received from the Association
Française d'Action Artistique (AFAA), the Austrian Cultural
Institute, the Embassy of Brazil, British Airways,
the Consulate General of Canada, the Department of
Foreign Affairs and International Trade of Canada,
Pro Helvetia Arts Council of Switzerland,
the Henry L. Hillman Foundation, the Juliet Lea Hillman
Simonds Foundation, the Mondriaan Foundation,
and the Trust for Mutual Understanding.

ISSN 1084-4341
ISBN 0-88039-028-X

Published 1995
The Carnegie Museum of Art
4400 Forbes Avenue
Pittsburgh Pennsylvania 15213-4080

Contents

Thomas H. O'Brien **Sponsor's Statement**
Chairman and Chief Executive Officer
PNC Bank Corp.

Since its beginnings in Pittsburgh 100 years ago, Carnegie Institute has remained a vibrant and vital part of this region's cultural fabric. The opening of the 1995 *Carnegie International* marks the inaugural event of the Institute's yearlong centennial celebration. This exhibition, which celebrates its own one-hundredth anniversary in 1996, is known throughout the world for its promotion of contemporary art and artists.

PNC Bank Corp., which also originated in Pittsburgh and has grown into one of the nation's largest and strongest financial-services providers, is proud to be the principal corporate sponsor of this important event. On behalf of our twenty-one thousand employees and the millions of customers we serve, we at PNC Bank are honored to support the innovation and creativity represented in the 1995 *Carnegie International*.

Phillip M. Johnston **Foreword**
The Henry J. Heinz II Director
The Art Museums of Carnegie Institute

The 1995 *Carnegie International* marks the beginning of a yearlong celebration of the centennial of Carnegie Institute: indeed, November 5, 1895, was the date the institution opened. This concurrence is singularly fitting because the Institute's founder, Andrew Carnegie, initiated in 1896 the exhibition series known today as the Carnegie International. He intended that the Museum of Art "should not purchase Old Masters, but confine itself to the acquisition of such modern pictures as are thought likely to become Old Masters with time." Over its 100-year history, the International has brought distinction to The Carnegie Museum of Art, giving it a role unique among American museums and serving as the Museum's most significant source of collection acquisitions. Now a triennial exhibition, the fifty-second Carnegie International opens this year.

Richard Armstrong organized the 1995 *Carnegie International*. To this complex project he has brought focused, intelligent, and energetic leadership. He articulated the parameters of the exhibition, selected the artists, directed the formation of its accompanying catalogue, and wrote the catalogue's essay. We are grateful to him for an outstanding accomplishment.

An exceptional three-member committee offered Mr. Armstrong counsel as he prepared the exhibition: Bice Curiger, Editor-in-Chief, *Parkett* magazine, Zurich; Mark Rosenthal, Curator of 20th-Century Art, National Gallery of Art, Washington, D.C.; and Vicente Todolí, Curator, IVAM, Centre Julio Gonzalez, Valencia, Spain. He joins me in thanking them for their sound advice and for the affirmative spirit they brought to the project.

To the artists in the 1995 *Carnegie International* we express profound gratitude. The rewards of an International are the opportunities it affords to work closely with the participating artists.

The cooperation we received from their gallery representatives did much to facilitate the exhibition. We are also grateful to the many lenders who have generously shared their works of art with us for this exhibition. Trustees of the Museum also have aided us immeasurably in the organization of this project. Finally, my gratitude and admiration go to the staff of the Museum for a job well done.

Acknowledgments

Richard Armstrong **Acknowledgments**

Chief Curator and Curator of Contemporary Art

As is fitting for a project of the scope and ambition of the *Carnegie International*, my gratitude is both immense and widespread. I am especially indebted to the hundreds of artists in twenty-seven countries who welcomed me into their studios, freely sharing their work and ideas. To the many curators, critics, academics, and collectors who guided me to the artists and helped me articulate impressions of our encounters, I am equally indebted. Meeting and coming to know these members of the global art community has been my greatest reward.

Architect Richard Gluckman formulated plans for the show's extensive layout; his work serves as a profound complement to the art. Anita Meyer and her office at plus design inc., Boston, brilliantly devised the exhibition's graphics, working against harrowing deadlines. Editor Phil Freshman held firmly to high standards in performing his task for this book.

At the Museum, the wholehearted support and guidance of Phillip M. Johnston, Director, and Michael J. Fahlund, Assistant Director, sustained our labors. My colleagues Ellen Baxter, Diane Becherer, Gillian Belnap, Don Brill, Elissa Curcio, James Dugas, Matthew Fleischman, James Hawk, Geralyn Huxley, William Judson, Ross Kronenbitter, Jill Larkin, Nona Martin, Sarah Nichols, Frank Pietrusinski, Jennie Prebor, Rachel Rampa, Will Real, Cindy Sacco, Cheryl Saunders, Jack Schlechter, Leslie Shaffer, Ray Sokolowski, Monika Tomko, John Vensak, Anne Walters, Ellen White, Marcia Whitehead, and Doris Carson Williams have contributed immeasurably to the organization of the show. Interns Liz Beaman and Paola Cabal ably assisted our research. With Lynn Corbett's help, Paola Morsiani headed the exhibition team. Their goodwill and tireless attention to detail are reflected in every aspect of the exhibition; their exemplary sense of responsibility has been inspiring.

The Women's Committee of The Carnegie Museum of Art, led by Janet Krieger, has once again, and with characteristic élan, assumed responsibilities for the Founder-Patrons dinner; our thanks go to Lu Damianos, Stephanie Flannery, Ruth Garfunkel, Betsy Marcu, Karen Muse, Maureen O'Brien, Ann Schroeder, Carol Sharp, Suzie Steitz, and Ellen Walton. Organizers of past Internationals have been uniformly generous with good advice; I salute and thank Leon Arkus, Lynne Cooke, Mark Francis, Jack Lane, and the late John Caldwell. Museum of Art Trustees have, as always, been supportive of the Museum staff's tremendous efforts; in particular we thank Milton Fine, Konrad Weis, and Lea Simonds, who have taken a special interest in the show, to its benefit.

Juana de Aizpuru
Brooke Alexander
Carolyn Alexander
Audrey Alpern
Paul Andriesse
Roland Augustine
Michael Auping
Eva Badura-Triska
Dudley del Balso
Douglas Baxter
Neal Benezra
Flora Biddle
Sydney Biddle
Justine Birbil
René Blouin
Ted Bonin
Mary Boone
Russell Bowman
Susan Brundage
Diana Bulman
Bernhard Bürgi
Karla Camargo
Dan Cameron
Laura Carpenter
Leo Castelli
John Cheim
Angela Choon
Jim Cohan
Paolo Colombo
Paula Cooper
Jan Debbaut
Chris Dercon
Corinne Diserens
Gary Dufour
Susan Dunne
Anne Duroe
Sheila Fine
Daniel Fischer
Jim Fisher
Toto Fisher
Richard Flood
Dana Friis-Hansen

Paulette Gagnon
Carmen Giménez
Barbara Gladstone
Arne Glimcher
Marge Goldwater
Bernardino Gomes
Julie Graham
Carol Greene
Dietlev Gretenkort
Tanja Grunert
Madeleine Grynsztejn
Marcia Gumberg
Stanley Gumberg
Alicia Haber
Kathy Halbreich
Jane Hamlyn
Yuko Hasegawa
Drue Heinz
Jorge Helft
Marion Helft
Fred Henry
Annick Herbert
Anton Herbert
Paulo Herkenhoff
Elsie Hillman
Henry Hillman
Murray Horne
Yoshiko Isshiki
Junko Iwabuchi
Marc Jancou
Michael Janssen
Jörg Johnen
Jane Johnston
Flavin Judd
Marshall Katz
Wally Katz
Jim Kelly
Anton Kern
Ethel Klemmer
Takako Kobayashi
Hilda Kozari
Richard Lanier
Steingrim Laursen
Jolie van Leeuwen
David Lieber
James Lingwood
Dietmar Löhrl
Jean de Loisy

Rose Lord
Soledad Lorenzo
Barbara Luderowski
Lawrence Luhring
Tom MacGregor
Ellen Mahoney
David Maupin
DeCourcy McIntosh
Helen van der Meij
Justo Pastor Mellado
Ivo Mesquita
Suzanne Meszoly
Robert Miller
Chisa Misaka
Maria Morzuch
Edna Moshenson
Juan Muñoz
Fumio Nanjo
Louise Neri
Tim Neuger
Tim Nye
Anthony d'Offay
Michael Olijnyk
Seiji Oshima
Alfred Pacquement
Peter Pakesch
Frédéric Paul
Peggy Pelletier
Yves Pepin
Ivona Raimonova
Singer Rankin
Stuart Regen
Janelle Reiring
Richard Rhodes
Rayne Roper
Anda Rottenberg

Karsten Schubert
Douglas Schultz
Debbie Sellman
Nicholas Serota
Sarit Shapira
Edward L. Shaw
Junko Shimada
Keiko Shimada
Natasha Sigmund
João Silverio
Milada Slizinska
Elizabeth Smith
Alice Snyder
Jacques Soulillou
Lisa Spellman
Alexander C. Speyer III
Ellen Still
Monika Szczukowska
Page Thomas
Harry Thompson
Janie Thompson
Edward Thorp
Jack Tilton
Serge Vaisman
Jairo Valenzuela
Robin Vausden
Gordon VeneKlasen
Annemarie Verna
Gianfranco Verna
Marcantonio Vilaça
Theodora Vischer
Sheena Wagstaff
Jim Walton
Ziba de Weck
Marie-Christine Wehry
Michael Werner
Angela Westwater
Mindy Williams
Helene Winer
Donald Young
Dina Zaccagnini
Yigal Zalmona
Michèle Zaugg
Catherine de Zegher
David Zwirner

Lenders to the Exhibition

Albright-Knox Art Gallery, Buffalo, New York
The Bohen Foundation
Museum Boymans-van Beuningen, Rotterdam
The Eli Broad Family Foundation, Santa Monica
The Art Institute of Chicago
Modern Art Museum of Fort Worth
The Harwood Museum of the University of
 New Mexico, Taos
Emanuel Hoffmann-Stiftung,
 Museum für Gegenwartskunst, Basel
Lannan Foundation, Los Angeles
Milwaukee Art Museum
Musée national d'art moderne,
 Centre Georges Pompidou, Paris
The Saint Louis Art Museum
The Trustees of the Tate Gallery, London
Walker Art Center, Minneapolis

Brooke Alexander Gallery, New York
Alexander and Bonin, New York
Art 45, Inc., Montreal
Mary Boone Gallery, New York
Galeria Camargo Vilaça, São Paulo
Frith Street Gallery, London
Barbara Gladstone Gallery, New York
Dorothy Goldeen Gallery, Santa Monica
Marge Goldwater, Inc., New York
Galerie Tanja Grunert and Michael Janssen, Cologne
Galerie Löhrl, Mönchengladbach
LondonProjects
Luhring Augustine Gallery, New York
Helen van der Meij, London
Metro Pictures, New York
Robert Miller Gallery, New York
Tim Nye Productions, New York
Anthony d'Offay Gallery, London
PaceWildenstein, New York
Regen Projects, Los Angeles
Karsten Schubert Contemporary Art, London
Gallery Shimada, Tokyo
Sperone Westwater, New York
Edward Thorp Gallery, New York
303 Gallery, New York
Jack Tilton Gallery, New York
Annemarie Verna Galerie, Zurich
Galerie Michael Werner, Cologne and New York
Donald Young Gallery, Seattle
David Zwirner, New York

Ricard Akagawa
Carolyn Alexander, New York
David and Carol Appel, Toronto
Credit Suisse London Art Collection
Rosa and Carlos de la Cruz, Miami
Linda and Ronald F. Daitz, New York
Mr. and Mrs. Milton Fine, Pittsburgh
The Carol and Arthur Goldberg Collection
Joseph Hackmey, The Israel Phoenix Assurance
 Company, Tel Aviv
Charles Heilbronn, New York
Susan and Michael Hort, Scarsdale, New York
Jedermann Collection, N.A.
The Donald Judd Estate
Penny and David McCall, New York
David Meitus, New York
Estate of Joan Mitchell
Sophie van Moerkerke
Marvin and Elayne Mordes, Baltimore
Michael and Judy Ovitz
Tony Podesta, Washington, D.C.
João Leão Satamini, Rio de Janeiro
Sandra Simpson, Toronto
Ellen and Jerome Stern
Südwest LB, Stuttgart
Lynn and Allen Turner, Chicago
Mary Jo and James L. Winokur, Pittsburgh
Private collection, London
Private collection, Miami
Private collection, Switzerland
Private collection, Switzerland
Two anonymous lenders

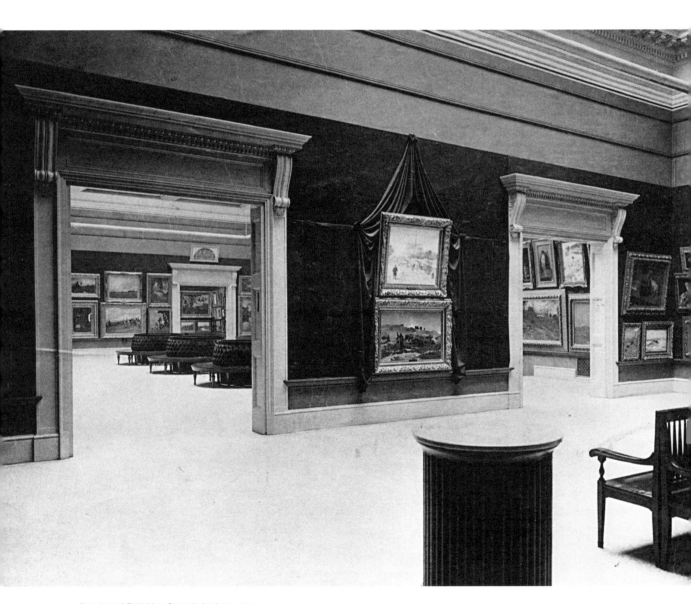

First *Annual Exhibition*, Carnegie Institute, 1896

Richard Armstrong **Introduction**

This *Carnegie International* is part of a continuum, now a century old, of fifty-two such exhibitions to have been presented in Pittsburgh. First organized in 1896 at the behest of industrialist Andrew Carnegie as an annual event for the then newly founded Carnegie Institute, the show was intended both as a survey of recent paintings by American artists to be seen alongside the work of their European counterparts and as a vehicle for assembling a collection of contemporary art. Carnegie stated his position in an undated letter to the Institute's leadership that was incorporated into its 1909 by-laws. "The Art Department should not purchase 'old masters,'" he wrote, "but confine itself to the acquisition of such modern pictures as are thought likely to become 'old masters' with time. The Gallery is for the masses of the people primarily, not for the educated few."[1] Novel in its emphasis on the future, this position was as canny as it was outwardly populist. Carnegie's recognition that his new institution was unlikely to catch up with established museums in New York City, Boston, Philadelphia, or even Chicago translated into an acquisition policy that was both economical and properly exploitative of the International. While the collection of The Carnegie Museum of Art now includes many works dated much earlier than 1896, a significant portion of its contents come from various Internationals — just as the private collections in the Pittsburgh area also reflect the history of the exhibition. Its rhythm, now triennial, has been a kind of pulse for the regional art community. And, as the only museum-sited, globally oriented survey regularly presented in North America, it has gained even wider significance.

1 Letter from Carnegie to the president and members of the Board of Trustees of the Carnegie Institute, n.d., but probably written April 2, 1907. Reproduced in the 1909 edition of the by-laws of the Carnegie Institute.

The three most recent versions of the show — in 1985, 1988, and 1991 — have arguably been the finest in its history. A widespread curiosity about European painting and sculpture generated by such landmark events as *A New Spirit in Painting* (organized by the Royal Academy of Arts, London, in 1981) and *Zeitgeist* (organized by the Martin-Gropius-Bau, West Berlin, in 1982) attracted attention to the wider stage of contemporary art as at no time since the late 1950s.[2] In those years, the force of action painting as practiced in New York, and, to a lesser degree in Paris, had catalyzed an art world recovering from the psychic and physical devastation of World War II. Common to the 1950s and 1980s was a general prosperity. The economic expansion of the 1980s in particular fueled a burst of private collecting (often speculative) in the United States, Europe, and Japan. Concomitantly, dozens of museums were constructed in all three parts of the world. The 1985 International and related 1988 show reflected an avant-garde culture whose reactivated interest in painting (especially by German artists) made large-scale survey exhibitions especially relevant. Throughout the decade, a robust, multinational market developed such as had not been seen since the heyday of Pop Art in the 1960s. By 1990, however, that market had shrunk considerably and another of the cyclical periods of painting's hegemony had ended.

The European-trained curators Lynne Cooke and Mark Francis were charged with organizing the 1991 International. They quickly established a program meant to reflect the bibliographic-scientific-artistic amalgam of the Carnegie Institute as a whole. Citing "the widespread interest of many contemporary artists in issues relating to collecting and display, to the acquisition and circulation of information and hence knowledge, and to the different systems, taxonomies, and values which underpin the numerous scientific and art historical discourses [they] decided to address this unique situation by selecting a number of artists who [they] felt would be intrigued and engaged by such possibilities in the works they made for the exhibition."[3] Ultimately, Cooke and Francis invited artists to work at sites around the city of Pittsburgh as well as within galleries typically reserved for the Museum of Art's permanent collection. The curators argued that "the focus of current activity has veered away from painting to other media: to installation and assemblage, to sculpture, and to photography."[4] Evocative, architecturally scaled constructions distinguished this International, which summarized the impulse to order exhibition space through large-scale installations more cogently and with greater acuity than any other recent show of contemporary art.

2 Norman Rosenthal and Christos Joachimides organized these exhibitions as well as a number of other large-scale shows. *A New Spirit in Painting* (curated with Nicholas Serota) was especially galvanic.

3 Lynne Cooke and Mark Francis, *Carnegie International 1991*, exh. cat. (Pittsburgh: Carnegie Museum of Art; New York: Rizzoli 1991), vol. 1, p. 14.

4 Ibid. p. 15. Such Pittsburgh sites as R.K. Mellon Hall at Duquesne University, the Mattress Factory and nearby houses, branches of the Carnegie Library, and the intersection of Penn and Liberty avenues at Stanwix Street were utilized for artists' installations. The curators cited two important European exhibitions, *Chambres d'Amis* (Ghent, 1986) and *Skulptur Projekte in Münster, 1987*, as precedents for their efforts.

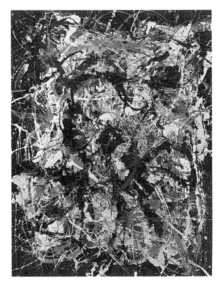

Jackson Pollock (American, 1904–1956) *Number 4*, 1950

Oil, enamel, and aluminum paint on canvas 48 7/8 x 37 7/8 in.

(124.1 x 96.2 cm) Collection of The Carnegie Museum of Art,

Pittsburgh; Gift of Frank R.S. Kaplan, 54.15

Because the 1991 International had realized its aims so fully, it seemed to me that an attempt to recapitulate its approach in 1995 would be fated to redundancy. Thus, other than avoiding the 1991 participants and directly comparable artists, I sought to keep my mind open, to consider carefully anything I might encounter during visits to studios, galleries, and public and private collections in the United States and abroad. This search, which ultimately took me to twenty-seven countries on four continents, began in earnest in February 1993. Its success depended on my soliciting a critical consensus from informed observers at the locales I visited. Their advice and shepherding of me while I was in their cities — in addition to innumerable telephone and telefax consultations with them and other colleagues around the world — lent structure to my peripatetic impressions.

As I searched, I gradually became aware of the validity of an observation by the cultural critic Edward Said about the ubiquity of the American point of view. "Rarely before in human history," he wrote in 1994, "has there been so massive an intervention of force and ideas from one culture to another as there is today from America to the rest of the world."[5] I labored under the biases inherent in this cultural myopia, my ignorance compounded by years of working, prior to the Carnegie, at a museum whose exclusive focus is on American art. Thus my benchmarks were objects from the Whitney Museum of American Art and The Carnegie Museum of Art collections that I knew best from having spent years with them as a curator. All the same, I was determined, even anxious, to broaden my acquaintance with the range of contemporary art to the greatest extent possible, while recognizing that my decisions would nonetheless bear an American cast.

Fortunately, the International's advisory committee, which convened starting in 1994 for three meetings meant to help guide the selection process, offered checks and balances to my curatorial excesses and limitations. These meetings — in Como, Italy, San Francisco, and Pittsburgh — were in essence extended conversations about the uses and limits of survey exhibitions in general and of this one in particular. Since there had been almost no preconceived notions about the eventual make-up of the show other than it not include any of the artists invited in 1991, each one considered was seen both in isolation and as representative of a broader, even global, manifestation of a given aesthetic. Hence two congruent sets of criteria were applied to measure every artist: The first centered on the overall body of work each has produced, with special emphasis on work made since 1991; and the second concerned the salience and stature of that work in contrast to work by each artist's recognized peers and counterparts. As it became clear that the Museum of Art would be the sole site of the exhibition, it seemed imperative to include fewer artists than in past shows in order to allow an in-depth view of each. More than 270 recent works by thirty-six artists from sixteen countries comprise the 1995 *Carnegie International*. While the variety and accomplishment of the work I saw was invigorating, and occasionally overwhelming, broad commonalities of reference and intention suggested themselves frequently enough that their reflections surface in the exhibition.

5 Edward W. Said, *Culture and Imperialism* (London: Vintage, 1994), p. 387.

A prejudice in favor of transformative impulses, toward artists attempting to give form, rather than borrow or interpret it, compelled me to look for painters, and, even more insistently, sculptors. Confronted with their work, I so frequently saw imagery of what was at hand—family, friends, the ordinary things around us — as to generalize about the present moment in art as one of fierce self-examination. As the German painter Georg Baselitz wrote, referring to his own artistic evolution, "I want to use only what's been here for years."[6] This focus is most obvious in the many and various portraits and other uses of the body seen in the exhibition, but it is also visible in re-creations of landscapes both domestic and natural — the former symbolized by the many allusions to furniture and architecture, the latter as depicted in impressions derived from nature. Even the more conceptually oriented artists represented here transform generative ideas into objects, mostly as sculpture or in paintings that willingly operate as such. Often intended to serve as demonstrations of rationality (however delusory), these paintings (and photographs) can be viewed as two-dimensional equivalents of certain of the sculptors' feats. Thus three main motifs—the first anatomical, the second natural, and the third mathematical or conceptual — emerge in much of the work on view. The film and video artists here engage another dimension, since their material assumes meaning in time. But their essential concern with linguistic narrative could be seen as constituting a fourth motif. In all cases, we are witnessing a search for order, however baffling it may appear at first.

6 The remark is from Baselitz's 1994 text "Painting Out of My Head, Upside Down, Out of a Hat," as reproduced in Diane Waldman, *Georg Baselitz*, exh. cat. (New York: Solomon R. Guggenheim Museum, 1995), p. 248.

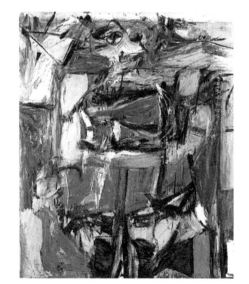

Willem de Kooning (American, b. Netherlands, 1904) *Woman VI*, 1953

Oil on canvas 68 1/2 x 58 1/2 in. (174 x 148.6 cm) Collection of

The Carnegie Museum of Art, Pittsburgh; Gift of G. David Thompson, 55.24.4

The ideological rivalries and general loss of faith in modernity that have bedeviled and enlivened the field of contemporary art during the last thirty years have been especially threatening to the production and reception of abstract painting. Sculpture, which is by nature tangible, bulky, and physically recalcitrant, has developed more slowly but with no less force than painting during the same period. Like the allied practice of architecture, sculpture matures slowly and seems to gain particular momentum at the exact moments, as now, when the urgency of painting appears to have become dispersed. For these reasons, and because the medium has in recent years proven attractive to many younger artists, a great deal of sculpture was considered for and finally included in this exhibition. Indeed, the sculptural pieces here variously embody all of the motifs just cited.

As a fusion of utility and decoration, furniture is both a small-scale demonstration of the grid as structure and enormously symbolic. It has been variously exploited by artists during this century and with special force in recent years. Richard Artschwager's stubbornly mute yet discursive furniture-derived sculptural pieces (some of them more than thirty years old) are crucial precursors of works by many of today's younger sculptors. The profusion of crates that has constituted most of his sculpture exhibitions of the last three years allude both to his wide repertoire of forms and to René Magritte's 1950 coffin-populated oil-on-canvas version of Edouard Manet's famous *Le Balcon* (1868). Just as the Belgian encapsulates the elegant French ladies in their own coffins, Artschwager fills spaces with crates—or coffins—whose shapes recall the profiles of his own past work. As an ensemble they propose an abstracted, mostly prone, group portrait. As a series of quixotic memorials to his sculptural fecundity and an extended spoof on utility, Artschwager's crates purposefully bastardize the essentially cubical forms that were so important to the advanced sculptors of the 1960s. His intent to hybridize the values of sculpture with the illusory values of painting, and vice versa, is demonstrated in the aluminum, Formica, and wood piece *Table Prepared in the Presence of Enemies* (1993), in which a crate metamorphoses from a state of ambiguous opacity into a furnished site of nourishment.

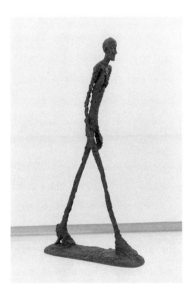

Alberto Giacometti (Swiss, 1901–1966) *Walking Man I*, 1960
Bronze 71 3/4 x 38 x 10 1/2 in. (182.2 x 96.5 x 26.7 cm)
Collection of The Carnegie Museum of Art, Pittsburgh; Patrons
Art Fund, 61.48

An altogether different kind of furniture-derived object, though similarly memorial, is Robert Therrien's gargantuan and oppressively real ensemble *Under the Table* (1994). Therrien is entranced by the intrinsic beauty of the ordinary things around him, and his scrutiny of his immediate surroundings is like that of many other artists with subjects as otherwise diverse as Chuck Close and Doris Salcedo. Certainly, this table and set of six chairs are directly inspired by furniture Therrien has sat on and eaten from for years. Its scale (about three-and-one-half times actual size) introduces an element of awe that echoes and magnifies the artist's own deep reverence for the used, worn, and patinated. Invested with much human activity, all of his work addresses the structure of made things and, by implication, durability and survival.

Related concerns also distinguish the recent work of Doris Salcedo and Rachel Whiteread, both of whom generate abstract sculpture out of familiar objects. Using cast-off furniture she finds on the streets of Bogotá, Salcedo reorients and combines the wooden forms into an armature that she fills with concrete. Bitterly aware of the recent horrific violence in Colombia induced by the insatiable greed inherent in drug trafficking, Salcedo conceives of these pieces as monuments to victims of her native country's strife. More than twenty of them are gathered here to make up a gallery-scaled environment. Somewhat like Artschwager's crates, her pieces are three-dimensional geometric abstractions that mournfully furnish a room. In her case, their doleful air recalls the extinguished lives that once made use of the furniture now encased by concrete. They are weighty, handmade tombs.

Earlier in her young career, Rachel Whiteread similarly captured the things around us — mattresses and portions of floors, for example — casting from molds made of such materials as plastic and rubber. More recently, she has focused on making concrete inhabited space itself by casting rooms or, most spectacularly, an entire house in the East End of London. With this work, entitled *House* (1993), Whiteread's previously domestic scale assumed new physical and psychological dimensions — that of the sole remaining row house in a neighborhood heavily bombed during World War II. Impenetrable, obdurately perched over a busy street, naked for want of neighbors, and a poignantly detailed negative of the home it replaced, *House* made loss visible. For the International, Whiteread has cast in translucent resin the spaces beneath nine different chairs to make 100 objects presented in a large grid. The untitled work summons an effect of moving through part of a miniaturized city whose buildings are aglow and systematically separated from one another. Giving form to nine distinct voids, Whiteread establishes a dynamic pattern of negative interstitial space, inverting generally held notions about large-scale sculpture to portray instead negative, non-monumental space.

Mirosław Bałka freely exploits the tactile, visual, and olfactory powers of evocation in his sculptures. Scaled to his two-meter height, Bałka's work is a highly schematized re-creation of the objects and modest interiors he knew growing up outside Warsaw. His appeal to memory, unlike that of Salcedo and Whiteread, is deliberately, if obliquely, autobiographical. Bałka's floor-bound rectilinear forms expand on a formal vocabulary that was first explored by the American Minimalists of the 1960s and 1970s, but his concessions to sentiment mark him as a member of another generation of artists willing to admit an emotional dimension into their work. Poland's tragic history, the one imposed on it by Germany and the Soviet Union, suffuses Bałka's work. In his hands the implied welcoming shelter of architecture is transformed into planar abbreviations that speak of severity, physical deprivation, and intellectual isolation.

In this way, Guillermo Kuitca's *La Tablada* suite of paintings, rendered on canvas in acrylic or oil with graphite overdrawing, might be considered kin to Bałka's sculptures. The paintings are elaborated plans, made from such models as that of a Jewish cemetery in Buenos Aires (known as La Tablada), stadiums, apartment buildings, and hospitals, that carefully chart the potential dispositions of bodies, alive and dead. Kuitca's obsessively rendered reinterpretations of the plans — the most sterile architectural notations — are situated atop fields of pastel paint, subverting the mechanical impartiality typically ascribed to that kind of drawing. Kuitca further heightens the associative values implied by the ground colors by making the architectural drawings smudged, obviously touched and individuated. Thus the proportions — immense and densely populated — that are delineated by their charcoal marks are as physically charged as they are geometrically schematic.

In them, we seem to look down on the ruins of a grand, or better, grandiose, civilization; ostensibly rational, its architecture appears so controlled and condensed as to be unbuildable.

Idealized architecture, that is, constructed form freed of the obligations of shelter, inspires the brick structures of the Danish artist Per Kirkeby. Evoking the elegantly austere churches of Jutland, he utilizes shape, glazes, and bonds in *Untitled (Cliff Dwelling under the Hanging Rock)* (1995) in the same ways that he employs drawing, impasto, and color in his well-known paintings. The work, installed in the Museum of Art's Sculpture Court, stands as a refuge and as a frame to the sky. Its walls establish privacy from the crowds who pass through the glass-walled corridors of the museum and serve as conduits to the changing light overhead. The darkness and illumination of his painted passages have direct counterparts in these brick sculptures; in both media, Kirkeby's determining of appropriate structure is essential to his search for meaning.

The salience of the natural landscape in the work of so many contemporary artists is noteworthy and surprising, given our highly urbanized world. Few postwar painters considered landscape as a subject as long and as deeply as did the late Joan Mitchell. For nearly forty years she painted impressions of the countryside around her studio on the Seine River outside Paris. Mitchell reflexively sought a repertoire of painted marks capable of re-embodying the sites before her as filtered through recollection. A genuine heir to the ethos of New York action painting, she remained both astonished by and slightly skeptical of her métier, insisting on its primacy as a source of sensual experience. For her, paint and gesture alone could describe; words, and certainly theory, were subordinated, even excluded.

In this respect, Mitchell was truly representative of the generation of artists who came of age during the 1950s. For such younger artists today as Angela Grauerholz, Cristina Iglesias, and Beatriz Milhazes, a comparable stance apart from the concept-laden discourse of contemporary art is undesirable, even unimaginable. Each of them addresses nature differently, but, like Mitchell, they make the experience of the landscape universal rather than site-specific. Grauerholz's long-exposure photographic technique leads to images that can be blurrily panoramic — enveloping yet unlocatable. A German émigré to Canada, she seems particularly drawn to the boundless woods of North America, perhaps, as she admits, to re-enact for herself the search for the natural sublime that motivated so many of the German romantics. A tenebrous muted light and a compositional taste for a full frame is common to her photography, even lately, as the scale and presentation of much of her work have changed. From the large (up to forty-eight by seventy-two inches) framed prints that have been her preferred format, Grauerholz has turned to small formats for *Eclogue or Filling the Landscape* (1994). This composite work consists of 216 silver prints that are boxed and stored in twenty-seven portfolios in a translucent, six-drawer acrylic cabinet. The photographs must be removed by hand from their drawers and containers to be seen and held. *Eclogue* emphasizes the intimate aspect of the photograph and reasserts its historical role as private treasure and aide-mémoire. The images in *Eclogues* are mostly unpopulated views of nature, trees in particular; we apply to them the searching focus typically brought to bear in portraits. Grauerholz's images are so charged, in fact, that nature assumes an anthropological air, and, conversely, the body seems to be an intrinsic part of its landscape.

Our light-determined perceptions of nature — its enclosures and vistas, vast and confining spaces — lie at the heart of Cristina Iglesias' sculpture. Installed to mimic our conscious and rote everyday encounters with upright vegetation, her recent casts propose an architecture of nature. Weighty, finely detailed condensations of plants (bamboo, in the case of the untitled pieces in the present show), her work surrounds us with an abbreviated landscape of opacity and solidity instead of the customary one of wind and light, animated flexibility, and daily transformation. Iglesias' forms are monochromatic, reflective, unnaturally compacted. Like Grauerholz, she offers just enough detail to tempt us to specify locale, even while her sculpture remains evocative of experience itself to the exclusion of place.

By contrast, Beatriz Milhazes' paintings — vividly colored abstractions with repeated circular motifs — seem emphatically rooted in her native Brazil. Rio de Janeiro, her hometown, is one of the most spectacular urban sites in the world, a densely inhabited mountainous rain forest spilling into the South Atlantic. Milhazes deftly supersedes all the clichés of tropical vivacity and folkloric affinity in her work, connecting it instead to the Western tradition of occultist abstraction; her paintings' link with certain of Franz Kupka's early twentieth-century abstractions, for example, is striking. Her process is to germinate each painting by transferring its initial imagery from another surface onto the canvas, almost as an overscaled monotype. From this impression she improvises a composition, typically enhancing the transferred ground then freely embellishing the overall surface as well. Often composed of rosettes and other concentrically circular forms that allude to flowers, these paintings are nonetheless largely abstract. It is Milhazes' special strength both to localize and to make universal her motifs, rendering them in a palette of insistent, singular brilliance.

Landscape, memory, and loss structure Moshe Kupferman's paintings. A Holocaust survivor settled on a kibbutz in northern Israel, Kupferman works in a restricted palette of green, mauve, white, and gray that signals the fusion of nature and recollection forming the core of his work. If the linear subdivisions of his untitled canvases mimic the episodic nature of consciousness, his enlarged signature (in English and in Hebrew) on the paintings seems to reiterate the fact of his own survival. The gestural sweeps atop Kupferman's grids relate to his handwriting — and both kinds of drawing offer the barest of autobiographical evidence. No doubt his arrangement of pictorial space is descended from the planar vocabulary of Cubism, but his application of paint owes much to the gestural freedoms of action painting. He furthers the modernist project, transplanting it from its European roots to the dry and vibrant light of the Middle East, reinvigorating its ethical force.

A sense of long-term suffering and an eloquently expressed need to monumentalize detritus literally suffuse Leonardo Drew's large wall reliefs. Constructed of trash and ordinary items like rope, cotton, and rags, such gridded landscapes as *Number 45* (1995) speak of his reverence for the immense toil that underlies African-American history and embodies his own experience as an urban survivor. Drew integrates his torn, shredded, worn-out material into an endlessly detailed plane that displays its own fabrication, perhaps as a grander metaphor for the joining together of disparate parts and people. Adapting the gesture-derived working methods of

Post-Minimalism to his transformative powers over gritty raw material, Drew convincingly imparts order and harmony to the discarded and spent remnants of contemporary American life.

Fundamentally a gestural artist, Louise Fishman builds her paintings with layers of broadly applied strokes. Her technique owes much to drawing; her vision is linear. Most recently she has opened the dense weave of paint characteristic of such works as *Mars* (1992) in favor of an open and more revealing structure, as in *Blonde Ambition* (1995). Like Joan Mitchell, she attempts to create a picture world that refers to, but is not part of, the larger physical world. Though resolutely abstract, her work, by force of gesture and color, can have considerable emotional impact. While Fishman's more opaque paintings portray a dark and complicated state of mind, her work of late has become less constricted, freer. Less idealistic perhaps than the action painters of the 1940s and 1950s, she nonetheless partakes of a painting ethos that mirrors the psychic condition of its practitioner.

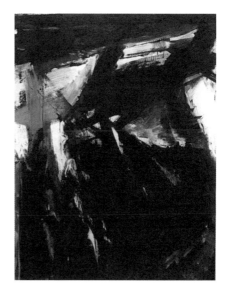

Franz Kline (American, 1910–1962) *Siegfried*, 1958

Oil on canvas 102 15/16 x 81 1/8 in. (261.5 x 206 cm)

Collection of The Carnegie Museum of Art, Pittsburgh;

Gift of Friends of the Museum, 59.21

Fishman, Kupferman, and Drew organize their impressions on grids, setting up a tension between their private expression and the linear system that orders them. For more than thirty-five years, Agnes Martin has also employed grids but to ends that subsume gesture within an image of tranquility. At five feet by five feet, the seven horizontally organized square paintings on view are smaller in format than her previous work, and their means are even more pared down. Here Martin's drawing consists of the faintest of parallel lines, which provide a general guide to her thin washes of blue acrylic paint. Many years of residence in northern New Mexico inform both her palette and her composition. While bands of blue and white are common to the surfaces of all seven works, variations of scale lead us to have radically different impressions before each picture. Martin has consistently cited elements of the New Mexican landscape as her primary sources; however, these works have an essence that is as much celestial as terrestrial. In them, we see the heavens in a measured and comprehensible manner that nonetheless allows for awe and wonderment.

If Martin's paintings appear to exist to be seen through, Tomoharu Murakami's encrusted untitled works function as full stops. Their uniform, black relieflike surfaces, made up of accumulations of stippled marks, yield almost no extraneous information. Each painting constitutes a deliberate act of self-obliteration by the artist. Executed with equal intensity from edge to edge, the opaque canvases are abstractions as rigorous as any produced by the most orthodox of anti-representational artists. Yet Murakami works outside this history. Though he is a Roman Catholic, the holistic perceptual aspirations of Zen Buddhism seem to underpin his paintings. He offers us a field for meditation without words or images. The severity and sense of ascetic remove in these works mark them as part of traditional Japanese artistic practice.

Few contemporary American artists have more consistently sought those same Zen ideals than Richard Tuttle, whose work is a celebration of modest materials (including cardboard, plywood, and Styrofoam, as here) gracefully combined and presented by him at idiosyncratic heights and places within galleries. Tuttle's work acts as a visual catalyst, always suggesting that we broaden our tolerance for assessing beauty. His artistic maturation in the late 1960s and early 1970s coincided with a general art-world reaction against the theory and practice of Minimalism. While he exemplified a quest for new media, form, and composition that was common to such otherwise unallied sculptors as Barry Le Va, Alan Saret, and Richard Serra, his subsequent career has so extended the definitions of sculpture and how and where it is to be placed as to mark him as a radical even in their influential, avant-garde company. Tuttle's fanciful and mutable aggregations of such materials as wire and paper are, despite their legible origins, insistently abstract. While its components may be individually recognizable, the whole of any single work describes a state of aestheticized balance. The handmade quality of his work further reiterates a sense of purpose, neither descriptive nor comic, that might best be characterized as a private illumination.

The Cologne-based artist Thomas Locher analyzes imagery and seeks balance in a completely different way than Tuttle, choosing to superimpose taxonomic orders atop classes of such things as furniture, color blocks, and photographs. Locher uses letters (sometimes singly), words, and numbers to classify. Since he also fabricates many of the images he labels and photographs, Locher's ambitions can be said to extend beyond the given world into an imaginary one that he both furnishes and categorizes. Twenty-seven of his panoramic works are installed at The Carnegie as an environment occupying a heavily traversed ramp, a loading area, and a telephone rest room antechamber — all contiguous. The walls offer evidence of a consuming search for and assertion of rationality. However, the evidence presented is fictive and, when read carefully, seems to be more a monologue than a disquisition. The whole, as one critic has noted of Locher's work in general, "is a conclusive demonstration of the impossibility of representing the reality of global creation."[7] Locher's guiding system remains deliberately indecipherable, finally as subjective as any "invented" image.

The central activity of nonrepresentational sculpture—the ordering of space—links it to architecture, sometimes to the mutual discomfort of both architects and artists. In the enormous scaled works by Richard Serra or the late Donald Judd, for instance, architectural concerns (and ambitions) become congruent with sculptural ones.[8] Judd's uncompromising and deliberate consideration of the cube culminated not only in such works as the untitled five-part aluminum floor piece from 1991 included here but also in his reorganization of a vacated military base in Marfa, Texas, into a preserve for his work and sculpture by his friends that he had collected. The utilitarian structures of the military and wide expanse of West Texas became propitious backdrops for his geometries. As he noted in the essay excerpted in this catalogue, "There is no neutral space, since space is made, indifferently or intentionally, and since meaning is made, ignorantly or knowledgeably."[9] This strongly suggested to us that his works be placed in the museum's great neoclassical Hall of Sculpture, a 1907 version of the Temple of Athena at the Acropolis (replete with a duplicated frieze and marble quarried from the site of the Greek original). Judd's insistence on essence — expressed both in his art and in his published art criticism—led him to a kind of modernist classicism. Because he had divorced himself from the mimetic responsibilities inherent in three-dimensional representational sculpture, Judd could construct ideal, even Platonic, forms. The Douglas fir-and-Plexiglas wall reliefs in this exhibition, like the aluminum floor piece noted above, offer strong proof of the consistency of his artistic project, reminiscent as they are of the earliest pieces he produced. Here they offer continuity within the short history of abstract sculpture.

7 Bernhard Bürgi, "On the Structures of the World," in *Wörter Sätze Zahlen Dinge — Tableaus, Fotografien, Bilder* (Zurich: Kunsthalle Zürich, 1993), n.p.

8 See "A Conversation with Richard Serra and Alan Colquhoun, New York, January 28, 1991," in Lynne Cooke and Mark Francis, *Carnegie International 1991*, exh. cat. (Pittsburgh: Carnegie Museum of Art; New York: Rizzoli, 1991), vol. 1, pp. 23–34.

9 Donald Judd, "21 February 93," in *Donald Judd: Large-Scale Works*, exh. cat. (New York: Pace Gallery, 1993), p. 9.

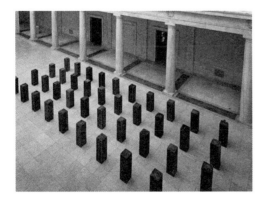

Carl Andre (American, b. 1935) *Fallen Timbers*, 1980

40 redwood timbers 36 x 12 x 12 in. each (91.4 x 30.5 x 30.5 cm); 36 x 443 x 155 in. (91.4 x 1125.2 x 393.7 cm) (overall)

Collection of The Carnegie Museum of Art; A.W. Mellon Acquisition Endowment Fund, 86.30

The pilasters and colonnade of the Hall of Sculpture serve as frames for Rémy Zaugg's paintings featuring language. A longtime collaborator of the Basel architects Jacques Herzog and Pierre de Meuron (whose work is in turn represented in the concurrent exhibition *Monolithic Architecture* in The Heinz Architectural Center), he takes special care in locating his works to establish a visual-verbal dynamic. Besides his long fascination with architecture, Zaugg has previously written about Judd's work. Hence we have a serendipitous juxtaposition of two artists who utilize abstraction differently. Zaugg's subject in the works seen here, as expressed in English, French, and German, can be seen as an extended introspective monologue provoked by art. Generated initially by notes he made about a reproduction of a painting by Paul Cézanne, Zaugg's aesthetic inquiry has taken on public import by assuming forms as paintings and by being placed in a gallery setting. His use of language has a particular resonance in this museum space because of its proximity to Lothar Baumgarten's installation *The Tongue of the Cherokee* (1988), commissioned at the time of the 1988 International. Inscribed into the skylight windows are the eighty-five characters devised by a nineteenth-century Cherokee to signify his people's spoken language. Three narratives are thus layered here: the first in Cherokee; the second in the relief of the reconstituted Parthenon frieze and related freestanding casts of classical figures; and the third, a contemporary one manifested in Zaugg's paintings and Judd's sculptures.

Film and video offer even more potent narrative vehicles, as works here by Chantal Akerman, Stan Douglas, Gary Hill, and Tony Oursler amply demonstrate. Akerman, famed as a cinematographer and director, turns her patient and inquisitive camera eye toward life in newly free Eastern Europe. The images on the twenty-four video screens, arranged as an electronic landscape that we pass through, record what the Belgian-born filmmaker saw on a long trek through the former Soviet bloc, including the homelands of her Jewish forebears. A lengthy color film, *D'Est* is projected at one end of Akerman's installation, documenting the daily routine of Muscovites. Seen indoors and in public, through all the seasons, these people and their drab existence make for a solemn, almost suffocating, cinematic diary. The staggered, freestanding monitors in the exhibition show fixed-frame portraits drawn from the film's slow panoramas. At the opposite end of the installation, a single monitor shows Moscow at dusk, a setting that is amplified by Akerman reading in Hebrew from the Book of Exodus and from her own writings produced in the course of making the film. The words supply solace and help rationalize this almost insupportable examination of a disintegrating society. Bleak almost beyond our imagining, *D'Est* delivers evidence directly from a geopolitical fault line that is shifting still.

Der Sandmann (1994), the Canadian artist Stan Douglas' two-reel film and related still photographs, examine the Schrebergarten phenomenon of modern Germany, that is, the government's practice of allotting small garden plots to city dwellers. During a long stay in Berlin in 1994 Douglas availed himself of the Babelsberg film studio in nearby Potsdam. His script joins portions of E.T.A. Hoffmann's original tale *Der Sandmann* (1817) with parts of an essay by Sigmund Freud, both of which have been altered by Douglas for narrative reasons. Filmed images of a garden set merge on-screen with panning shots of real gardens — some being destroyed for the construction projects that are now common in parts of the former East Germany. Douglas' keen eye for social commentary and his imaginative use of a fable provide metaphorical power to fortify his seamless, dispassionately delivered work.

Gary Hill's videos, most often screened as here within a complementary sculptural arrangement, examine then electronically distort mind-body consciousness, particularly as it finds expression through the sounds our voices make. The title of his video-and-sound work *Dervish* (1993–1995), seen in this exhibition, alludes to the rapidly accelerated suite of images of a man reaching that are flashed across a curved wall and accompanied by a crescendo of related sounds. Because the mechanisms of the work are supported in a wooden tower in the middle of the gallery space, its technology looks crude. But in fact, Hill's techniques are as advanced as is his ambition to dissect the human instinct to verbalize. His "scripts" have ranged from the amplified sound of his own breathing to recondite texts on aesthetics, but, as in *Dervish*, he often employs a repertoire of sounds that articulate feelings as much as thoughts. In *Dervish*, Hill suspends us between an instantaneous and sequential visual narrative and a sound track made up of phonemes.

Tony Oursler's videos employ relatively basic projection methods to give voice to a kind of narrative very different from that of Hill. Projecting close-ups of actors' faces on the heads of stuffed dolls, he animates dummies (or other receptive surfaces, such as jars) with superimposed mouths, eyes, and noses. The actors' words are written by Oursler using street vernacular; they are sometimes strident, often confrontational. His narrative style is that of the storyteller (occasionally, the confessor). And by projecting the action, as he frequently does, on life-size dolls, he magnifies the fascination, identification, pity, and terror that the stories elicit.

Bruce Nauman (American, b. 1941)

Having Fun / Good Life, Symptoms, 1985

Fabricated neon 69 x 131 1/4 in. (175.3 x 333.4 cm) Collection of

The Carnegie Museum of Art, Pittsburgh; Museum purchase:

gift of Partners of Reed Smith Shaw and McClay, and Carnegie

International Acquisition Fund, 85.32

A plethora of exhibitions in recent years focusing on the human body, often seen through such sociopolitical filters as an ideological construction of identity, have made us keenly aware of the body's continuing validity for contemporary artists. The trajectory of the American sculptor Robert Gober's career over the past ten years reflects the growing acceptance and theoretical authority of figurative art. Recently, he has elaborated on the body fragments that in his earlier work had been seen in eerie isolation to produce pieces on the order of the two sculptural installations presented here: The first, from 1993–1994, is a floor grate and deep drain in which a male torso accepts the rushing water; and the second, from 1994–1995, is a recessed fireplace in which children's legs and shod feet "burn." Taciturn, disturbing, and unforgettable, Gober's sculpture refines and repositions aspects of Surrealism for a somber era, one that is obsessed not only with human death but also with the death of the natural world and the planet itself. Like the best of its Surrealist antecedents, Gober's work confounds our expectations in such a way as to make us reconsider such elements of life as mortality that the avant-garde, in its hermeticism, had abandoned.

Chuck Close's detailed and overscaled bust portraits of friends and family members have asserted a strong influence for twenty-five years. Working from portrait photographs, Close has devised a gridded transfer technique that uses thousands of additive, circular marks to fabricate a likeness. This muscular pointillism, especially evident in his paintings of the last five years, is a particularly vibrant reminder of the artist's fundamental interest in visual perception, which continually allows him to subordinate the relatively uninteresting concerns of portraiture to an ongoing examination of vision, cognition, and recognition.

The principal bearer of the human likeness in our century has been photography, and that genre of the art remains potent today. The works of three photographers included here — Nobuyoshi Araki, Craigie Horsfield, and Cindy Sherman — exploit that power in three different ways. Araki's voluminous and diarylike photographic suites capturing life in contemporary Tokyo suggest him as a modern-day Japanese Brassaï. Like that French photographer, Araki has a taste for worldly pleasure — as evidenced in the unblinking stares at the demimonde seen in the work of both artists. The women Araki photographs are his nightly companions, and many are posed to arouse desire — some of it sadomasochistic. Araki himself has noted that his central subject is death. The narrative taking place over the course of the 113 black-and-white photographs that make up *Sentimental Journey, Winter Journey* (1991–1995) first shows the artist and his wife at their wedding and on their honeymoon, then depicts her hospital confinement and death some years later. These images are interspersed with twenty large color prints of brilliantly hued flowers, entitled *Equinox Flowers* (1995). Pushpinned sequentially to the wall, the unframed prints recall Araki's favored format of the photo album, involving us in an ambulatory "read" of a joyful time and a mournful time that is punctuated by floral exclamation points. His hunger to record Tokyo not only drives him to produce thousands of images each year but also keeps him from traveling away from the city. His ambition is to portray it fully, in all its immense physical and social complexity.

Urban life, principally in Kraków and London, also occupies Craigie Horsfield. English by birth, he spent eight years in socialist Poland, living in Kraków as an act of self-imposed exile motivated by his political beliefs. His time there and, subsequently, in London's economically depressed East End have provided him with images that he holds on to and considers for years before printing. In contrast to Araki's snapshot approach, Horsfield's deliberative process yields images in which the large, framed object is chronologically dislocated from its source. In his view, "No matter the appearance of fast and escalating change that surrounds us, the frenzied static of media and commerce, the mechanisms of social life — change is slow in the way we stand to one another, the common place between us."[10] His examinations of the scenes and people around him are stark reiterations of the intense scrutiny characteristic of many of the artists represented here. Portraits are an especially significant part of his work, including the many he makes of his wife. The intimacy implicit in Horsfield's photographs distinguishes them; the connection between artist and sitter is highly charged, almost magnetic. The viewer very nearly has a sense of having walked in front of the camera, of having interrupted one of those only too rare moments of real exchange.

Always compelling, Cindy Sherman's photographs operate in another public-private sphere altogether. After years of reconfiguring herself in her images with costumes, sets, and makeup, she has lately turned to dolls as subjects. She fragments, recombines, and arbitrarily frames the dolls to produce results that give these works a kinship with Robert Gober's Surrealistic deployment of body parts. As portraits of the miniaturized totems of childhood, her large-scale photographs distort and demonize the dolls, subjecting the maternal/adoptive impulse to a mock horror and provoking questions about all manner of role-playing. Sherman's recent taste for the horrific has moved her away from the inscrutability of her earlier work, suggesting that its seeming neutrality — and her role as ingenue — was a misreading.

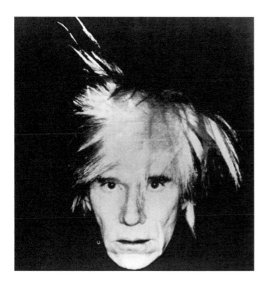

Andy Warhol (American, 1928–1987) *Self-Portrait*, 1986
Acrylic and silkscreen on canvas 80 x 80 in. (203 x 203 cm)
Collection of The Carnegie Museum of Art, Pittsburgh;
Fellows of the Museum of Art Fund, 86.47

10 Craigie Horsfield, "April 4, 1994: A Project for *Artforum* by Craigie Horsfield," *Artforum* 32 (May 1994), p. 78.

In her highly improvisational ink and ink-on-crayon drawings, Marlene Dumas proposes a kind of imaginary snapshot portrait. The stark and fluid faces she creates in such works as *Betrayal* (1994) are, if not likenesses, recognizable as ordinary people. In fact, they are often based on photographs. Her gridded formats lead the drawings to resemble the composite pages of a photo album. She uses the human figure in a way that fuses innocence with the promise of sensuality. Using mostly female figures, Dumas consciously seeks an erotic response to her work rather than a voyeuristic one. As an anti-apartheid Afrikaans South African living abroad, she is particularly sensitive to the numbing generalities of race, ethnicity, and gender. She means to particularize each image, giving each its life and a full complement of empathetic power.

Standing in sharp contrast are Stephan Balkenhol's highly generalized wooden totems and wall reliefs, such as *Large Man's Head* (1993). Indeed, his works in this vein seem to be portraits — but of folks whom we see without knowing. Usually starting from a drawing, Balkenhol carves away large blocks and slabs of wood to make his figures, coloring them with stain and pigment to increase verisimilitude. His likenesses, however, are rough-hewn idealizations that symbolize more than they specifically portray. Ranging in scale from miniature to larger-than-life, Balkenhol's people literally stand facing us. Totemic yet profoundly familiar, his work has reintroduced classical concerns of figurative sculpture into the realm of contemporary art — and further demonstrates the continuing validity of figuration.

During the late 1970s, the protean vision and boundless energy of Joseph Beuys provoked renewed interest in postwar German art. At that time, the work of younger German painters became widely known — Georg Baselitz and Sigmar

Polke foremost among them. The gestural force of Baselitz's expressionist works recalled the action paintings that had captured the art world's imagination in the decade following World War II. By 1967 Baselitz had come upon the radical and liberating device of rendering his images — many of which were human figures — upside down; it has sustained him ever since. In our anti-heroic day, Baselitz has assumed increasing significance in his role as heir to a modernism that seemed to have been extinguished under the combined weight of the many variations of conceptualism. With his recent turn to the floor as his preferred painting site, he consciously produced works, such as his newest, the enormous *Bildeinunddreißig 6.XI–1.XII.1994* (1994), in a process that evokes Jackson Pollock. Traces of the artist — often his footprint — add directly personal touches to the compositions. These gestures visceralize and monumentalize Baselitz's will to draw.

Admired for a radically different, fundamentally ironic approach to painting is Sigmar Polke. Like Baselitz a refugee in his own country (having moved from the east as a student), Polke from the start adopted the aesthetic strategies of Pop Art, critiquing the overarching ambitions and self-seriousness of abstract painters by freely admitting anecdotal, even comic, qualities into his work. An inspired scavenger, he transforms both found imagery and materials into fable paintings that can be both elegant and grand. Often allowing his liquid media to complement his narratives, Polke incorporates the pattern of the fabric into his compositions — as if to juxtapose the accidental with the mechanical. His subjects come mostly from art history and historical illustrations. Superimposed on such highly charged grounds, they offer evidence that painting is both object and image — its contemporary significance dependent on the artist's ability to conjure and simultaneously permit both readings.

Three artists who care deeply about the social role of their work are the Viennese sculptor Franz West, the Dutch artist Rob Birza, and Rirkrit Tiravanija, a Thai educated abroad who lives in New York City. West's eccentrically shaped and presented papier-mâché sculptures might be thought the most traditional work among that of this trio; certainly, he employs a classical vocabulary in discussing his art. He also invents words to categorize it, such as the many portable sculptures that he calls *Paßstücke*, an amalgam of *passen* (to fit) and *Stücke* (pieces). In this exhibition, we have his newer *Telephonesculptures*, which the viewer, who is invited to use a working telephone that West has placed near a sofa, likely encounters with divided attention. The sculptures, sofa, and phone recall physical positions and catalytic roles in his studio. West's gestural expression, manifest both in the idiosyncratic and frequently torqued shape of his forms and in his application of paint, is filtered through a sensibility preoccupied with self-consciousness. Each of the *Telephonesculptures* projects a somewhat different meaning, mutable by the implied invitation either to change it by rearranging the given ensemble or to consider it almost peripherally while talking on the phone. Either way, these works are incomplete without our direct participation in them.

Like West, Rob Birza utilizes pieces of furniture as sites of acquired meanings. Mostly of a circa 1970 thrift-shop variety, Birza's chosen objects act as props set in front of his large-scale painted fields. At first these ensembles, such as *Sleeping Mary* (1994), seem descended from Pop sculpture. But in their incorporation of abstract symbols, their symmetry, and their status as literal salvages, they might better be seen as contemporary manifestations of the metaphysical impulses of Birza's artist-forebears such as Piet Mondrian and Theo van Doesburg. Birza's work calls for a leap of faith on our part, one that requires us to synthesize its outré components with the greater aspirations, formally embodied, in his paintings.

Rirkrit Tiravanija's events, structures, and videotapes — most of them centered on the preparation and eating of food — seem mundane without our participation. The elements of *Untitled (Free)* (1992) reconstituted here as *Untitled (Still)* (1995) — cooking utensils, food and water, tables, chairs, a shelter, videotapes of earlier events, and such architectural components as the doors from the New York gallery where the piece was first sited — are anthropological rather than aesthetic in nature. Tiravanija's artistic role is as an activator, a provider of sustenance, a giver of video stories. He relinquishes artistic ego first by giving us food and second by letting us invent meaning for the experience on our own. His videotapes ramble through real space in real time — much like Chantal Akerman's filmic work. Deliberately anti-illusionistic, they record the ordinary tedium of such everyday acts as cooking, talking, and getting around. Modesty and utility are the cardinal virtues of Tiravanija's action "art." Curried rice is to be served daily in this installation, throughout the run of the International. All the things necessary for making and eating large quantities of food will be on view on the second level of the stairwell leading from the Sculpture Court to the Museum of Art foyer, revealing ingredients and utensils that are usually stored out of sight. Tiravanija's enhancement of common experience (or leveling of it, depending on one's point of view) extends to all aspects of the installation. Storage becomes display, food becomes sculpture, cooking a performance, and leftovers archaeology.

Opening his introduction to the cata-
logue accompanying the 1958 International,
Gordon Washburn, the show's organizer, wrote that
"human societies delegate to artists, beyond all
other members of the community, the duty of full
freedom."[11] His assertion, jarringly romantic to our
ears, is nonetheless one of continuing validity.
Today we would articulate the thought differently,
but the fundamental wish — that our world be con-
tinually examined and reformed by imaginative
people — endures. If that period's hopes and
expectations were embodied by the exploration of
outer space, ours might be characterized as a
moment of introspection and atomized political
desire, embodied by the newly enlarged means
symbolized by cyberspace. The shared goal of
reaching the moon or neighboring planets has
been replaced by a private, if universal, assump-
tion that we should be able to reach one another,
instantaneously, with an almost limitless battery
of data. Knowledge and judgment, let alone expe-
rience, assume different roles within this newly
configured, mostly simulated, universe that prizes
simultaneity above all else. As this new world's
processes become more and more "interactive,"
our dialogue with mechanized, artificial intelli-
gence will expand if not deepen. Richly sensuous
and physically manifest, art can serve as an alter-
native and international language. As always,
its articulation depends on the ambitions and
abilities of artists. Its development and exchange
depend on us.

11 Gordon Bailey
Washburn, Introduction,
*The 1958 Pittsburgh
Bicentennial International
Exhibition of Contemporary
Painting and Sculpture*,
exh. cat. (Pittsburgh:
Department of Fine Arts,
Carnegie Institute,
1958), n.p.

Guillermo Kuitca

Moshe Kupferman

Thomas Locher

Agnes Martin

Beatriz Milhazes

Joan Mitchell

Tomoharu Murakami

Tony Oursler

Sigmar Polke

Doris Salcedo

Cindy Sherman

Robert Therrien

Rirkrit Tiravanija

Richard Tuttle

Franz West

Rachel Whiteread

Rémy Zaugg

Chantal Akerman

There is a crucial moment, about two-thirds of the way through D'Est, that takes place in a Moscow train station. The shot begins with people entering the station through a set of doors. The camera starts to move, very slightly backwards, and then to the left. We spot a paraplegic in the crowd looking absently at the camera. Eventually he is left behind as the camera continues to circle around the space, completing over the course of several minutes a 360-degree arc, returning to the original starting point and recommencing the circle. In this sequence, just as we, the viewers, adapt to the presence of these people on the screen and to our role as onlooker, so do they matter-of-factly adapt to the presence of the camera in their space and to their role as subject. For all of the pyrotechnics of the movement, it is as if the camera has become invisible.

The film's next shot functions as a continuation of the previous one: it seems to take place in another part of the train station and features another right-to-left camera movement (this time lateral rather than circular). Many people, seen mostly in profile, are sitting in a waiting room. A man is eating an apple. Another man is singing. We find people stretched out, trying to sleep on the marble dividers of a staircase. The camera continues its steady, lateral movement through this huge space, affording a view of its subjects that is somewhere between a glimpse and a gaze. Yet the overall impression is of time passing, time that is being monitored (it is a waiting room after all), time that seems to have stood still. The inexorable movement of the camera does not activate this space: it simply marks it, creating a path of movement that seems endless.

In a speech delivered to the Cinémathèque Française in Paris on the occasion of a Louis Lumière retrospective in 1966, Jean-Luc Godard, in a typically counter-intuitive argument, drew a distinction between Lumière, whose actuality films inaugurated the cinema in France, and Georges Méliès, an early filmmaker whose fantastic "trick" films marked the beginning of cinematic spectacle. Godard discredited the usual distinction that is made between the two as producers of documentary and fantasy films, respectively: "What interested Méliès was the ordinary in the extraordinary; and Lumière, the extraordinary in the ordinary."[1] Thus, according to Godard's account, Méliès may have been the first realist of the cinema because he used all of the medium's properties in order to achieve his phantasmagoric tales. At the same time, Lumière may have been the first expressionist because he realized that the most "hallucinatory," "expressive" use of the camera was to let it film reality, to record simply what passed before it.

Akerman's films, and D'Est in particular, manage to incorporate both cinematic approaches. As the camera records the groups of people passing through the doors of the train station, one may think of the very first film of the Lumière Brothers made one hundred years ago, The Workers Leaving the Lumière Factory, *in which a simple, everyday act takes on an added level of importance by the very fact of its being recorded and witnessed. It demands our attention. The rewards of giving that attention are such that we are able to see more than is in the frame. We see beyond and into the image.*

Walker Art Center, Minneapolis, Minnesota. *Bordering on Fiction: Chantal Akerman's* D'Est (1995). Exhibition catalogue, with introduction by Kathy Halbreich and Bruce Jenkins, essays by Catherine David and Michael Tarantino, and text by Chantal Akerman. Excerpt, pp. 53–55, from Tarantino's essay, "The Moving Eye: Notes on the Films of Chantal Akerman."

Bordering on Fiction: Chantal Akerman's *D'Est* 1994
25 video laser disc players, 25 video laser discs, 25 video monitors, projection screen, 2 16mm film projectors, and a full-length feature film
Courtesy of Walker Art Center, Minneapolis

1 Jean-Luc Godard, "Thanks to Henri Langlois," in *Godard on Godard*, ed. Jean Narboni and Tom Milne, trans. Tom Milne (New York: The Viking Press, 1972), p. 235. First published in French as *Jean-Luc Godard par Jean-Luc Godard* (Paris: Pierre Belfond, 1968).

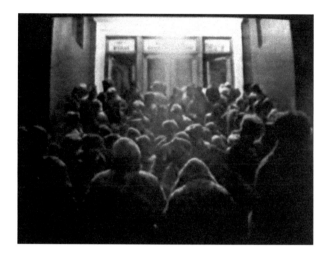
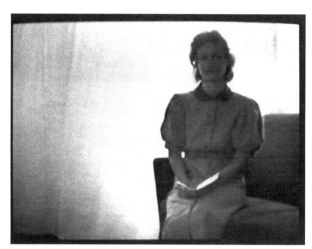

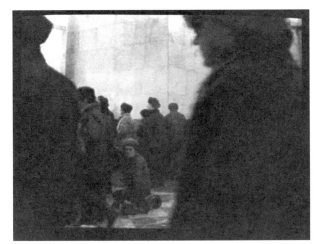

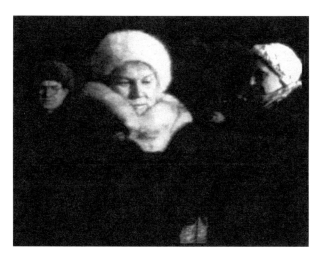 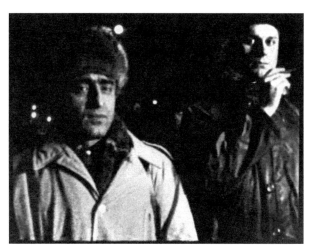

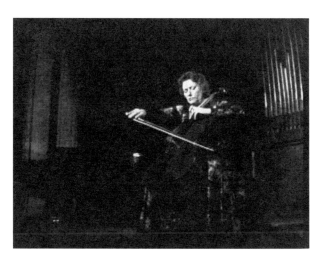 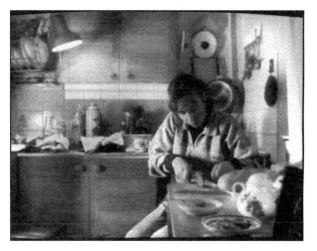

Nobuyoshi Araki

Nan Goldin: One of the things Westerners feel about Japan is that it's a very conformist society — as in that Japanese proverb, "The nail that sticks out must get hammered down." Are you a nail sticking out?

Nobuyoshi Araki: No, I'm not the nail that sticks out, probably because of my in-born virtue. I'm more like a naughty boy.

In the text you wrote for our book together, Tokyo Love, you say you now only want to photograph happiness.

Yes, but happiness always contains a mixture of something like unhappiness. When I photograph unhappiness I only capture unhappiness, but when I photograph happiness, life, death, and everything else comes through. Unhappiness seems grave and heavy; happiness is light, but happiness has its own heaviness, a looming sense of death.

Why do you always say that photography itself has a smell of death?

To make what is dynamic static is a kind of death. The camera itself, the photograph itself, calls up death. Also, I think about death when I photograph, which comes out in the print. Perhaps that's an Oriental, Buddhist perception. To me, photography is an act in which my "self" is pulled out via the subject. Photography was destined to be involved with death. Reality is in color, but at its beginnings photography always discolored reality and turned it into black and white. Color is life, black and white is death. A ghost was hiding in the invention of photography.

A lot of master photographers who have been working for a long time, like Robert Frank, Larry Clark, and William Klein, have become frustrated by still photography and have started making films.

I resolve that feeling by working on the Arakinema show. It's not the artistic process of shifting to another kind of expression that attracts me, it's something more emotional — the biological impulse to bring the dead to life. I want to revive what photography has killed. Every photograph kills sound and words, reducing them to a flat print. I want to add sound and words. Films come close, but films by a photographer are usually another way of showing photographs. The photographer is just using movies to enhance the photo's liveliness. Even if Frank, Clark, and Klein try filmmaking, I would doubt they become cineastes. They'd always remain photographers — just photographers presenting their photographs as films.

What is the Arakinema — a movie? Stills shot on video?

Arakinema is slides shown simultaneously on two slide projectors, so that the photographs overlap. What makes Arakinema compelling is that there's a sort of sensuality of vision when photographs intertwine. My relationship with my subject is extremely important to me — I value that time and space of communication between myself and the subject when I'm working — so the more sensual the photograph is, the better. And if I mix old photographs with new ones in Arakinema, something I hadn't noticed may come out. When I take photographs I collaborate with the subject; when I show photographs they collaborate with each other. And the relationship with the audience comes on top of that....

What photographers have influenced you?

I like photography so I like all the photographers before me, even if they're lousy or not my style. But among foreign photographers, Frank, Klein, Eugène Atget, Walker Evans, Ed van der Elsken, and Brassaï were the ones who stood out when I was young. I was working in advertising, at Dentsu, so I had access to foreign magazines and plenty of information. I remember seeing work by Richard Avedon and Irving Penn.

I've always had the impression you particularly admire Frank. How did you meet him?

Someone from Japan gave him my book Araki's Tokyo Erotomania Diary. Later, when he was asked what Japanese photographers interested him, he said "Araki." We met when he came to Tokyo. I think of him as an older brother. But he's more serious than I am....

Does success in Europe or America interest you?

Not much. I don't travel abroad. I don't have much of a desire to have everyone around the world see my stuff. My new book, Bokuju-kitan, has only a thousand copies, but that's all right.

You wouldn't just travel for pleasure, or to visit me?

If it's going to be just the two of us, Nan, I'll start English classes tomorrow.

But you wouldn't travel to take photographs?

I did photograph in New York once, in 1979, and it was really exciting. But I use words in the process of photographing, so it's difficult taking pictures overseas. I usually talk to the model as I'm shooting — it's a "word event." Words wouldn't be necessary if I were looking at the subject as a "thing," an object, but I want to capture my relationship with the subject, the action between us, the flow of time and mood. If I were photographing foreigners I'd really have to study the language....

What's your latest obsession, your latest body of work?

I have an obsessional subject: "From death toward life." And I'm working on a diaristic work — a book of photos all taken with a compact camera, to be published in the spring.

For me, the fact you've done so many books is one of the things that's inspiring about your work. Another is that you're the only photographer I know who uses whatever format you want.

Photography is a collaboration with the camera, and every camera is unique; our time can't be captured by a single camera. Using one camera is like being confined to a fixed idea. If I photograph a woman with a six-by-seven, medium-sized camera and then fast with a compact camera, the photo will be different. If you take the camera as "man," it's as if I throw four or five men at a woman. Obviously her response differs depending on who he is. There's also a difference depending on whether it's a camera I have a lot of experience with, one I'm using for the first time, or one that's hard to use.

Goldin, Nan. "Naked City: Nan Goldin Talks with Nobuyoshi Araki." *Artforum* 33 (January 1995), pp. 54–59, 98. Excerpt, pp. 57–58, 98.

Sentimental Journey, Winter Journey with **Equinox Flowers** 1995
113 black-and-white photographs, each 9 x 11 in. (22.9 x 27.9 cm); 20 color photographs, each 23 5/8 x 35 7/16 in. (60 x 90 cm) Installation dimensions variable Collection of the artist

Richard Artschwager

Admittedly, an installation of art shipping crates, the readymade signifiers of international art commerce, sounds dumb: the one-line tactic of some slacker on the artwork as commodity, almost ten years too late. However, as they form the bulk of Richard Artschwager's installation entitled Archipelago, these only slightly modified pine and plywood containers transform the gallery at Portikus into an encapsulation of this characteristically cryptic artist's work. In the presence of these obdurately empty objects, one comes up hard against the self-governing rule of Artschwager's painting and sculpture: that art is "pre-literate vision."[1] Guided by this notion, moving through this installation is a surprisingly full experience.

Fourteen crates fill the gallery. From floor, to walls, to ceiling, they cover in candid coolness what the artist calls: "the three 'hot' levels of contact: there is the visual at eye level, and then somewhere around the waist/crotch/navel level which can also involve the hands — eating dinner for example, and the other is where your feet are, and that's your contact with everything else that's around."[2] Some crates go to eccentric lengths to achieve this coverage. One is actually suspended in a corner, high up on the wall. Another is a veritable Brancusian endless-crate-column, poking through one of the panes in the gallery skylight with its heaven-kissing aspirations.

Although they range in size from hassock, to piano, and beyond, the crates are uniformly muscular in their construction with heavily built-up corners and reinforced fronts, as if to endure a great deal of internal or external force. This lends their presence authority, making their command of the gallery absolute....

Upon entering the gallery, four crates create an immediate front line, giving one pause in what makes for an anxious mental vestibule. "Is the gallery closed?" "Is the exhibition fully installed?" "Did I use the wrong door?" "Is this it?" Having been invited to make a work especially for Portikus — where the program regularly gives rise to such provocations — Richard Artschwager takes his turn at posing these mysteries with deadpan seriousness. Like Marcel Duchamp's little teaser, With Hidden Noise *(1916),[3] Artschwager's crates appear to keep clandestine some tantalizing contents as if perpetrating a prank on the ostensibly thwarted viewer.*

Portikus, Frankfurt. *Richard Artschwager: Archipelago* (1993). Exhibition catalogue, with foreword by Helmut Friedel, Martin Hentschel, Kasper König, and Ulrich Wilmes and essay by Ingrid Schaffner. Excerpt, pp. 25, 27, 45, from Schaffner's essay, "Archipelago *Bop.*"

1 In discussing his work, the artist frequently uses this term; it recently surfaced in print in Artschwager's response to "What & Who was 'POP'?, A Questionnaire." *Modern Painters: A Quarterly Journal of the Fine Arts*, vol. 4, no. 3, Autumn 1991, p. 56.

2 Artist speaking with Brooke Alexander about the multiple entitled *Mirror* (1988), quoted in *Richard Artschwager: Complete Multiples*, New York: Brooke Alexander Editions, 1991, n.p.

3 For this collaborative piece, Duchamp gave his friend and patron Walter Arensberg a ready-made ball of twine and asked him to contribute the noise which would be sealed inside. Whatever this was, it remained hidden from the artist who never asked to learn the identity of this aurally mysterious object. Also called *Ready-made, Ball of Twine* and *A Bruit Secret*, The Louise and Walter Arensberg Collection, Philadelphia Museum of Art.

Installation views, Portikus, Frankfurt
April–May 1993

Table Prepared in the Presence of Enemies
1993
Aluminum, Formica, and wood
59 x 60 x 75 in. (149.9 x 152.4 x 190.5 cm)
Collection of the artist

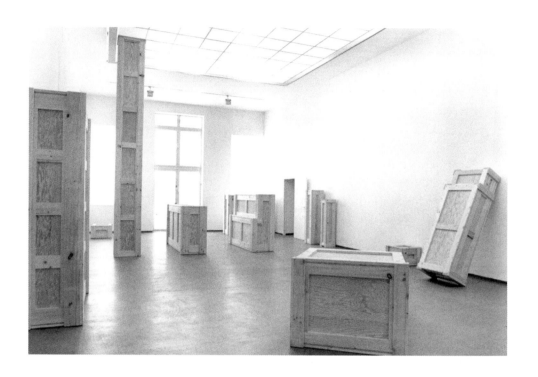

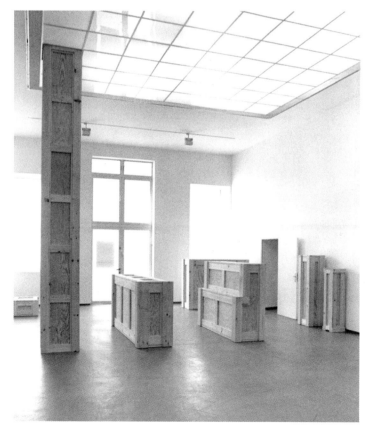

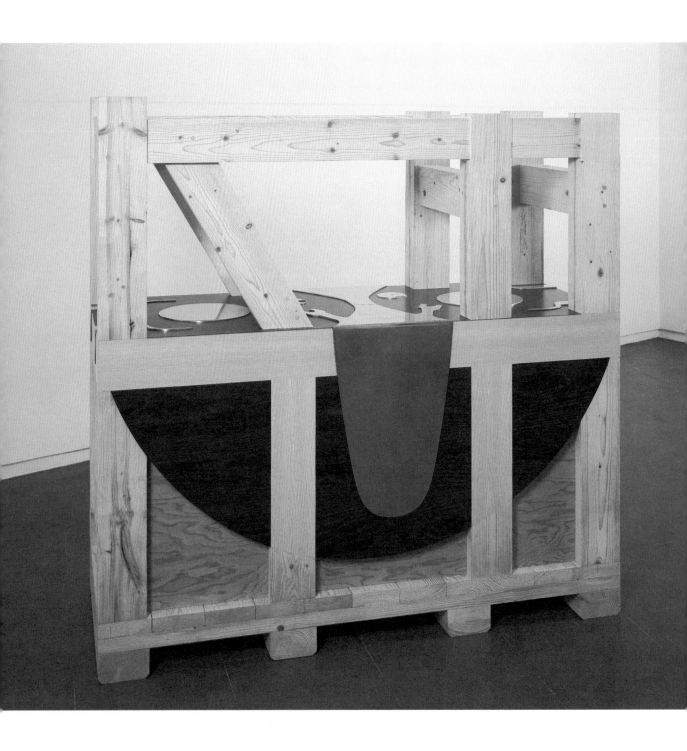

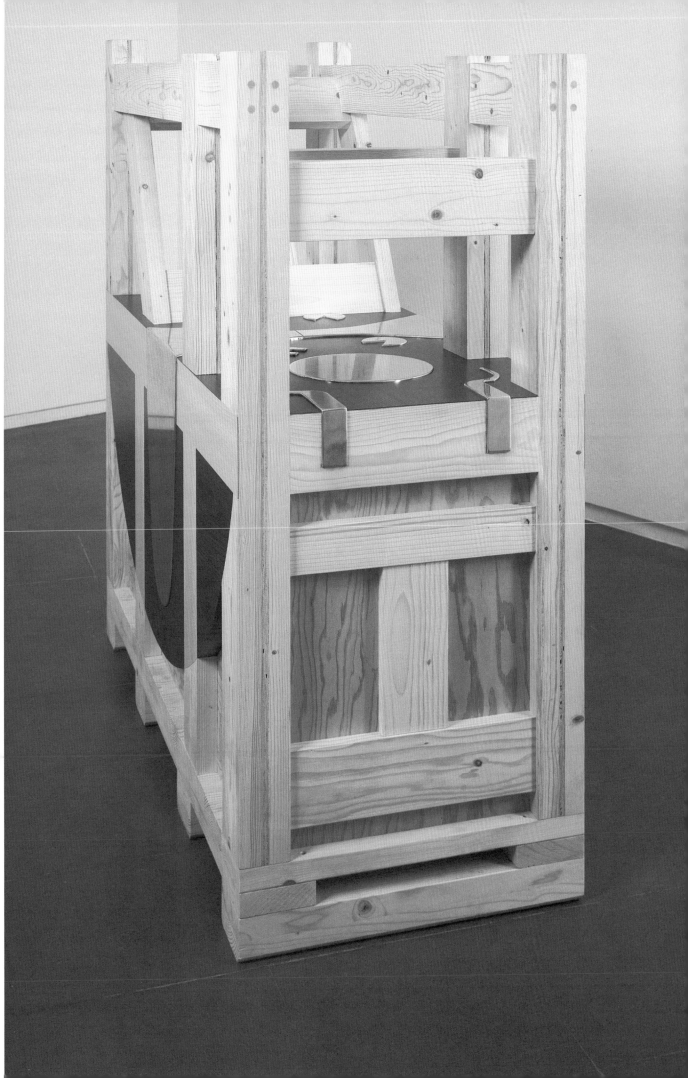

Mirosław Bałka

In various civilisations, the overcoming of fear implies crossing the threshold of something, going through an initiation rite. The threshold is an element that frequently appears in the works of Mirosław Bałka. It denotes the passage between various spaces and contexts, between territories which Bałka discovers with his body, which serves him as a kind of map. The objects used for his works are usually detached from his personal world, which is seemingly the only one that he knows, or, to put it more accurately, has control of. Once the objects are transferred into a public place, a gallery, their meaning becomes wider. Thus they also give evidence of the history from which they had been excluded. Growing up at a time that propagated collectivism, Bałka turned to his intimate world, resolving to rely upon individual, first-hand experience.

His works are autobiographical and, in a certain way, anthropomorphic. They are imbued with his recollections and made after the actual size of his body. Living in a society of historical constructs, he clung to his emotive memory, to everything his body would register through all its senses. Bałka's contemporaries in the West entertain an apprehension à la Blade Runner, doubting even the most intimate memory. In comparison with this predominantly visual, collective experience of the West, it could be said — I hope, however, that this does not sound too cynical — that the Eastern experience is more haptic. It involves the whole body, and therefore it is more genuine. How on earth could anyone simulate freezing, hunger and pain?

Bałka's memory is emotional, even poetic, and far from making any pretensions whatsoever to being considered objective. I venture to say that, in terms of classical iconography, Winterhilfsverein *is — as indeed the majority of his works are — a kind of self-portrait. It reveals his physiognomy (the dimensions of all the structures corresponding to the dimensions of his body), discloses his intimate world and work environment (the threshold is actually made from a piece of linoleum used as a floor-covering in his studio before it burnt down), and through this Bałka relates his feelings and reflections, his emplacement in the world. What a host of figures Courbet depicted in his studio to demonstrate the rootedness of his art in a particular social context! And how little Bałka needs for the same end — no more than an air of poverty, the smell of glue and that hole, a piece of pipe placed upright on the floor reminiscent of all those drainage outlets with which toilets, sinks or our bodies are provided! In his work, the attention remains focused on Bałka the artist, or, to put it otherwise:* Winterhilfsverein *exists because of him and through him. Once we enter the* Mala Galerija, *when we step over the linoleum threshold and find ourselves in the "house," lit by a single light bulb, we in fact step into his second skin.*

Being haptic rather than visual, the reading of Bałka's work elicits associations that are metonymic rather than metaphoric. All that is present in the gallery space conjures up an atmosphere that differs from reality. At the same time actual reality is, through authentic objects and personal memories, preserved as a trace. On another level, it is retained as topicality, a presence here and now, in the warmth of the electric bulb, in the smell of the animal glue and in all the transitory conditions that make our bodily experience possible.

14 x 3 x 7, 14 x 3 x 7, 300 x 170 x 8, 280 x 190 x 8, Ø0.8 x 1100, Ø25 x 27, Ø25 x 27, 60 x 20 x 15, 60 x 20 x 15, 242 x 170 x 15, 242 x 170 x 15, 50 x 30 x 40, 50 x 30 x 39, Ø20 x 2 1994

Steel, linoleum, terrazzo, paper, salt, ash, felt, and heating cables
$5\frac{1}{2}$ x $1\frac{3}{16}$ x $2\frac{3}{4}$, $5\frac{1}{2}$ x $1\frac{3}{16}$ x $2\frac{3}{4}$, $118\frac{1}{8}$ x $66\frac{15}{16}$ x $3\frac{1}{8}$, $110\frac{1}{4}$ x $74\frac{13}{16}$ x $3\frac{1}{8}$, Ø$\frac{5}{16}$ x $433\frac{3}{8}$, Ø$9\frac{13}{16}$ x $10\frac{5}{8}$, Ø$9\frac{13}{16}$ x $10\frac{5}{8}$, $23\frac{5}{8}$ x $7\frac{7}{8}$ x $5\frac{7}{8}$, $23\frac{5}{8}$ x $7\frac{7}{8}$ x $5\frac{7}{8}$, $95\frac{5}{16}$ x $66\frac{15}{16}$ x $5\frac{15}{16}$, $95\frac{5}{16}$ x $66\frac{15}{16}$ x $5\frac{15}{16}$, $19\frac{11}{16}$ x $11\frac{13}{16}$ x $15\frac{3}{8}$, $19\frac{11}{16}$ x $11\frac{13}{16}$ x $15\frac{3}{8}$, Ø$7\frac{7}{8}$ x $\frac{13}{16}$ in.
(title of work refers to its components' dimensions in centimeters)
Collection of the artist.
Courtesy of LondonProjects

Mala Galerija, Moderna Galerija Ljubljana. *Mirosław Bałka: Winterhilfsverein* (1995). Exhibition catalogue by Zdenka Badovinac. Excerpt, n.p., from Badovinac's untitled essay (translated from the Slovenian by Mika Briški).

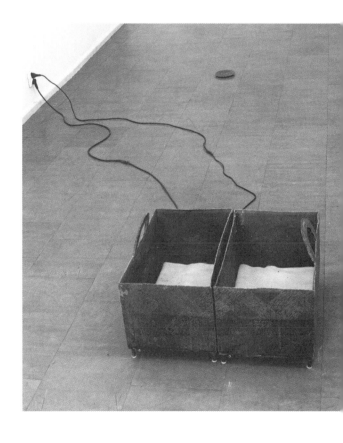

Stephan Balkenhol

*Although the form of Balkenhol's sculpture appears familiar, his use of the language is less so. Rather than unequivocally representing either the unique or the universal, Balkenhol's sculptures embody the unresolvable dialectic which lies at the heart of human existence — the dialectic between the experience of the human being as a distinct individual, and his or her experience as part of a community, society, or crowd. When seen from a distance, as many of Balkenhol's outdoor sculptures are, it is relatively clear that they represent an individualised rather than an idealised figure, someone more ordinary than heroic. Even if these standing figures and monumental heads lack some of the more evident intimacy of the smaller reliefs, the painted eyes and lips, the coloured hair and skin and the casual clothes they wear place them within the parameters of individual experience — as someone we might know, or even be.
They are not smooth or refined. Carved at speed from single pieces of wood, they retain the sense of a momentary impression within their monumental form. The wood, and its evident physical transformation, enables the sculptures to have a lightness directly counter to the weight and permanence of bronze. They are more human than a statue even if they are insufficiently distinct to be an individual.*

From a distance, therefore, they are recognisable as sculptural representations of individual members of contemporary society. The expectation is that this generality will be superseded, as one gets closer, by a more specific individuality, a personality even. But as the features become more distinct, the promised individuality paradoxically fails to materialise. A scrutiny of the face reveals a certain physiognomic definition, but the face refuses to become a portrait. Its absolute individuality insists on remaining elusive. The figures are not animated by expression; they remain passive and distanced. Balkenhol's sculptures oscillate between the promise of naturalism and the distancing action of abstraction. This recalls Balkenhol's experience when he visited the British Museum. He found the more abstracted and schematic representations of the face and figure in Egyptian sculpture more compelling than the refined naturalism of Roman sculptures. To Balkenhol, the Egyptian sculptures embodied a stronger sculptural presence.

Neither specific portraits (nor self-portraits), nor generalised representations of Everyman, Balkenhol's outdoor sculptures represent the state of the anonymous individual, a person whom we recognise, but do not know. Such a person demands little attention in the metropolis since the city, unlike the small town or village, is a company of strangers. To negotiate the intense daily activity of metropolitan life, he needs to avoid making physical contact, even eye contact, with most strangers. It is preferable to ignore them, keep a distance, remain apart. The nature of the relationship between strangers in the metropolitan environment was articulated by Georg Simmel in his essay entitled "The Stranger": "…the stranger is near and far at the same time, as in any relationship based on merely universal similarities. Between these two factors of nearness and distance, however, a particular tension arises, since the consciousness of having only the absolutely general in common has exactly the effect of putting a special emphasis on that which is not common."[1] This paradox — that "one who is close by is remote [but] one who is remote is near" — seems integral to an understanding of the contemporary meaning and importance of Balkenhol's sculptures.

1 Georg Simmel, "The Stranger," first published 1903. Reprinted in translation in "The Conflict in Modern Culture and Other Essays," ed. Peter Etzkorn, New York 1968, p. 146.

Another way of articulating this duality is to consider that Balkenhol's sculptures shift between the individual and the crowd. However, the crowd at the end of the 20th century differs fundamentally from the crowd at its beginning. Simmel was writing in a city, Berlin, and at a time (the first two decades of the century) which embodied two mutually dependent phenomena — the great collective of the urban proletariat, and the great epoch of the individual. Balkenhol's heads and figures also exist within and embody a specific historical moment. But this moment comes after the cathartic historical experiences of mass collective action, of the seething urban proletariat and after the apotheosis of the Romantic individual (from Théophile Gautier to Nietzsche, the uniqueness of the individual was emphasized in opposition to the conformity of the bourgeois and the anonymity of the urban crowd). In Western Europe, the era of heavy industry is in its twilight. The intensity of the concentrated mass has dissipated into the atomised existence of the suburban sprawl; the transformative potential of the proletariat diluted by the passive acquiescences of the consumer age where collectivity is constituted most frequently by small units of television and video watchers, consuming the same images on different screens. Balkenhol's sculptures exist in the age of mass communication rather than the era of mass action. They look like they might have watched a lot of television. They are not only normal, but normalised.

Witte de With, Rotterdam. *Stephan Balkenhol: über Menschen und Skulpturen/About Men and Sculpture* (Stuttgart: Edition Cantz, 1992). Exhibition catalogue, with introduction by Chris Dercon and Gosse Oosterhof, essays by James Lingwood and Jeff Wall, interviews with Ulrich Rückriem and Thomas Schütte, and text by Stephan Balkenhol. Excerpt, pp. 61–62, 64, from Lingwood's essay, "Reluctant Monuments."

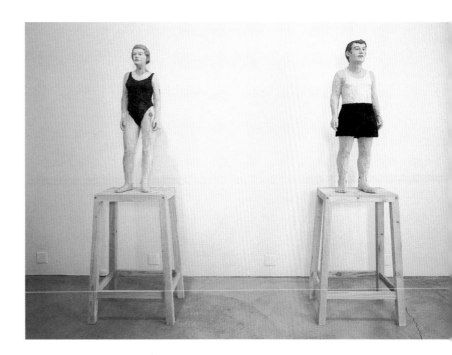

Woman in Green Bathing Suit 1993
Man in Black Trunks 1993
Sugar pine and stain, wooden pedestals
Each 86 x 27½ x 20 in.
(218.4 x 69.8 x 50.8 cm)
Regen Projects, Los Angeles

Grosser Mann 1994
Painted cedar
88 x 39 x 22 in. (223.5 x 99.1 x 55.9 cm)
Collection of Ellen and Jerome Stern.
Courtesy of Barbara Gladstone Gallery,
New York

Kleiner Mann 1994
Painted wawa-wood
63 x 12½ x 11 in. (160 x 31.7 x 27.9 cm)
Collection of Sophie van Moerkerke.
Courtesy of Barbara Gladstone Gallery,
New York

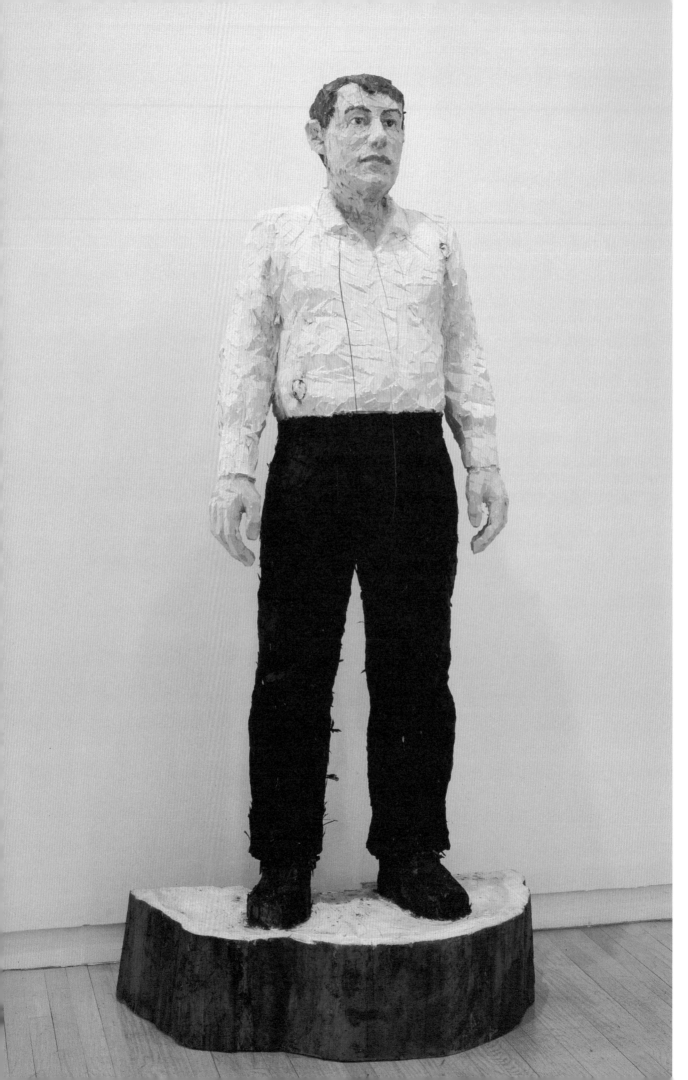

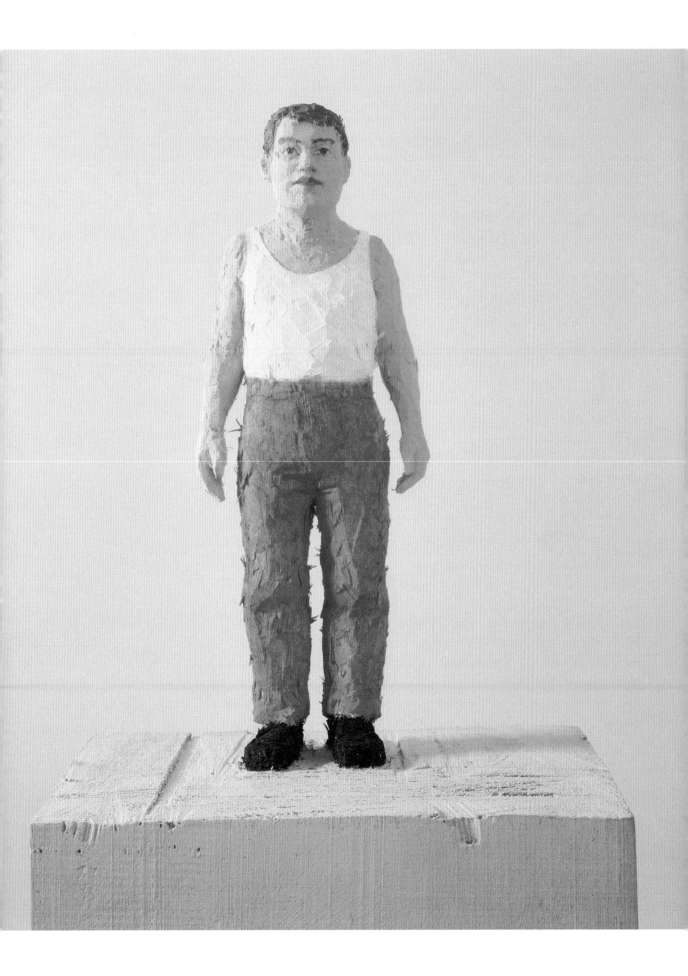

Georg Baselitz

These paintings are painted — sort of painted. They are painted, but then again they are not. They are painted somewhat differently than the way I used to paint. The pigments are put on the canvas, and the canvas is stretched on a stretcher. By the time I stretch the canvas, I've already done the painting and completed it on the floor. The canvas lay on the floor, and I applied the pigments. It's precisely this painting technique that separates these from the previous paintings. One reason, for instance, is that I don't have a wide or full view of what I've done while painting. In order to get an overview I would have had to climb up a high ladder. But I didn't want to. So I can only see the little bit that I'm doing on the large surface — I stand, walk, and kneel on the canvas while I squeeze out my colors. The ground, which is white or, most often, black, was done at the very start. If anything — say, the drawing — doesn't work, work out as it should, then I cover the entire canvas with black and start the drawing all over again.

If I have to say now — that is, after the fact — what it is that I'm drawing, I'm tongue-tied. For when I crawl around the canvas and squeeze out the pigments, I know what I'm doing but not what it is that I'm doing. I once thought of describing it as painting or drawing something that's under, somehow under, underneath, under the canvas. And it's certainly not wrong to say that these are — perhaps to a very essential extent — my own old drafts, drawings, paintings, and so on. Anyone can see it, after all. The old heroes, lumberjacks, and friends can be seen, and also hares, dogs, pigs, trees, and lakes — although more linear, more ornamental than in the past. I've now done a better job of getting them to the surface. I've put them down, sort of like painting vases, like painting ceramic tiles. Then again, these things that are made today are no knock-offs or projections of old things, they can't be, for nothing was lying under the canvas, nothing that could be physically felt or that could fall from the head as a cipher that was stamped on the mind.

During the past few years my attitude toward painting and my observation of painting have changed profoundly — in such a way that I can't explain what is really happening on the canvas, because it's important and it has to happen, and because most of what other people call paintings cannot be compared with what I'm trying to do in paintings. Previously there was more consensus. There was more security in the company of painters. I often do like other artists' paintings, but I find less and less to relate to in them. I don't mean a comparison of quality or whatnot. What I mean is that the things I make are not paintings. Nor do I know what else they may be. I don't mean that they're better or worse or different, I just mean that they're totally different. Be that as it may, now that I've already started to interpret them, I really want to take a stab at it.

*It could be possible that there is a congruence, an overlapping between, on the one hand,
what I've been thinking for years and what I've accordingly drawn and painted and, on the other hand,
my current activity as a painter — whereby this painter won't let in something that wants to come
through the door. That is, I don't want to use any new material, I want to use only what's been here for
years — something that's so restless that it constantly keeps turning more and more into lines
and colors in its own circulatory system. We shouldn't picture that as a nice person without curiosity.
No, it isn't like that. What I see instantly arouses a memory of something I once saw, and it has
turned into pictures, and meanwhile I see the pictures more and more sharply as models for pictures.
The colored strokes and splotches and dots are already filled, occupied by the appropriate
pictures, they are no longer free, can no longer be used in any other way, can no longer be formed anew.
My entire kaleidoscopic system is gathered in a cardboard tube that I don't want to give away.
I myself threw in all the multicolored glass shards at some point. Earlier I broke open this cardboard
tube and tried to fill in new and different variants. Then everything fell apart, and so the system
has to be kept shut. The gathered stuff is seething and simmering and trying to get out. The mind, as a
catalyst, can process things that come from outside. You look into the landscape and make
it into a picture. But the reverse can also happen. The catalyst with a vent is the untight place on the
vessel, on me, and it lets the squeezed things fly out. The imagination spreads like the spores
of the trodden puffball. This concept of painting is not unpleasant. I think that's how it is.*

*A child has no biography, has gathered nothing, but his imagination already spread inside him
before he was born, and when he draws he tries to harmonize his imagination with whatever he sees
and experiences. But sooner or later you're no longer a child, then you've done enough comparing
and measuring and drawing; and at that point, when every stroke, dot, or splotch is no longer used to
compare with a thing, to approach it, then that's enough. Now you only need to talk to yourself
and you've got a lot to say — and so much for that.*

Derneburg, November 25, 1993

Zwei Steine 12.I.91–13.II.91 1991
Oil on canvas
118⅛ x 98⁷⁄₁₆ in. (300 x 250 cm)
Galerie Michael Werner, Cologne
and New York

Abilgards Kirche 4.II.91–9.II.91 1991
Oil on canvas
118⅛ x 98⁷⁄₁₆ in. (300 x 250 cm)
Collection of Lynn and Allen Turner,
Chicago

Bildeinunddreißig 6.XI–1.XII.1994 1994
Oil on canvas
114³⁄₁₆ x 177³⁄₁₆ in.
(290 x 450 cm)
Galerie Michael Werner, Cologne
and New York

Solomon R. Guggenheim Museum, New York. *Georg Baselitz* (1995). Exhibition catalogue by Diane Waldman, with text by Georg Baselitz. Excerpt, pp. 247–249, from Baselitz's text, "Painting Out of My Head, Upside Down, Out of a Hat" (translated from the German by Joachim Neugroschel). First published in German and English as "Malen aus dem Kopf, auf dem Kopf oder aus dem Topf/Painting: Out of My Head, Head Downward, Out of a Hat," trans. David Britt, in *Georg Baselitz: Gotik — neun monumentale Bilder*, exh. cat. (Cologne: Galerie Michael Werner, 1994), pp. 24–25, 28–29.

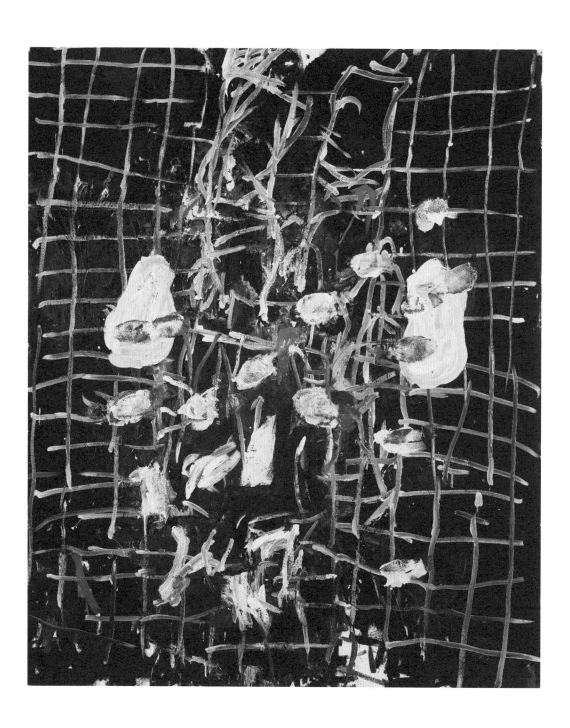

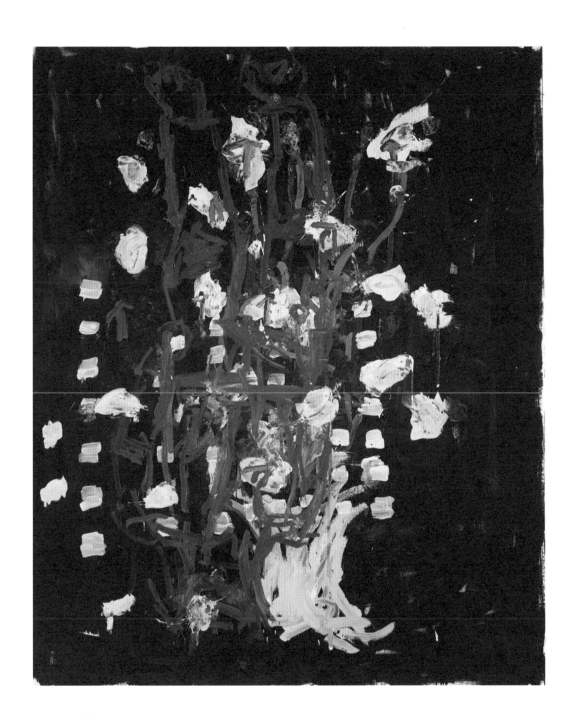

Rob Birza

Post-modern? Broadly speaking, Rob Birza's paintings run synchronously with (by now) famous notions such as fragmentation, reflection and image explosion, but on the other hand, they are not doing that at all. The absence of an ideological framework does not create an impasse or form a menace, but is simply ignored, or in other words: it is a fact. The fluid is void and still, but in full motion, and in that sense overtakes the disorientation of post-modernism — perhaps on the way to a new destination. Sticking to aerospace terminology: the ship may be off course, but lets itself be borne along willingly, navigated by the principle of inversion. To the left or the right? Is forwards the same as backwards, or is space the same as time? Birza's presentation of questions flows out into an indefinable, but open tone, resonating in the paintings as an undertone of expectation and mystery (or is it doom?). Despite the earthly origin, the quotes and derivations hardly seem to refer to the outside world, or to higher spheres, but — in the spirit of the Holbein copy — to a lost era. Our excessively well-informed society is reflected in it as a mirage, while the fragmentation represents the way in which the image information wanders through the memory, to subside in the ocean of the subconscious — Rob Birza's secret workshop.

It goes without saying that Birza is turning against a one-sided use of the ratio, but advocates a form of "overall thinking." This standpoint is reflected in his working method, which does not show any marks of cynicism or "novelty," but rather has assumed the "familiar" form of painting. Although among "cutters and stickers" it is now fashionable to leave the execution to others, Birza invariably reproduces the "stolen fragments" in his own handwriting, with the help of an age-old painters' medium, which owes something "magical" to its composition: egg tempera. Style may be lost,

but painting has not been given up; stronger even, with intuition as a guideline, it offers a significant counter-balance. In practice, this leads to a kind of over-concentration, bordering on trance. Egg tempera dries quickly and requires alert action, which over-pressures the decision-making. Hit or miss — painting by feel. To banish beforehand any associations with lyrical forms of painting such as the écriture automatique, a provisory term like image automatique is more appropriate. Although with Birza, too, the locomotion of painting brings about a ritual spell, it serves a different purpose....Within this context, painting does not seem the aim as such, but a vital, almost magical medium, evoking one phantasmagoria after another as a matter of course. On the other hand, there is the inversion. On the principle that nothing is impossible, Birza's basic package contains a hybrid multitude of contradictory methods and views. Decoding functions, rational studies, conceptual models and highly stratified compilations are opposed, not only by offhand and casual notes, but also by purely painterly exercises, while the over-all image is as good as synonymous with a celebrative consecration of the art of painting. However, the urge to "disappear into the paint" is curbed by conceptual reservation — a critical reflection on the history and ontology of the art of painting. This turns painting into something more or less fatal, and it is the source of a path which in the past year has been twisting between the extremes of disarmament and destruction towards a setting dramatic in tone.

Stedelijk Museum, Amsterdam. *Rob Birza* (1991). Exhibition catalogue, with essays by Wim Beeren, Toine Ooms, and Marjolein Schaap. Excerpt, pp. 59–60, from Schaap's essay, "A Mickey Mouse with White Stick: Racing Thoughts" (translated from the Dutch by Olivier and Wylie, Eindhoven).

Frost and Frowzy 1994
Ceramic, wood, paint, and electric lights
80 11/16 x 90 9/16 in. (205 x 230 cm)
Collection of the artist

From Soap to Soap 1995
Ceramic, wood, and tempera on canvas with two cloth-covered tables
55 1/8 x 129 15/16 in. (140 x 330 cm)
Collection of the artist

Sleeping Mary 1995
Lacquer on canvas, ceramic, and chairs
118 1/8 x 157 1/2 x 60 in. (300 x 400 x 152.4 cm) (overall)
Collection of the artist

Chuck Close

Treating his head-shot prototypes simply as a pretext for painting for the first time, Chuck Close's pictures of the last several years are at once more decorative and more emotionally revealing than anything that preceded them. Of course when one thinks of the decorative portraits, what comes to mind are privileged pretty faces surrounded by ruffs or wrapped in swaths of luxurious cloth: Sir Thomas Lawrence, for example, or John Singer Sargent. It is a tradition of psychological demurral and flattering flourishes. The fabric of Close's newest paintings (more homely and American in its associations but equally pyrotechnic in its effects) is a hook-rug system of dots, dashes, rings and bars, and the faces as usual, are pleasant but rarely pretty. Good looks suffer especially when subjected to Close's reweaving — as they do when plastic surgery erases the slight asymmetries which accent the near-ideal and make it tolerable and interesting — but average and eccentric faces come to life. As the dabs and loops of paint pull away from the exact point at which their linkage with or superimposition upon another map a nostril or facial tuck or glint in a pupil or curl of a beard or forelock, the subject's features quicken, as if by a muscular tic or the barely suppressed temptation to mug at the viewer....

All this from two studio head-shots and hundreds upon thousands of paint fragments and printer's gauges. Confronted by any single example, one wonders how Close manages to sustain the effort, but confronted by several the answer suggests itself with magical clarity. For at some point in each picture there must come a moment and a mark which causes all the elements to rearrange themselves and the entirety to take on its essential character. At that point the artist's intention and the model's identity are subsumed and exceeded by a vision of both which unfettered vision imposes. Method advances the process to that crucial event, and from there on out the eye takes over, composing and recomposing the buzzing electrons of optical fact around the complex nuclei of given form. If this conjecture is accurate, then from that time until his picture's completion Close himself must feel like a spectator to its making, laying in all that remains of the image to see what will happen next but knowing, as the ordinary viewer soon knows, that the end-product will continue to "make faces" as the bits and pieces of which it is constructed continue to blink, flare and slide in unsettled relation to each other. Their animation lends Close's most recent work its peculiarly life-like vitality and so, at the edge of becoming schematically abstract, his pictures have achieved new realism and a new warmth. At that edge — beyond trompe-l'oeil *where the eye, unfooled, is free to fool around and tell its* truth — *seeing is indeed believing.*

Staatliche Kunsthalle Baden-Baden.
Chuck Close: Retrospektive (Stuttgart: Edition Cantz, 1994). Exhibition catalogue edited by Jochen Poetter and Helmut Friedel, with essays by Margrit Franziska Brehm and Robert Storr. Excerpt, pp. 51, 53, 57, from Storr's essay, "Not Just Another Pretty Face."

Alex 1991
Oil on canvas
100 x 84 in. (254 x 213.4 cm)
Collection of Lannan Foundation, Los Angeles

Janet 1992
Oil on canvas
100 x 84 in. (254 x 213.4 cm)
Collection of Albright-Knox Art Gallery, Buffalo, New York
George B. and Jenny R. Mathews Fund, 1992

Self-Portrait 1993
Oil on canvas
72 x 60 in. (182.9 x 152.4 cm)
Private collection

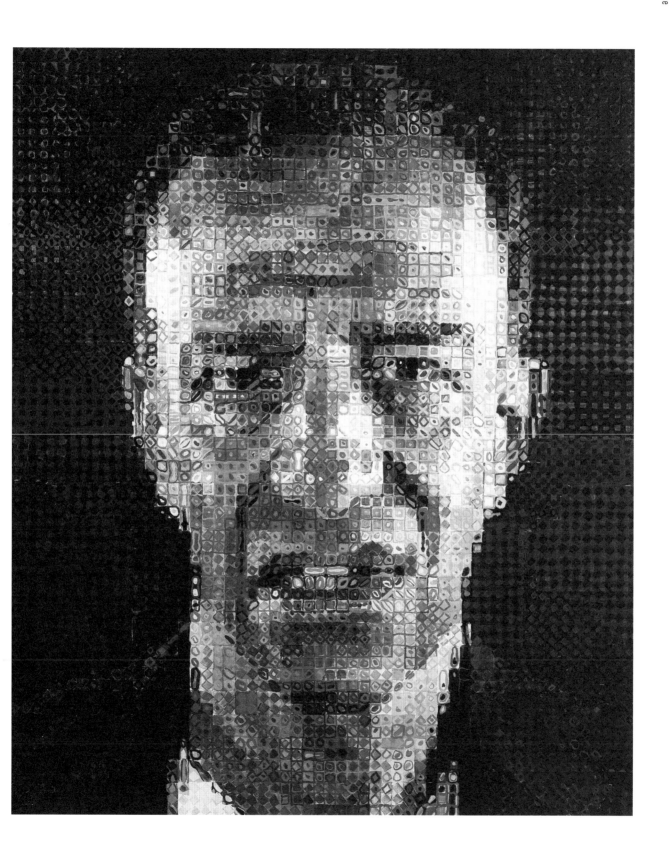

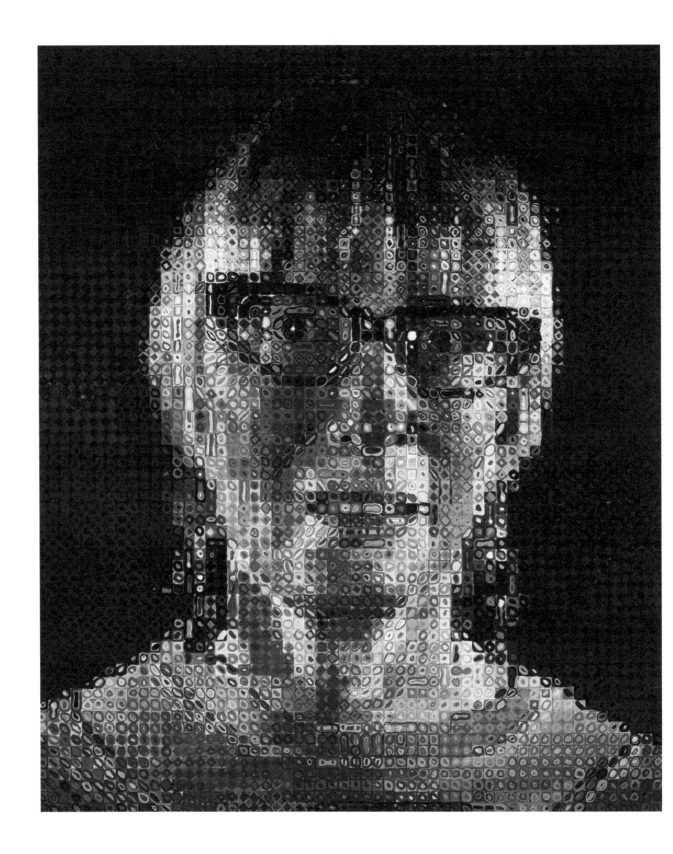

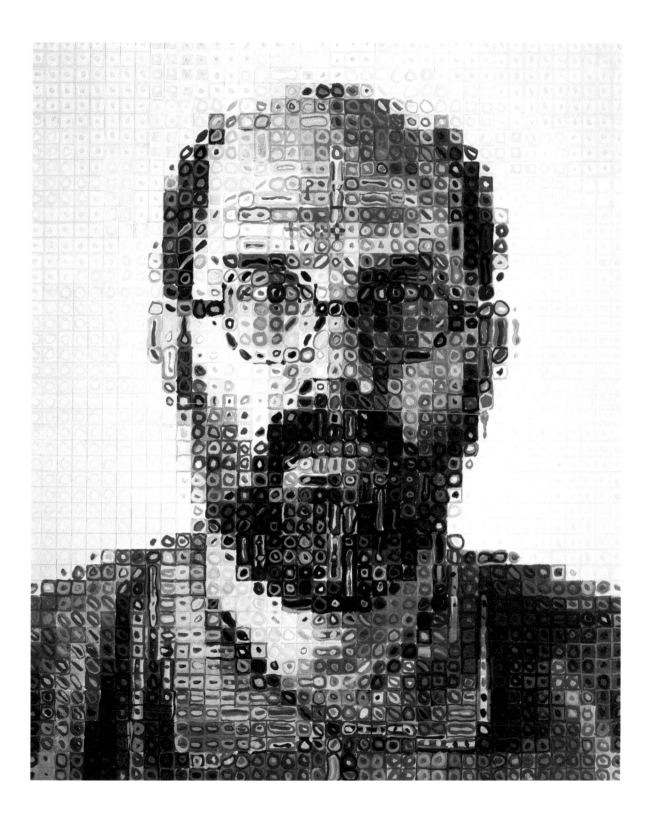

Stan Douglas

Der Sandmann was shot in December 1994 at DokFilm Studios in Potsdam-Babelsberg. A large set depicting a local Kleingartenkolonie *was constructed in DokFilm's* kleines Atelier *— and a motion-controlled camera placed at the centre of the room was used to record two 360-degree pans revealing both our construction at one end of the room and, in the other, the Narrator framed by film equipment and the surround of the 1920s-vintage Ufa/DEFA studio. One pass of the set presents the* Kleingarten *as they appeared some twenty years ago, and the second shows the half-garden half-construction site today. Just as the studio and the Narrator remain more or less identical in appearance, some aspects of the set also remain constant — in particular the "Sandman" and his garden, where the old man mixes sifted soil with boiled loam that is pumped into the earth by a contraption with which he hopes to grow* Spargel *(asparagus) out of season. Twenty years later he still hasn't found the right formula, even though his plumbing has grown more and more elaborate.*

The film is presented by two 16mm projectors with looping mechanisms that will allow continuous exhibition. Both machines project copies of the same film but they are out of phase by exactly one half of the film's total duration (i.e. one rotation of the studio). The two projections are seen on the same screen; however, the left of one and the right of its double are masked out and they meet seamlessly in the centre of the projection area. Although the images are temporally distinct, they are spatially identical and in exact registration, so they create the effect of a "temporal wipe": As the screen's vertical suture passes them, objects and spaces in the garden are caused to appear and disappear — old being wiped away by the new and, with the next rotation, vice versa — while the Narrator and the studio in which he stands remain the same.

The Narrator reads a text based on the exchange of letters that opens E.T.A. *Hoffmann's tale,* Der Sandmann (1817) *— whose layers of misrecognition appealed to Sigmund Freud who used its narrative tropes as exemplary of estrangement and repression in his 1919 essay* Der Unheimlich (The Uncanny). *In the present version names and events have been somewhat skewed. Nathanael (the Narrator) has returned to Potsdam after a long absence, and is disturbed by the sight of a character obsessively sifting sand in a* Schrebergarten. *He writes his childhood friend Lothar for clues. As the camera's gaze enters the* Kolonie, *we hear Lothar's response, amazed that Nathanael could forget that this was the one the pair believed to be that malevolent Sandman who steals the eyes of sleepless children. One night, the young friends venture into his garden, intending to reclaim the stolen organs, only to be cursed by the old man whose piles of sand and strange machines were merely the tools of a luckless inventor who thought he had discovered a new method of growing asparagus in winter. Nathanael's sister, Klara, who read her brother's letter to Lothar, writes also to console her sibling. And to remind him that the night of his escapade with Lothar was the same night that their father was killed in a bar fight, and this must have been why the young Nathanael could not stop crying that it was his own fault, that "The Sandman did it!"*

Douglas, Stan. Der Sandmann: *Installation Instructions 1.0, 1995* (1995).

Potsdam Schrebergarten portfolio
1994
15 C-prints
David Zwirner, New York

"Contemporary" set for *Der Sandmann*
1994
December 1994, DokFilm studios,
Potsdam, Babelsberg

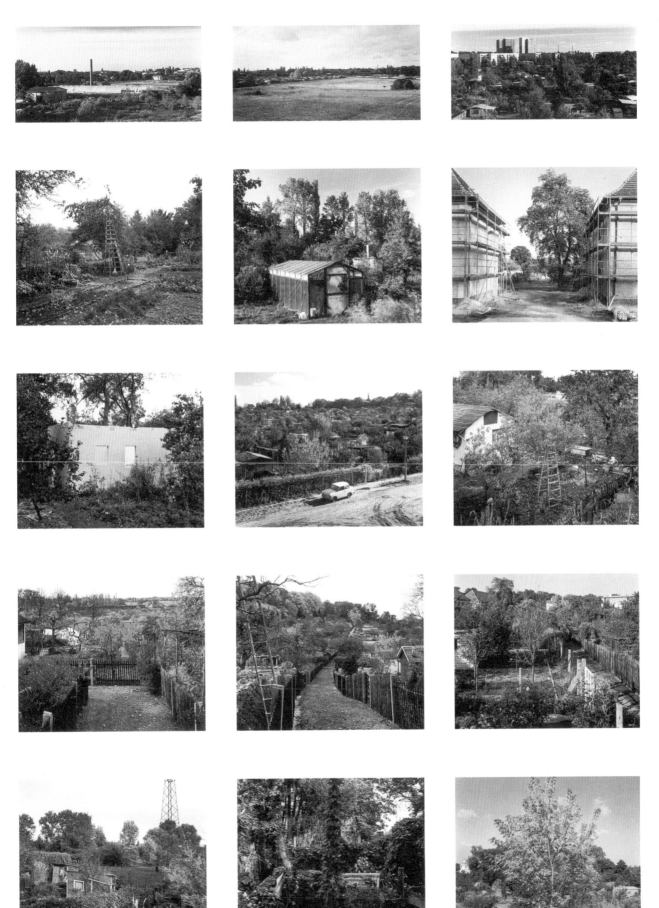

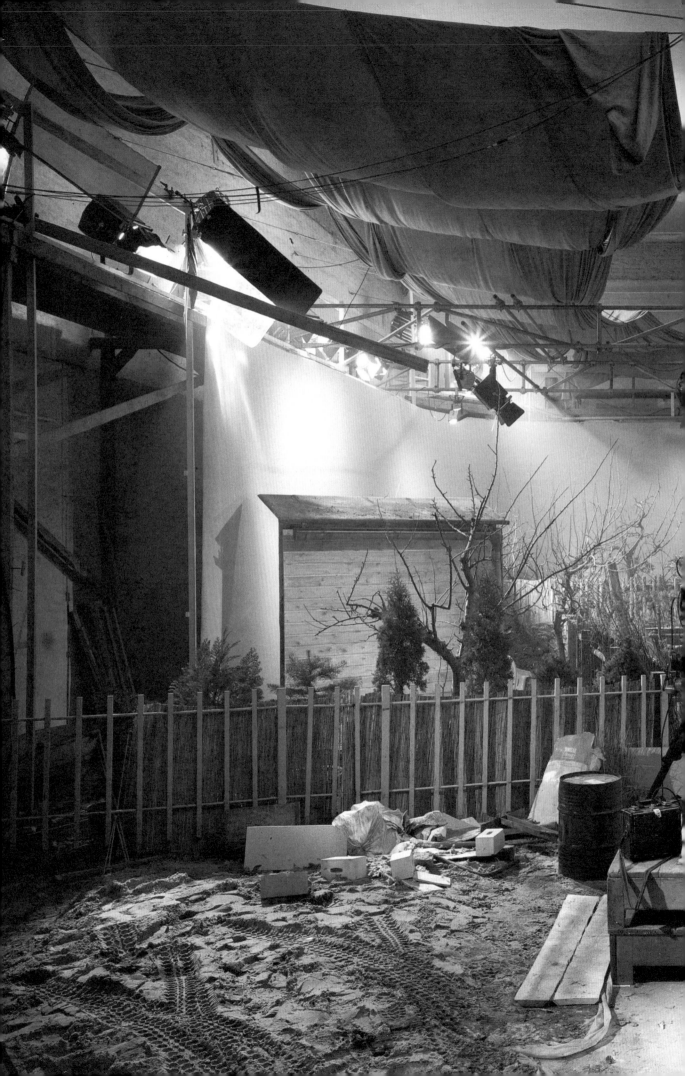

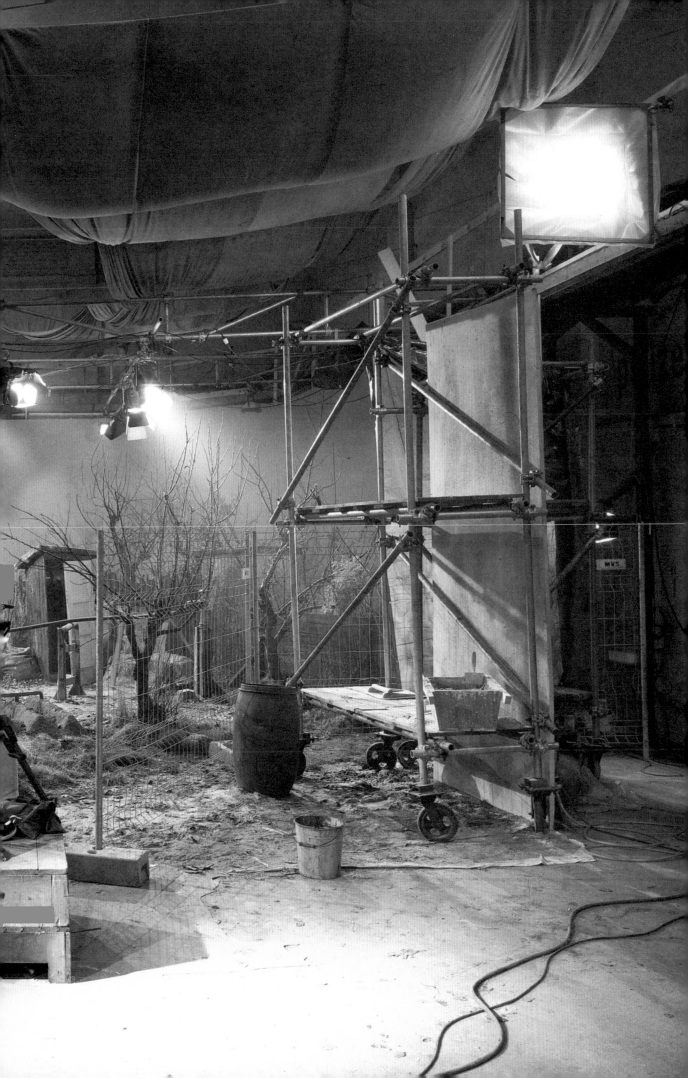

Leonardo Drew

For his large sculptural installation, Number 43, Leonardo Drew has chosen cotton rags and other detritus such as wood, rope, canvas, and nails, all of which have been made to carry a reddish dusting of surface rust and thereby rendered chromatically harmonious and compatible. In that Drew's materials are mostly "found," and found in forsaken places like an industrial refuse dump near the housing project in Bridgeport, Connecticut, where the artist grew up, his sculptures literally arise from and resonate with a gritty but crumbling urban life and history. Furthermore, Drew's incorporation of raw and/or processed and discarded cotton in this and earlier works serves symbolically to invoke the history of the American South (Drew was born in Tallahassee, Florida) and commemorate the African and African-American plantation slaves upon whom the labor-intensive cultivation of "king cotton" once depended. As if in mimetic homage to his ancestors' labor, Drew's sculptures are all intensely worked; and they convey in their painstakingly obsessive accumulations of cast-off stuffs both the rude but fastidiously detailed handicraft and the talismanic folk mysticism of Southern black or outsider art.[1] Paradoxically, from such humble, neglected, and even disreputable materials and working methods, Drew constructs highly complex and powerfully integrated epic sculptures — wall-bound sculptures that are like panoramic barriers or dense curtain walls oriented as much toward pictorial as toward real space.

Drew's working method looks as much to postwar New York art-making as to black folk art or to an imaginary reconception of the procedural essence of Southern black labor. At a very early age, Drew became acquainted through photographs with Jackson Pollock's late "all-over" compositions. What interested him was less "the sublimated Pollock,"[2] that is, that quality of Pollock's paintings indicative either of the unconscious or an unattainable metaphysicality, than the aggressive, even violent physicality of Pollock's technique. This energy allowed not only for large "gesture," but also for the action of gravity and the irruption onto the canvas of unlikely banal materials: "a residue of 'dumping' ... a heterogeneity of trash — nails, buttons, tacks, keys, coins, cigarettes, matches."[3] Drew learned from Pollock the potential visceral charge that the evidences of process can pack; and retaining the imprint of his hand or touch in a manipulation of his materials, Drew has gone on to develop a working method similarly capable of transforming gesture into art and, in this case, into sculpture.[4] Number 43, however, as an homage to consuming labor, whether voluntary or involuntary — the labor "of the slave... [as well as] of the artist"[5] — goes beyond being an essay in process and artistic performance to plumb persistent personal cultural memories. Every inch of this mammoth but oddly delicate work is conspicuously touched, fingered, adjusted, manipulated, rehandled, and rethought so that Number 43 reverberates as if it were a living body with an active residue of generative energy, vigorously entertained recollection, and ongoing desire.

1 Thomas McEvilley, "Leonardo Drew," in New York, Thread Waxing Space, *Leonardo Drew*, exh. cat., essay by Thomas McEvilley (1992), pp. 13–14. McEvilley continued: "The years of gathering cast-off materials have left a mark on Drew's work that parallels to some extent the tradition of the southern African-American *bricoleur*."

2 Rosalind E. Krauss, *The Optical Unconscious* (Cambridge, Mass.: MIT Press, 1993), p. 248.

3 Rosalind E. Krauss, discussing Jackson Pollock's 1947 painting *Full Fathom Five*. Ibid., p. 293.

4 In speaking about the American postminimalist generation of artists, Richard Armstrong has succinctly stated that "for many, process connoted a wholesale adoption of gesture into sculpture." See "Between Geometry and Gesture," in New York, Whitney Museum of American Art, *The New Sculpture, 1965–75: Between Geometry and Gesture*, exh. cat., ed. by Richard Armstrong and Richard Marshall (1990), p. 12.

5 McEvilley (note 1), p. 15.

6 Armstrong (note 4), p. 14.

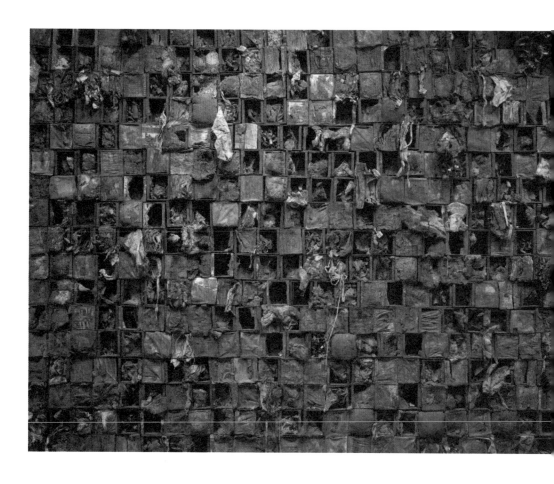

Not unexpectedly, as an additional means of sharpening the vulnerable physical character of his work, Drew has made use of processes of weathering and corrosion and decay. He has, in fact, taught himself how to modulate both the rate and the intensity of rusting, employing the range of oxide or dry earth-red colors that result from his "chemistry" to arresting and often moving compositional ends. That Drew welcomes a certain controlled deterioration of his sculpture's constituent materials links his practice to that of the Italian Arte Povera school and somewhat less directly to Robert Smithson's sculptural investigations of entropy. The latter's "lifelong fascination with the disorder of the industrial landscape, particularly that of his native New Jersey,"[6] also finds a parallel in

Drew's interest in the outcast sites and dumping areas and the accumulating detritus of urban collapse. In Number 43, Drew salvaged his distressed and cast-off materials by creating for them a new domicile within the vast field of small boxlike containers comprising the sculpture. Crude stuffs, which, because they have been processed, used, worn, and roughly thrown away, inescapably evoke a sometime human presence, are gathered up by the artist and ordered, stored, arrested in their decay, and at last preserved and transformed.

Art Institute of Chicago. *About Place: Recent Art of the Americas* (1995). Exhibition catalogue by Madeleine Grynsztejn, with essay by Dave Hickey. Excerpt, pp. 38–39, 51, from Grynsztejn's essay, "The Artists."

Number 43 1994
Wood, rust, fabric, cotton, string, and mixed media
132 x 288 x 4 in. (335.3 x 731.5 x 10.2 cm)
Collection of the artist. Courtesy of
Tim Nye Productions, New York

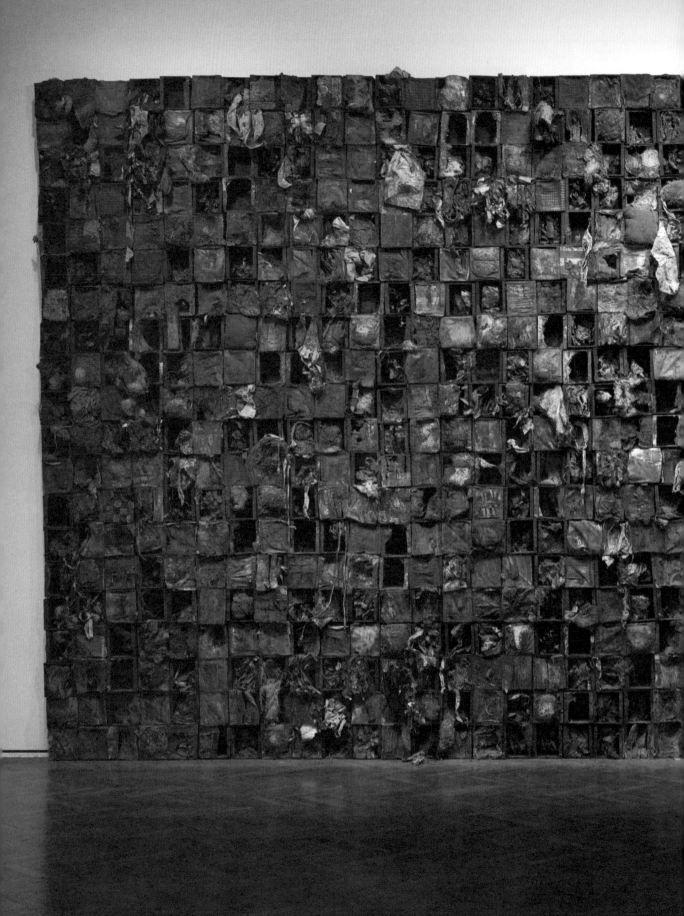

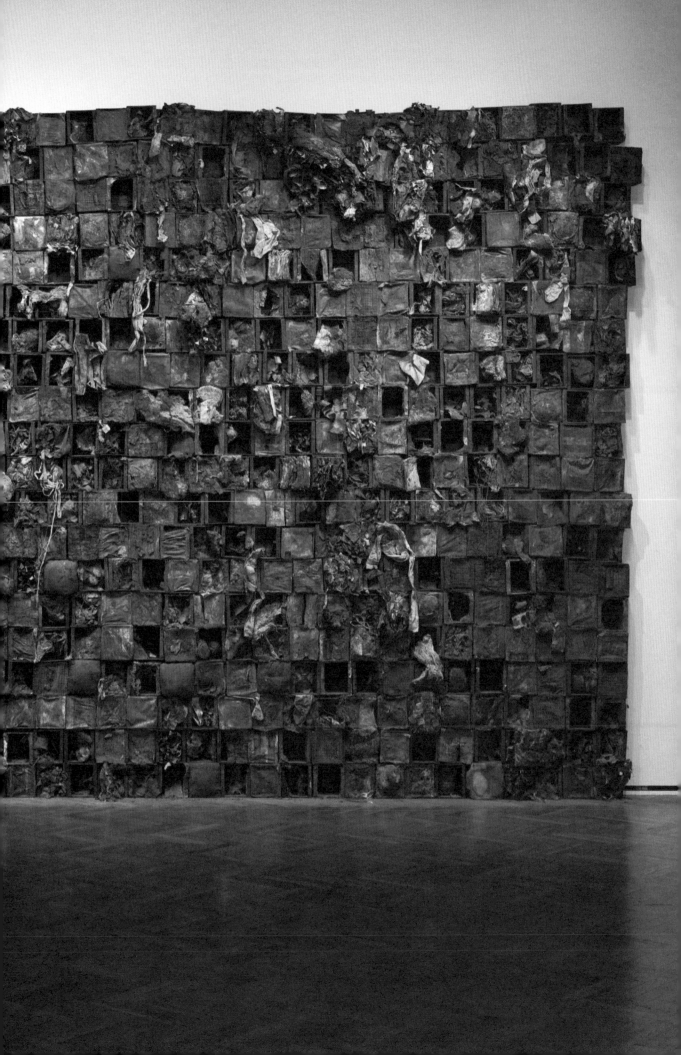

Marlene Dumas

Dumas depicts the human figure in a referential manner. Despite the apparently "expressionist" style of her paintings and drawings, Dumas' images do not deal with undefined feelings, but with ideas and emotions that have already been articulated and named. She shows us human beings in situations where they are in conflict, either with themselves or with others. The conflict is seldom unambiguous: Dumas makes it plain that the "truth" of these situations is always slippery; a slight shift in perception is all that is needed to undermine the certainty of our convictions.

Meaning, Dumas suggests, is determined by context. She shapes contexts for her pictures with words; as well as providing us with titles and commentary, Dumas inscribes thoughts on her images, thereby expanding or undercutting their more predictable meanings. Her art draws from the physicality of its gestural expressiveness, but it is always at a certain remove and self-aware. Similarly, Dumas creates a sense of ambivalence in the work by basing many of her paintings on photographs, thereby creating tension between "subjective" expression and "objective" representation. Reality, she seems to say, arises from the collision between inner and outer frames of reference; it is continually in flux, always subject to fresh resolution — and to misunderstanding.

In the art of Marlene Dumas, nakedness has much to do with guilt and innocence. The human form, depicted unclothed, can evoke the full range of our experience in and of the world; Dumas uses it to explore questions of love and fear, of intimacy and distance. Typically, these qualities are seldom polarised in her images: they coexist in uncomfortable proximity. She does not allow us to settle easily on received values or preconceptions; we are forced to see intimacy where we would normally perceive distance, to sense fear where we would wish to find love. She tells us that intimacy is the consequence of engagement with the object of our gaze and that distance, conversely, results from detachment.[1] She also explains that while a "nude" displays generalities, a "naked" figure embodies particularities and evokes a sense of "revelation." Dumas makes a similar division between pornography and eroticism. Pornography is voyeuristic and treats people as objects; it is a kind of representation that is confined to a small and crude vocabulary of feelings, all relating to the prospect of hurt and shame. Eroticism, in contrast, is the gradual revelation of two subjects confronting each other's nakedness and particularity.

What her paintings and drawings also reveal, however, is the instability of these two genres. "My art," she has said, "is presently situated between the pornographic tendency to reveal everything and the erotic tendency to keep what it's all about secret."[2]

Douglas Hyde Gallery, Dublin. *Marlene Dumas: Chlorosis* (1994). Exhibition catalogue, with essay by John Hutchinson and text by Marlene Dumas. Excerpt, pp. 4–6, from Hutchinson's essay, "On Guilt and Innocence."

1 Dumas writes about these topics in *The Private versus the Public*, published in the catalogue of *Miss Interpreted*, Van Abbemuseum, Eindhoven, 1992, pp. 42–43.

2 Ibid., p. 19.

Betrayal 1994
Ink on paper
29 sheets, each 24 x 19¾ in.
(61 x 50.2 cm)
Jack Tilton Gallery, New York

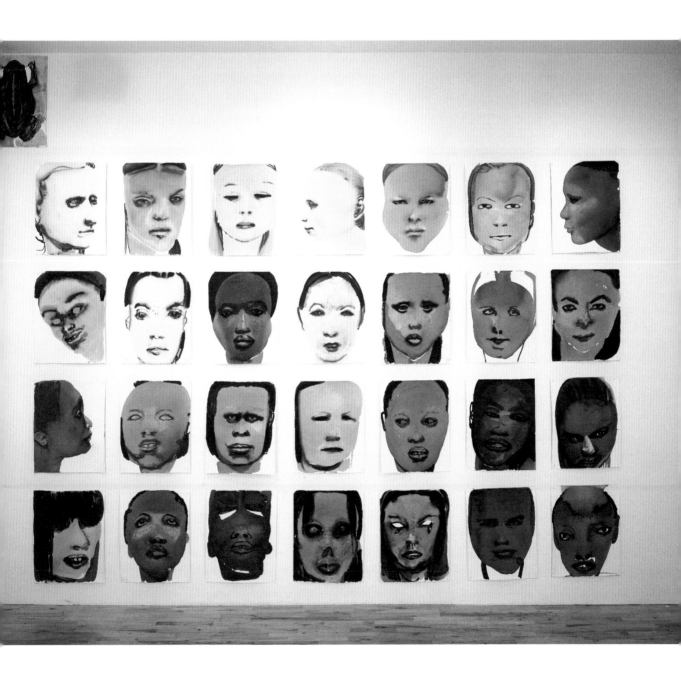

Louise Fishman

To allow for the uncontrollable factors that enter the working process and as an exercise in yielding to the natural order, Louise Fishman has incorporated chance techniques in her art since the early seventies. The inspirational figures of this seminal period were John Cage, whose art relied on chance operations derived from Chinese philosophy, and Ellsworth Kelly, who used such techniques to depersonalize his art and broaden his formal repertoire during his brief but critical period in Paris from 1949 to 1951. Kelly's interest in relief sculpture as an extension of Mondrianesque relational composition, the observation of the actual world — as opposed to adherence to a style (particularly at a time when abstract expressionism was all-consuming) — as the formal basis of his art, and the use of unusual materials, such as string, and cutout, nonrectilinear shapes, were all influential for Fishman....

Somehow a sense of emotional power and spirituality emanates from this straightforward task of blocking and gridding the canvas. Mars (1992), named after a type of paint and at the same time conjuring the mystery of the planet, embodies this confounding effect of her work. The largest of the current group of works, Mars stands nine feet tall by six and a half feet wide like a great gate. Paths of dark paint crisscross the surface in a misregistered grid, culminating in a grate of brushstrokes so flat and dense that they resemble metal sheeting. This final layer, set down with great physical and mental concentration, seems to barricade what lies behind it. Like all her grids, this one is centered on the canvas to give it the fixity of an iconic image. At first imposing in its steely darkness and towering height, the grid gradually opens and softens. With the warm light of red underpainting and the glow of embedded surfaces scraped down to brighter levels, the depth and rhythm of the overlapping grids reveal themselves. Levels of luminosity and a variety of textures emerge as if one were looking into a dense wood in moonlight. The squares are slightly irregular but bear the natural uniformity of a planted field. Face-sized, the windows of the grid help the body find its way through this immensity. The squares, diminutive relative to the whole, prevent a heroic grandeur this scale would normally effect.

Works like Mars have disposed critics to make Fishman heir to the abstract expressionist legacy. Indeed, few painters working today achieve the sense of genuine exploration, in which a formal language speaks with emotional conviction, found in the work of that stellar generation. Robert Storr observes the reliance of current expressionistic painting on abstract iconography and "archetypal sign systems" whose "emotional charge is necessarily more narrative or imagist than it is a product of formal experimentation."[1] An analysis of Fishman's development and the artistic and theoretical forces that shaped it, however, brings a new level of understanding to her work. The emphasis on materiality and process evident in the current work is informed as much by the empiricism of antiformal art and the methods of craft as it is by abstract expressionist gesturality. Thus, Fishman's work necessitates a rethinking of the relationship between abstract expressionism and aspects of conceptual art, a link not readily made.

Robert Miller Gallery, New York. *Louise Fishman* (1993). Exhibition catalogue, with essay by Melissa E. Feldman. Excerpt, n.p., from Feldman's untitled essay.

1 Robert Storr, "Louise Fishman at Baskerville & Watson," *Art in America* (February 1985), 140.

Mars 1992
Oil on canvas
110 x 80 in. (279.4 x 203.2 cm)
Robert Miller Gallery, New York

Olympus Mons 1992
Oil on linen
55 x 45 in. (139.7 x 114.3 cm)
Robert Miller Gallery, New York

Blonde Ambition 1995
Oil on linen
90 x 65 in. (228.6 x 165.1 cm)
Robert Miller Gallery, New York

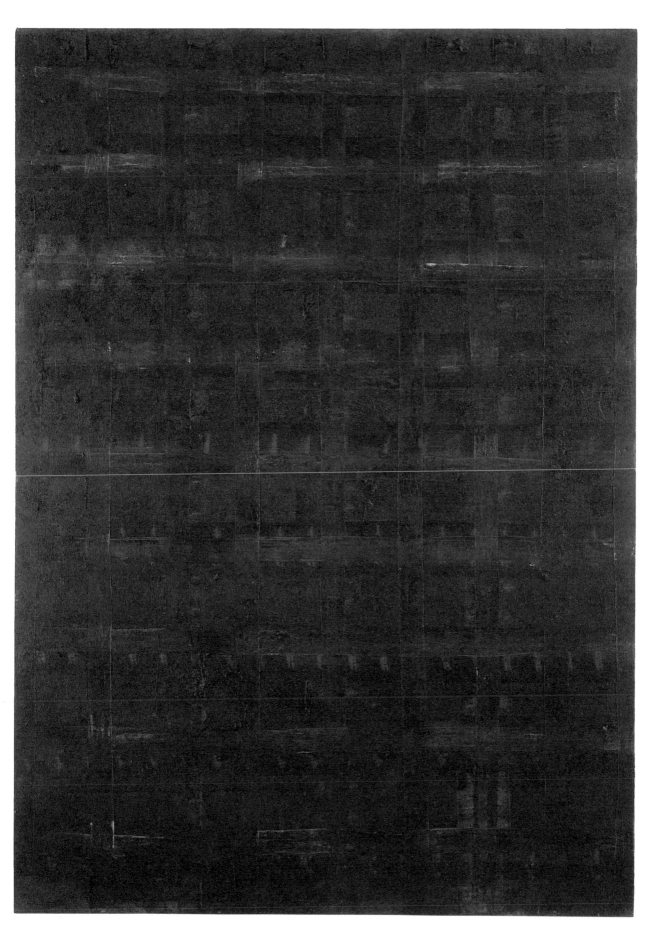

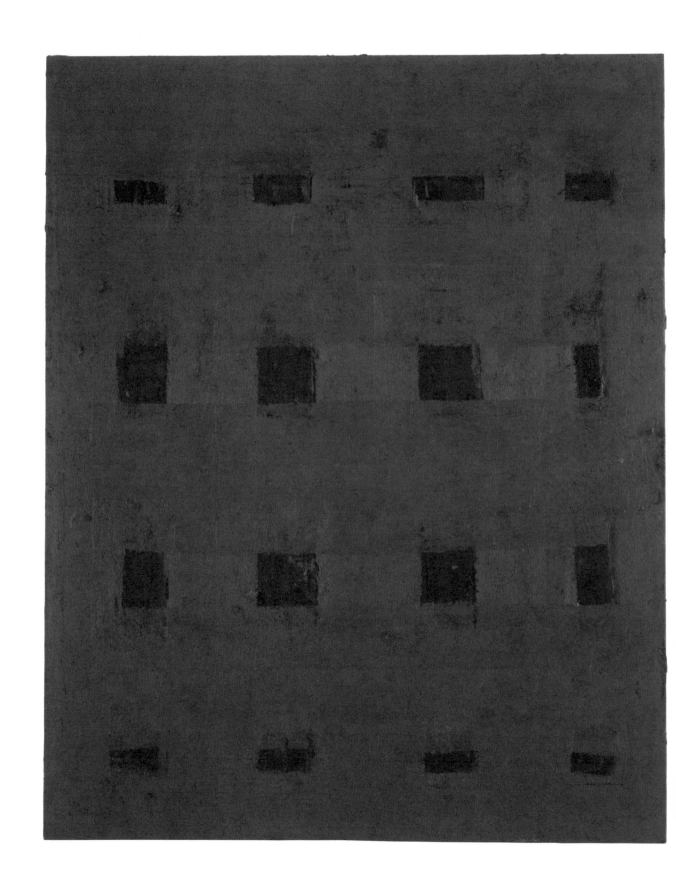

Robert Gober

For several recent wax works, Gober has taken the form of the body fragment from an image in Bosch's Garden of Earthly Delights. He has taken a figure, severed at the waist, its pair of legs and butt seen from above and the rear, which in the Bosch panel is seen as issuing from under the giant mandolin which has crushed it. In one, a riff on Bosch's musical set, the butt is painted with a piece of sheet music. Gober found the sheet on the street and thought it looked upbeat, lively. He never played it, or had it played, though, but rather selected bits and pieces for his rendering. The body, being literally played on and with, enlivened by the music and the hand strokes of the brushwork, implies songs of innocence and experience, mortality and immortality, the Surrealists' dismembered mannequin, the morgue and the waxwork museum. If music be the song of love, play on. Though Gober has long been known as the exception to the Appropriationists' rule of the store-bought found object (as well as the Assemblagists' appropriation of the grittier found object) by virtue of his hand-making almost all his pieces, he has with his recent work confounded a number of expectations. He can and does (sometimes in a single piece) draw on images from his own previous works, from the high road of art history as well as the low roads of advertising, cartoons, embroidery patterns, magazines and finds from the gutter. As to the last, Gober keeps a bulletin board in his studio, where are now to be found an assortment of solo children's mittens and gloves, a collection that conveys a sense of poignancy and loss, but also a goofy sense of optimism. No one saves one lost mitten without the vague though highly improbable idea that its mate will reappear.

These mittens might find their way into his sculpture, much as the sheet music did, and as the single red child's shoe (which Gober also found on the street) turned up in a 1990 edition.

Gober's most recent redoings of the Boschian fragment — and also of the isolated leg — have heightened the deconstruction, the sense of decomposition. He has put holes in them — his pewter drains, as he previously implanted them in walls and tables — making them read as pock-marked or bullet-ridden. He has also in a sense used the drain-like form as candle-holders and, inserting candles into the bodies as well, turned them into shrines and votive altars....

Gober's works always hang in the balance between a hermetic object that stands alone or displays a social self. If his work refuses and refutes this and other either/or dichotomies (among them, art/craft, naivety/mastery, male/female, abstraction/representation) that is our problem and its promise.

Galerie nationale du Jeu de Paume, Paris. *Robert Gober* (1991). Exhibition catalogue by Catherine David, with essay by Joan Simon. Excerpt, p. 83, from Simon's essay, "Robert Gober and the Extra Ordinary."

Installation view, Dia Center for the Arts, New York September 1992–June 1993

Untitled (Man in Drain) 1993–1994
Bronze, wood, brick, aluminum, beeswax, human hair, chrome, pump, and water (second edition)
56 x 37½ x 34 in.
(142.2 x 95.2 x 86.4 cm)
Collection of the artist

Untitled 1994–1995
Wood, wax, brick, plaster, plastic, leather, iron, charcoal, cotton socks, electric light, and motor
31 x 31 x 30½ in.
(78.7 x 78.7 x 77.5 cm)
Collection of Emanuel Hoffmann–Stiftung, on permanent loan at the Museum für Gegenwartskunst, Basel

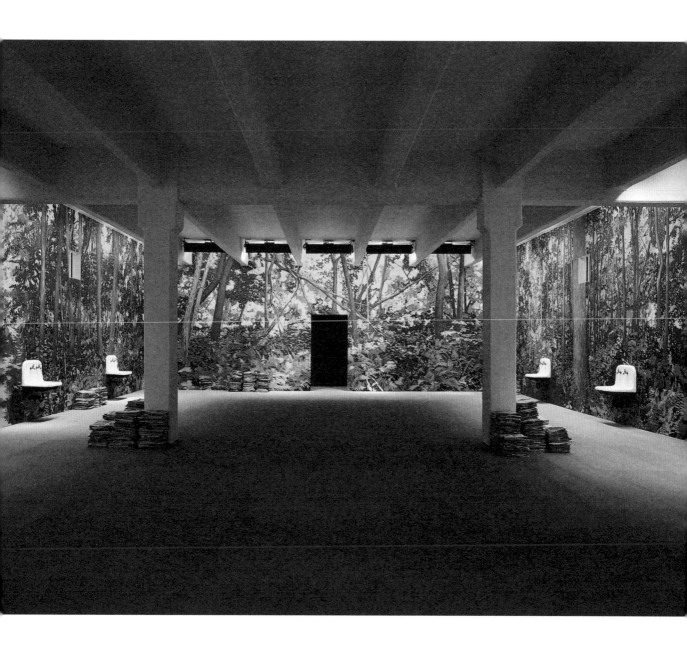

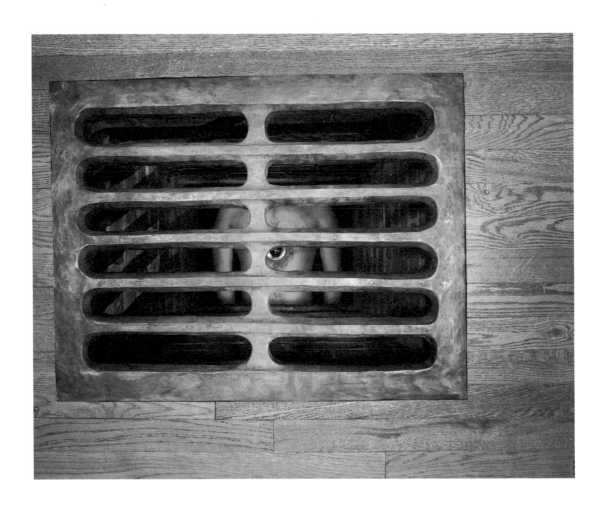

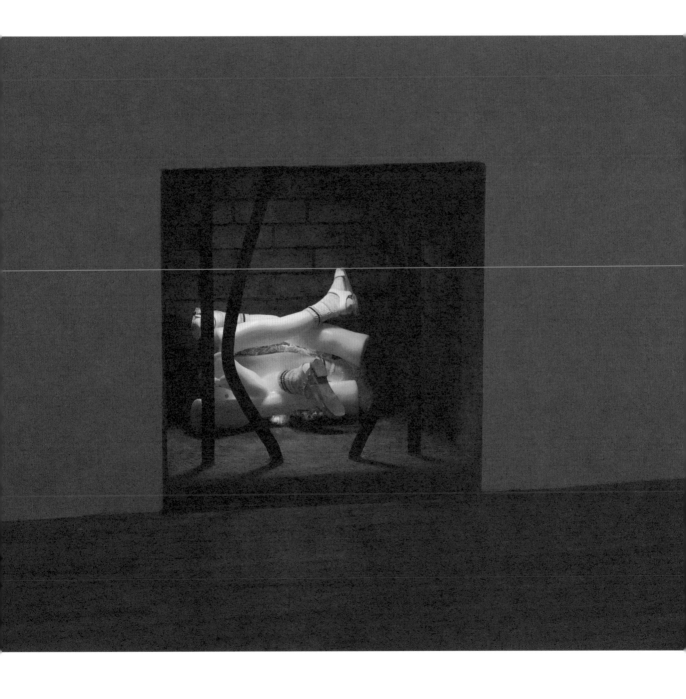

Angela Grauerholz

Perhaps the most salient aspect of your work is its ephemeral quality: a blurred mark of indistinction which suggests a pictorialist style. Yet it's not laid over as simply a gesture, and neither do I want to render it to simple metaphor. For this ephemeral quality, coupled with the photographs' contents of everyday, banal occurrences, strongly evoke the "blurriness," or the fleeting, mundane moments which make up our everyday lives. Simultaneously, the work underscores the contingent and conjunctural nature of meaning. As viewers of these photographs, we are forever looking to concretely grasp something absolute, something knowable, but we are continuously deferred in this task; forever moving on. Our eyes cannot rest long upon one identification, or one truth in the image. While these photographs do tell stories, they are not discrete, self-contained creations. Rather, like the stories which we construct for ourselves, they are stories without resolution; timely stories tenuously built upon conjunctural relationships with people and things. Do you see such an interaction taking place?

I want these photographs to be as open as I can possibly make them, so that the viewer can reinvest what he or she feels into a particular scene, into a particular image. But I'm never quite sure how to deal with meaning. How do you begin to think about what something means to a particular person; what it means universally, collectively, individually; what it means in relation to photographic imagery?

The painterly quality of these photos may be attributed to a notion of conceptual and visual continuity. And in much the same way, their mundane contents refer to a particular continuity as well. Yet, there are distinct differences in the blurry subject matter of these photographs, and in these differences, a type of tension arises. You see, I definitely want to create a universal space. By this I mean a universal imagery which is so recognizable that it becomes totally devoid of any affect, and yet in its application it starts to become reinvested with something....

For me, the photographic work is very much a kind of self-definition. Since beginning this work in 1978, I've come to realize more and more what it is I'm doing. I started out doing much the same thing, but I didn't know why and how. As you learn over time what it is you're doing, it also becomes more important. And as you start constructing it, you start understanding how you're doing it and why you're doing it....

Basically, I do this work because it gives me pleasure, and that pleasure is also a part of dealing with certain things which are inside me. But it can also be talked about in terms of my cultural upbringing. I was a grown-up coming to Canada, and so I had a big, heavy bag. Much of my thinking is very much rooted in a kind of German Romanticism. I studied German literature, specifically, Schiller and Goethe, because coming from Northern Germany, it already resided within me. It confirmed my cultural behavior. Two years ago I worked upon a series of photographs where I recreated a type of Northern German Romantic landscape. Still, I don't know if art making is essentially a recreation of some earlier feelings. I'm not sure. I may not now be doing Northern German Romantic landscapes, but I'm dealing with German Romantic ideas. I don't know how far I've taken them out of what they were, or how far I've changed them but I do know that they are still there. I draw from memory. And I'm now very comfortable with this sense of displacement: of the necessity of being in constant flux in order to create the work; of drawing from fleeting images and fleeting ideas; I don't think I could do the work if I wasn't comfortable with it. Displacement used to be a very scary word, but it is no longer.

Eclogue or Filling the Landscape 1994
Installation
6–drawer acrylic cabinet with
27 portfolios containing 216 silver
prints of various dimensions
59 1/16 x 59 1/16 x 34 1/4 in.
(150 x 150 x 87 cm)
Art 45, Inc., Montreal

Seaton, Beth. "Angela Grauerholz: Mundane Re-Membrances. An Interview by Beth Seaton." *Parachute*, no. 56 (October–December 1989), pp. 23–25. Excerpt, pp. 24–25.

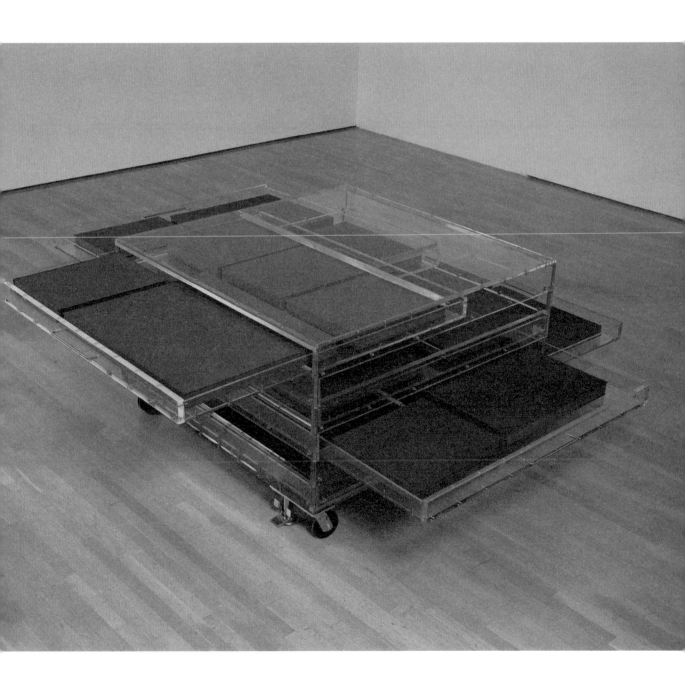

Gary Hill

From his first attempts to his recent works, Gary Hill has worked on a register of human or natural sounds, stopping more particularly at the voice which, from simple phoneme to speech, is given with the image: "Sounding the image, imaging the sound" (Soundings). The voice is in the image, follows it or else gives rise to it, precedes it or completes it, but the image is also in the voice. Their simultaneity, achieved through the mingling of the texture of the image with the texture of the voice, throws into perfect relief the natural character of speech discoursing on things, as the conventional system of words which serve to describe them. The images of things that appear on the screen take their rhythm, form and meaning in and through language, they seem to be inseparable from it, indissociable, and that without any mystical or ontological act of naming, for the words uttered are not the things and even try to set aside any coincidence between signification and object. The voice and the word are mediations which enable us to go beyond visual realities, while also being tools for exploring these realities to which the mind cannot be indifferent, inasmuch as they form part of its subjects of thought. A superimposition of image and voice considered as matter and material is needed in order to extract their differential processes more effectively, for some of these works consist in showing that the voice is not connected to reality but comes looking for it, the better to rid itself of forms already given.

Gary Hill pays close attention to volume, vibration, pronunciation, intensity and inflection, in order to establish certain sound correspondences between the materiality of the world and the physicality of the voice. The forms he gives them are never fixed, and although one can find certain analogies between the timbre, pitch and warmth of a voice and the images with which it is articulated, one can equally put forward contrasting examples with disturbing, haunting voices which produce a sensation of unease. Most of these voices (those of the artist or actors) are voices off and are naturally out of sight, but they are nevertheless present in the image phonically in order to accentuate its resonant handling, its expressiveness, the effect of dramatisation, what we might call the "optophonetics" of the image. In the recent works, the images of reality — pond, bridge, house, path, forest, rain, car — are not accompanied by their natural noises, as if the human voice had to replace them. But it is not a question of making verbal what is mute in Nature through speaking instead of things and objects, since the appearance of the voice in their midst marks the insuperable distance between the naturalness of what is and its perpetual reformulation through our words. The very materiality of the world sets itself against them, because despite the fact that our voice is the fruit of education, work and apprenticeship, and so of an artificial system, it is a part of our materiality, and our world is literally embodied in it.

Centre del Carme, IVAM, Valencia. *Gary Hill* (1993). Exhibition catalogue, with essays by Christine van Assche, Lynne Cooke, Jacinto Lageira, and Hippolyte Massardier and text by Gary Hill. Excerpt, p. 154, from Lageira's essay, "The Image of the World in the Body of the Text."

Withershins 1995
Interactive sound installation with video projections
Installation views, Venice Biennale, June–October 1995.
Donald Young Gallery, Seattle

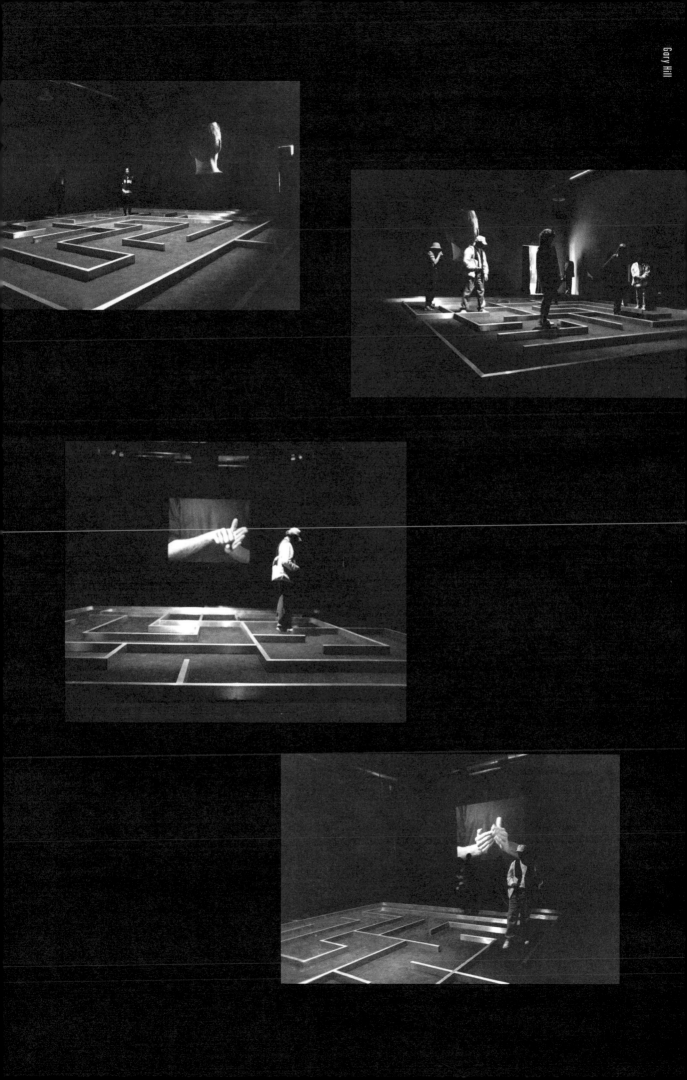

Craigie Horsfield

No matter the appearance of fast and escalating change that surrounds us, the frenzied static of media and commerce, the mechanisms of social life — change is slow in the way we stand one to another, the common place between us. Even so, these shifts finally engulf the world in vast and subterranean turmoil. There have been so many shifts, small adjustments and large, that the world is set sliding on its axis into a new orbit, a dizzying skittering movement, sliding and slipping, a kermesse at the millennium. By chance or by determination we live in a time when everything is to be reshaped, when the myths of progress and of a utopian end do not sustain life, and when the present shows evidence of their failure. Certainty is fragmented, the orthodoxies of ideology and faith are destroyed or in turmoil.

In relation to this present, art appears to be in an enfeebled state of bad faith, separated from a shared life. It is lost in formalism without meaning, another separation in the vast catalogue of the 20th century. Yet though history is said to be at an end, it is not history that is ended, but an idea of history; history as an expression of the present, as an account that we embody, is without end or beginning. And though the land we inhabit lies in confusion, doubt, and darkness, yet we have the astonishing possibility of affecting the world — of shaping within the world a means of thinking and acting that will account for this place.

Art, whatever else it may be, can mark an attention to a real rather than a fantasied space, to a real rather than the mythologized time of commerce and fantasy that denies death and slides over the present. To overcome alienation demands conceiving identity in relation not to some myth of past community but to the specificity of place and time, so that the weight, the substance, the grain of the physical world is recognized in its present. Art can be a marker at once of the physical world and of the world of the spirit — for there is no (true) separation. A photograph may tell this world in such a way that the physical place it shows is accounted for in the physical fact of its being. It may exist in this present as it tells another present, so that all time may be conceived of as simultaneous.
The photograph decays in light as the world decays, as in our thinking the world decays and is born.

Perhaps we might travel to see such an image in the only place in which it exists, rather than seeing it reproduced ten thousand times as if in the pretense that we might escape the limit of life. In such a photograph we may recognize another, be together with another, in the recognition of our shared plight. Such an art might recount the fragile space of a community through compassionate attention.
This movement away from self, where together we may resist death — in this lies the trace of a moral universe. A universe in which art may be not wounding but healing, not offering the false consolations and panaceas of generalities but speaking of a specific and discrete place, of this moment, this present at the turning of the world.

Andrzej Klimowski. Crouch Hall Rd, North London. October 1969 1995
Black-and-white unique photograph
73 5/8 x 55 1/8 in. (187 x 140 cm)
Collection of Tate Gallery, London
Purchased 1995

Kraków. May 1994 1995
Black-and-white unique photograph
110 1/4 x 94 1/2 in. (280 x 240 cm)
Frith Street Gallery, London

Sumner Street, South London. December 1994 1995
Black-and-white unique photograph
54 5/16 x 69 5/16 in. (138 x 176 cm)
Frith Street Gallery, London

Horsfield, Craigie. "April 4, 1994: A Project for *Artforum* by Craigie Horsfield." *Artforum* 32 (May 1994), pp. 76–83, 119. Excerpt, pp. 78, 119.

Cristina Iglesias

Space as reality and symbol at the same time is one of the most outstanding discourses that Cristina Iglesias centres upon. She directly avoids the figure of man, but talks about his cavities and his surroundings; she even talks about human proportions through the abodes and height of the pieces. This "humanisation" is also put into practice in the treatment of the materials, where industrial intervention is combined with the direct intervention of the artist's hand, where regular surfaces and geometrical purity are combined with others of more organic and irregular type, where light intervenes provoking peculiar effects, or where the suggestions of vegetation, water or other natural elements and materials become familiar. In this universe of proteic appearance there is no room for chaos, although chance is directly implied. On the contrary, a kind of interior law establishes coherent relationships between even the most unmatched ingredients that form it....

Indeed, while the contemporary artist has understood that with a direct action on space — introducing his objects into it and making it into the principal participant of his creative project — he was breaking with the traditional limitations that situated the stage of art outside the stage of life, the art works have exchanged the pedestal for a free position in any chosen terrain, establishing close ties with a real context by now implied in the artistic operation itself. Sculptures fixed in constructed places can simply maintain an attitude of complicity with these spaces, emphasizing above all the material character of their three dimensions and concentrating most of their significance there, or they can rebel against this passivity within the situational context, trying to intervene there in an active and modifying way. This later option has been clearly assumed by a large part of contemporary sculpture and particularly in Cristina Iglesias' work, where other spaces and other times are present, maximizing the possibilities for perception.

Cristina Iglesias' works possess a marked strength of evocation. The spaces constructed or suggested by the artist are very tropological, leading us from a physical to a mental place, or vice versa. As a result the ingredients of memory and the temporal factors are important. In this sense, it is necessary to point out that the consciousness of time and of becoming implies a condition fundamental to approaching the production we are commenting on, since it is probably absurd to have a vivid idea of space without putting into practice the same operation with time. What has happened throughout this century has to do with the situation of man in the centre of any reflection. Space has stopped being inaccessible for him; on the contrary, he tries to apprehend it, to value and organise it. How different from Newton's absolute space, a space unalterable by physical events. It could act on mass, but nothing had the power to disturb it. On the other hand, today's man is distant from the consciousness of that imprecise and to an extent determinate "continuum" which is time....

And these sharp observations are put into practice by Cristina Iglesias when she combines illusion with reality, thought and the unthought, the result of rational clarity and the other, no less important in the configuration of human nature, that comes from the territories of shadow which are directly related to those of light.

Ministerio de Asuntos Exteriores de España. *Cristina Iglesias* (Barcelona: Àmbit Servicios Editoriales, S.A., 1993). Exhibition catalogue, with essays by Aurora García and José Ángel Valente. Excerpt, pp. 52, 55–56, from García's essay, "Dwellings of the Being" (translated from the Spanish by Cristina Ward).

Untitled (Eucalyptus Leaves I) 1994
Aluminum
98 7/16 x 69 11/16 x 36 1/4 in.
(250 x 177 x 92 cm)
Galerie Konrad Fischer, Düsseldorf

Installation views, Galerie Konrad Fischer, Düsseldorf
October–November 1994

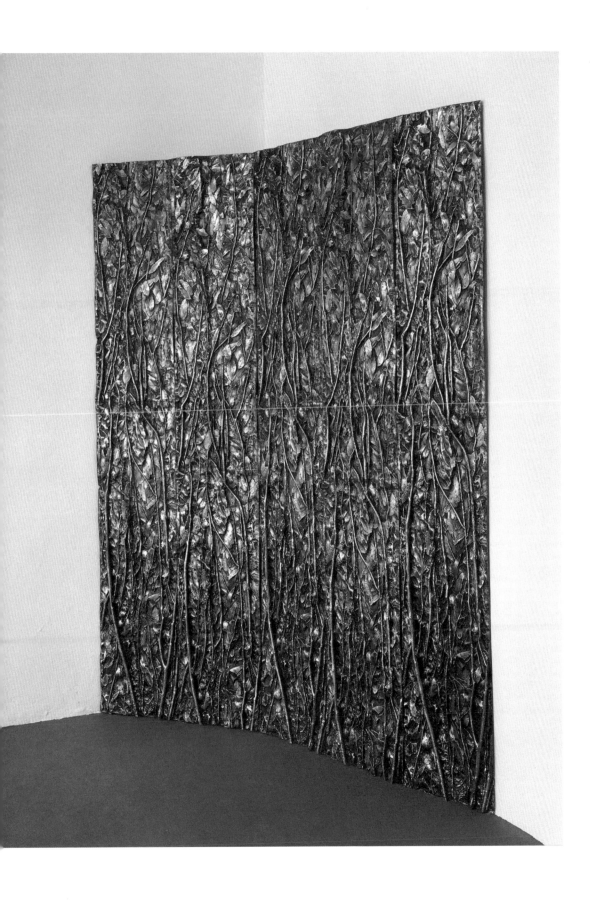

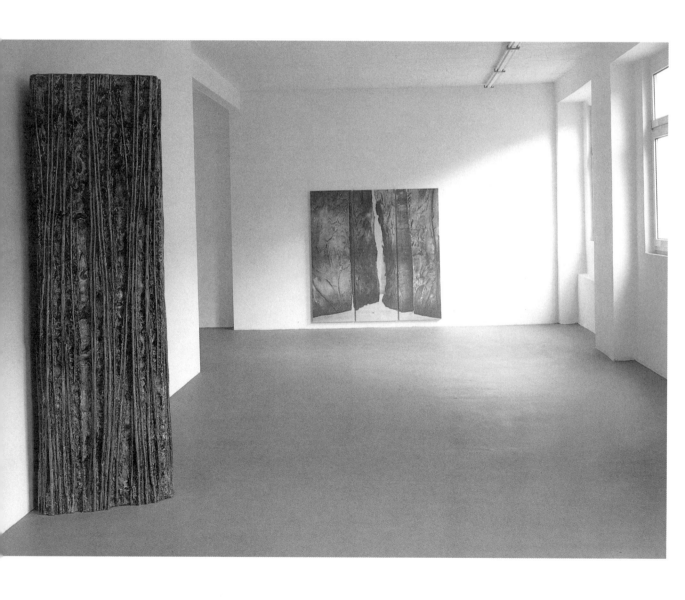

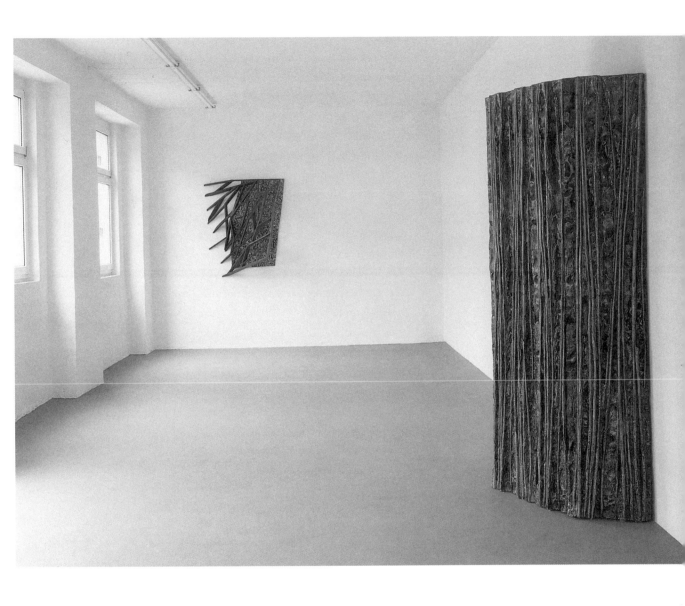

Donald Judd

Space is new in art and is still not a concern of more than a few artists. It is generally accepted that vertical, anthropomorphic, totemic sculpture is no longer possible, although I don't know that those who believe this know why, but a general interest in space has not replaced the interest in such solids. (There are other solids.) There is no vocabulary for a discussion of space in art. There was a traditional vocabulary about space in architecture, about proportion, volume and sequence, East and West, but it was discredited in the seventies by the architects who are not architects, and so could not judge. They appropriated the appearance without knowing the substance. For both art and architecture, the vocabulary of space of the past should be reconsidered and in relation, but newly, which is not impossible, a vocabulary should be built. There has been more discussion of color than space, at least since Goethe and Chêvreul, and recently by Albers and Itten, but there is much more to say about color. There is much more to say about art. Color is still new in art. It hardly occurs as a reality in architecture. I intend to write about it some for the Sikkens Foundation, which was established for color. I remember reading that when the Duke of Gloucester was given the second volume of the Decline and Fall of the Roman Empire *he said: "Always scribble, scribble, scribble! Eh, Mr. Gibbon?"*

Pace Gallery, New York. *Donald Judd: Large-Scale Works* (1993). Exhibition catalogue, with essay by Rudi Fuchs and text by Donald Judd. Excerpt, pp. 9, 13, from Judd's text, "21 February 93."

Any work of art, old or new, is harmed or helped by where it is placed. This can almost be considered objectively, that is, spatially. Further, any work of art is harmed or helped, almost always harmed, by the meaning of the situation in which it is placed. There is no neutral space, since space is made, indifferently or intentionally, and since meaning is made, ignorantly or knowledgeably. This is the beginning of my concern for the surroundings of my work. These are the simplest circumstances which all art must confront. Even the smallest single works of mine are affected....

Untitled 1991
Douglas fir plywood with aluminum tube
19½ x 45 x 30½ in.
(49.5 x 114.3 x 77.5 cm)
The Donald Judd Estate

Untitled 1991
Mill aluminum
5 units, each 59 x 59 x 59 in. (149.9 x 149.9 x 149.9 cm); 59 x 59 x 331 in. (149.9 x 149.9 x 840.7 cm) (overall)
The Donald Judd Estate

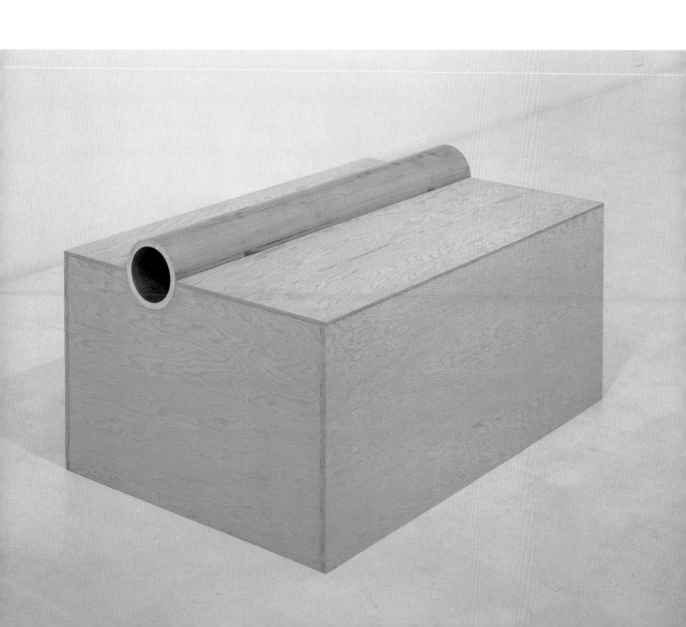

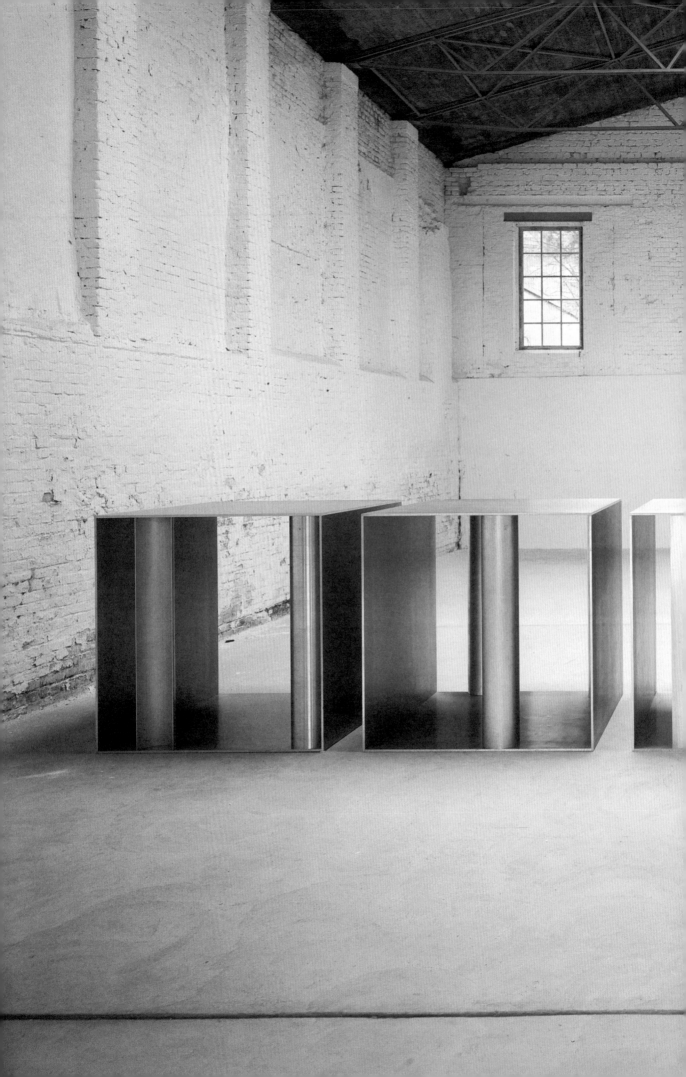

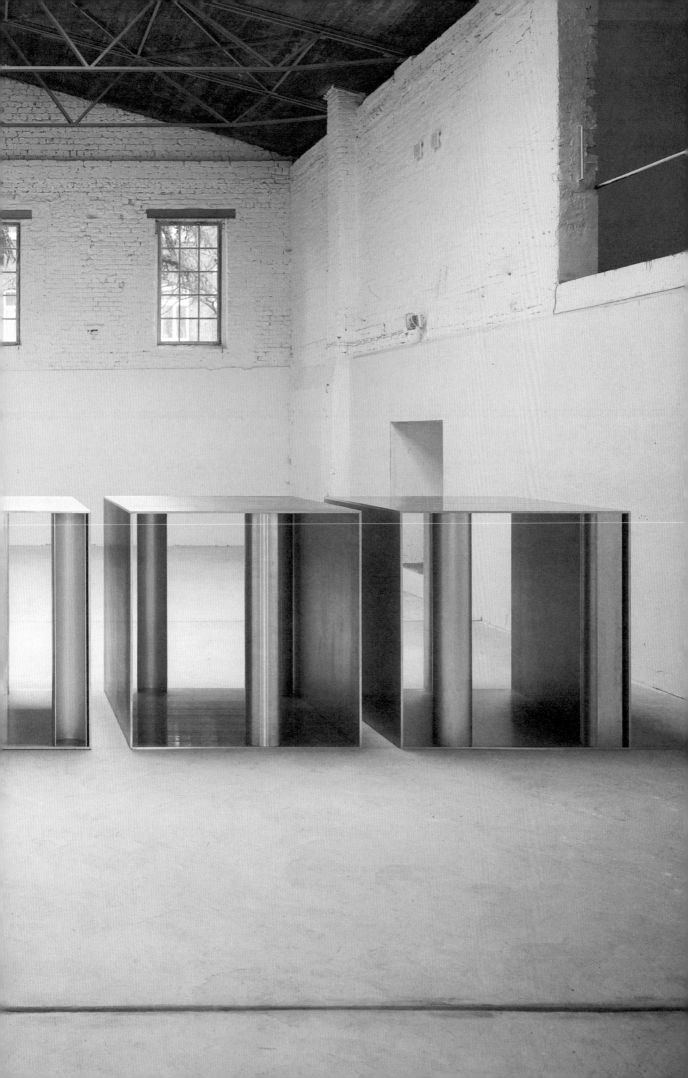

Per Kirkeby

In a letter from the Cologne exhibition of 1912, Munch wrote: "Here are collected all the wildest things that are being painted in Europe. I myself am purely classical and faded. Cologne Cathedral is shaking to its foundations."

The great Classicism. The first attempt to find the way. The first brick sculptures I made sprang from a naive idea that once drove and supported my work: that art moved between pure and impure. Not in any narrow moralistic sense, but as tangible artistic dimensions. The impure was what contained all the associations and references. The pure was the structure, purely and simply. Naturally, all art had its share of both parts, but in those years (the beginning of the sixties) the ideal was the pure. The ideal of the Zeitgeist. Therefore, all the rest perhaps was called the impure. Up to and including that time I also wished for the pure, but only functioned impurely. Therefore, I probably operated with these categories so that I could dose my impurity with a suitable amount of purity. Then there was, at the same time, more moralism in it than I want to believe. It was not just a dosing free from value judgment.

All the time I was clear and shocked about the immense banality of "the system," but I had use for naivety. With it, for example, I could make a blue color useful: both pure and impure; both sky and blue out into the blue. And with it I could substantiate my partiality for brick: the brick and its rules, thus proscribed, and what otherwise belonged to the thousand-year-old craft was a pure structure; it took care of what one called conceptual concepts. And, on the other hand, brick was full of associations and references. References to great and historically profound architecture, with ruins and other set pieces, drifting mists, moonlight.

And for me, full of associations with childhood experiences in the shadow of huge pieces of brick Gothic....

In principle I see no difference between the sculptures I myself make by hand and the ones I have built with bricks. In one particular regard the brick sculptures, however, look distinctive: They hold out that anonymity is a paradoxical dimension in any superior work of art. Old painters often achieve an almost terrifying anonymity in their works, a hard-won "emptiness." Sculptures have an innate anonymity to a far higher degree than paintings. To model an "object" is an almost supra-personal action. The laid-down, and anonymous, is far clearer than in painting, where the anxiety about anonymity can be more easily averted by originality-seeking tricks. And where only the sovereign, the original, sees the real wisdom of anonymity. In sculpture, to shape with the hand is to shape with the hand, to chisel is to chisel, to build is to build. Anonymity is more concrete. To paint is to paint, materiality, etc.; at times painting has attempted to imitate the naturalness of sculpture, but this is not so self-evident.

Anonymity, thus understood, is perhaps the closest I can come to a description of what I understand by Classicism. A concept I like to use because of the scent, the airiness and sound of trumpets. It is also this anonymous quality that we find most difficult to understand in historical Classicism. But which, on the other hand, is first seen when it becomes inescapable. This is my Thorvaldsen.

Therefore, I myself use the brick sculptures to refer to and maintain Classicism, anonymity, in the handmade sculptures. And use the handmade to maintain the intuitive, the convinced, in brick sculptures. But every sculpture is, of course, itself, and contains both elements, but should rather avoid sought and petty originality. Also even though the bricks no longer follow the norms.

Brick Sculpture, Göteborg, Sweden
1992
Brick
315 x 511¾ x 511¾ in.
(800.1 x 1299.8 x 1300 cm)

Kirkeby, Per. "Sculptures in Brick." *Arti* 20 (May–July 1994), pp. 50–55. Excerpt.

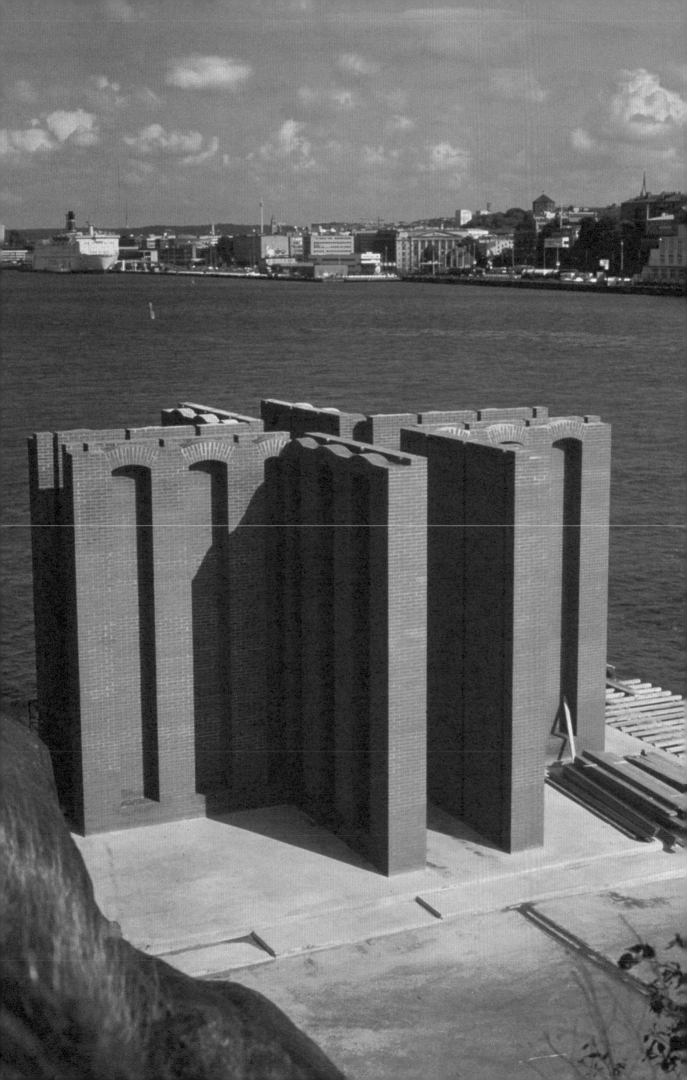

Guillermo Kuitca

Gravity-bound and ruled by geometries both plane and solid, architecture has for centuries helped painters to anchor their visions to Earth and to reason. What a shock, then, to see it in a strange new role, as a homeless phantom no more capable than a spiderweb of housing human beings. In Kuitca's architecture of memory, walls and roofs, ground and sky have all vanished, leaving only a free floating idea of a building that has come to haunt us from another era.

Typically for the Tablada Suite (named for a Jewish cemetery in Buenos Aires, the artist's native city), this ground plan of a stadium belongs to a familiar utilitarian category we recognize as our own, but is magically transformed into a gossamer diagram that would evoke a time-traveler's archaeological reconstruction of a world similar to ours but as chillingly lifeless and airless as a distant planet. And the sheer size of this stadium (similar to, but not identical to Madison Square Garden) plunges us into awesome extremes of the gargantuan and Lilliputian, shifting our scale abruptly from dimensions rivaling the French visionary architecture of the late eighteenth century to the minuscule rendering required to mark each of the myriad places for spectators. Incised with microscopic precision, this ghost of a building takes on further mystery as it becomes a fixed, abstract emblem that nevertheless hovers and flickers like an apparition. Suddenly, the static, centralized purity of these ovoid patterns that once teemed with noisy crowds looks as remote as a lost civilization, perhaps our own.

Contemporary Art Foundation, Amsterdam.
Guillermo Kuitca: Burning Beds. A Survey, 1982–1994 (1994).
Exhibition catalogue by Eduardo Lipschutz-Villa, with essays by Josefina Ayerza, Donald Baechler, Douglas Blau, John Coffey, Robert Rosenblum, et al. Excerpt, p. 62, from Rosenblum's untitled essay.

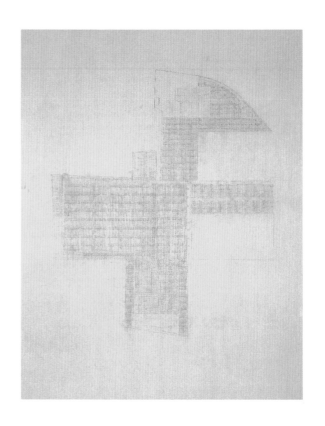

The Tablada Suite I 1991
Acrylic and graphite on canvas
94 1/8 x 74 13/16 in. (239 x 190 cm)
Collection of Milwaukee Art Museum,
Gift of Contemporary Art Society

The Tablada Suite III 1991
Acrylic and graphite on canvas
57 x 77 5/8 in. (144.8 x 197 cm)
Credit Suisse London Art Collection

The Tablada Suite IV 1992
Acrylic and graphite on canvas
76 1/2 x 49 1/4 in. (194 x 125 cm)
Sperone Westwater, New York

The Tablada Suite V 1992
Acrylic and graphite on canvas
71 1/4 x 49 5/8 in. (181 x 126 cm)
Private collection, Miami

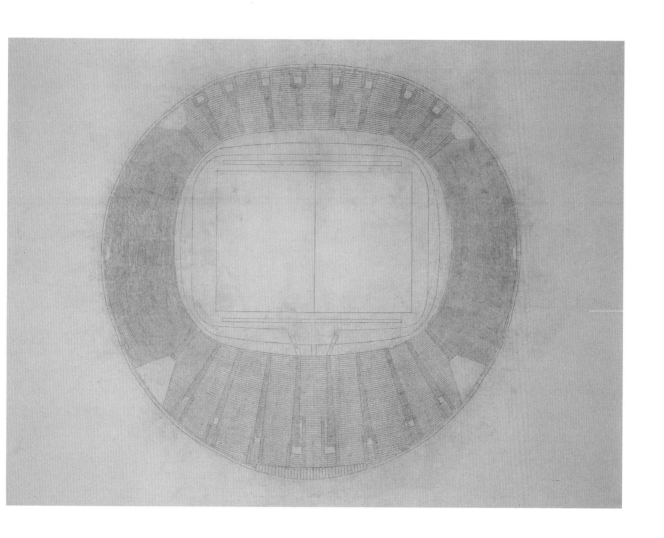

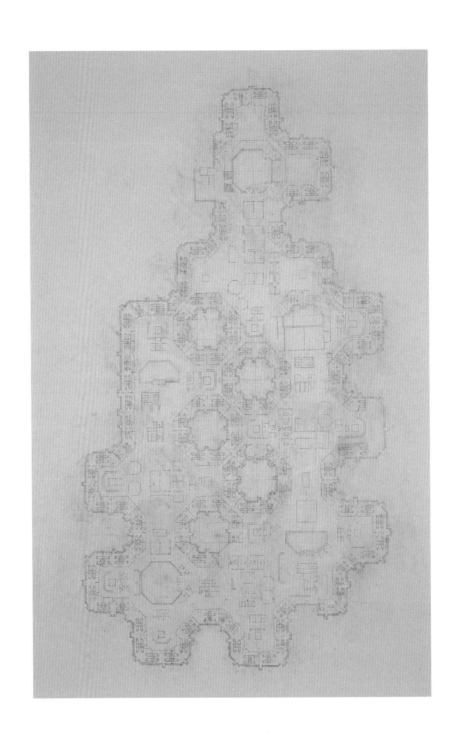

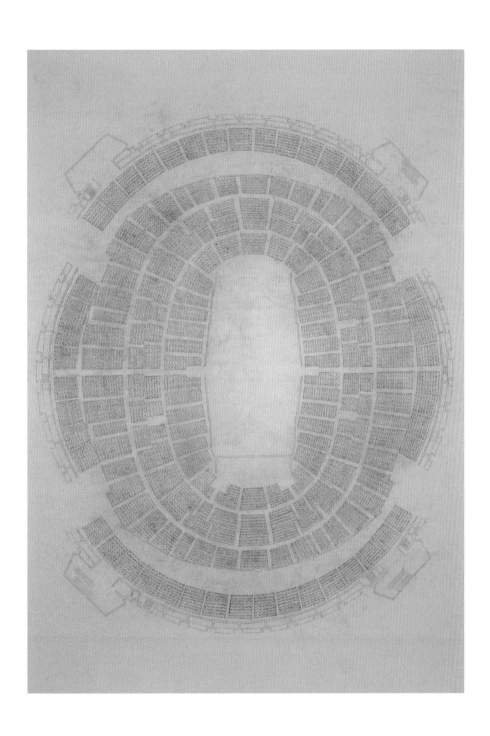

Moshe Kupferman

Each of Kupferman's paintings is an occurrence within a given time; whatever takes place does so within a dictated system. Particular attention is devoted to allowing the layer of color to speak, to turning it into the flesh and blood of the painting rather than letting it remain just a layer of color, to manipulating it and working it in such a manner that every square centimeter of painted canvas contains information on the entire layer — the intimacy, the power, the care and the corporeal dimension.

The abstinent discipline imposed on the painting in advance charges the scanty means with great responsibility; it is a series of acts through which the making of the painting is rendered present, as an ethical deportment which gives birth to a different situation each time in a unique articulation. This situation is the summing up of the process of democratization undergone by the painted surface: each centimeter being deemed worthy and taken care of. Kupferman himself summarized this abstract speech as "Jewish painting."

Interpretation of Kupferman's work, ever since he reached his prime (toward the end of the 1960s) has been split into two trends. The first, once dominant but having waned over the years, interpreted the paintings as an image of reality. The intersecting lines were described as a fence, more specifically as the fence of a concentration camp. The painting was viewed as painted memories of the Holocaust. The fact that Kupferman is a member of Kibbutz Lohamei Hageta'ot (the Ghetto Fighters kibbutz) has possibly encouraged such speculation. However, the obvious conceptual explicitness and the abstractness of the works have become clearer with time, and mimetic attributions have consequently disappeared from the interpretations. Nonetheless, even those who see the labor of construction and destruction, the veiling and unveiling in Kupferman's work, as operations constituting the art of painting, as did those who belong to the second trend, feel that this painting is difficult to sum up in any formal sense. The twenty years during which Kupferman's work has reverted back to the same forms, the same operations, the same strange color, have made it neither transparent nor comprehensible, nor have they made it susceptible to verbalization. The opposite is probably true. The compulsive decades-long repetition of what seems to be a variation on one theme only enhances the enigma in the basis of the work, the secret cast in it, the black hole it covers, the constant mourning labor it performs. All of this makes Kupferman's work more than just routine lyrical minimalism. Kupferman has introduced a new dimension into Israeli painting, a different tone of speech — abstinent, hard, stubborn. This tone is mainly conspicuous against a background of the secular, simple, well-known means used in the creation of every work.

Künstlerhaus Bethanien, Berlin. *Positionen Israel: Collection Höcherl/Asperger* (Munich: Verlag Dr. Rainer Höcherl; Zug: W. Asperger Gallery AG, 1992). Exhibition catalogue, with essay by Sarah Breitberg-Semel. Excerpt, pp. 23–24, from Breitberg-Semel's essay, "Identical Twins and the Model of Modernism in Israeli Art" (translated from the Hebrew by Almuth Lessing).

Untitled 1994
Oil on canvas
51 3/16 x 76 3/4 in. (130 x 195 cm)
Collection of the artist. Courtesy of
Marge Goldwater, Inc., New York

Untitled 1994
Oil on canvas
76 3/4 x 51 3/16 in. (195 x 130 cm)
Collection of the artist. Courtesy of
Marge Goldwater, Inc., New York

Untitled 1994
Oil on canvas
51 3/16 x 76 3/4 in. (130 x 195 cm)
Collection of Joseph Hackmey,
The Israel Phoenix Assurance Company,
Tel Aviv

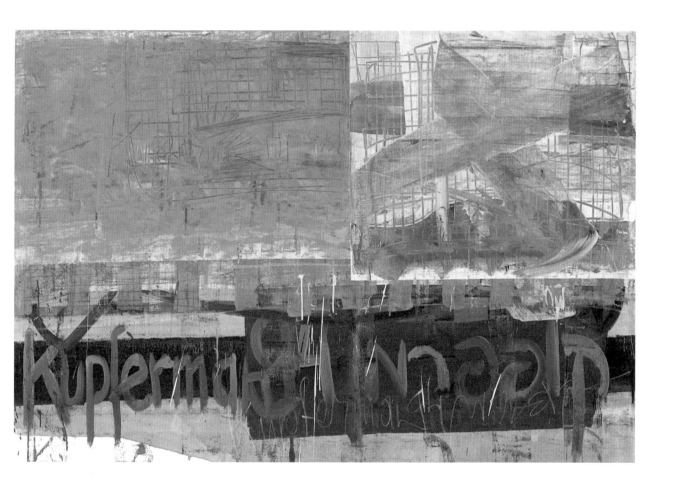

Thomas Locher

Thomas Locher is exploring structural systems, especially of a linguistic and pictorial nature, in a way that is both exemplary and highly seductive. Canonically, terms and expressions are categorized under various criteria ("logic," "cross-references") and listed in spacious, framed panoramas or serialized sequences. Thus the terminological index for the structure of the German language as constituted from sound, via the word through to actual phrase is laid out solidly and meticulously across the wide expanse of his work Grammatik *(1990). This demonstrative display panel of grammatical headings and subcategories we use every day without thinking has been recorded strictly in line with the Duden German Dictionary which reflects the German language as a well-ordered, rational system. In marked contrast we have words such as "Hund," "Hysterie" or "Pegel" — or their English equivalents in the English version,* The World *(1987) — in Locher's very first linguistic image,* Die Welt *(1983), intuitively arranged by their sounds. As much as the former work adheres to the standards of analytical consequence, irritating the viewer only through the almost fictional excess of scientific terminology, so the latter is a conclusive demonstration of the impossibility of representing the reality of global creation. These "textual images" with their mass of terminological attribution, classification, and dialectic opposites (*Everybody/Nobody, *1988) — including idiomatic examples which could escalate into imaginary dialogue — are contrasted with a series of works ordered by pictorial structures which on first impression seem to present consistent concepts just as conclusive and harmonic.*

Related species of commodities such as electrical appliances, doors and their assorted locks, or piles of crockery are photographically recorded and then arranged amongst shop window displays or mail order catalogues, labelled with numbers, and apparently numerically catalogued. In analogy, numbers or letters are applied on astralon squares on wood. These colour fields in various sizes and constellations are, of course, formally redolent of the elementary artistic language of the Constructivist tradition, be it the abstract icons by Casimir Malevich, the systematic colour series by Richard Paul Lohse, or Colors for a Large Wall *by Ellsworth Kelly, which are a random succession of uniform-sized, monochrome oil paintings. Intended as deconstructions, however, Thomas Locher's panels break free of the painterly skill of his predecessors and their different respective idealistic precepts: brilliantly shiny, they are made from industrially prefabricated plastic material. The application of numbers or letters to the sensually perceptible base elements adds a discursive dimension to the works, though remaining without meaningful decipherment — the code, an explanation are missing — discourse turns out to be arbitrary in the same way as the choice of colour for the actual colour fields themselves.*

The direct aesthetic experience which Thomas Locher creates with great formal skill and playful intuition is immediately taken back by means of abstract codification: the work of art loses its much-proclaimed autonomy. The attention of the viewer is not directed to the variable and exchangeable elements such as words, colour fields, or familiar objects but rather to their classification, to the rift and non-identity between object world and linguistic world, sign and signified: "I believe that this kind of perpetual difference is also an amazing metaphor for us, for human nature. The non-conformity of name and object, this kind of eternal separation is something you simply have to accept, and actually can accept." (Thomas Locher)

Kunsthalle Zürich. *Wörter Sätze Zahlen Dinge — Tableaus, Fotografien, Bilder* (1993). Exhibition catalogue, with essays by Bernhard Bürgi and Boris Groys. Excerpt, n.p., from Bürgi's essay, "On the Structures of the World" (translated from the German by Jörg Stein).

A Small Hermeneutics of Silence
1994
Aluminum and wood engraved with
English text
28¾ x 78¾ x 27⁹⁄₁₆ in.
(73 x 200 x 70 cm) (table);
30¹¹⁄₁₆ x 16⁹⁄₁₆ x 20⅞ in.
(78 x 42 x 53 cm) (chairs)
Collection of Südwest LB, Stuttgart

Installation views, Kunsthalle Zürich
January–March 1993

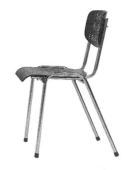

I am saying nothing.
I don't want to talk any more.
I'm not talking to you because you lied to me.
I can't talk any more.
I would rather say nothing than be misunderstood.
I'm not saying any more at all.
I don't want to talk to you any more.
It is better that I say no more.
I could have said something but to what ends.
I don't want to talk to anybody.
I have nothing to say.
I could say something but I don't want to do.
I can't say it.
One who has nothing can't be misunderstood.
I've said everything, now I'm not saying anything wrong.
I have reasons for not saying anything.
One who says nothing can be misunderstood.
I'd rather say nothing than say something wrong.
I simply can't talk any more.

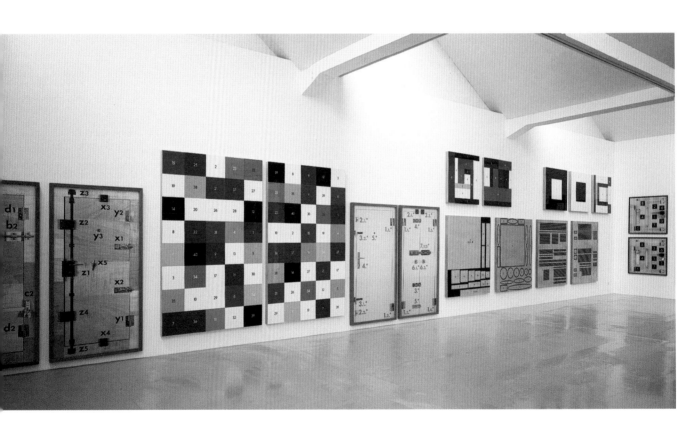

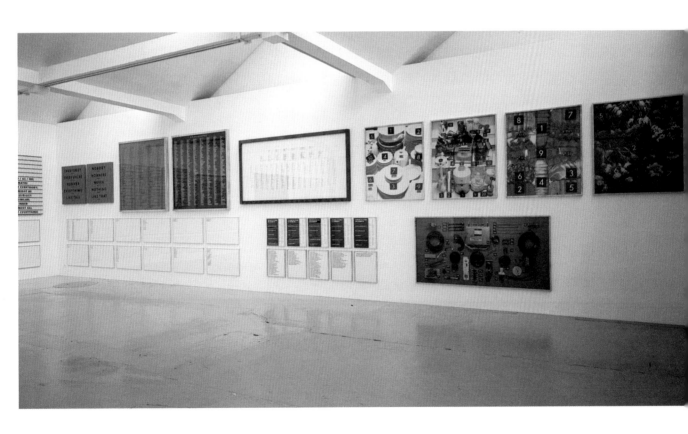

Agnes Martin

Irving Sandler: To begin with a general question, what would you like your pictures to convey?

Agnes Martin: I would like them to represent beauty, innocence and happiness; I would like them all to represent that. Exaltation....

At the same time that you value a detached and cool art, you require that your art express feeling. It is commonly thought that detachment and feeling are antithetical, yet you would like to bring them together.

I think that personal feelings, sentimentality and those sorts of emotions, are not art but that universal emotions like happiness *are* art. I am particularly interested in the abstract emotions that we feel when we listen to music. All music is absolutely abstract, except for one piece, "The Flight of the Bumble Bee," which is not abstract! People are not aware of their abstract emotions, which are a big part of their lives, except when they listen to music or look at art. These are the emotions that align with art....

Your art is non-objective which, as you have written, is of extreme importance to you.

I think that the abstract emotions, of which we are not conscious, are tremendously important, especially since they are all positive. I mean they are happy emotions that we only feel when we get away from daily care and turn away from this common life. I don't think human welfare and comfort are the artist's responsibility. I mean every other activity, every other kind of work contributes to human welfare and comfort. But art has no time for that materialistic area. The reason I think that music is the highest form of art is because it manages to represent all our abstract emotions. I don't think that artists should be involved in political life because it's so distracting....

John Cage was a follower of Zen Buddhism; were you friendly with him?

Well, just to speak to. But I don't agree with him.

Why not?

Well for one thing, he wrote a book called *Silence* and in the very first line he said "there is no such thing as silence." But I think there *is*. When you walk into a forest there are all kinds of sounds but you feel as though you have stepped into silence. I believe that is silence. John Cage believed in chance, and I very strongly disagree. Every note Beethoven composed was invested with his whole mind and being. I think that composition depends on accepting what you put down. Our mind asks, "is this right?" And it answers, "yes" or "no."

But you did remark once that you were no more responsible for your work than a potato farmer is for his crop.

I don't take responsibility for the inspiration. I mean that artists are all required to do exactly what they are told to do. In the morning we get up and we know what we have to do. At night the intellect goes to sleep and gives inspiration a chance. When people have a decision to make, they say they will sleep on it; that is the part of the mind that's responsible for artwork. It's not an intellectual process....

Another point of disagreement between you and John Cage is his belief that art ought to break down all barriers between art and everyday life.

I don't share that opinion.

Two artists that you admire are Mark Rothko, who tried to suggest what he termed "transcendental experience" in his painting, and Barnett Newman, who preferred the term "sublime."

I agree with them. I have great respect for their work and philosophy, their transcendentalism. They gave up so many things; they gave up line, they gave up form, they gave up organic form. They created an undefined space. I think that was so important. The abstract expressionists found that you can have an entirely objective reality that may be totally abstract. That's revolutionary. And they had so many different expressions.

Your paintings are non-objective and yet… I want to talk a bit from my own experience because we have something in common in that we both lived on the great plains in Canada. I spent part of my boyhood in Winnipeg and memories of that landscape remain vivid.

Yes, mine too.

I sense that there are references to that nature in your work, for instance, in the horizontal in your grids, or more emphatically, the openness and expansiveness in your work.

A lot of people say my work is like landscape. But the truth is that it isn't, because there are straight lines in my work and there are no straight lines in nature. My work is non-objective, like that of the abstract expressionists. But I want people, when they look at my paintings, to have the same feelings they experience when they look at landscape, so I never protest when they say my work is like landscape. But it's really about the feeling of beauty and freedom that you experience in landscape. I would say that my response to nature is really a response to beauty. The water looks beautiful, the trees look beautiful, even the dust looks beautiful. It is beauty that really calls.

You prefer the grid because it exemplifies wholeness, boundlessness and quiet.

And egolessness.

It is also non-hierarchical, no point having more emphasis than another.

That is the point, all the rectangles are the same size. I think that the rhythms are tranquil, don't you? Everything that bothers us is left out. One man couldn't stand that so he painted one of the rectangles!…

You commented once that you adopted the grid because it was universal, yet your lines are handmade, they emphasize touch which is associated with the personal, the idiosyncratic. Do you see any contradiction in that?

No. I drew them just as perfectly as I could, I didn't think at all about my hand, but in nature it is impossible to make a perfect line, so the lines have that lack of perfection. The composition carries it.

But the sensitivity of the lines is very important, at least in my perception of the work; indeed, the fluctuations in the line contribute to a sense of atmosphere in the work.

I didn't expect it but I value it. But then the sensitivity is obvious. Of course besides trying to make them all perfect, I have wanted them to illustrate the sensitivity of perfection. When I say that I want perfection, I don't mean a perfect sheet of work. I believe that life is perfect. We have an ego orientation, and so we are far from perfect. But everlasting life is perfect, and it is that perfection, a transcendental perfection, that I want in my painting. We can't have it because we are in nature but you can have a hint of perfection. It's enough to make a painting alive.

Untitled No. 2 1994
Acrylic and graphite on canvas
60⅛ x 60⅛ in. (152.7 x 152.7 cm)
Collection of Mr. and Mrs. Robert Lehrman, Washington, D.C.

Untitled No. 7 1994
Acrylic and graphite on canvas
60⅛ x 60⅛ in. (152.7 x 152.7 cm)
Collection of Linda and Harry Macklowe

Sandler, Irving. "Agnes Martin Interviewed by Irving Sandler." *Art Monthly*, no. 169 (September 1993), pp. 3–11. Excerpt, pp. 3–7.

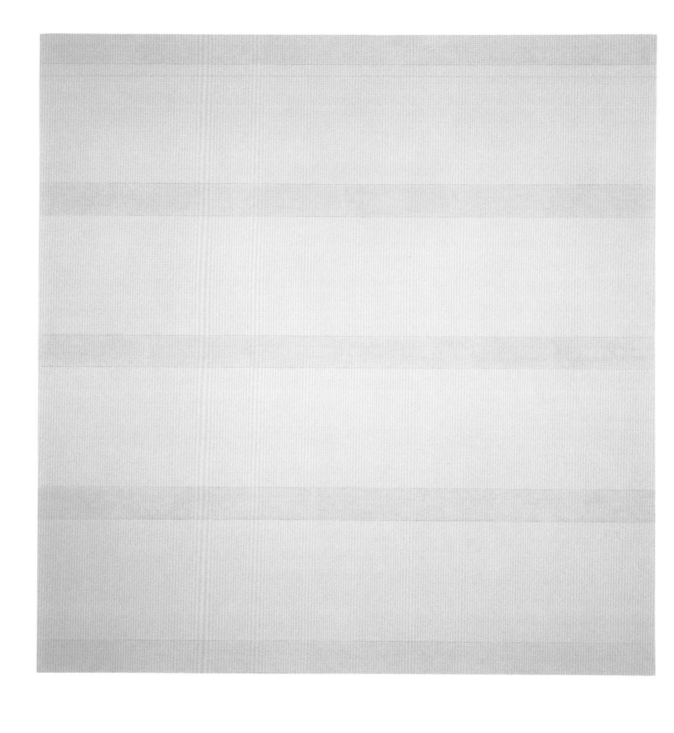

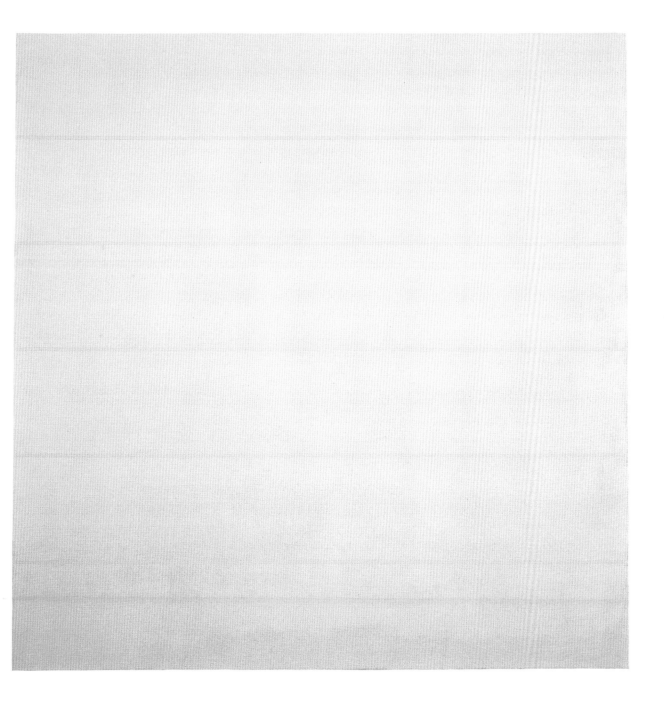

Beatriz Milhazes

In the paintings of Beatriz Milhazes, conceptual rigor and constructive discipline struggle passionately with images of a baroque insinuation, generating autophagic tensions. Working with a monotype method where the images are prepared on transparent plastic at a rate inverse to that with which they are printed on the canvas, the artist controls the reduced thickness of the pictorial subject, conceals the gesture of painting, and congeals the transferred image. In this settling of the thin film, skin on skin, dermis upon dermis, the collision of the circular forms with the geometric principle creates a painting of hyperbolic sensitivity, born of the mad struggle between baroque figuration and rigorous construction — not of the battle between one element against another, of one watershed against another, but of the mutual exaltation which incarnates a Baroque sensuality overlaid with Matisse-like color and which sets free the work's embryonic constructive emotion.

The circular forms reinforce nuclei while they generate concentric and expansive displacements, and disturb any desire for hierarchy which rational construction may insist upon reinventing. This is why they are paintings which do not surrender themselves to a first viewing. It is not possible to determine planes or favor one form over another, for these are paintings which give themselves up completely, and force the gaze to glide over them, without managing to singularize any instance.

For Beatriz, the Baroque is maintained as a cultural given, but only as archetypal memory. As emotion, it is displaced and misleads nostalgic motivations. It has doubtless been extracted by her from the deep roots gathered from our historical time, yet it has been transformed into a mirror image, a simulacrum which enters and reinforces the vortex of the work's constructive structures. These are extremely receptive and propitious to the collision, for they are closer to the frenetic and unstable musical rhythm of Mondrian's Boogie-woogie than to the crystalline stability of more rigid geometric compositions. The result could only be explosive.

It is a conjunction which favors sudden arrests of the gaze, but which also immediately convulses them, in a challenge to any sort of acritical retaking or mere updating of the past. If one can think of the reinvention of the Baroque, this is because the molded forms of its original language are displaced and subverted by the new mobile character which the artist stamps upon them. The medallions, arabesques, angels, flourishes, volutes, ruffles, lace and necklaces (skins glued to the skin of bodies…), and the entire iconographical exacerbation, at the very limit of anarchy and chaos. And not only the Baroque, but also the popular imaginary, plastic decorativism and elements symbolic of the feminine universe, all these are introduced in the same dialectic.

Nevertheless, the symbology of the topoi is voided by the reification of the flattened painting, without distinction of background and surface, where the images are constructed and destroyed in a cold ambiguous manner in superimpositions and transparencies. It is a painting where reflection plastically traces the tensions which settle upon the apparent solidity of history, but which happens like a new way of seeing the articulations, in search of a new perception of the phenomena and meanings of creation and artistic expression.

Sala Alternativa Artes Visuales, Caracas, and Galeria Camargo Vilaça, São Paulo. *Beatriz Milhazes: Pinturas Recentes* (1993). Exhibition catalogue, with essay by Stella Teixeira de Barros. Excerpt, n.p., from Teixeira de Barros' untitled essay (translated from the Portuguese by Stephen Berg).

Paraora 1994–1995
Mixed media on canvas
78 11/16 x 118 7/8 in.
(199.9 x 301.9 cm)
Edward Thorp Gallery, New York

Beijo 1995
Acrylic on canvas
75 9/16 x 118 1/8 in. (192 x 300 cm)
Dorothy Goldeen Gallery,
Santa Monica

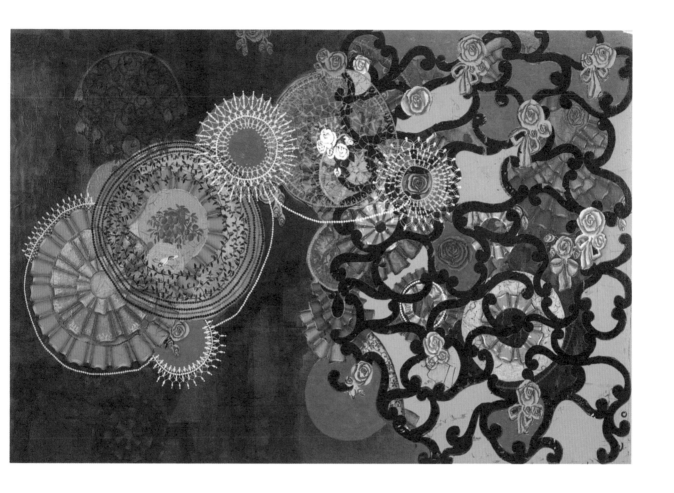

Joan Mitchell

I happened to see Joan Mitchell's first show, at a gallery called the New Gallery, in 1952. I was new to New York and the painting of New York was new to me. I wouldn't have known enough to go to the show if a painter friend, Jane Freilicher I believe, hadn't guided me there, mentioning that this was something one should see. I remember only a sensation of gyrating fan-blade shapes, chilly colors, and an energy that seemed to have other things in mind than the desire to please. I must have seen the large painting called Cross Section of a Bridge, since it was in the show. I don't remember it, but when I look at it now in reproduction it sums up the mood of those early pictures: a fierce will to communicate and an equally frantic refusal to make this task any easier for the sender and the receiver of whatever message was being transmitted. A cross-section of a bridge is not going to help anyone get from here to there; at most it will analyze and dissect the structure that would let us do so if it were placed subserviently under our feet rather than flung in our faces, as this confused, wildly flailing aggregate of jagged planes and wiry outline was.

When I got to know Joan in Paris a few years later she had already abandoned this early planar style for a different one that she would continue to practice and perfect throughout her life, and which her name now evokes for us: shaggy, dense forms that might be a haystack or a coat of burrs or anything that might suggest these forms, and the luscious brushwork that confines color amazingly within paint, so that one can never again look at raw pigment squeezed from a tube without wondering where the color is, and where Joan got it from. One's first urge is simultaneously to taste, caress and roll around in this theater of color; to rehearse its speeches and submit to its rules like an actor following stage directions, loving the coming and going they propose: "Going with the flow," a force that is tidal and inescapable once one accepts the terms of the engagement. And it is as difficult not to do

so as it was difficult not to take Joan herself on her own terms.

For Joan was a tough lady, a hard drinker, hard on her friends and harder on herself. Yet her thorniness made you want to hug her, as one thinks (twice) of embracing a rosebush: Such passion is hard to resist, even when it confronts you in uncomfortable ways. A French critic who knows and loves her work recently asked me how I remembered her, and I found myself saying, "She had a knack for putting you ill at ease immediately." He seemed a little shocked by this, yet I meant it as a compliment. It was one of the things that drew you to her, paradoxically. Being shaken up a little, in the context of so much friendly warmth, was invariably a refreshing experience, from which one emerged with new ideas, especially since one usually saw her in her studio, with her newest paintings on the walls or the easel....

Ici — Here!, Mitchell seems to be saying at the end of her life, is where life is, is what it is — one of those truths under one's nose that one ignores for that reason but which, in the right circumstances, can transform itself from truism into palpitating reality. Of course this isn't the first time Mitchell made that discovery, but its coming at the end reminds us again how often she has done her best and then done even better than that, without greatly altering the rules of the game, only redefining them a little more precisely each time, hundreds of times. "To go is to go farther," wrote the poet Kenneth Koch. Joan Mitchell seems to have lived that truth literally, and if it is tragic for us that she can now go no farther, we are still left with a body of work whose will to continue stays with us, helping us to "go farther" along the common way that all of us travel.

Tilleul 1992
Oil on canvas
2 parts, 110 ¼ x 157 ½ in.
(280 x 400 cm) (overall)
Collection of Musée national d'art
moderne, Centre Georges Pompidou,
Paris

Ici 1992
Oil on canvas
2 parts, 102 ⅜ x 157 ½ in.
(260 x 400 cm) (overall)
Collection of The Saint Louis
Art Museum,
Purchase: The Shoenberg
Foundation, Inc.

Robert Miller Gallery, New York.
Joan Mitchell 1992 (1993). Exhibition
catalogue, with foreword by John Ashbery.
Excerpt, n.p., from Ashbery's foreword.

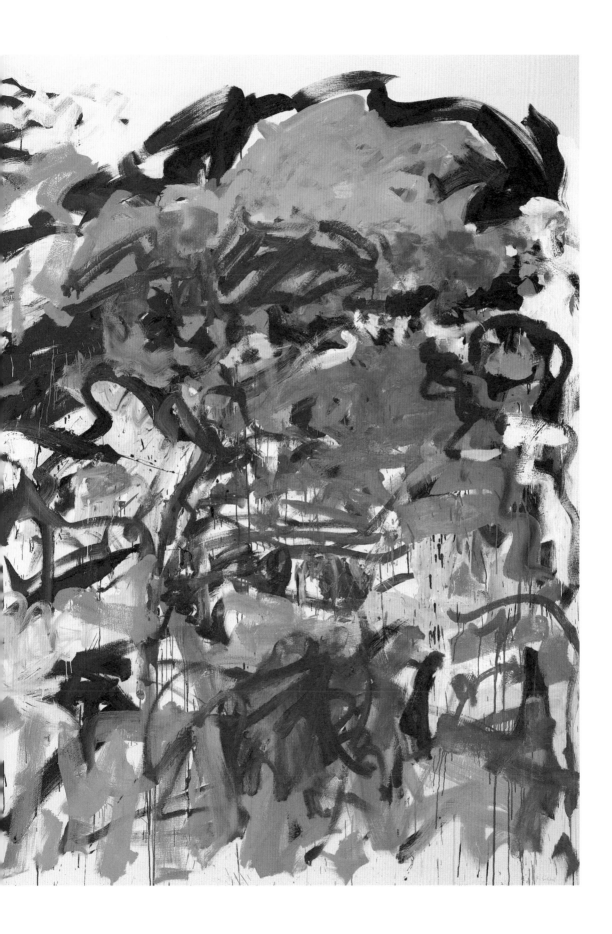

Tomoharu Murakami

Any picture of the kind that we are accustomed to looking at addresses the qualities of the image or space it represents. The image is substantial in the picture, and whether it is concrete or abstract, it exists in no place other than that picture, that is to say, expression must be accompanied by some concept or formal arrangement, and accordingly what matters is the quality of the image. However, Murakami's works do not offer any image that has that characteristic quality. As stated above, each work is a whole form in and of itself, and it is finished by repeatedly applying the same method to every part of it. If this is so, the condition of each spot or mark of paint is independent of the external form of the picture, and the image or the whole as an object is of little importance in this case. In other words, its present form or size has no special meaning nor does it imply any quantitative character that is contingent on the space where it is exhibited. Here, form and size are conditional attributes. In terms of spatial properties, his pictures' rough, lightly variegated surface is merely material, and nothing in it or in front of it, above or below it, or to the right or left of it provokes any sensation of dimension. Consequently our eyes, prohibited from penetrating, are driven back from their materially painted surfaces. Thus what we face is not the extension of so-called pictorial space, but no more than this coarse black surface.

Gallery Shimada, Tokyo, and Galerie Katrin Rabus, Bremen. *Tomoharu Murakami* (1992). Exhibition catalogue, with essays by Thomas Deecke and Mikio Takata. Excerpt, n.p., from Takata's essay, "Penetrating the Painted Surface."

Standing in front of Tomoharu Murakami's monochrome works, do words exist that we can use to describe them? Most of them seem to have a size that just fits our visual field, but the sight of closely, uniformly applied strokes forces our eyes to first wander on their surface without any point to focus on. None of these works evokes an image of palpable form, but it may be possible to say that each work is a form as a whole. No distinct space is made perceptible by color, so these works are different from those so-called monochrome pictures which, by means of an unbounded self-referential use of color go to extremes in enhancing the two-dimensionality of pictorial art. In Murakami's case, monochrome is separate from flatness, and as we come to realize that this feature arises from his pictures' dense texture, we return our eyes to their surfaces again, more attentively this time.

Untitled 1993–1995
Oil on canvas
63 13/16 x 51 3/16 in. (162 x 130 cm)
Gallery Shimada, Tokyo

Tony Oursler

For some time now Tony Oursler's work has shown an obsession with conjuring up horror, a naked terror, the laborious constraint of which seems only to be possible by employing means of laconic irony. This lends a spectacular aspect to the works on the one hand, but it is, at the same time, a great obstacle to their acceptance. More often than not, when watching his installations, we are faced sooner or later with that moment we know from watching violence on the movie or television screen: the "I-can't-stand-it-any-more"-reflex, which causes us to look away, to no longer expose ourselves to that which is being shown. This observation, viewed from a position of the greatest possible distance to the artist's work, could of course be described as a cleverly thought-out strategy in the art business, combining sensualist elements of the aesthetic experience with the subversion of well-worn patterns of reception. Then, horror would function merely as a disposition for the artist's real intention of prescribing to the observer the time of observation of his own works of art, although usually the observer himself determines the tempo at which he observes a work of art (on statistical average a maximum of approximately twenty seconds). This would indeed serve an important category of modern art, that of shock.

Such a cynical view is, however, for its part a reflection on the paleo-anthropological dimension of Oursler's work. Terror in Oursler's work is also to be seen within this framework, as an emanation of primal horror. What picture of man and the characteristics determining him is behind the dummies which Oursler has been exhibiting since 1991? Oursler has described them as the "most paranoid." This basically psychic dimension describes their relationship to the observer who sees himself confronted with these curious beings consisting only of old jackets and pants, the legs of which have mostly been tied at the lower end. And they are arranged in such a way, hanging or lying down, that they allude to the dimensions of the human body which, indeed, under normal circumstances fills out these clothes. However, the bodies have disappeared and in their place video cameras loom out of the clothing, mostly above the jackets, making technical restitution of only one of the human sense organs, partly transmitting the image into one of the monitors placed on top of the dummy, partly into monitors distributed around the room. These arrangements radiate an unbelievable hopelessness, an absence of any vital energy, expressing itself in the absence of the body, which is only partially replaced by technical energy. As Oursler himself observes, "That's part of their sad beauty; what they are not, cannot be. It's part of their design: provocation through absence." Nor does the medicine offered in the form of large-scale capsules filled with clothes provide a remedy. The absence of the body is, however, an important sign for the spiritual presence of technologies in culture. Art, too, is affected as I have already shown elsewhere.[1] Bodies in art, apart from nostalgically kitschy approaches, now have a supernatural presence, a kind of astral presence, such as those allegorized in Oursler's projections on airbags. But where has the body gone?

1 Friedemann Malsch, "Das Verschwinden des Künstlers? Zum Verhältnis von Performance und Videoinstallation," in: "Video-Skulptur, 1963–1989," ed. by Wulf Herzogenrath and Edith Decker, Cologne, 1989, pp. 25–34.

2 Bruce Chatwin, "Traumpfade," Munich, 1990, p. 342 ff.

3 Peter Sloterdijk, "Sendboten der Gewalt. Zur Metaphysik des Action-Kinos," in: "Die Zeit," Hamburg, 30.4. 1993.

4 Friedrich Kittler, "Grammophon, Film, Typewriter," Berlin, 1986, p. 192.

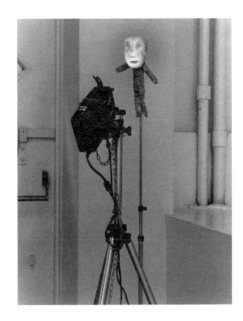

In his The Songlines, Bruce Chatwin has attempted to define the basic designation of man as nomad searching for his existence in his history by walking and singing along his way. According to Chatwin, man has in this way successfully treated therapeutically his own primal horror which, in the early history of mankind, had controlled his fleeing instinct from the dinofelis (false sabre-toothed tiger) specialized in primate flesh.[2] This image of peaceable man as runner and singer is contrasted to that interpretation which sees primal horror restrained not by spiritual sublimation but by aggression. Sloterdijk sees man rather as runner and thrower: at a certain point in the history of his development, man no longer simply tried to run away but turned on his pursuer. In order to compensate for his physical disadvantage, he developed auxiliary technical tools, above all the axe and spear, so as to be in a position to exercise "preventive" aggression.[3] Such an image captures the whole dimension of the development of technology which has only ever served to replace the human body. This development experienced a new dimension in the nineteenth century through the "differentiation of the human senses by the recording systems,"[4] from the consequences of which emerge Tony Oursler's helpless, amputated "dummies." Yet Oursler's works are not pessimistic. On the contrary, they are an expression of a concealed optimism which is founded on the transparency inherent in electronics. The video camera, which as a

construction is an allegory of man as a runner and thrower (for it bridges distances and "throws" glances which are readily compared with weapons), is, when removed from the apparatus which keeps it in working order, only a simple object released for the projection of man's wishes. The camera built as a silicone or papier-mâché replica is therefore a totemistic dummy to which our horror at the technically caused absence of our bodies can form ritual ties and thereby be restrained. The optimistic power of Tony Oursler is unexpectedly revealed at this point; the "dummies," "Poison Candies" or the "Designer Drugs" are therefore not so much a sign of a lost hope but rather heralds of a new era of self-discovery and self-determination.

Portikus, Frankfurt, Les Musées de la Ville de Strasbourg, France, Centre d'Art Contemporain, Geneva, and Stedelijk Van Abbemuseum, Eindhoven, Netherlands. *Tony Oursler* (1995). Exhibition catalogue edited by Friedemann Malsch, with essays by Paolo Colombo and Elizabeth Janus, Tony Conrad and Constance DeJong, Friedemann Malsch, et al., and text by Tony Oursler. Excerpt, p. 31, from Malsch's essay, "A Kind of Primal Horror: On Dummies, Clothing and the Absence of the Body in the Works of Tony Oursler" (translated from the German by Ann Thursfield).

MMPI (I Like Dramatics) 1994
Video projector, videocassette recorder, videotape, tripod, light stand, and cloth
Dimensions variable
(Tracy Leipold, performer)
Metro Pictures, New York

Telling Vision No. 4 1994
Video projector, videocassette recorder, videotape, tripod, light stand, and cloth
Dimensions variable
(Tony Oursler, performer)
Collection of The Carnegie Museum of Art; Second Century Acquisition Fund, Oxford Development Acquisition Fund, and Carnegie Mellon Art Gallery Fund, 95.5

Organ Play No. 2 1994
Two video projectors, two videocassette recorders, glass, formaldehyde, animal organs, and table
Dimensions variable (Tony Oursler and Constance DeJong, performers)
Metro Pictures, New York

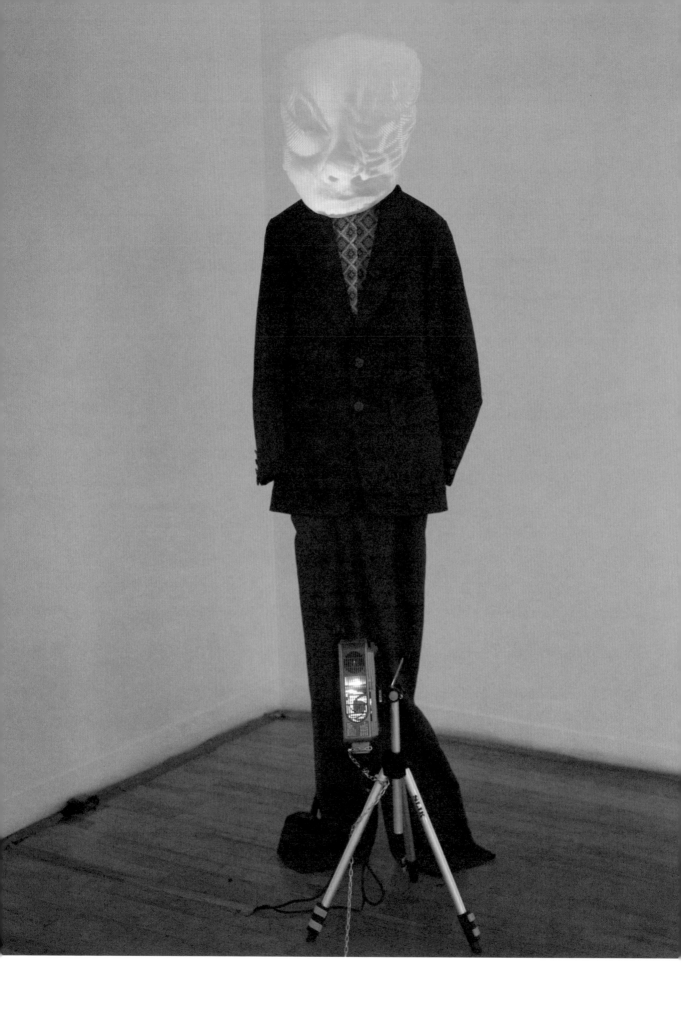

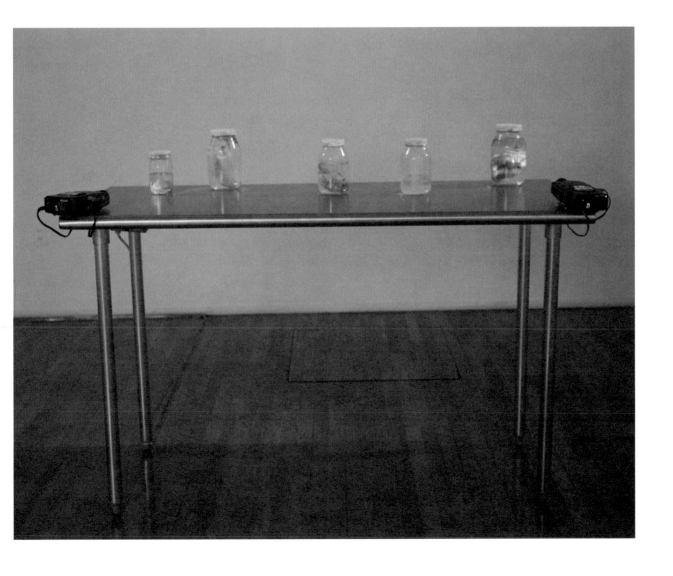

Sigmar Polke

Sigmar Polke intrigues, sets problems, provokes, amuses himself, investigates and disturbs. He subverts through irony and play. These are what might be called classic Post-modern strategies. To include irony and play in no way means excluding seriousness and purpose. Parody paradoxically enacts both change and cultural continuity. Indeed the Greek prefix "para" can mean both "against" and "beside." This is a duplicity that Polke would happily embrace. Jameson argues that in Post-modernism "parody finds itself without a vocation" replaced by pastiche, which he sees as neutral or blank parody. Polke looks, with equal interest, at everything that arouses his curiosity and inevitably what interests him eventually finds its use. He undermines as a means of advance, challenging or questioning both the tyranny of heroic High Modernism and the consumer hymn of American Pop Art. He obsessively explores what things can do, surrendering himself to the surprise of process and discovering along with the things themselves. Should we look for a common denominator in this wide range of work that stretches from drawing notebooks to images projected onto textiles, from experiments with rare and dangerous materials to film, and from photography to actions, it may well be the qualities of surprise and a kind of perversion and sophistication that lift the work to a point where they become charged with mystery and with a resistance to being appropriated at any single level of meaning. He moves forward "tongue-in-cheek" bringing everything into a zone of doubt, putting all under erasure, wilfully mis-reading. He delights in cultivated contradictions: a sumptuous artist who is paradoxically anti-peinture; an image-maker who is passionately involved with the chemical processes of the materials he uses and exploits the principle of non-interference and accident; an explorer of our image-world who wilfully plunders and insists on its fundamental banality....

In all of Polke's work — and it does not matter if we are referring to the "screen" style paintings, to the works that experiment with the nature of the materials themselves, or to the Transparents — there is always the constant of some inner life that escapes being pinned down however much it is inferred through the complex processes of production. He uses chemistry and optics almost as techniques of revelation for some underlying mystery that he himself does not understand, for a darkness that can never be fully appropriated. The Transparents are open to multiple readings and declare themselves differently from different perspectival positions. The angle of incidence of the light creates new meanings, as if seeking to be analogous to our changing vitality and to the way we glimpse "content" or register the nature of experience. Forms contain forms; images contain images; life contains life. The same metaphor stands for Polke's chemistry of colors that become "houses" to a whole hidden range of nuances. The Transparents present dual and contradictory worlds. Their dense fusion, their play with contamination and contiguity, their sense of iconic saturation, all open up new ways of reading our image-world. He uses art references, caricatures, images from his drawing-books, comics, pictographs, classical emblems with the same insistence that they are what they are but they are also vehicles for other layers of discourse. For Polke, the ultimate banality of the icons becomes a starting point, a means of liberating himself from all pretence and of gaining access to the voyage of discovery.

Centre del Carme, IVAM, Valencia. *Sigmar Polke* (1994). Exhibition catalogue, with essays by Bernard Marcadé, Kevin Power, and Guy Tosatto (expanded version of catalogue published in conjunction with exhibition coorganized by Centre del Carme, IVAM, and Carré d'Art, Musée d'Art contemporain, Nîmes). Excerpt, pp. 115–116, 121, from Power's essay, "Sigmar Polke: Subverting Intent."

Frau Herbst und ihre zwei Töchter (Mrs. Autumn and Her Two Daughters)
1991
Polyester resin and acrylic on synthetic fabric
118 x 196¾ in. (299.7 x 499.7 cm)
Collection of Walker Art Center, Minneapolis
Gift of Ann and Barrie Birks, Joan and Gary Capen, Judy and Kenneth Dayton, Joanne and Philip Von Blon, Penny and Mike Winton, with additional funds from the T.B. Walker Acquisition Fund, 1991

Camp 1994
Mixed media on canvas
118⅛ x 196⅞ in. (300 x 500 cm)
Courtesy of Helen van der Meij, London

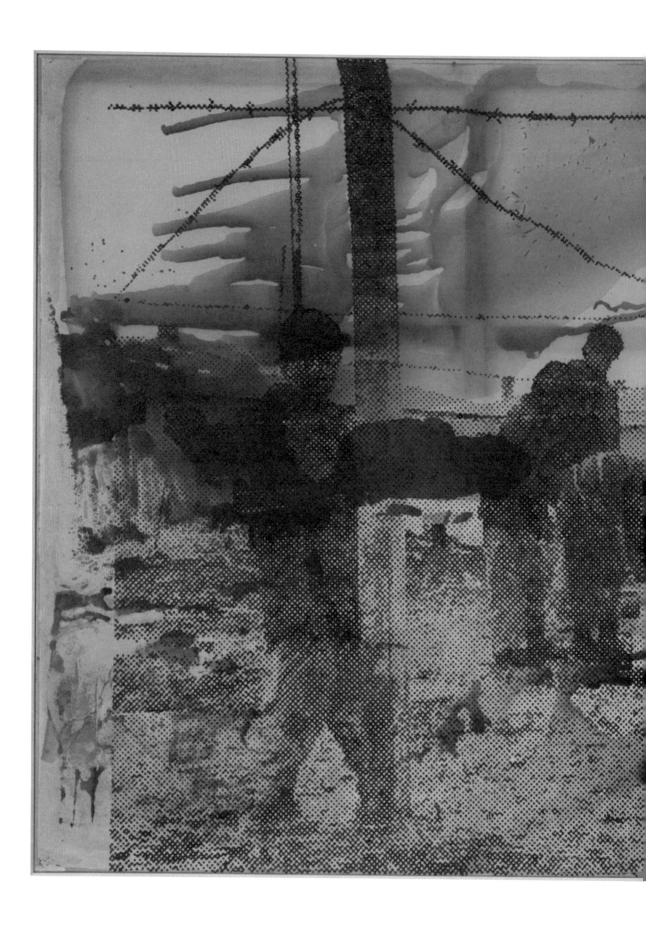

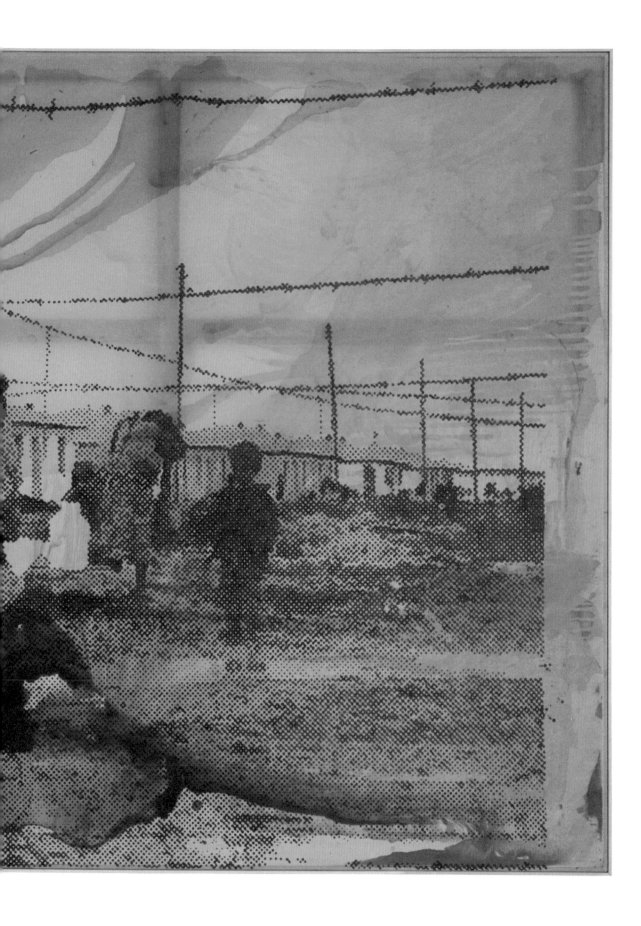

Doris Salcedo

Since the mid-eighties, the sculpture of Doris Salcedo can be considered as an ongoing exploration of how to address and articulate the subject of violence and loss. Utilizing mundane domestic objects and organic materials, her work seeks to draw an audience closer to the locality and affective dimension of an experience which leaves only its trace within the community of those who have suffered loss. While approaching materials as metaphors for the human body, her interest in the processes of manipulation and gestures of elaboration serve as signs for agencies of repression. Although influenced by Joseph Beuys and Eva Hesse, and the strong sculptural traditions of constructivism within Colombia, Salcedo eschews both metaphysical pretensions and adherence to an ideology of technological neutrality.[1] Rather, using salvaged objects, industrial and organic materials, she both maintains the original function of the found object, such as the hospital trolley, the bench, etc., whilst also drawing attention to the facture and procedures of working. Her work seeks to generate a form of symbolic and affective meaning precisely through the application of organic materials, and their interaction with heavy industrial materials. The combinations of metal, wax, latex, cloth, plastic and barbed wire create a series of opposites: cold/warm, malleable/hard, etc., working not only to release an interplay of textures, surfaces and internal energies, but also to subject the object to a process of radical transformation. However, unlike constructivism, emphasis is not given to the spatial dynamics between form and environment or to the valorization of the artist's hand; nor is meaning generated through recontextualization in a Duchampian manner, but rather through attention to the tactile, visceral quality of the material and the interventions to which it has been subjected. Pushed up against a wall or into corners, her work intrudes into the space as if designed to control and threaten those bodies that view them. The challenge that this work faces is that in seeking to re-present the scene of violence, it folds the sacrificer and victim into one another; to speak of one implies, produces, the presence of the other. Compelled to repeat the scene of violence, the danger lies in producing a vicious and suffocating circularity, whose symbolic unity comes to stand for the social fabric of Colombia as a "culture of violence."

Merewether, Charles. "Naming Violence in the Work of Doris Salcedo." *Third Text*, no. 24 (Fall 1993), pp. 35–44. Excerpt, pp. 37–39.

1 This includes most especially Negret, Ramírez, Villamízar, Carlos Rojas, John Castles, Ronnie Vayda or Hugo Zapata.

Untitled (Armoire) 1992
Wood, cement, and steel
45 x 73½ x 20 in.
(114.3 x 186.7 x 50.8 cm)
Collection of The Carnegie Museum of Art; Carnegie Mellon Art Gallery Fund, 93.153

Installation view, Brooke Alexander Gallery, New York March–April 1993

Untitled 1992
Wood, cement, steel, and glass
51 x 84¼ x 23 in.
(129.5 x 214 x 58.4 cm)
Collection of The Art Institute of Chicago, Gift of the Society for Contemporary Art

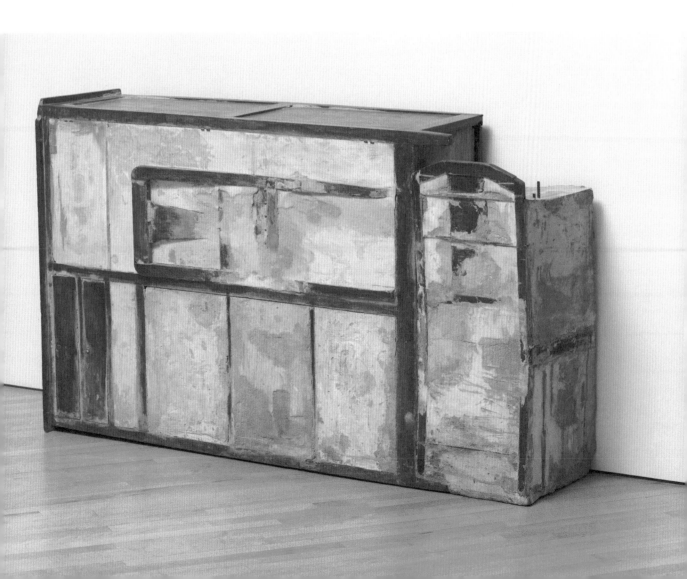

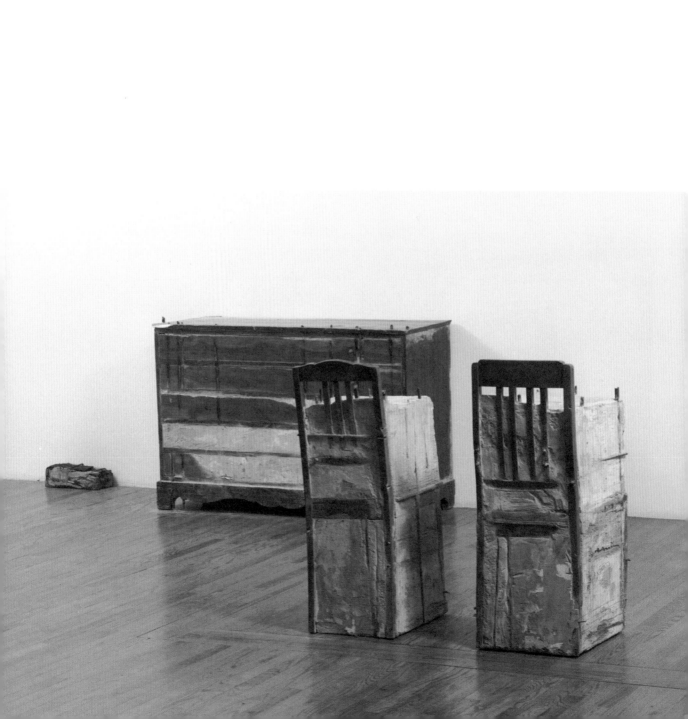

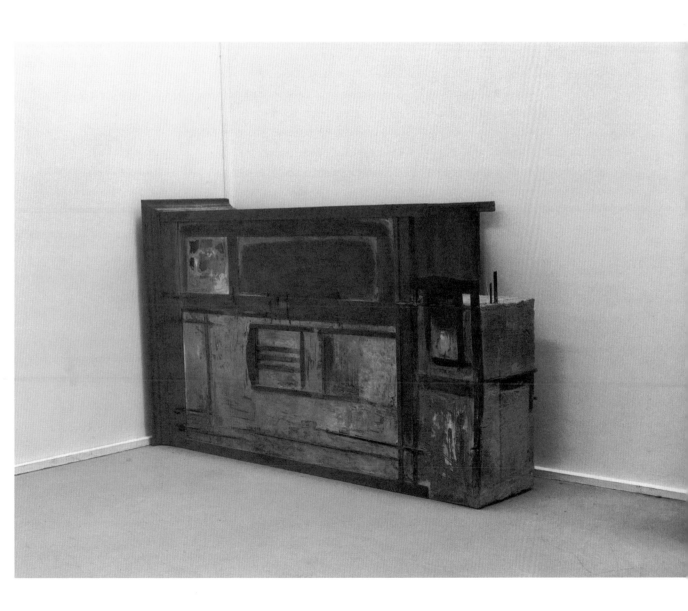

Cindy Sherman

For more than a decade, Cindy Sherman has delivered what many have regarded as one of the most sustained and eloquent disquisitions on the morphology of the image and the structure of desire. By contrast, the response to Sherman's most recent work has been nothing if not circumspect. Admittedly, as a group the latest series of photographs lacks a clear agenda; its language is polyglot and its subject matter elusive: Sherman draws on Christian icon-ography, the legacy of Surrealism, the cult of the grotesque, and horror-movie schlock. If Caravaggio is here, along with Hans Bellmer, and Joel-Peter Witkin, so is Chucky. Indeed, in the face of this panoply of possibilities, even the loquacious Peter Schjeldahl seemed at a loss for words. Faced with the lack of programmatic intentions, Schjeldahl took the easy way out, asserting that these works are a means of con-founding "a present cottage industry of inter-preters who presume to understand her," while begging the question of whether or not the "evolution" of Sherman's career has out-stripped the dense exegeses that have attended it to date.

Experimenting for the first time with photographic techniques inherited from the Surrealists — multiple exposures, superimpositions, and the manipulation of the photographic negative (low-tech effects whose obsolescence has been guaranteed by the computer) — Sherman's most recent images have a faintly Victorian feel. Ghostly residues, the aftermath of some photochemical séance, they combine hokeyness with a diffuse sense of menace. A pair of hands frame the truncated torso of a bald male mannequin, who, though armless, seems to cradle the body of a child wearing the head of a life-size woman. The blurring of the double exposure creates a space that is simultaneously tremulous and pulsating, implosive as well as explosive — the central motif suspended in querulous equilibrium. In another image, also blurred and indistinct except for the scratching on the print that suggests a halo or crown of thorns, an emanation is formed from two differently scaled bodies. Here, body proper and body-prop stand in for each other. Artifice is foregrounded in a way that aligns Sherman's low-tech methods with the psychic terrain she explores.

Hung salon-style, a series of six images make plastic origami of gruesome prosthetic masks. A deep red vortex of heads and hands suggests the kinesthetic space of horror pioneered by the hot-head camera mount and the Steadycam. In another image, a head floats above the body from which it is separated, connected by an umbilical cord made of bandages in which its disguised features are swaddled. But if these images adopt the protocols of horror films, they do so in the name of convulsive beauty. Never truly repulsive, they speak of a colonization of the abhorrent. Deprived of their atavism, these signifiers of fear become something mildly antiquated and quaint: they occupy a place where the image becomes disentangled from the danse macabre of interpretation.

Wakefield, Neville. "Cindy Sherman: Metro Pictures."
Artforum 33 (April 1995), p. 89. Excerpt.

Untitled (315) 1995
Cibachrome print
60 x 40 in. (152.4 x 101.6 cm)
Collection of Sandra Simpson, Toronto

Untitled (305) 1994
Cibachrome print
49¾ x 73½ in. (126.4 x 186.7 cm)
Collection of Charles Heilbronn, New York

Untitled (306) 1994
Cibachrome print
76 x 51 in. (193 x 129.5 cm)
Metro Pictures, New York

Untitled (316) 1995
Cibachrome print
48 x 32 in. (121.9 x 81.3 cm)
Metro Pictures, New York

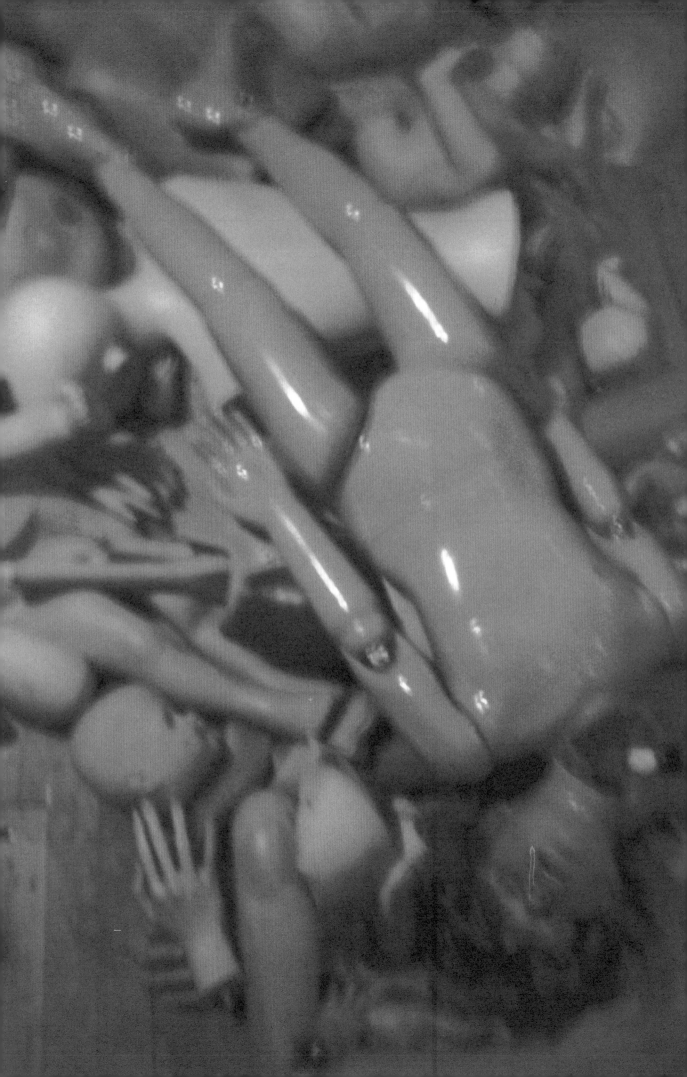

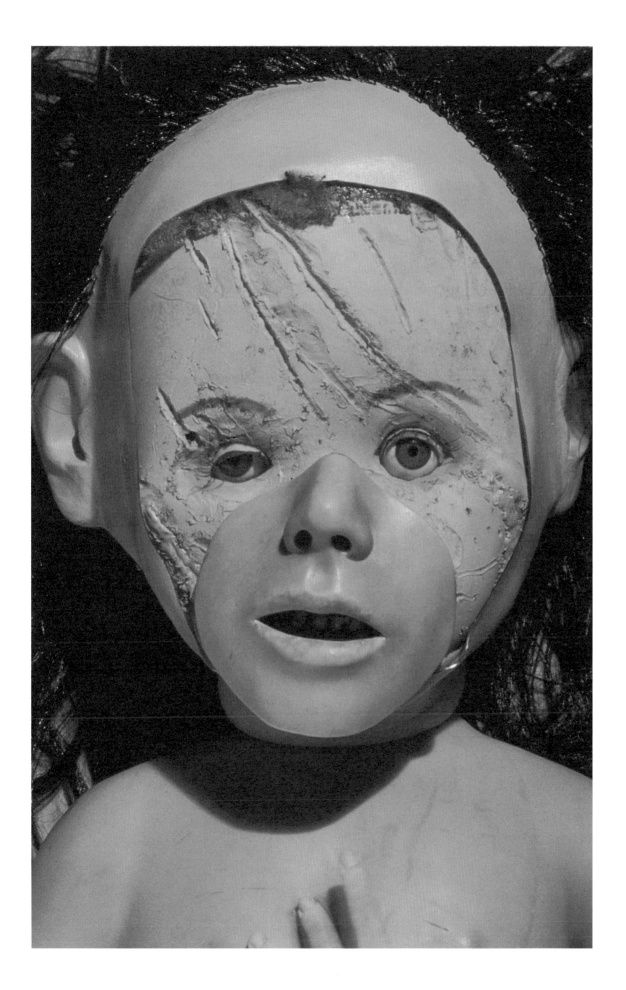

Robert Therrien

Therrien's process is exemplary of how subjective experience may be translated into an intellectually and technically controlled generic form. But more than that, it is representative of why artists make art: in order to see something they imagine and desire or, to quote Barnett Newman, "to have something to look at."[1] Similarly, the writer writes to tell himself a story, in order, once again, quoting Newman, "to have something to read."

The primary model of all literature is the story. Deceptively simple, deceptively familiar, for this is the first literary mode we encounter in childhood, the narrative, story, and more particularly the fairy tale or fable, obey rigorous conventions. The setting, in terms of time and place, is not specifically defined. The characters are nameless and correspond to symbolic functions. The structure and images are clear and compact, so that the story may be remembered and retold. And whereas the storyteller weaves his tale with a coherence which makes it credible, the events portrayed do not lend themselves to analysis or verification. In fact, the story, in its pure archaic form, represents a collective wishful thinking, a blend of the ordinary and the extraordinary. And in actualizing certain fantasies, it serves to correct reality.

It is somehow appropriate that Therrien uses the term "narrative" in speaking of his own artistic activity: "not formalist, not conceptual, but narrative." And in fact, he makes sculptures, reliefs, paintings "to see what they will look like." Therrien's art is not a nostalgic art, expressing a desire to return to a former place or time. It is an art of illusion which corrects the reality that inspired it. The resulting objects, fictions of his subjective vision cast in concrete form, like the story, open a door to another reality, a utopian world (by definition, an ideal nowhere). And we, the viewers, we are invaded by a sense of the uncanny, in front of the extraordinary aura of these ordinary things.

Museo Nacional Centro de Arte Reina Sofía, Madrid. *Robert Therrien* (1991). Exhibition catalogue, with essay and interview by Margit Rowell. Excerpt, pp. 26–27, from Rowell's essay, "Ordinary–Extraordinary: The Work of Robert Therrien."

1 From Barnett Newman, *Selected Writings and Interviews*, New York 1990, p. 160.

Under the Table 1994
Wood and mixed media
116 x 312 x 216 in.
(294.6 x 792.5 x 548.6 cm)
Collection of The Eli Broad Family
Foundation, Santa Monica

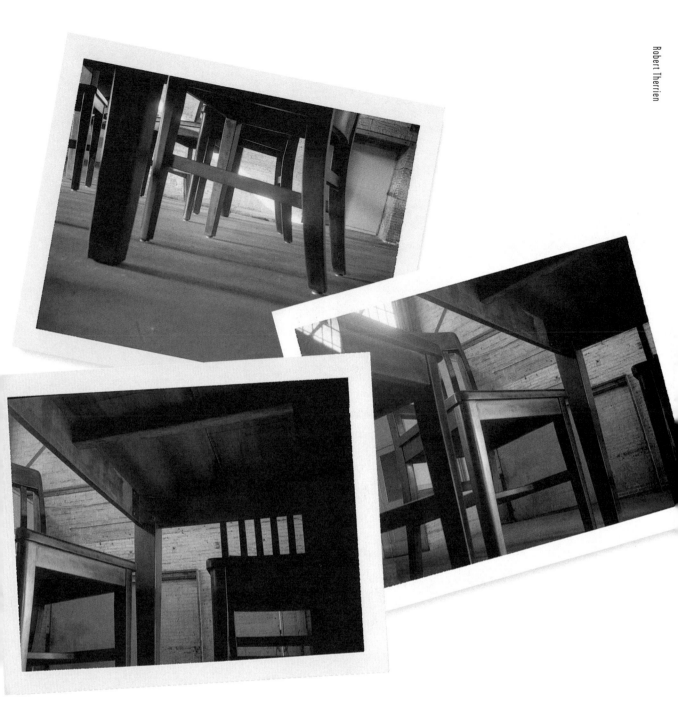

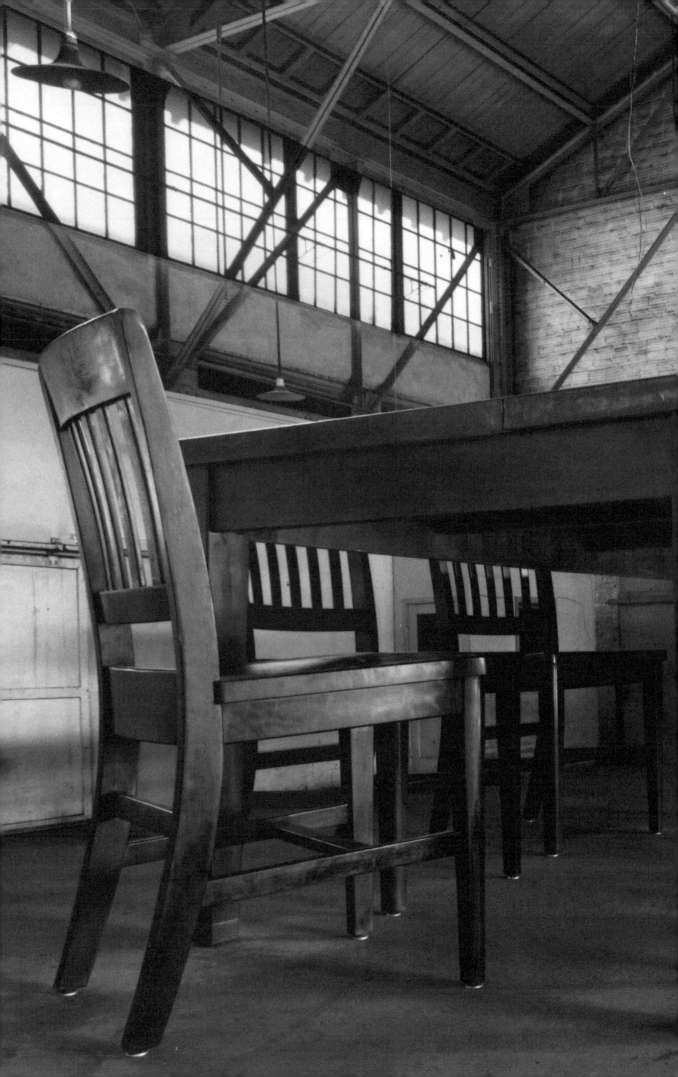

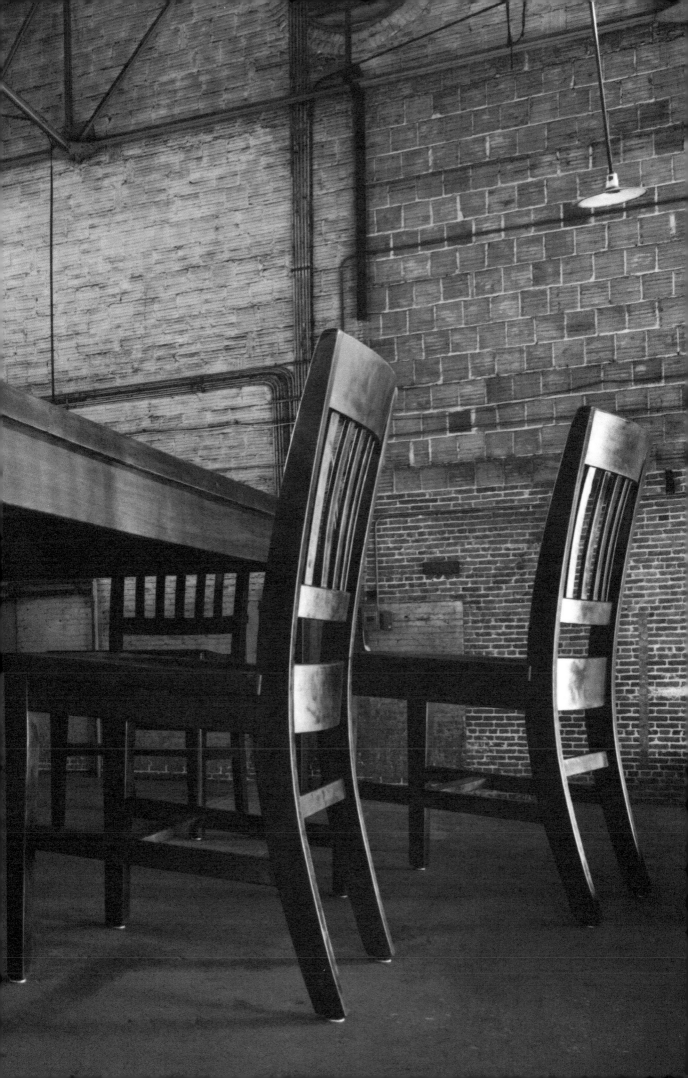

Rirkrit Tiravanija

Rochelle Steiner: With your cooking pieces, nothing is ever thrown away, right? The remains are put into tupperware containers.

Rirkrit Tiravanija: Yes, in a way it's a kind of archeology or something, and at the same time it's about not wasting anything. There's this kind of economy to not throw things away, as much as it's not that important either to be keeping things.

There are two things going on. I think partly it's about not wasting things, but then if you don't make too much then you don't have to keep it… I think one of the good things about art is that it's a place where you can store all the garbage, you know, all the refuse. We briefly talked about this at the "garbage" show ["Garbage!" Thread Waxing Space, New York City, 1995]. It was ironic to think about putting all the garbage in the museum; then we wouldn't have to make landfills.

We'd just have to make bigger art storage.

Yeah [laughing], just make more art museums.

It seems like there has been a shift in your work from the first cooking pieces, which were useful at the moment that you ate something but then became garbage. Now the things you're making are useful in the gallery, and then can be used in your house or in whatever situation you take them to.

Right, it can always be used. The first food piece was really a process piece. In a way it has always been a process. It may be the same thing now — I may be cooking again — but it has changed. The first things were just objects sitting on pedestals, not even pretending to be anything, but it was already quite different from most art in terms of one's relationship to looking at it and dealing with it.

Later I made Pad Thai and put it into a vitrine. After the end of the show it was taken out of the case and stored away. Everything was kept.

That work was recently sold, wasn't it?

Yes. I made it and put it in storage until two months ago… I never thought about having to sell my work, or that someone would buy it… As time passed I basically said, look, if somebody wants this thing, the only way to have any relationship to it is to re-do it, which means to re-make the meal and put it back into the vitrine.

With the old remains?

Yes, the old things and the new things together.

Basically I started to make things so people would have to use them, which means if you want to buy something then you have to use it. It doesn't have to be all the time. It's not meant to be put out with other sculpture or like another relic and looked at, but you have to use it. I found that was the best solution to my contradiction in terms of making things and not making things. Or trying to make less things, but more useful things or more useful relationships.

My feeling has always been that everyone makes a work — including the people who take it to re-use it. When I say re-use it, I just mean use it. You don't have to make it look exactly how it was. It's more a matter of spirit. And if you can understand that, then you don't have to worry about how it works. It just comes back together….

What do you think is forcing that shift from just looking at art?

I think we are coming to the end of the century and we've been dealing with art in a dimension that we've gone past. We're going to be dealing with things in the future in a completely different dimension, which is basically virtual. I think art will be very important in the future, but it will have to operate in a very different space than it does and than it has up until now.

Untitled (Free) 1992
Installation views, 303 Gallery,
New York, September 1992

Parkett, no. 44 (July 1995), issue featuring Rirkrit Tiravanija, with essays by Liam Gillick and Alexandre Melo and essay-interview by Richard Flood and Rochelle Steiner. Excerpt, pp. 116–117, 119, from Flood and Steiner's essay-interview, "En Route."

Richard Tuttle

[The] quest for a different quality of time is Richard Tuttle's main concern in coming to terms with
Modernism. Despite their overall failure, the Abstract Expressionists did succeed in wresting a moment's
pause from a Modernism intoxicated by movement by postulating the experience of the sublime,
where the individual's intellect and creative energies come together in a space of their own. For Tuttle,
this conquest was the springboard of his artistic development. The cancellation of linear time
in pictures with no beginning and no goal, and the attendant delusion of having vanquished death in
dripping, calligraphy and gesture, reappear in his work in a reduced form. When in 1967 he
spent a month working on one of his wrinkled and very simply dyed Cloth Octagonals, *he was not trying*
to produce a perfectly crafted result but rather to capture time in order to make it timeless,
unrecognizable, unmeasurable. When he placed painted wood reliefs outdoors, his intention was to
demonstrate the destruction of stored time through biological decomposition. But it was
not until he started making his Wire Pieces *(1971–74) that he found a means, in the form of cyclical*
principles, that would convert the full stop at the end of linearity back into movement and out
into a different time-space continuum. Pencilled marks on the wall are often mutually opposed vectors
of energy, most simply illustrated by his preference for V-shapes. At first Tuttle's wires replicated
these marks and later they formed a contrapuntal response, casting linear shadows on the wall that
vary according to the source of the light. Tuttle thus transformed linear movement into several
different interactive courses of movement. The time axis becomes a time-space vessel for a variety of
equivalent temporal qualities. All forty-eight works in the cycle have no temporal historical
vector with the exception perhaps of the last one in which one end of the wire floats loosely in space.
The conversion of time into space and space into time and their confluence through movement
formed the basis of the assemblages in the years that followed.

The elimination of linear time brought about a gradual change in Tuttle's concept of consciousness.
The attainment of timelessness through a process of emptying out, as in the reductive mantras of Zen,
gradually gave way to a balancing of various forces. Many of the drawing elements that Tuttle used —
wavy or zigzag lines, crosses and curves that enclose but also exclude — recall the signs that
Hopi Indians use to mark their (now primarily spiritual) wanderings, or the symbols of movement in the
work of Forest Bess, a highly appreciated artist who belonged to the circle of Tuttle's former
gallerist Betty Parsons. The resemblance may be coincidental, but Tuttle was certainly familiar with
Bess's work from his days with the Betty Parsons Gallery in the early sixties. And Indian thought, most
likely the subject of countless conversations with his close friend Agnes Martin, impressed
him so deeply that he purchased a mesa which had long been inhabited by Indians. In any case, the
coincidence indicates a renewed awareness of time as a whole that merits a space of its own.
The Hopi language contains no tenses and in Hopi mythology worlds are vertically superimposed upon
each other. Similarly, Tuttle speaks of three levels of consciousness — middle, front and back —
united on a vertical axis.

Sezon Museum of Art, Tokyo. *Richard Tuttle: Selected Works, 1964–1994* (1995). Exhibition catalogue by Shigemi Oka,
with essay by Gerhard Mack and text by Richard Tuttle. Excerpt, pp. 28–29, from Mack's essay, "Walking the Time Line on
Richard Tuttle's Art" (translated from the German by Catherine Schelbert).

Untitled 1991
Acrylic, electric lights,
vinyl/cardboard, and wood
55 x 20 in. (139.7 x 50.8 cm)
Sperone Westwater, New York

Whiteness 19 (Memory of Alan Houser)
1994
Wood, paint, Styrofoam, cloth, and
nails
74 $13/16$ x 27 $9/16$ in. (190 x 70 cm)
Private collection, Switzerland.
Courtesy of Annemarie Verna
Galerie, Zurich

Whiteness 3 1994–1995
Paint on Masonite, latex/fabric, and
Styrofoam
39 x 64 in. (99.1 x 162.6 cm)
Mary Boone Gallery, New York

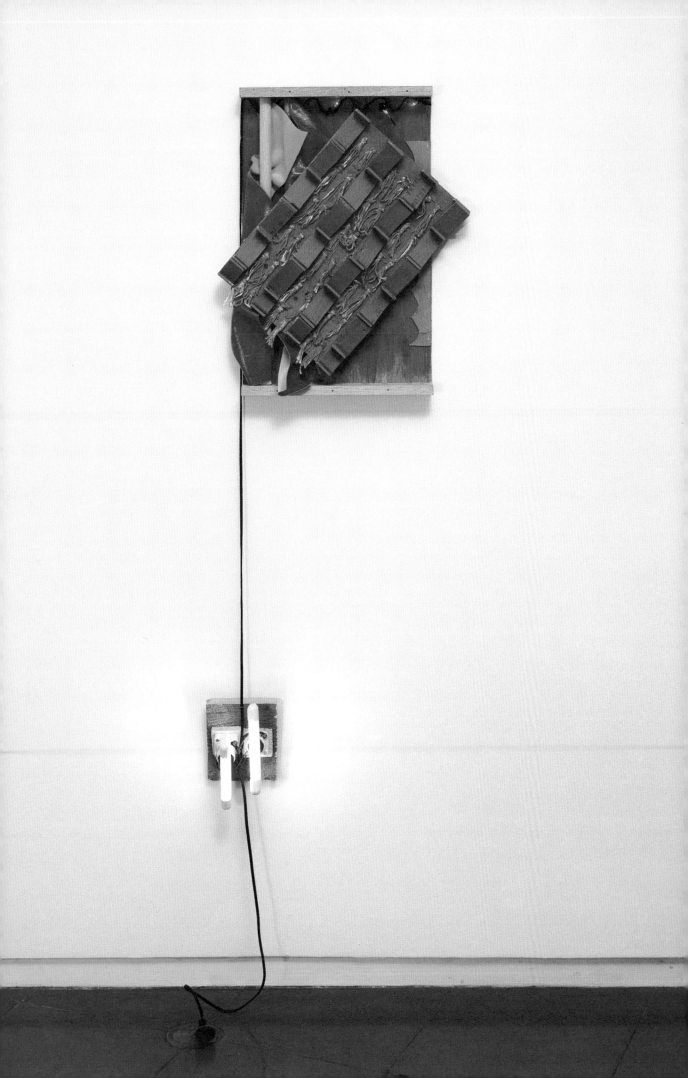

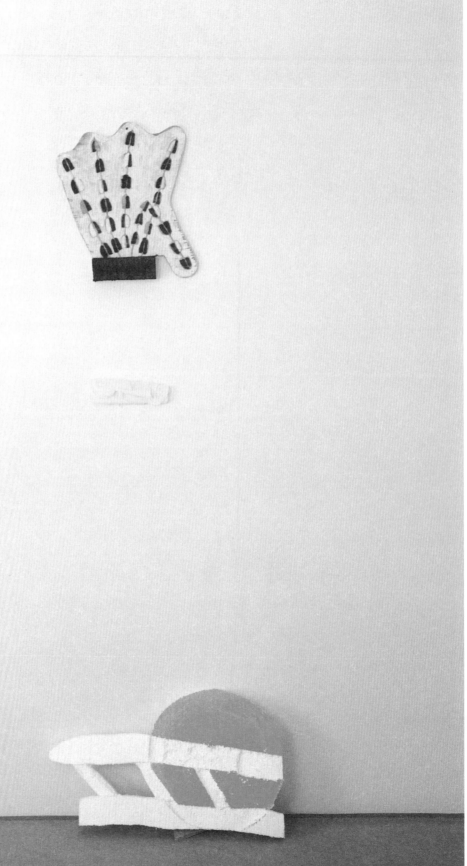

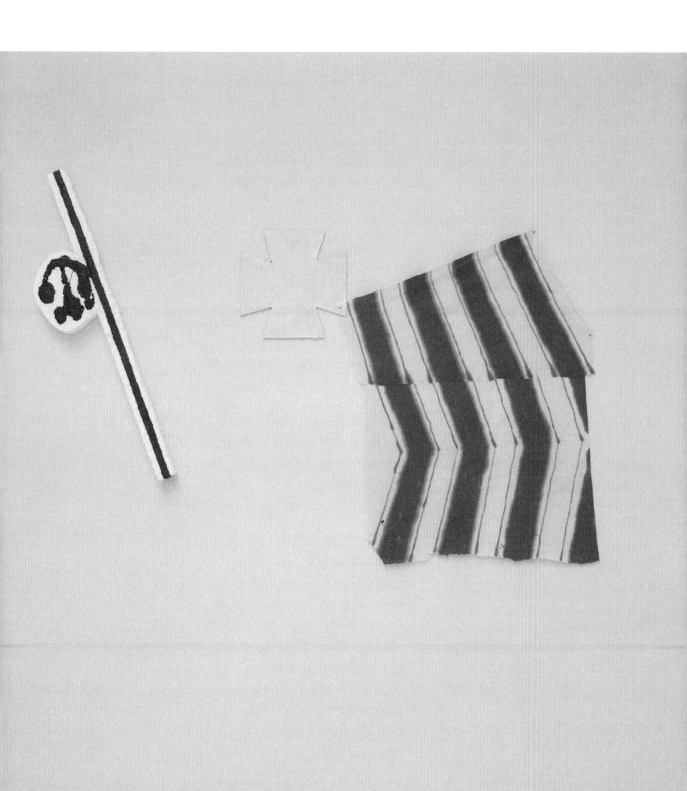

Franz West

Franz West's sculptures belong in a somewhere that doesn't exist, except in lost moments. It is a somewhere where the observer feels he is in the navel of the world — not his world, the world — accepting at the same time that there are many other navels, the sculpture for example which he encounters. The observer is nearly at ease and is perceived as being active. The works are ready to be dealt with....

Normally we suppose objects to be concerned with what we tell them they ought to be. The chair is supposed to try to become a chair, its maker going from the outside inwards, concentrating himself on being busy shaping what be believes a chair should be, searching a form to resolve the constructive and practical demands contained in the word "chair." These things here have been touched in every one of their wickedly weak points, they have been reformed and deformed, and have resisted nevertheless. They have been denied and have denied, have gone through the contacts one can describe as well in loving as in raging terms, but which seem to be finally too detached to be either of those. They stand in a gentle, unsentimental middle.

The eye is here not perceived as an instrument for control and command, leading to recognising and situating. It becomes again a tactile sense, opening up a space of experience like the other senses do.

The deviation is the only standard.

The sculptures give the impression that they made the demands as soon as they did their primal twists and that only those could be continued, demanding to be finished up to a certain point where the demand became negation. They must slowly have gotten out of hand.

They become this perfectly clumsy thing, awkward to start with and awkward in its conclusion. Countless small aberrations fulfill it, make it happen. They believe they lead their own life, like the waves on the water would do if they were intelligent. The gesture of the sculpture is surrounded and accompanied by a forest of moments.

Isn't clumsiness a basic fact of life? If one should have forgotten that, the Paßstücke may make the image complete again. That might be a rather soothing experience. It might ease the tension created by a habitude of trying to veil the weight and slowness of one's body, its outgrowths which are everything it is, its protruding from the axis it believes itself to be, one's obstinate pretending that one's awkwardness doesn't or shouldn't exist. Oh my. A lump is a face is a lump. In that it reminds every face of that quality. The failure here is the very beginning and, with that, the possibility the very end.

It is being active. It is. (The leanest way to say real.)

Formverlust.

The work and the world are linked by their apparent failure, a mastership of humbleness in the case of the work, a sea of deviations in the case of what we like to assume as the world.

Culture comes short by definition. The work of Franz West is retreating into the space of factuality as an act of cleansing. Thinking is completed by action.

In fact, one might write a beautiful article about the beauty in his work.

Like with any vital body, a great many approaches are potentially there, together with the deformations that are proper to every existing form.

Studio view, Vienna June 1995

Telephonesculptures 1995
Papier-mâché, stucco, paint, and table
Various dimensions
David Zwirner, New York

Rondell 1995
Papier-mâché, stucco, and paint on metal armature
78 3/8 x 66 1/8 x 30 5/16 in.
(199 x 168 x 77 cm)
David Zwirner, New York

Papille 1995
Papier-mâché, stucco, and paint on metal armature
59 1/16 x 34 5/8 x 19 11/16 in.
(150 x 88 x 50 cm)
David Zwirner, New York

Mala Galerija, Moderna Galerija Ljubljana. *Franz West* (1993). Exhibition catalogue, with essay by Bart De Baere. Excerpt, n.p., from De Baere's essay, "Don't Imagine."

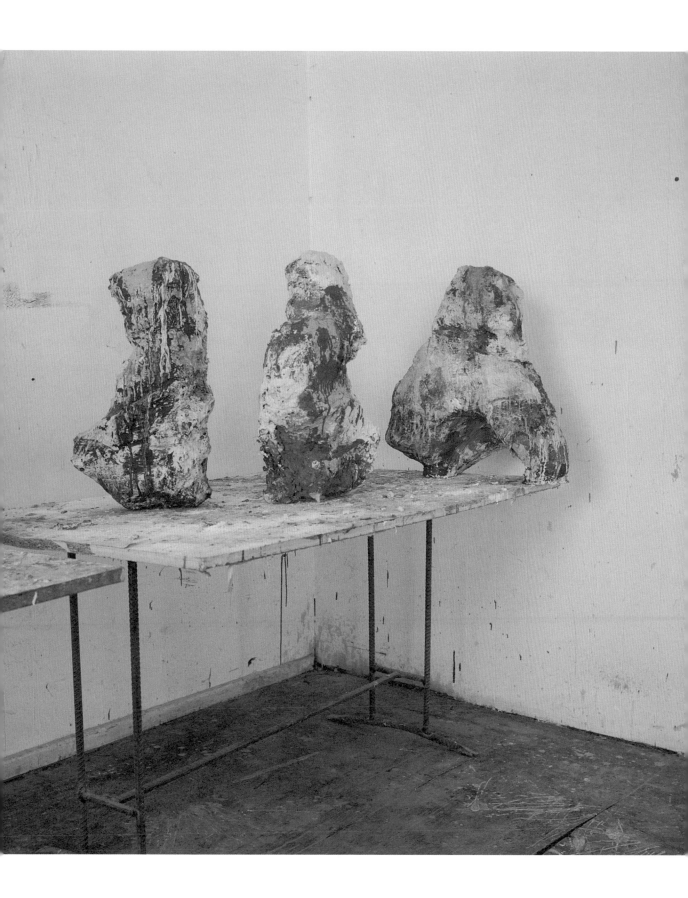

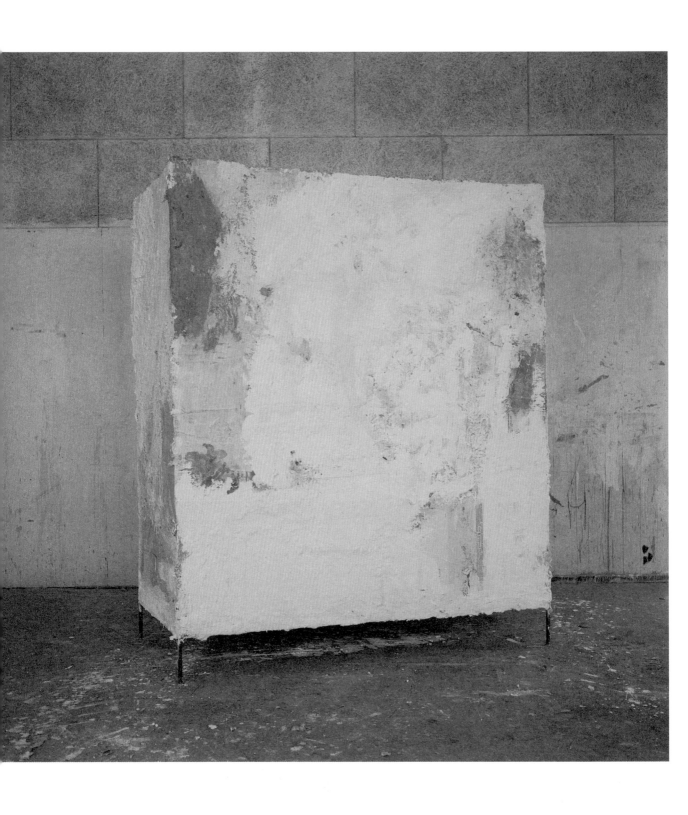

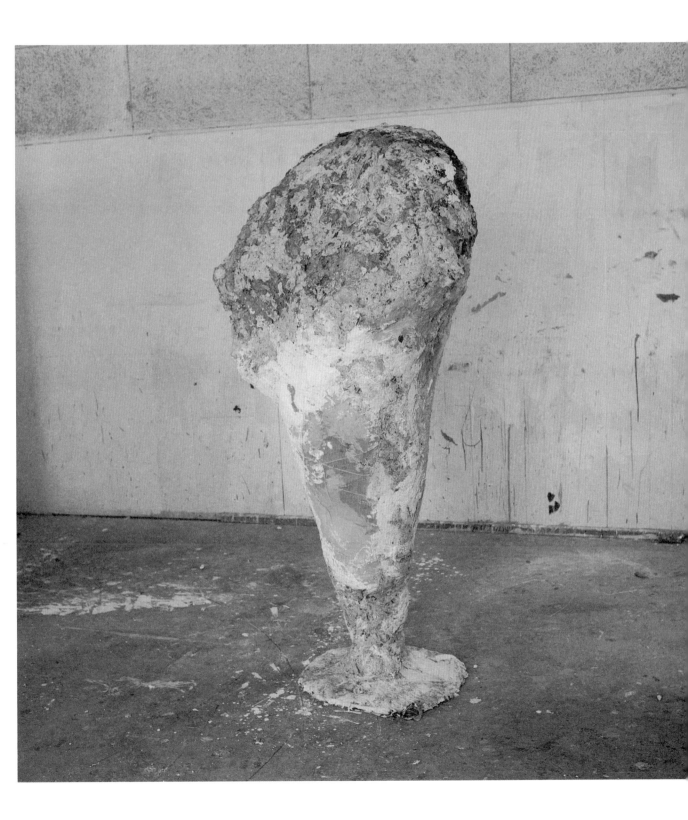

Rachel Whiteread

"Kings do not touch doors," Francis Ponge writes. "They do not know the joy of giving one of those familiar fillings a gentle or violent shove, then turning around to put it in place again — of holding a door in one's arms... The joy of grabbing the porcelain knob on the belly of one of those tall obstructions to a room; this unexpected body-to-body contact when one takes a measured step, opens one's eyes, and one's entire body adjusts to its new habitat."[1]

1 Francis Ponge, "Das Vergnügen mit der Tür," in *Einführung in den Kieselstein und andere Texte* (Frankfurt: Fischer Verlag), 1986, p. 53.

Has Rachel Whiteread felt this joy? Most certainly, although, in her case, it is not a definitive kind of joy. Nonetheless, although her terrain is different, she has succeeded in doing what Francis Ponge tried to do: not to write about things but rather through them, to let them write themselves. The form she has chosen eliminates anthropomorphic residue so that viewers walking through her shows feel slightly fossilized themselves: descendants of a world in movement, trying to sidestep the artist's honey-colored flycatchers, clotted flycatchers that lure the gaze into a diffuse interior despite its clear-cut, sharply delineated contours.

Rachel Whiteread's sculptures permit this kind of entry, even as compressed cores of time and space. "Core" is, of course, not the most suitable word: it is not a question of quality and definition but rather of producing a uniform density of even and indifferent fillings that paradoxically define the artist's attitude with great precision. Whiteread's sculptures incorporate the process of accumulative production, which acts as a constant corrective and processual lining for what the eyes perceive....

The potential of wrong combinations, or rather, combination as a device, seems to be targeted in Rachel Whiteread's latest works. Table and Chair, made of polyester, rubber, and polystyrene, evokes the drag marks, the afterimages of movement, similar to those registered by a video camera in blinding light. That her work has something to do with blinding is indisputable. It is blinding compensated by an overwhelmingly haptic counterweight. The invisibility of the space in which we find ourselves has been cast in its entirety so that we can touch and feel it. We have not only the need but also the chance to escape this space whose aura envelops us. Our ties to this space are so existential that we wax triumphant in the face of such a formal solution.

Rachel Whiteread applies a contemporary strategy to the classical dream of mastering fullness on a "grand" scale. It is contemporary because the fulfillment of this dream entails a leveling of events. The occurrences, movements, emotions, biographies that we inevitably associate with her selection of spaces, containers, architectural fragments are sucked into a homogenizing mold. It would seem that Whiteread has a distinct aversion to a certain kind of articulation — as if she were seeking a return to the general, to a primal substance. This has nothing to do with nostalgia. Although her work appears to make sweeping statements, it is still future-oriented. It is as if — despite unavoidable concurrence — she were fending off our fashionable obsessions with spaces, bodies, events, choreographies, specific objects with unmistakable finality.

In the wake of such reflections, we must not underestimate the quality of difference that stubbornly persists in Whiteread's œuvre. The artist does not reach out; she waits for things to come to her. She withdraws by "drawing in." Her position is stationary, and from there she invests in global enterprises. She stays put to explore her near-inexhaustible universe. The artist goes to infinite lengths in her indefatigable devotion to what is at hand.

Untitled (House)

October 1993 – January 1994

Commissioned by Artangel, London

Courtesy of Karsten Schubert

Contemporary Art, London

Untitled (Twenty-five Spaces)

1994 – 1995

Resin, 25 parts

16 x 156 x 156 in. (40.6 x 396.2 x 396.2 cm)

Karsten Schubert Contemporary Art,

London

Parkett, no. 42 (December 1994), issue featuring Rachel Whiteread, with essays by Trevor Fairbrother, Rudolf Schmitz, Neville Wakefield, and Simon Watney. Excerpt, pp. 100–102, from Schmitz's essay, "The Curbed Monumentality of the Invisible" (translated from the German by Catherine Schelbert).

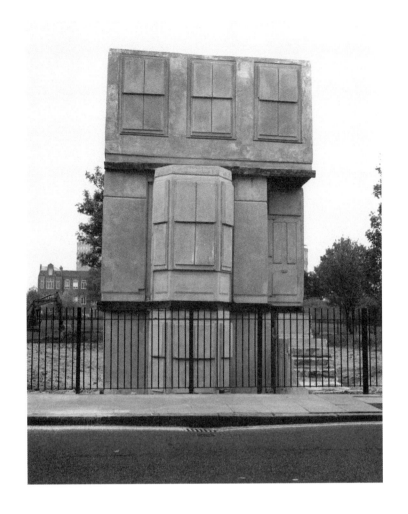

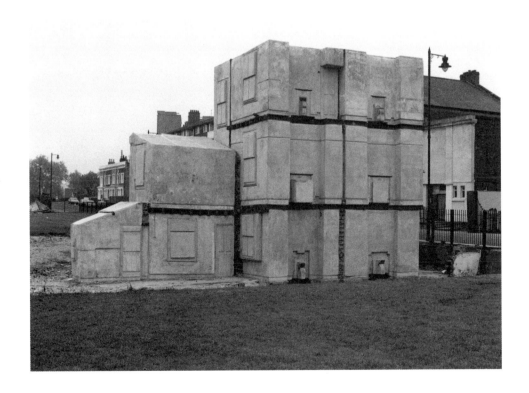

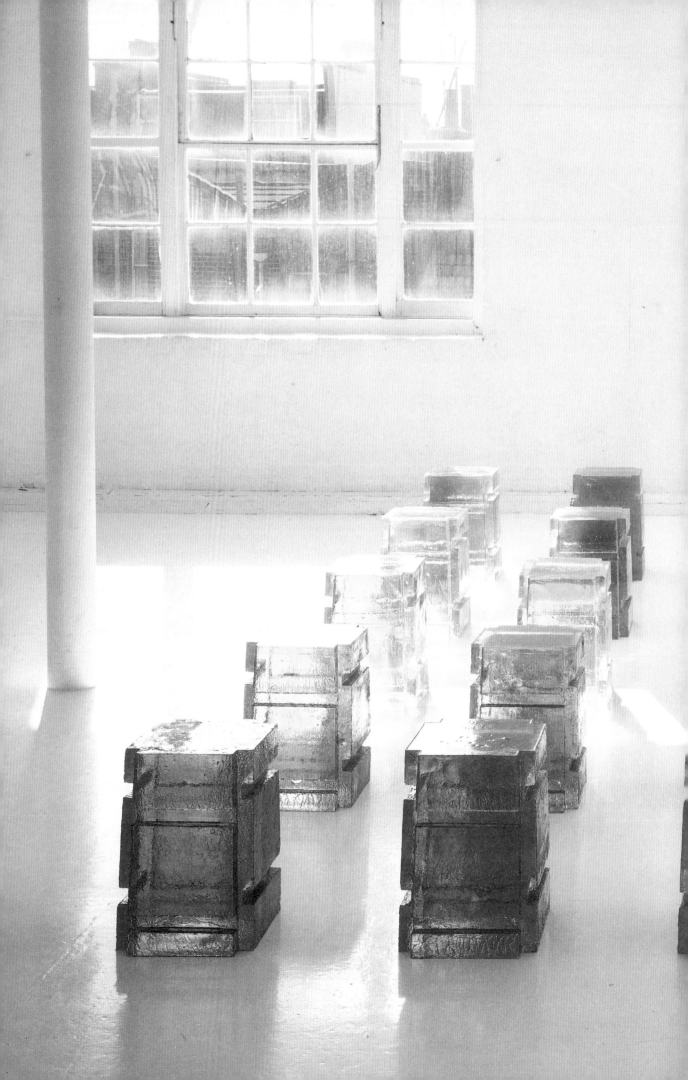

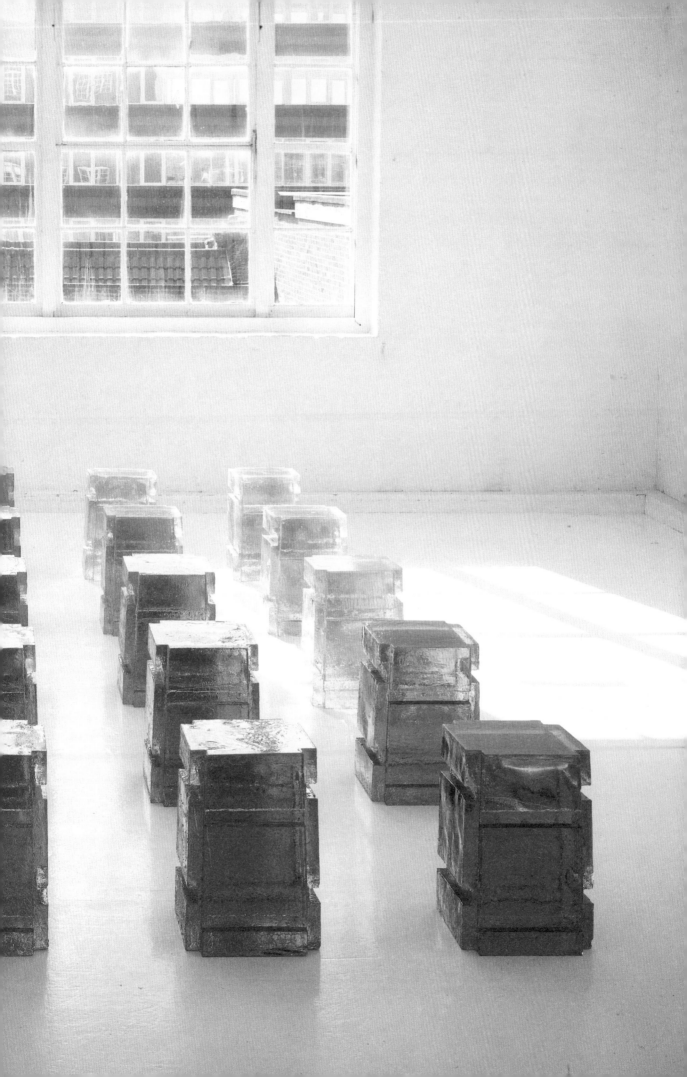

Rémy Zaugg

A painting is said to be a closed, separate space, something complete and concluded, inhabited or haunted by a privileged individual, the artist.

A closed, separate space. The frame confirms this opinion by overtly enclosing and isolating the painting. And, if it is true that it protects the painting, it also rejects what is around it. It shows up, lends value — especially if it is refined and made of precious materials. The topography of within and without is governed by an undeniable geometrical rationality. It is clear-cut, and seems to be a part of the very essence of things. This typology of two worlds leaves no room for doubt in our minds. Around it, there is the usual, the ordinary, the commonplace; these are things that count for nothing or for little; they are not noticed, one barely sees them, they do not express themselves; they are there, mute and docile, ordinary things made by ordinary people to accompany, serve and reassure them. In total contrast, the space within the frame, the framed and surrounded space: it enjoys the privilege of expression; it receives the imaginary of a demiurge, it benefits from subtlety or surplus. It is easy to believe that it is estranged from the world. It might even be outside the world, or from another world. It is a world in itself, its own world, a world apart. Autarkic. Perfect. It requires no commentary. This world is governed by its own laws, which have nothing in common with those of everyday man or everyday things. The painting and the everyday world appear as two separate and distinct universes. Inside the frame: the presence of a sovereign expressive will. Outside it: the quiet existence of unchanging things or of unchanging man. Aseptic partitioning, a dichotomy almost pathetic in its simplicity. And, if osmosis does occur, in spite of everything, it is due to the naive lure of illusion set out by the painting. And when, sometimes, the painting appears to belong to everyday life, it is because it is seen as no more than a forgotten curio. And so, it is said that the painting is more or less

complete and finished. But this is no more than logic. To say that a space is closed and separate is to condemn it to being finite, to being finished: it cannot be in the process of becoming. Inversely, to be complete and finished condemns it to being closed and separate; it cannot be open to the world. The two things necessarily go together. Completion and finiteness are the foundations of closure and separation. They put a seal on isolation. They call up narcissistic and solipsistic sufficiency. They justify the stagnation of that which stays within itself, they legitimise a definitive petrification....

The painting closed and separate, complete and finished, suffices unto itself. It is, it does not show. If it did, then it would relate to something beside itself. But it ignores and is ignorant of the other. Is it not closed and separate? It has no interest in the other. It is. Attractive or cold, spectacular or ascetic, voluble or mute, it matters little which, for it is. That is the essential thing. It is not perceived, it is registered as a presence. Is it not closed and separate, complete and finished? It is, without discrimination, indifferent.

But who is the speaker? Who is talking? Who registers a presence? Who desires such a situation, and to what end? To what advantage? And what is this painting which suffices so well unto itself that it can ignore everything, even the being who articulates such a state of affairs? Man, we know, is a worshipper of idols. But is this out of respect or humility? Some say it is out of fearful impotence. Others admit cowardice as the motive. I would say it is out of quietude. Nothing has been seen, nothing heard, nobody is responsible: one simply is. Perhaps one is just like the painting, isolated from everything else, to which nothing has been done, and upon which the desire has been projected to be what one has always been by necessity or by fate.

Studio views, Allschwil, Switzerland
August 1994 and May 1995

Zaugg, Rémy. *Voir Mort* (Basel: Wiese Verlag, 1989). Excerpt, pp. 79–80, from Zaugg's untitled text (translated from the French by Charles Penwarden).

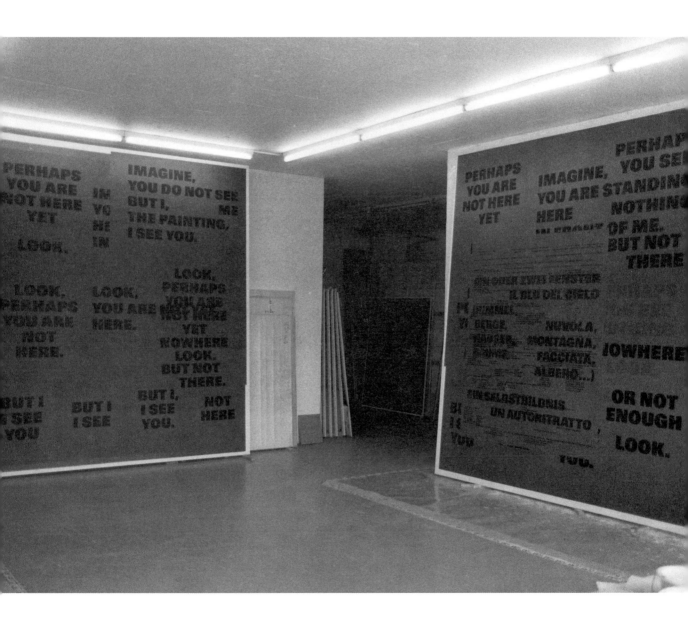

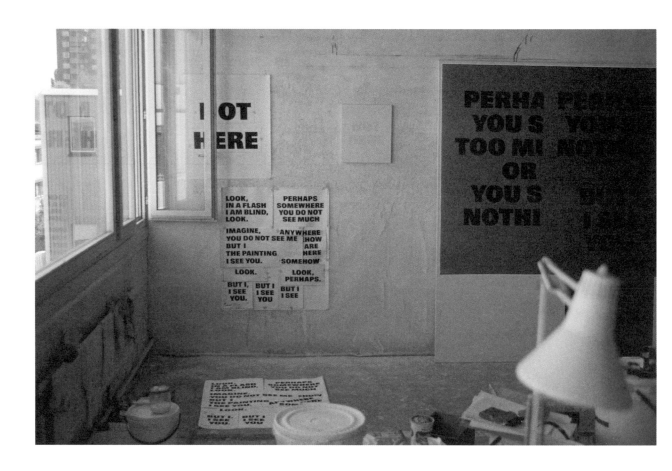

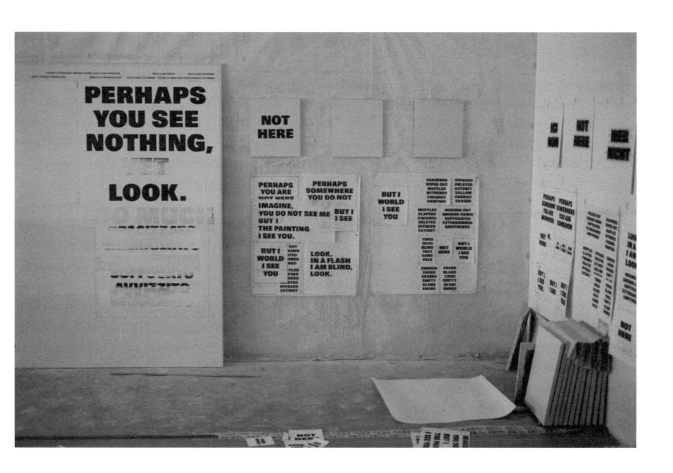

Chantal Akerman

b. 1950, Brussels, Belgium

lives in Paris, France

Filmography

Portrait d'une jeune fille de la fin des années 60, à Bruxelles, 1993 (35mm, color, 60 minutes).

D'Est, 1993 (35mm, color, 107 minutes).

Le Déménagement, 1992 (35mm, color, 42 minutes).

Nuit et jour, 1991 (35mm, color, 90 minutes).

Trois strophes sur le nom de Sacher, 1989 (video, color, 12 minutes).

Les Trois dernières sonates de Franz Schubert, 1989 (video, color, 49 minutes).

Histoires d'Amérique (English title: *American Stories: Food, Family, and Philosophies*), 1988 (35mm, color, 92 minutes).

Mallet-Stevens, 1986 (video, color, 7 minutes).

Letters Home, 1986 (video, color, 104 minutes).

Le Marteau, 1986 (video, color, 4 minutes).

La Paresse, 1986 (35mm, color, 14 minutes).

Golden Eighties (aka *Window Shopping*), 1985 (35mm, color, 96 minutes).

Lettre d'un cinéaste, 1984 (16mm, color, 8 minutes).

New York, New York bis, 1984 (35mm, black-and-white, 8 minutes; lost).

Family Business: Chantal Akerman Speaks about Film, 1984 (16mm, color, 18 minutes).

J'ai faim, j'ai froid, 1984 (35mm, black-and-white, 12 minutes).

L'Homme à la valise, 1983 (16mm, color, 60 minutes).

Un jour Pina m'a demandé, 1983 (16mm, color, 57 minutes).

Les Années 80, 1983 (video / 35mm, color, 82 minutes).

Toute une nuit, 1982 (35mm, color, 89 minutes).

Dis-moi, 1980 (16mm, color, 45 minutes).

Les Rendez-vous d'Anna, 1978 (35mm, color, 127 minutes).

News from Home, 1976 (16mm, color, 85 minutes).

Jeanne Dielman, 23 quai du Commerce, 1080 Bruxelles, 1975 (35mm, color, 200 minutes).

Je tu il elle, 1974 (35mm, black-and-white, 90 minutes).

Hanging Out Yonkers 1973, 1973 (16mm, color, 90 minutes; unfinished).

Le 15/8, 1973 (16mm, black-and-white, 42 minutes).

La Chambre 2, 1972 (16mm, color, 11 minutes, silent).

La Chambre 1, 1972 (16mm, color, 11 minutes).

Hôtel Monterey, 1972 (16mm, color, 65 minutes, silent).

L'Enfant aimé ou je joue à être une femme mariée, 1971 (16mm, black-and-white, 35 minutes).

Saute ma ville, 1968 (35mm, black-and-white, 13 minutes).

Selected Bibliography

Walker Art Center, Minneapolis, Minnesota. *Bordering on Fiction: Chantal Akerman's D'Est* (1995). Exhibition catalogue, with introduction by Kathy Halbreich and Bruce Jenkins, essays by Catherine David and Michael Tarantino, and text by Chantal Akerman.

Margulies, Ivone. "'Nothing Happens': Chantal Akerman's Hyperrealist Everyday." (Ph.D. dissertation, New York University, 1993. Duke University Press, forthcoming).

McRobbie, Angela. "Chantal Akerman and Feminist Filmmaking." In Cook, Pam, and Philip Dodd, eds. *Women and Film: A* Sight and Sound *Reader* (Philadelphia: Temple University Press, 1993), pp. 198–203.

Mayne, Judith. *The Woman at the Keyhole: Feminism and Women's Cinema* (Bloomington: Indiana University Press, 1990).

Canby, Vincent. "The Facts Please, Just the Facts." *The New York Times*, June 30, 1989, p. C12.

Fischer, Lucy. "Shall We Dance? Feminist Cinema Remakes the Musical." *Film Criticism* 13 (Winter 1989), pp. 7–17.

Daney, Serge. "*Toute une nuit*: Chantal Akerman." In *Ciné Journal, 1981–1986* (Paris: Editions Cahiers du Cinéma, 1986).

Silverman, Kaja. "Dis-embodying the Female Voice." In Doane, Mary Ann, Patricia Mellencamp, and Linda Williams. *Re-Vision: Essays in Feminist Film Criticism* (Frederick, Maryland: University Publications of America, 1984).

Hoberman, J. "*Jeanne Dielman*: Woman's Work." *Village Voice*, March 29, 1983, pp. 1, 48.

Kruger, Barbara. Review of *Les Années 80*. *Artforum* 22 (December 1983), pp. 84–85.

Rich, B. Ruby. "Chantal Akerman's Meta-Cinema." *Village Voice*, March 29, 1983, pp. 1, 51.

Aubenas, Jacqueline, ed. *Chantal Akerman*. Cahiers, no. 1 (Brussels: Atelier des Arts, 1982).

Doane, Mary Ann. "Woman's Stake: Filming the Female Body." *October*, no. 17 (Summer 1981), pp. 23–36.

Kinder, Marsha. "The Meetings of Anna." *Film Quarterly* 33 (Fall 1979), pp. 40–46.

Lakeland, Mary Jo. "The Color of *Jeanne Dielman*." *Camera Obscura* 3–4 (1979), pp. 216–218.

Mulvey, Laura. "Guest Appearances: Interview with Chantal Akerman." *Time Out*, May 25, 1979, p. 19.

Bergstrom, Janet. "*Jeanne Dielman, 23 Quai du Commerce, 1080 Bruxelles*." *Camera Obscura* 2 (Fall 1977), pp. 114–118.

Kinder, Marsha. "Reflections on *Jeanne Dielman*." *Film Quarterly* 30 (Summer 1977), pp. 2–8.

Nobuyoshi Araki

b. 1940, Tokyo, Japan

lives in Tokyo, Japan

Selected One-Person Exhibitions

Galerie Chantal Crousel, Paris, 1995, *Nobuyoshi Araki.*

Fondation Cartier pour l'art contemporain, Paris, 1995, *Nobuyoshi Araki: Journal intime, 1994* (catalogue).

Index Gallery, Stockholm, 1995, *Nobuyoshi Araki: Erotos.*

Torch, Amsterdam, 1995, *Nobuyoshi Araki.*

White Cube, London, 1994, *Nobuyoshi Araki. Unconscious Tokyo: Tokyo Cube.*

Luhring Augustine Gallery, New York, 1994, *Tokyo Nude: Private Diary.*

Jablonka Galerie, Cologne, 1994, *Nobuyoshi Araki: Photographien.*

Yūrakuchō Asahi Gallery, Tokyo, 1994, *First-Person Photography.*

Gallery Verita, Tokyo, 1993, *Fine Tokyo Days.*

Parco Gallery, Tokyo, 1993, *Erotos.*

Forum Stadtpark, Graz, Austria, 1992, *Nobuyoshi Araki: AKT-TOKYO, 1971–1991* (catalogue).

Egg Gallery, Tokyo, 1992, *Photomania Diary.*

Seed Hall, Tokyo, 1991, *Colorscapes.*

Egg Gallery, Tokyo, 1991, *Winter Journey.*

Egg Gallery, Tokyo, 1990, *Towards Winter: Tokyo, a City Heading for Death.*

Kinokuniya Gallery, Tokyo, 1980, *Wet Dreams on a Summer Night and the End of the War.*

Nikon Salon, Tokyo, 1976, *Yoko, My Love.*

Selected Group Exhibitions

Museum of Contemporary Art, Tokyo, 1995, *Art in Japan Today.*

Galerie Paul Andriesse, Amsterdam, 1995, *The Flowers from the Other World: Erik Andriesse, Nobuyoshi Araki.*

Ginza Art Space, Tokyo, 1994, *Tokyo Love: Nobuyoshi Araki and Nan Goldin.*

Fruitmarket Gallery, Edinburgh, 1994, *Liquid Crystal Futures: Contemporary Japanese Photography* (catalogue).

Spiral Building, Tokyo, 1994, *Of the Human Condition: Hope and Despair at the End of the Century.*

Luhring Augustine Gallery, New York, 1993, *Nobuyoshi Araki, Sophie Calle, Larry Clark, Jack Pierson.*

Frankfurter Kunstverein, Steinernes Haus am Römerberg, 1993, *Das Bild des Körpers* (catalogue).

Setagaya Art Museum, Tokyo, 1993, *Love You Tokyo! The Photographs of Kineo Kuwabara and Nobuyoshi Araki* (catalogue).

Schweizerische Stiftung für die Photographie, Kunsthaus Zürich, 1993, *In die Felsen bohren sich Zikadenstimmen: Zeitgenössische japanische Photographie* (catalogue).

Tokyo Metropolitan Museum of Photography, 1991, *Japanese Photography in the 1970s: Memories Frozen in Time* (catalogue).

Círculo de Bellas Artes, Madrid, 1986, *Fotografía Japonesa Contemporánea* (catalogue).

International Center of Photography, New York, 1979, *Japan: A Self-Portrait* (catalogue).

National Museum of Modern Art, Tokyo, 1974, *Fifteen Photographers Today* (catalogue).

Tokyo Metropolitan Art Museum, 1971, *The 10th Modern Japanese Art Exhibition.*

Selected Bibliography

Fondation Cartier pour l'art contemporain, Paris. *Nobuyoshi Araki* (Paris: Editions Contrejour, 1995). Exhibition catalogue, with essay by Gabriel Bauret and interview with Kohtarō Iizawa.

Goldin, Nan. "Naked City: Nan Goldin Talks with Nobuyoshi Araki." *Artforum* 33 (January 1995), pp. 54–59, 98.

Friis-Hansen, Dana. "Kineo Kuwabara and Nobuyoshi Araki at the Setagaya Museum." *Art in America* 82 (January 1994), p. 114.

Fruitmarket Gallery, Edinburgh. *Liquid Crystal Futures: Contemporary Japanese Photography* (1994). Exhibition catalogue, with introduction by Shinji Kohmoto and essays by Yūko Hasegawa and Graeme Murray.

Hagen, Charles. "Nobuyoshi Araki: Luhring Augustine Gallery." *The New York Times,* July 1, 1994, p. C18.

Frankfurter Kunstverein, Steinernes Haus am Römerberg. *Das Bild des Körpers* (1993). Exhibition catalogue by Peter Weiermair.

Schweizerische Stiftung für die Photographie, Kunsthaus Zürich. *In die Felsen bohren sich Zikadenstimmen: Zeitgenössische japanische Photographie* (Zurich: Verlag Lars Müller, 1993). Exhibition catalogue, with foreword by David Streiff and essays by Masafumi Fukagawa and Gertrud Koch.

Setagaya Art Museum, Tokyo. *Love You Tokyo! The Photographs of Kineo Kuwabara and Nobuyoshi Araki* (1993). Exhibition catalogue, with essay by Naohiro Takahashi.

Forum Stadtpark, Graz, Austria. *Nobuyoshi Araki: AKT-TOKYO, 1971–1991* (1992). Exhibition catalogue, with essays by Toshiharu Itō and Taeko Tomioka, poem by Hiromi Itō, and text by Nobuyoshi Araki.

Silva, Arturo. "Nobuyoshi Araki: Apt Gallery." *Artforum* 30 (January 1992), p. 120.

Kobata, Kazue. "Laments." *Artforum* 30 (December 1991), pp. 93–95.

Tokyo Metropolitan Museum of Photography. *Japanese Photography in the 1970s: Memories Frozen in Time* (1991). Exhibition catalogue, with essay by Fuminori Yokoe.

Círculo de Bellas Artes, Madrid. *Fotografía Japonesa Contemporánea* (1986). Exhibition catalogue, with essays by Alejandro Castellote and Etsurō Ishihara.

International Center of Photography,
New York. *Japan: A Self-Portrait* (1979).
Exhibition catalogue, with foreword by
Cornell Capa and Shōji Yamagishi
and introduction by Taeko Tomioka.

Matildenhöhe Darmstadt, Magistrat der Stadt
Darmstadt, West Germany. *Neue Fotografie
aus Japan* (1978). Exhibition catalogue, with
essays by Otto Breicha, John Szarkowski, and
Ben Watanabe.

National Museum of Modern Art, Tokyo.
Fifteen Photographers Today (1974). Exhibition
catalogue, with introduction by Tsutomu
Watanabe.

Selected Books by the Artist

Nobuyoshi Araki (Tokyo: Photo Musée, 1994).

Obscenities (Tokyo: Photo-planète, 1994).

Bokuju-kitan (Tokyo: AaT Room, 1994).

Satchin (Tokyo: Shincho-Sha, 1994).

Araki, Nobuyoshi, and Nan Goldin.
Tokyo Love (Tokyo: Ohta Shuppan, 1994).

Shi Sha Shin (Tokyo: Asahi Shimbun, 1994).

Araki, Nobuyoshi, and Toshiharu Itō. *Erotos:
Nobuyoshi Araki* (Tokyo: Libro Port, 1993).

The Banquet (Tokyo: Akt-Tokyo Press, 1993).

Tokyo. Biyori. Yoko and Nobuyoshi Araki
(Tokyo: Chikuma Shobō, 1993).

Photo-manic Diary (Tokyo: Switch
Corporation, 1992).

Colorscapes (Tokyo: Magazine House, 1991).

Araki, Nobuyoshi, Kohtarō Iizawa,
Arturo Silva, and Gozo Yoshimasu.
Laments: Skyscapes / From Close Range
(Tokyo: Shinchōsha, 1991).

Sentimental Journey / Winter Journey
(Tokyo: Shinchōsha, 1991).

Tokyo Lucky Hole
(Tokyo: Ohta Shuppan, 1990).

Araki, Nobuyoshi, and Toshiharu Itō.
Towards Winter: Tokyo, a City Heading for Death
(Tokyo: Magazine House, 1990).

Tokyo Nude (Tokyo: Ohta Shuppan, 1989).

Tokyo Story (Tokyo: Heibonsha, 1989).

Araki's Tokyo Erotomania Diary
(Tokyo: Bayakuya-Shobō, 1986).

Yoko, My Love (Tokyo: Asahi Sonorama, 1978).

Richard Artschwager

b. 1923, Washington, D.C., USA

lives in Brooklyn, New York, USA

Selected One-Person Exhibitions

Galerie Xavier Hufkens, Brussels, 1995,
Richard Artschwager.

Mary Boone Gallery, New York, 1994,
Richard Artschwager.

Daniel Weinberg Gallery, San Francisco,
1994, *Richard Artschwager: New Work.*

Fondation Cartier pour l'art contemporain,
Paris, 1994, *Richard Artschwager* (catalogue).

Portikus, Frankfurt, 1993, *Richard Artschwager:
Archipelago* (catalogue).

Galerie Franck + Schulte, Berlin, 1992,
Richard Artschwager: New Works, 1991–1992
(catalogue).

Museum of Fine Arts, Boston, 1992,
Connections: Richard Artschwager (brochure).

Brooke Alexander Editions, New York,
1991, *Richard Artschwager: Complete Multiples*
(catalogue).

Mary Boone Gallery, New York, 1990,
Richard Artschwager: Destruction Paintings.

Galerie Ghislaine Hussenot, Paris,
1990, *Richard Artschwager: Recent Works.*

Akira Ikeda Gallery, Tokyo, 1989,
Richard Artschwager: New Works.

Leo Castelli Gallery, New York, 1989,
Richard Artschwager.

Whitney Museum of American Art,
New York, 1988, *Richard Artschwager*
(catalogue).

Mary Boone Michael Werner Gallery,
New York, 1986, *Richard Artschwager*
(catalogue).

Daniel Weinberg Gallery, Los Angeles, 1986,
Richard Artschwager.

Kunsthalle Basel, 1985, *Richard Artschwager*
(catalogue).

Mary Boone Gallery, New York, 1983,
Richard Artschwager.

Young / Hoffman Gallery, Chicago, 1981,
*Richard Artschwager: Paintings and Objects from
1962–1979.*

Museum of Art, Rhode Island School
of Design, Providence, 1980, *Sculpture by
Richard Artschwager.*

Albright-Knox Art Gallery, Buffalo,
New York, 1979, *Richard Artschwager's
Theme(s)* (catalogue).

Clocktower, Institute for Art and
Urban Resources, New York, 1978,
Richard Artschwager.

Texas Gallery, Houston, 1978,
Richard Artschwager.

Galerie Neuendorf, Hamburg, 1975,
Richard Artschwager.

Jared Sable Gallery, Toronto, 1975,
Richard Artschwager.

Leo Castelli Gallery, New York, 1975,
*Artschwager: Door, Window, Table, Basket,
Mirror, Rug.*

Dunkelman Gallery, Toronto, 1973,
Richard Artschwager: Paintings.

Leo Castelli Gallery, New York, 1972,
Richard Artschwager: Paintings.

Lo Giudice Gallery, Chicago, 1970,
New Paintings by Richard Artschwager.

Galerie Konrad Fisher, Düsseldorf, 1968,
Artschwager.

Leo Castelli Gallery, New York, 1967,
Richard Artschwager.

Leo Castelli Gallery, New York, 1965,
Artschwager.

Selected Group Exhibitions

Martin-Gropius-Bau, Berlin, and Royal Academy of Arts, London, 1993, *American Art in the 20th Century: Painting and Sculpture, 1913–1993* (catalogue).

Royal Academy of Arts, London, 1991, *Pop Art* (catalogue).

Martin-Gropius-Bau, Berlin, 1991, *Metropolis* (catalogue).

Carnegie Museum of Art, Pittsburgh, Pennsylvania, 1988, *Carnegie International*.

Westfälischen Landesmuseums für Kunst und Kulturgeschichte in der Stadt Münster, West Germany, 1987, *Skulptur Projekte in Münster, 1987* (catalogue).

Kassel, 1987, *documenta 8* (catalogue).

Arnhem, Netherlands, 1986, *Sonsbeek 86* (catalogue).

Whitechapel Art Gallery, London, 1986, *The Painter-Sculptor in the Twentieth Century*.

Hirshhorn Museum and Sculpture Garden, Smithsonian Institution, Washington, D.C., 1984, *Content: A Contemporary Focus, 1974–1984* (catalogue).

Tate Gallery, London, 1983, *New Art* (catalogue).

Whitney Museum of American Art, New York, 1983, *1983 Biennial Exhibition* (catalogue).

Kassel, 1982, *documenta 7* (catalogue).

Institute of Contemporary Art, University of Pennsylvania, Philadelphia, 1977, *Improbable Furniture* (catalogue).

Venice, 1976, *XXXVII Biennale di Venezia* (catalogue).

Institute for Art and Urban Resources, Long Island City, New York, 1976, *Rooms (P.S. 1)* (catalogue).

Whitney Museum of American Art, New York, 1976, *200 Years of American Sculpture* (catalogue).

Kassel, 1972, *documenta 5* (catalogue).

Museum of Modern Art, New York, 1970, *Information* (catalogue).

Hayward Gallery, London, 1969, *Pop Art Redefined* (catalogue).

Kunsthalle Bern, 1969, *Live in Your Head: When Attitudes Become Form: Works — Concepts — Processes — Situations — Information* (catalogue).

Jewish Museum, New York, 1966, *Primary Structures: Younger American and British Sculptors* (catalogue).

Selected Bibliography

Fondation Cartier pour l'art contemporain, Paris. *Richard Artschwager* (1994). Exhibition catalogue, with introduction by Marie-Claude Beaud and essay by Ingrid Schaffner.

Schjeldahl, Peter. "Crate Expectations." *Village Voice*, December 13, 1994, p. 54.

Martin-Gropius-Bau, Berlin, and Royal Academy of Arts, London. *American Art in the 20th Century: Painting and Sculpture, 1913–1993* (Berlin: Zeitgeist-Gesellschaft; Munich: Prestel, 1993). Exhibition catalogue by Christos M. Joachimides and Norman Rosenthal, with essays by Brooks Adams, David Anfam, Richard Armstrong, John Beardsley, Neal Benezra, et al.

Portikus, Frankfurt. *Richard Artschwager: Archipelago* (1993). Exhibition catalogue, with foreword by Helmut Friedel, Martin Hentschel, Kasper König, and Ulrich Wilmes and essay by Ingrid Schaffner.

Documenta IX (Stuttgart: Edition Cantz; New York: Harry N. Abrams, 1992). 3 vols. Exhibition catalogue, with introduction by Jan Hoet and essays by Bart De Baere, Cornelius Castoriadis, Hilde Daem, Claudia Herstatt, Heiner Müller, et al.

Galerie Franck + Schulte, Berlin. *Richard Artschwager: New Works, 1991–1992* (1992). Exhibition catalogue.

Kimmelman, Michael. "In Boston, A Blend of Wit and Pathos." *The New York Times*, May 17, 1992, p. H29.

Elvehjem Museum of Art, University of Wisconsin, Madison, 1991. *Richard Artschwager: Public (public)* (1991). Exhibition catalogue, with essays by Germano Celant, Herbert Muschamp, and Russell Panczenko.

Martin-Gropius-Bau, Berlin. *Metropolis* (New York: Rizzoli, 1991). Exhibition catalogue edited by Christos M. Joachimides and Norman Rosenthal, with essays by Achille Bonito Oliva, Jeffrey Deitch, Wolfgang Max Faust, Vilém Flusser, Boris Groys, et al.

Royal Academy of Arts, London. *Pop Art* (1991). Exhibition catalogue, with introductions by Marco Livingstone and Sarat Maharaj and essays by Dan Cameron, Constance W. Glenn, Thomas Kellein, Alfred Pacquement, and Evelyn Weiss.

Parkett, no. 24 (March 1990), issue featuring Richard Artschwager, with essays by Arthur C. Danto, Georg Kohler, Alan Lightman, Patrick McGrath, Joyce Carol Oates, et al. and text by Richard Artschwager.

Bankowsky, Jack. "Richard Artschwager: The New Conventionalism in Art Reveals Artschwager's Prescience." *Flash Art*, no. 139 (March–April 1988), pp. 80–83.

Carnegie Museum of Art, Pittsburgh, Pennsylvania. *Carnegie International* (Munich: Prestel, 1988). Exhibition catalogue, with essays by John Caldwell, Vicky Clark, Lynne Cooke, Milena Kalinovska, and Thomas McEvilley.

Madoff, Steven Henry. "Richard Artschwager: Sleight of Mind." *Artnews* 87 (January 1988), pp. 114–121.

Smith, Roberta. "Art: Work by Richard Artschwager." *The New York Times*, January 29, 1988, p. C32.

Whitney Museum of American Art, New York. *Richard Artschwager* (New York and London: W.W. Norton, 1988). Exhibition catalogue by Richard Armstrong.

Westfälischen Landesmuseums für Kunst und Kulturgeschichte in der Stadt Münster, West Germany. *Skulptur Projekte in Münster, 1987* (Cologne: DuMont Buchverlag, 1987). Exhibition catalogue edited by Klaus Bußmann and Kasper König, with essays by Marianne Brouwer, Benjamin H.D. Buchloh, Antje von Graevenitz, Thomas Kellein, Hannelore Kersting, et al.

Kunsthalle Basel. *Richard Artschwager* (1985). Exhibition catalogue by Jean Christophe Ammann.

Hirshhorn Museum and Sculpture Garden, Smithsonian Institution, Washington, D.C. *Content: A Contemporary Focus, 1974–1984* (1984). Exhibition catalogue by Howard N. Fox, Miranda McClintic, and Phyllis Rosenzweig.

University Art Museum and Pacific Film Archive, University of California, Berkeley. *Richard Artschwager: Matrix 71* (1984). Exhibition brochure by Constance Lewallen.

Museum of Art, Rhode Island School of Design, Providence. *Furniture, Furnishing: Subject and Object* (1983). Exhibition catalogue by Judith Hoos Fox.

Albright-Knox Art Gallery, Buffalo, New York, Institute of Contemporary Art, University of Pennsylvania, Philadelphia, and La Jolla Museum of Contemporary Art, San Diego. *Richard Artschwager's Theme(s)* (1979). Exhibition catalogue by Richard Armstrong, Linda L. Cathcart, and Suzanne Delehanty.

Smith, Roberta. "The Artschwager Enigma." *Art in America* 67 (October 1979), pp. 93–95.

Institute of Contemporary Art, University of Pennsylvania, Philadelphia. *Improbable Furniture* (1977). Exhibition catalogue, with essays by Suzanne Delehanty and Robert Pincus-Witten.

Leo Castelli Gallery, New York. *Basket, Table, Door, Window, Mirror, Rug: 53 Drawings by Richard Artschwager* (1976). Exhibition catalogue, with essay by Catherine Kord.

Fine Arts Gallery, University of Massachusetts, Amherst. *Critical Perspectives in American Art* (1976). Exhibition catalogue, with essays by Hugh M. Davies, Sam Hunter, Rosalind Krauss, and Marcia Tucker.

Whitney Museum of American Art, New York. *American Pop Art* (New York: Collier Books; London: Collier MacMillan, 1974). Exhibition catalogue by Lawrence Alloway.

Park Sonsbeek, Arnhem, Netherlands. *Sonsbeek Buiten de Perken* (1971). Exhibition catalogue, with interview by Wouter Kotte.

Museum of Modern Art, New York. *Information* (1970). Exhibition catalogue by Kynaston L. McShine.

Hayward Gallery, London. *Pop Art Redefined* (1969). Exhibition catalogue, with introduction by Suzi Gablik and John Russell and essays by Lawrence Alloway, John McHale, and Robert Rosenblum.

Kunsthalle Bern. *Live in Your Head: When Attitudes Become Form: Works — Concepts — Processes — Situations — Information* (1969). Exhibition catalogue by Harald Szeemann, with essays by Scott Burton, Grégoire Muller, and Tommaso Trini.

Jewish Museum, New York. *Primary Structures: Younger American and British Sculptors* (1966). Exhibition catalogue by Kynaston McShine.

Mirosław Bałka

b. 1958, Warsaw, Poland

lives in Otwock, Poland

Selected One-Person Exhibitions

Mala Galerija, Moderna Galerija Ljubljana, 1994, *Mirosław Bałka: Winterhilfsverein* (catalogue).

Galerie Nordenhake, Stockholm, 1994, *Mirosław Bałka: Rampen.*

Lannan Foundation, Los Angeles, 1994, *Mirosław Bałka: 37.1 (cont.).*

Galería Juana de Aizpuru, Madrid, 1994, *Mirosław Bałka: Buenos Días, 1994, Buenas Noches, 1994.*

Stedelijk Van Abbemuseum, Eindhoven, Netherlands, 1994, *Mirosław Bałka: Laadplatform plus 7 werken, 1985–1989,* and Muzeum Sztuki, Łódź, Poland, 1994, *Mirosław Bałka: Rampa* (catalogue).

Galerie Marc Jancou, Zurich, 1993, *Die Rampe.*

Galeria Foksal, Warsaw, 1993, *37.1* (catalogue).

Renaissance Society at the University of Chicago, 1992, *Mirosław Bałka: 36.6* (catalogue).

Museum Haus Lange, Krefeld, Germany, 1992, *Mirosław Bałka: bitte* (catalogue).

Galerie Peter Pakesch, Vienna, 1992, *No body.*

Burnett Miller Gallery, Los Angeles, 1991, *Mirosław Bałka: XI / My Body Cannot Do Everything I Ask For.*

Galerie Isabella Kacprzak, Cologne, 1991, *IV / IX / My Body Cannot Do Everything I Ask For.*

Galeria Foksal, Warsaw, 1991, *April / My Body Cannot Do Everything I Ask For* (catalogue).

Stichting De Appel, Amsterdam, 1991, *Mirosław Bałka* (catalogue).

Galerie Nordenhake, Stockholm, 1990, *Mirosław Bałka.*

Galeria Dziekanka, Warsaw, 1990, *Good God* (catalogue).

Żuków, Poland, 1985, *Remembrance of the First Holy Communion.*

Selected Group Exhibitions

Galeria Zachęta, Warsaw, 1995, *Where Is Abel, Thy Brother?* (catalogue).

Nykytaiteen Museo, and Valtion Taidemuseo, Helsinki, 1995, *Ars 95: Yksityinen / Julkinen, Private / Public* (catalogue).

Burnett Miller Gallery, Santa Monica, California, 1995, *The Mind Has a Thousand Eyes.*

Kunstmuseum Wolfsburg, Germany, 1994, *Tuning Up #2* (catalogue).

Malmö Konsthall, Sweden, 1994, *Till Brancusi* (catalogue).

Visby, Sweden, 1993, *Baltic Sculpture, Visby 93* (catalogue).

Venice, 1993, *XLV Esposizione Internazionale d'Arte: Punti cardinali dell'arte* (catalogue).

Arnhem, Netherlands, 1993, *Sonsbeek 93* (catalogue).

Biennale of Sydney, 1992, *The Boundary Rider: The 9th Biennale of Sydney* (catalogue).

Neuer Berliner Kunstverein, Staatliche Kunsthalle, Berlin, 1992, *Polnische Avantgarde, 1930–1990* (organized in collaboration with the Muzeum Sztuki, Łódź) (catalogue).

Kassel, 1992, *Documenta IX* (catalogue).

Musée d'Art Contemporain de Lyon and Espace Lyonnais d'Art Contemporain, 1992, *Muzeum Sztuki w Łodzi, 1931–1992: Collection — Documentation — Actualité* (organized in collaboration with the Muzeum Sztuki, Łódź) (catalogue).

Bonner Kunstverein and Brühler Kunstverein, Germany, 1991, *Kunst, Europa* (catalogue).

Grazer Kunstverein, Graz, Austria, 1991, *Körper und Körper* (catalogue).

Galeria Zachęta, Warsaw, and Muzeum Sztuki, Łódź, Poland, 1991, *The Collection of 20th-Century Art at the Museum of Art in Łódź* (catalogue).

Pałac Sztuki, Cracow, 1991, *Europe Unknown / Europa nieznana* (catalogue).

Kunstverein Hamburg, 1991, *Le monde critique* (catalogue).

Martin-Gropius-Bau, Berlin, 1991, *Metropolis* (catalogue).

Institute of Contemporary Arts and Serpentine Gallery, London, 1990, *Possible Worlds: Sculpture from Europe* (catalogue).

Venice, 1990, *XLIV Esposizione Internazionale d'Arte: La Biennale di Venezia* (catalogue).

Kunstmuseum Düsseldorf, 1989, *Dialog* (organized in collaboration with the Centrum Sztuki Współczesnej, Warsaw) (catalogue).

Artists Space, New York, 1989, *Metaphysical Visions: Middle Europe* (catalogue).

Third Eye Centre, Glasgow, 1988, *Polish Realities: Polish Arts in the 1980s* (catalogue).

Selected Bibliography

Mala Galerija, Moderna Galerija Ljubljana. *Mirosław Bałka: Winterhilfsverein* (1995). Exhibition catalogue by Zdenka Badovinac.

Galeria Zachęta, Warsaw. *Where Is Abel, Thy Brother?* (1995). Exhibition catalogue by Anda Rottenberg, with essays by Wiesław Borowski, Michael Brenson, Nella Cassouto, Jean-François Chevrier, E.M. Cioran, et al.

Stedelijk Van Abbemuseum, Eindhoven, Netherlands, and Muzeum Sztuki, Łódź, Poland. *Mirosław Bałka: Die Rampe* (1994). Exhibition catalogue, with introductions by Jan Debbaut and Jaromir Jedliński, essays by Selma Klein Essink, Maria Morzuch, and Anda Rottenberg, and interview by Jaromir Jedliński.

Morgan, Stuart. "Last Rites: Stuart Morgan on Mirosław Bałka." *Frieze*, no. 14 (January–February 1994), pp. 22–25.

Myers, Terry R. "Mirosław Bałka: Lannan Foundation." *New Art Examiner* 22 (September 1994), p. 46.

Volkart, Yvonne. "Mirosław Bałka." *Flash Art*, no. 174 (January–February 1994), p. 106.

Arnhem, Netherlands. *Sonsbeek 93* (Ghent: Snoek-Ducaju and Zoon, 1993). Exhibition catalogue by Valerie Smith, coedited with Jan Brand and Catelijne de Muynck.

Galerie Marc Jancou, Zurich, 1993. *Restaurant* (1993). Exhibition catalogue, with foreword by Marc Jancou and essays by Yves Aupetitallot, Jan Avgikos, Terry R. Myers, and Frank Perrin (published in conjunction with exhibition at La Bocca, Paris).

Biennale di Venezia. *XLV Esposizione Internazionale dell'Arte: Punti cardinali dell'arte* (Venice: Marsilio Editori, 1993). 2 vols. Exhibition catalogue, with introductions by Achille Bonito Oliva and Ernst Jünger and essays by Fulvio Abbate, Giulio Alessandri, Francesca Alfano Miglietti, William Anastasi, Giulio Carlo Argan, et al.

Biennale di Venezia. *Mirosław Bałka: 37.1 (cont.)* (1993). Exhibition leaflet, with essay by Anda Rottenberg.

Visby, Sweden. *Baltic Sculpture, Visby 93* (1993). Exhibition catalogue, with essays by Sune Nordgren, Johan Pousette, Anda Rottenberg, Bjorner Torsson, and Norbert Weber.

Zeiger, Lisa. "Mirosław Bałka at Museum Haus Lange." *Art in America* 81 (January 1993), p. 112.

Neuer Berliner Kunstverein, Staatliche Kunsthalle, Berlin. *Polnische Avantgarde, 1930–1990* (1992). Exhibition catalogue, with essays by Peter Funken, Dieter Honisch, Jaromir Jedliński, Maria Morzuch, Inken Nowald, et al.

Documenta IX (Stuttgart: Edition Cantz; New York: Harry N. Abrams, 1992). 3 vols. Exhibition catalogue, with introduction by Jan Hoet and essays by Bart De Baere, Cornelius Castoriadis, Hilde Daem, Claudia Herstatt, Heiner Müller, et al.

Museum Haus Lange, Krefeld, Germany. *Mirosław Bałka: bitte* (1992). Exhibition catalogue, with essay by Julian Heynen.

Musée d'Art Contemporain de Lyon and Espace Lyonnais d'Art Contemporain. *Muzeum Sztuki w Łodzi, 1931–1992: Collection — Documentation — Actualité* (1992). Exhibition catalogue, with introductions by Jaromir Jedliński and Thierry Raspail and essays by Jean de Breyne, Urzula Czartoryska, Gladys Fabre, Serge Fauchereau, Janina Ladnowska, et al.

Renaissance Society at the University of Chicago. *Mirosław Bałka: 36.6* (1992). Exhibition catalogue, with introduction by Susanne Ghez and essays by Julian Heynen and Peter Schjeldahl.

Smolik, Noemi. "Mirosław Bałka: Isabella Kacprzak." *Artforum* 30 (January 1992), p. 118.

Biennale of Sydney. *The Boundary Rider: The 9th Biennale of Sydney* (1992). Exhibition catalogue, with essays by Stephen Bann, Anthony Bond, Ian Burn, Charles Merewether, Juan Muñoz, and John Welchman.

Stichting De Appel, Amsterdam. *Mirosław Bałka* (1991). Exhibition catalogue, with essay by Christoph Blase.

Arbeitsgemeinschaft deutscher Kunstvereine e.V. *Kunst, Europa* (1991). Exhibition catalogue, with introductions by Vilém Flusser, Heinke Salisch, Stephen Schmidt Wulffen, and Andreas Vowinckel and essays by Zuzaná Bartošová, László Béke, Stephan Berg, Marc Bormand, Jean Digne, et al.

Galeria Foksal, Warsaw. *April / My Body Cannot Do Everything I Ask For* (1991). Exhibition catalogue, with essay by Andrzej Przywara.

Martin-Gropius-Bau, Berlin. *Metropolis* (New York: Rizzoli, 1991). Exhibition catalogue edited by Christos M. Joachimides and Norman Rosenthal, with essays by Achille Bonito Oliva, Jeffrey Deitch, Wolfgang Max Faust, Vilém Flusser, Boris Groys, et al.

Kunstverein Hamburg. *Le monde critique* (1991). Exhibition catalogue by Christoph Blase.

Przywara, Andrzej, and Mirosław Bałka. "Mirosław Bałka: Foksal." *Flash Art*, no. 160 (October 1991), p. 152.

Galeria Zachęta, Warsaw, and Muzeum Sztuki, Łódź, Poland. *The Collection of 20th-Century Art at the Museum of Art in Łódź* (1991). Exhibition catalogue, with essays by Urzula Czartoryska, Serge Fauchereau, Jaromir Jedliński, Jacek Ojrzyński, and Ryszard Stanisławski.

Carrell, Christopher, Donald Pirie, and Jekaterina Young. *Polish Realities: The Arts in Poland, 1980–1989* (Glasgow: Third Eye Centre, 1990).

Galeria Dziekanka, Warsaw. *Good God* (1990). Exhibition catalogue, with essay by Joanna Kiliszek.

Institute of Contemporary Arts and Serpentine Gallery, London. *Possible Worlds: Sculpture from Europe* (1990). Exhibition catalogue by Iwona Blazwick, James Lingwood, and Andrea Schlieker, with curators' interviews.

Artists Space, New York. *Metaphysical Visions: Middle Europe* (1989). Exhibition catalogue, with foreword by Susan Wyatt, essays by Kathy Rae Huffman, Valerie Smith, and Biljana Tomíc, and text by Mirosław Bałka.

Kunstmuseum Düsseldorf. *Dialog* (1989). Exhibition catalogue, with essays by Ulrich Krempel, Gottlieb Leinz, Maria Morzuch, Anda Rottenberg, and Stephan von Wiese.

Galeria Labirynt 2, Lublin, Poland. *River* (1989). Exhibition catalogue, with essay by Maria Morzuch.

Galeria Pokaz, Warsaw. *Percepta Patris Mei Servivi Semper* (1986). Exhibition catalogue, with essay by Anda Rottenberg.

Stephan Balkenhol

b. 1957, Fritzlar / Hessen, West Germany

lives in Karlsruhe, Germany, and Meisenthal, France

Selected One-Person Exhibitions

Barbara Gladstone Gallery, New York, 1995, *Stephan Balkenhol*.

Mai 36 Galerie, Zurich, 1994, *Stephan Balkenhol*.

Nationalgalerie, Berlin, 1994, *Stephan Balkenhol: Skulpturen* (catalogue).

Kunstraum Neue Kunst, Hannover, 1994, *Stephan Balkenhol: Skulpturen*.

Galerie Löhrl, Mönchengladbach, Germany, 1994, *Stephan Balkenhol: Skulpturen und Zeichnungen* (catalogue).

Regen Projects, Los Angeles, 1993, *Stephan Balkenhol*.

Galerie Johnen & Schöttle, Cologne, 1993, *Stephan Balkenhol*.

Witte de With, Rotterdam, 1992, *Stephan Balkenhol: über Menschen und Skulpturen / About Men and Sculpture* (catalogue).

Irish Museum of Modern Art, Dublin, 1991, *Stephan Balkenhol* (catalogue).

Galerie Löhrl, Mönchengladbach, Germany, 1991, *Stephan Balkenhol: Köpfe* (catalogue).

Städtische Galerie im Städel, Frankfurt, 1991, *Stephan Balkenhol: Skulpturen im Städelgarten* (brochure).

Westwerk, Hamburg, 1990, *Stephan Balkenhol*.

Staatliche Kunsthalle Baden-Baden, 1989, *Stephan Balkenhol* (catalogue).

Galerie Rudiger Schöttle, Munich, 1989, *Stephan Balkenhol*.

Galerie Johnen & Schöttle, Cologne, 1988, *Stephan Balkenhol*.

Kunsthalle Basel, 1988, *Stephan Balkenhol* (with Marika Mäkelä) (catalogue).

Kunstverein Braunschweig, West Germany, 1987, *Stephan Balkenhol: Skulpturen und Zeichnungen* (catalogue).

A.O. Kunstraum, Hamburg, 1985, *Stephan Balkenhol*.

Galerie Löhrl, Mönchengladbach, West Germany, 1984, *Stephan Balkenhol*.

Selected Group Exhibitions

Galerie Johnen & Schöttle, Cologne, 1995, *Philip Akkerman and Stephan Balkenhol*.

Barbara Gladstone Gallery, New York, 1994, *Still Life*.

Centro Cultural de Belém, Portugal, 1994, *Depois de Amanhã / The Day after Tomorrow*.

Museum für Moderne Kunst, Frankfurt, 1994, *Szenenwechsel VI / Change of Scene VI*.

Musée d'Art Moderne de la Ville de Paris (ARC), 1992, *Qui, Quoi, Où?: Un regard sur l'art en Allemagne en 1992* (catalogue).

FAE Musée d'Art Contemporain, Pully / Lausanne, Switzerland, 1992, *Post Human* (catalogue).

Hayward Gallery, London, 1992, *Doubletake: Collective Memory and Current Art* (catalogue).

Malmö Konstmuseum, Sweden, *Tio års ung konst i Hamburg,* and Kampnagelfabrik, Hamburg, 1991, *Zehn Jahre junge Kunst in Malmö* (catalogue).

Institute of Contemporary Arts and Serpentine Gallery, London, 1990, *Possible Worlds: Sculpture from Europe* (catalogue).

Tyne International, Newcastle, England, 1990, *A New Necessity: First Tyne International, 1990* (catalogue).

Castello di Rivara, Turin, Italy, 1989, *Sei artisti tedeschi* (catalogue).

Frankfurter Kunstverein und Schirn Kunsthalle, 1989, *Prospect 89: Eine internationale Ausstellung aktueller Kunst* (catalogue).

Städtische Kunsthalle, Kunstsammlung Nordrhein-Westfalen and Kunstverein für die Rheinlande und Westfalen, Düsseldorf, 1988, *BiNATIONALE: Deutsche Kunst der späten 80er Jahre / German Art of the Late 80s, American Art of the Late 80s / Amerikanische Kunst der späten 80er Jahre* (organized with the Institute of Contemporary Art and the Museum of Fine Arts, Boston) (catalogue).

Westfälischen Landesmuseums für Kunst und Kulturgeschichte in der Stadt Münster, West Germany, 1987, *Skulptur Projekte in Münster, 1987* (catalogue).

International Cultureel Centrum, Antwerp, and Deweer Art Gallery, Zwevegem-Otegem, Belgium, 1986, *Neue Deutsche Skulptur* (catalogue).

Jenisch-Park, Hamburg-Othmarschen, 1986, *Jenisch-Park: Skulptur* (catalogue).

Austellungshallen Mathildenhöhe, Darmstadt, 1985, *Die Karl-Schmidt-Rottluff-Stipendiaten* (catalogue).

Kunstverein für die Rheinlande und Westfalen, Düsseldorf, 1984, *Es ist wie es ist* (catalogue).

Selected Bibliography

Ritchie, Matthew. "'Still Life': Barbara Gladstone, New York." *Flash Art*, no. 181 (March–April 1995), p. 65.

Frick, Thomas. "Stephan Balkenhol at Regen Projects." *Art in America* 82 (June 1994), p. 108.

Galerie Löhrl, Mönchengladbach, and Kunstverein Wolfsburg, Germany. *Stephan Balkenhol: Skulpturen und Zeichnungen* (1994). Exhibition catalogue, with essays by Klaus Hoffmann and Susanne Pfleger.

Nationalgalerie, Berlin. *Stephan Balkenhol: Skulpturen* (1994). Exhibition catalogue, with essay by Britta Schmitz.

Messler, Norbert. "Stephan Balkenhol: Johnen & Schöttle." *Artforum* 32 (December 1993), pp. 91–92.

Parkett, no. 36 (June 1993), issue featuring Stephan Balkenhol, with essays by Jean-Christophe Ammann, Neal Benezra, Max Katz, and Vik Muniz.

Vergne, Philippe. "Stephan Balkenhol: De l'autre côté du miroir." *Parachute*, no. 72 (October–December 1993), pp. 22–25.

FAE Musée d'Art Contemporain, Pully/ Lausanne, Switzerland. *Post Human* (1992). Exhibition catalogue by Jeffrey Deitch.

Hayward Gallery, London. *Doubletake: Collective Memory and Current Art* (London: South Bank Centre; Zurich: Parkett, 1992). Exhibition catalogue edited by Lynne Cooke, Bice Curiger, and Greg Hilty, with essays by Jacques Attali, J.G. Ballard, Georges Bataille, Pinckney Benedict, Roberto Calasso, et al.

Musée d'Art Moderne de la Ville de Paris (ARC). *Qui, Quoi, Où?: Un regard sur l'art en Allemagne en 1992* (1992). Exhibition catalogue by Laurence Bossé and Hans-Ulrich Obrist, with Peter Sloterdijk interview by Hans-Ulrich Obrist and essays by Durs Grünbein and John Miller.

Searle, Adrian. "Not Waving, Not Drowning." *Frieze*, no. 4 (April–May 1992), pp. 17–20.

Witte de With, Rotterdam. *Stephan Balkenhol: über Menschen und Skulpturen / About Men and Sculpture* (Stuttgart: Edition Cantz, 1992). Exhibition catalogue, with introduction by Chris Dercon and Gosse Oosterhof, essays by James Lingwood and Jeff Wall, interviews with Ulrich Rückriem and Thomas Schütte, and text by Stephan Balkenhol.

Städtische Galerie im Städel, Frankfurt. *Stephan Balkenhol: Skulpturen im Städelgarten* (1991). Exhibition brochure, with essay by Ursula Grzechca-Mohr.

Irish Museum of Modern Art, Dublin. *Stephan Balkenhol* (1991). Exhibition catalogue, with essay by Jörg Johnen.

Messler, Norbert. "Stephan Balkenhol: Johnen & Schöttle." *Artforum* 30 (November 1991), pp. 150–151.

Institute of Contemporary Arts and Serpentine Gallery, London. *Possible Worlds: Sculpture from Europe* (1990). Exhibition catalogue by Iwona Blazwick, James Lingwood, and Andrea Schlieker, with curators' interviews.

Tyne International, Newcastle, England. *A New Necessity: First Tyne International, 1990* (1990). Exhibition catalogue, with foreword by Declan McGonagle and essays by John Bird, Simon Herbert, Thomas McEvilley, and Annelie Pohlen.

Staatliche Kunsthalle Baden-Baden. *Stephan Balkenhol* (1989). Exhibition catalogue by Dirk Teuber.

Koepplin, Dieter. "Stephan Balkenhol." *Parkett*, no. 22 (December 1989), pp. 6–13.

Castello di Rivara, Turin, Italy. *Sei artisti tedeschi* (1989). Exhibition catalogue by Gregorio Magnani.

Kunsthalle Basel. *Stephan Balkenhol* (1988). Exhibition catalogue, with essays by Jean-Christophe Ammann and Jeff Wall.

Städtische Kunsthalle, Kunstsammlung Nordrhein-Westfalen and Kunstverein für die Rheinlande und Westfalen, Düsseldorf. *BiNATIONALE: Deutsche Kunst der späten 80er Jahre / German Art of the Late 80s, American Art of the Late 80s / Amerikanische Kunst der späten 80er Jahre* (Cologne: DuMont Buchverlag, 1988). Exhibition catalogue by Rainer Crone, Jürgen Harten, Ulrich Luckhardt, and Jiri Svestka, with essays by Jürg Altwegg and Dietmar Kamper, interview with Heiner Müller, and interviews with the artists by Marie Luise Syring and Christiane Vielhaber.

Westfälischen Landesmuseums für Kunst und Kulturgeschichte in der Stadt Münster, West Germany. *Skulptur Projekte in Münster, 1987* (Cologne: DuMont Buchverlag, 1987). Exhibition catalogue edited by Klaus Bußmann and Kasper König, with essays by Marianne Brouwer, Benjamin H.D. Buchloh, Antje von Graevenitz, Thomas Kellein, Hannelore Kersting, et al.

Georg Baselitz

b. 1938, Deutschbaselitz, Lower Saxony,
Germany

lives in Derneburg, Germany, and Imperia,
Italy

Selected One-Person Exhibitions

Solomon R. Guggenheim Museum,
New York, 1995, *Georg Baselitz* (catalogue).

Hamburger Kunsthalle, 1994, *Georg Baselitz:
Skulpturen* (catalogue).

Saarland Museum, Saarbrücken, 1994,
Georg Baselitz: Werke, 1981–1993 (catalogue).

Cabinet d'art graphique, Musée national d'art
moderne, Centre Georges Pompidou,
Paris, 1993, *Georg Baselitz: dessins, 1962–1992*
(catalogue).

Louisiana Museum of Modern Art,
Humlebaek, Denmark, 1993,
Baselitz: Værker fra 1990–93 (catalogue).

Kunsthalle der Hypo-Kulturstiftung,
Munich, 1992, *Georg Baselitz: Retrospektive,
1964–1991* (catalogue).

Staatliche Museen zu Berlin, Nationalgalerie,
Altes Museum, 1990, *Georg Baselitz:
Bilder aus Berliner Privatbesitz* (catalogue).

Pace Gallery at 142 Greene Street, 1990,
Georg Baselitz: 45, and Pace Gallery at 32 East
57th Street, New York, 1990, *Georg Baselitz:
The Women of Dresden* (catalogue).

Michael Werner Gallery, New York, 1990,
Baselitz: Hero Paintings (catalogue).

Fundación Caja de Pensiones, Madrid, 1990,
Georg Baselitz (catalogue).

Städtische Galerie im Stadelschen
Kunstinstitut, Frankfurt, 1988, *Georg Baselitz:
der Weg der Erfindung: Zeichnungen, Bilder,
Skulpturen* (catalogue).

Kestner-Gesellschaft, Hannover, 1987,
*Georg Baselitz: Skulpturen und Zeichnungen,
1979–1987* (catalogue).

Cabinet des estampes, Musée d'art et
d'histoire, Geneva, 1984, *Georg Baselitz:
gravures, 1963–1983* (catalogue).

Kunstmuseum, Basel, and Stedelijk Van
Abbemuseum, Eindhoven, Netherlands, 1984,
Georg Baselitz: Zeichnungen, 1958–1983
(catalogue).

Stedelijk Van Abbemusem, Eindhoven,
Netherlands, 1979, *Georg Baselitz: Bilder,
1977–1978* (catalogue).

Kunsthalle Köln, 1976, *Georg Baselitz:
Gemälde, Handzeichnungen und Druckgraphik*
(catalogue).

Kunsthalle Bern, 1976, *Baselitz: Malerei,
Handzeichnungen, Druckgraphik* (catalogue).

Kunstverein Hamburg, 1972, *Georg Baselitz*
(catalogue).

Kunstmuseum Basel, 1970, *Georg Baselitz:
Zeichnungen* (catalogue).

Galerie Michael Werner, Cologne, 1964,
Georg Baselitz.

Charlottenburg, West Berlin, 1961,
1. Pandämonium (with Eugen Schönebeck).

Selected Group Exhibitions

Martin-Gropius-Bau, Berlin, 1991, *Metropolis*
(catalogue).

Museums Ludwig in den Rheinhallen der
Kölner Messe, 1989, *Bilderstreit: Widerspruch,
Einheit und Fragment in der Kunst seit 1960*
(catalogue).

Carnegie Museum of Art, Pittsburgh,
Pennsylvania, 1988, *Carnegie International*
(catalogue).

Musée national d'art moderne, Centre
Georges Pompidou, Paris, 1987, *L'époque,
la mode, la morale, la passion: Aspects de l'art
d'aujourd'hui, 1977–1987* (catalogue).

Museum Ludwig, Cologne, 1986,
*Europa / Amerika: Die Geschichte einer
künstlerischen Faszination seit 1940* (catalogue).

Museum of Art, Carnegie Institute,
Pittsburgh, Pennsylvania, 1985,
Carnegie International (catalogue).

Museum of Modern Art, New York, 1984,
*An International Survey of Recent Painting and
Sculpture* (catalogue).

St. Louis Art Museum, Missouri, 1983,
*Expressions. New Art from Germany:
Georg Baselitz, Jörg Immendorff, Anselm Kiefer,
Markus Lüpertz, A.R. Penck* (catalogue).

Martin-Gropius-Bau, West Berlin,
1982, *Zeitgeist: International Art Exhibition,
Berlin 1982* (catalogue).

Biennale of Sydney, 1982, *The 4th Biennale
of Sydney: Vision in Disbelief* (catalogue).

Kassel, 1982, *documenta 7* (catalogue).

Royal Academy of Arts, London, 1981,
A New Spirit in Painting (catalogue).

Venice, 1980, *XXXIX Biennale di Venezia*
(catalogue).

Kassel, 1972, *documenta 5* (catalogue).

Selected Bibliography

Solomon R. Guggenheim Museum,
New York. *Georg Baselitz* (1995). Exhibition
catalogue by Diane Waldman, with text
by Georg Baselitz.

Kinzer, Stephen. "A German Loved and
Loathed Gets His Day in America." *The New
York Times*, May 21, 1995, pp. H33–H34.

Bourdon, David. "Georg Baselitz at Pace."
Art in America 82 (June 1994), pp. 95–96.

Hamburger Kunsthalle. *Georg Baselitz:
Skulpturen* (Stuttgart: Cantz Verlag, 1994).
Exhibition catalogue, with essays by
Günther Gercken, Dorothee Hansen, and
Uwe M. Schneed.

McEvilley, Thomas. "Georg Baselitz:
Pace / Wildenstein." *Artforum* 32 (April 1994),
p. 95.

Gohr, Siegfried. "Georg Baselitz: Paintings
Don't Come with Guarantees." *Flash Art*,
no. 171 (Summer 1993), pp. 67–72.

Louisiana Museum of Modern Art,
Humlebaek, Denmark. *Baselitz: Værker fra
1990–93*. Exhibition issue of *Louisiana Revy*,
vol. 33 (May 1993), with essays by Eric
Darragon and Heinrich Heil and text by
Georg Baselitz.

Cabinet d'art graphique, Musée national d'art moderne, Centre Georges Pompidou, Paris. *Georg Baselitz: dessins, 1962–1992* (1993). Exhibition catalogue, with essay by Fabrice Hergott and texts by Georg Baselitz.

Dornberg, John. "The Artist who Came in from the Cold." *Artnews* 91 (October 1992), pp. 102–106.

Kunsthalle der Hypo-Kulturstiftung, Munich. *Georg Baselitz: Retrospektive, 1964–1991* (Munich: Hirmer Verlag, 1992). Exhibition catalogue edited by Siegfried Gohr, with essay by Carla Schulz-Hoffmann.

Koether, Jutta. "Georg Baselitz: Galerie Michael Werner." *Artforum* 30 (February 1992), pp. 130–131.

Martin-Gropius-Bau, Berlin. *Metropolis* (New York: Rizzoli, 1991). Exhibition catalogue edited by Christos M. Joachimides and Norman Rosenthal, with essays by Achille Bonito Oliva, Jeffrey Deitch, Wolfgang Max Faust, Vilém Flusser, Boris Groys, et al.

Staatliche Museen zu Berlin, Nationalgalerie, Altes Museum. *Georg Baselitz: Bilder aus Berliner Privatbesitz* (1990). Exhibition catalogue, with essays by Martin G. Buttig, Rudi Fuchs, Per Kirkeby, A.R. Penck, Wieland Schmied, and Carla Schulz Hoffmann, and text by Georg Baselitz.

Heymer, Kay. "Spotlight: Georg Baselitz. Images That Find New Nourishment in Complex Interferences." *Flash Art*, no. 152 (May–June 1990), p. 149.

Fundación Caja de Pensiones, Madrid. *Georg Baselitz* (1990). Exhibition catalogue, with essays by Rudi Fuchs, Kay Heymer, Antoni Marí, and Kevin Power.

Smith, Roberta. "The Burden of Isolation, in Baselitz 'Hero' Paintings." *The New York Times*, March 30, 1990, p. C24.

_____. "Baselitz and the Aftermath of War." *The New York Times*, October 10, 1990, p. C30.

Kunsthaus Zürich and Städtische Kunsthalle Düsseldorf. *Georg Baselitz* (1990). Exhibition catalogue by Harald Szeemann, with essays by John Caldwell, Mario Diacono, Rudi Fuchs, Christian Klemm, Franz Meyer, et al.

Solomon R. Guggenheim Museum, New York, and Williams College Museum of Art, Williamstown, Massachusetts. *Refigured Painting: The German Image, 1960–88* (Munich: Prestel-Verlag, 1989). Exhibition catalogue edited by Michael Govan, Thomas Krens, and Joseph Thompson, with essays by Heinrich Klotz, Hans Albert Peters, and Jürgen Schilling.

Museums Ludwig in den Rheinhallen der Kölner Messe. *Bilderstreit: Widerspruch, Einheit und Fragment in der Kunst seit 1960* (Cologne: DuMont Buchverlag, 1989). Exhibition catalogue by Siegfried Gohr and Johannes Gachnang, with essays by Hans Belting, André Berne-Joffroy, Emile Cioran, Michael Compton, Piet de Jonge, et al.

Carnegie Museum of Art, Pittsburgh, Pennsylvania. *Carnegie International* (Munich: Prestel, 1988). Exhibition catalogue, with essays by John Caldwell, Vicky Clark, Lynne Cooke, Milena Kalinovska, and Thomas McEvilley.

Hamburger Kunsthalle. *Georg Baselitz: Bilder, 1965–1987* (Milan: Electa, 1988). Exhibition catalogue by Werner Hofmann and Christos M. Joachimides, with essays by Demosthenes Davvetas and Wieland Schmied.

Kestner-Gesellschaft, Hannover. *Georg Baselitz: Skulpturen und Zeichnungen, 1979–1987* (1987). Exhibition catalogue edited by Carl Haenlein, with essays by Stephanie Barron, Eric Darragon, Andreas Franzke, Carl Haenlein, and A.M. Hammacher, and interview by Jean-Louis Froment and Jean-Marc Poinsot.

Musée national d'art moderne, Centre Georges Pompidou, Paris. *L'époque, la mode, la morale, la passion: Aspects de l'art d'aujourd'hui, 1977–1987* (1987). Exhibition catalogue by Bernard Blistène, Catherine David, and Alfred Pacquement, with essays by Jean-François Chevrier, Serge Daney, Philippe Dubois, Thierry de Duve, Johannes Gachnang, et al.

Museum Ludwig, Cologne. *Europa/Amerika: Die Geschichte einer künstlerischen Faszination seit 1940* (1986). Exhibition catalogue, with introduction by Siegfried Gohr and essays by Craig Adcock, Dore Ashton, Alberto Boatto, John Cage, Rainer Crone, et al.

Parkett, no. 11 (December 1986), issue featuring Georg Baselitz, with essays by John Caldwell, Eric Darragon, Remo Guidieri, Rainer Michael Mason, and Franz Meyer, and interview by Dieter Koepplin.

Museum of Art, Carnegie Institute, Pittsburgh, Pennsylvania. *Carnegie International* (Munich: Prestel-Verlag, 1985). Exhibition catalogue edited by Saskia Bos and John Lane, with introduction by John Lane and John Caldwell and essays by Achille Bonito Oliva, Benjamin H.D. Buchloh, Bazon Brock, Germano Celant, Rudi Fuchs, et al.

Kunstmuseum Basel and Stedelijk Van Abbemuseum, Eindhoven, Netherlands. *Georg Baselitz: Zeichnungen, 1958–1983* (1984). Exhibition catalogue by Dieter Koepplin and Rudi Fuchs.

Martin-Gropius-Bau, West Berlin. *Zeitgeist: International Art Exhibition, Berlin 1982* (New York: George Braziller, 1983). Exhibition catalogue edited by Christos M. Joachimides and Norman Rosenthal, with essays by Walter Bachauer, Thomas Bernhard, Karl-Heinz Bonrer, Paul Feyerabend, Hilton Kramer, et al.

St. Louis Art Museum, Missouri. *Expressions. New Art from Germany: Georg Baselitz, Jörg Immendorff, Anselm Kiefer, Markus Lüpertz, A.R. Penck* (Munich: Prestel-Verlag, 1983). Exhibition catalogue, with essays by Jack Cowart, Siegfried Gohr, and Donald B. Kuspit.

Whitechapel Art Gallery, London. *Baselitz: Paintings, 1960–1983* (1983). Exhibition catalogue, with foreword by Nicholas Serota, essays by Richard Calvocoressi, and texts by Georg Baselitz.

Royal Academy of Arts, London. *A New Spirit in Painting* (1981). Exhibition catalogue by Christos M. Joachimides, Norman Rosenthal, and Nicholas Serota.

Kunsthalle Bern. *Baselitz: Malerei, Handzeichnungen, Druckgraphik* (1976). Exhibition catalogue by Johannes Gachnang, with essay by Theo Kneubühler.

Rob Birza

b. 1962, Geldrop, Netherlands

lives in Ouderkerk a. d. Amstel, Netherlands

Selected One-Person Exhibitions

Hohenthal und Bergen, Cologne, 1995, *Rob Birza: Bilder.*

De Vleeshal, Middelburg, Netherlands, 1994, *My Fuckin' Kangaroo Is Damn Right! (and So Is My Pelican).*

Galerie Van Krimpen, Amsterdam, 1992, *Kunst-Rai.*

Haags Gemeentemuseum, The Hague, 1992, *The Aquarium.*

Stedelijk Museum, Amsterdam, 1991, *Rob Birza* (catalogue).

Galerie Van Krimpen, Amsterdam, 1990, *Rob Birza.*

Galerie 't Venster, Rotterdam, 1989, *Rob Birza: Nieuwe Schilderijen.*

Galerie Van Krimpen, Amsterdam, 1988, *First Blossom* (catalogue).

Selected Group Exhibitions

Stedelijk Museum, Amsterdam, 1995, *Couplet V: Dansende Meisjes, ter ere van Gustav Mahler, langs de randen van het expressionisme / "Dancing Girls," in Honor of Gustav Mahler, along the Borders of Expressionism.*

Castello di Rivoli, Turin, Italy, 1994, *L'Orizzonte: da Chagall a Picasso, da Pollock a Cragg. Capolavori dello Stedelijk Museum di Amsterdam* (catalogue).

Hohenthal & Littler, Munich, 1994, *Z.*

Musée d'Art Moderne de la Ville de Paris (ARC), 1994, *Du concept à l'image: Art Pays-Bas, XXe siècle* (catalogue).

Musée national d'histoire et d'art, Luxembourg, 1994, *Rendez-vous provoqué* (catalogue).

Stedelijk Museum, Amsterdam, 1993, *Het Materiaal: een keuze uit de collectie / The Material: A Choice from the Collection.*

Witte de With, Rotterdam, 1992, *As Long as It Lasts* (catalogue).

De Pont Stichting, Tilburg, Netherlands, 1992, *De Opening* (catalogue).

Gymnasium Felisenum, Velsen, Netherlands, 1991, *Stof en geest* (catalogue).

Witte de With, Rotterdam, 1991, *Negen* (catalogue).

Haags Gemeentemuseum à l'Institut Néerlandais, Paris, 1990, *Coup d'œil* (brochure).

Museum Fodor, Amsterdam, 1989, *Prix de Rome 89* (catalogue).

Richard Demarco Gallery, Edinburgh, 1989, *Holland at the Festival: Contemporary Art from The Netherlands* (catalogue).

Stedelijk Museum, Amsterdam, 1988, *Aspecten van de Nederlandse Schilderkunst: van Breitner tot Birza / Aspects of Dutch Painting: From Breitner to Birza.*

Arti et Amicitiae, Amsterdam, 1988, *Sancho! finalmente están en formación* (catalogue).

Stedelijk Museum, Amsterdam, 1987, *Een Grote Activiteit / Great Activity* (catalogue).

Villa Arson, Nice, France, 1987, *Sous le regard* (catalogue).

Selected Bibliography

Musée national d'histoire et d'art, Luxembourg. *Rendez-vous provoqué* (1994). Exhibition catalogue by Wim Beeren and Enrico Lunghi.

Musée d'Art Moderne de la Ville de Paris (ARC). *Du concept à l'image: Art Pays-Bas, XXe siècle* (1994). Exhibition catalogue, with foreword by Suzanne Pagé and Béatrice Parent, introductions by Alain Cueff and Bert Jansen, and essays by Jan van Adrichem, Saskia Bos, Dominic van den Boogerd, Jean Frémon, Jacinto Lageira, et al.

Castello di Rivoli, Turin, Italy. *L'Orizzonte: da Chagall a Picasso, da Pollock a Cragg. Capolavori dello Stedelijk Museum di Amsterdam* (1994). Exhibition catalogue edited by Ida Gianelli, with essays by Rudi Fuchs and Geurt Imanse.

Witte de With, Rotterdam. *Witte de With — Cahier #1, October 1993* (Düsseldorf: Richter Verlag, 1993). Published to accompany the exhibition *As Long as It Lasts* at Witte de With; introduction by Chris Dercon.

De Pont Stichting, Tilburg, Netherlands. *De Opening* (1992). Exhibition catalogue, with essays by Wilma van Asseldonk, Dominic van den Boogerd, and Elly Stegeman.

Turner, Jonathan. "Inside Europe. The Netherlands: Changing Colors." *Artnews* 91 (December 1992), pp. 82–83.

Stedelijk Museum, Amsterdam. *Rob Birza* (1991). Exhibition catalogue, with essays by Wim Beeren, Toine Ooms, and Marjolein Schaap.

Schaap, Marjolein. "Who Are the Artists to Watch? The Netherlands: Rob Birza." *Artnews* 90 (April 1991), p. 105.

Witte de With, Rotterdam. *Negen* (1991). Exhibition catalogue, with introduction by Chris Dercon and Gosse Oosterhof and essays by Jan van Adrichem, Lynne Cooke, and Piet de Jonge.

Van Nieuwenhuyzen, Martijn. "Rob Birza: T'venster, Rotterdam." *Flash Art*, no. 148 (October 1989), p. 143.

Arti et Amicitiae, Amsterdam. *Sancho! finalmente están en formación* (1988). Exhibition catalogue by E. de Lipsitz Villa and T. Meyer zu Slochtern.

Galerie Van Krimpen, Amsterdam. *Rob Birza* (1988). Exhibition catalogue (published in conjunction with the exhibition *First Blossom*).

Stedelijk Museum, Amsterdam. *Een Grote Activiteit / Great Activity* (1987). Exhibition catalogue, with introduction by Wim Beeren and essays by Els Barents, Maarten Bertheux, Marja Bloem, Rini Dippel, Din Pieters, et al.

Chuck Close

b. 1940, Monroe, Washington, USA

lives in New York, New York, USA

Selected One-Person Exhibitions

Fondation Cartier pour l'art contemporain, Paris, 1994, *Chuck Close: 8 peintures récentes*.

Staatliche Kunsthalle Baden-Baden, 1994, *Chuck Close: Retrospektive* (catalogue).

Pace Gallery, New York, 1993, *Chuck Close: Recent Paintings* (catalogue).

Museum of Modern Art, New York, 1993, *Alex: A Print Project by Chuck Close*.

Virginia Museum of Fine Arts, Richmond, 1993, *Chuck Close: Portraits*.

Pace Gallery, New York, 1991, *Chuck Close: Recent Paintings* (catalogue).

Butler Institute of American Art, Youngstown, Ohio, 1989, *Chuck Close: Editions* (catalogue).

Pace Gallery, New York, 1988, *Chuck Close: New Paintings* (catalogue).

Fraenkel Gallery, San Francisco, 1985, *Chuck Close: Large Scale Photographs*.

Fuji Television Gallery, Tokyo, 1985, *Exhibition of Chuck Close* (catalogue).

Pace Gallery, New York, 1983, *Chuck Close: Recent Work* (catalogue).

Walker Art Center, Minneapolis, Minnesota, 1980, *Close Portraits* (catalogue).

Kunstraum München, 1979, *Chuck Close* (catalogue).

Museum of Modern Art, New York, 1973, *Chuck Close: Project*.

Museum of Contemporary Art, Chicago, 1972, *Chuck Close* (brochure).

Selected Group Exhibitions

Institute of Contemporary Art, University of Pennsylvania, Philadelphia, 1994, *Face-off: The Portrait in Recent Art* (catalogue).

National Portrait Gallery, London, 1993, *The Portrait Now* (catalogue).

Lingotto, Turin, Italy, 1992, *Arte Americana, 1930–1970* (catalogue).

Museum of Modern Art, New York, 1991, *Artist's Choice: Chuck Close. Head-on: The Modern Portrait* (brochure).

Museum of Fine Arts, Boston, 1990, *Figuring the Body*.

Whitney Museum of American Art, New York, 1989, *Image World: Art and Media Culture* (catalogue).

Walker Art Center, Minneapolis, Minnesota, 1989, *First Impressions: Early Prints by Forty-six Contemporary Artists* (catalogue).

Israel Museum, Jerusalem, 1986, *Big and Small*.

Museum of Contemporary Art, Los Angeles, 1983, *The First Show: Painting and Sculpture from Eight Collections, 1940–1980* (catalogue).

Musée national d'art moderne, Centre Georges Pompidou, Paris, 1979, *Copie conforme?* (catalogue).

Australian National Gallery, Canberra, 1977, *Illusion and Reality* (catalogue).

Kassel, 1977, *documenta 6* (catalogue).

Wallraf-Richartz-Museum and Kunsthalle Köln, 1974, *Projekt '74: Kunst bleibt Kunst, Aspekte internationaler Kunst am Anfang der 70er Jahre* (catalogue).

Centre National d'Art Contemporain, Paris, 1974, *Hyperréalistes américains, réalistes européens* (catalogue).

Serpentine Gallery, London, 1973, *Photo-Realism: The Ludwig Collection* (catalogue).

Würtembergischer Kunstverein, Stuttgart, 1972, *Amerikanischer Fotorealismus* (catalogue).

Kassel, 1972, *documenta 5* (catalogue).

Allen Memorial Art Museum, Oberlin College, Ohio, 1970, *Three Young Americans*.

Selected Bibliography

Staatliche Kunsthalle Baden-Baden. *Chuck Close: Retrospektive* (Stuttgart: Edition Cantz, 1994). Exhibition catalogue edited by Jochen Poetter and Helmut Friedel, with essays by Margrit Franziska Brehm and Robert Storr.

Gookin, Kirby. "Chuck Close: Pace Gallery." *Artforum* 32 (March 1994), pp. 84–85.

Institute of Contemporary Art, University of Pennsylvania, Philadelphia. *Face-off: The Portrait in Recent Art* (1994). Exhibition catalogue by Melissa Feldman, with essay by Benjamin H.D. Buchloh.

Auping, Michael. "Face to Face: Portraits from the Collection of the Metropolitan Museum of Art." *Artforum* 32 (October 1993), pp. 66–71.

National Portrait Gallery, London. *The Portrait Now* (1993). Exhibition catalogue by Robin Gibson.

Pace Gallery, New York. *Chuck Close: Recent Paintings* (1993). Exhibition catalogue, with essay by Arthur C. Danto.

Kimmelman, Michael. "Chuck Close Browses and Assembles an Exhibition." *The New York Times*, January 18, 1991, p. C32.

Museum of Modern Art, New York. *Artist's Choice: Chuck Close. Head-on: The Modern Portrait* (1991). Exhibition brochure, with foreword by Kirk Varnedoe and text by Chuck Close.

Pace Gallery, New York. *Chuck Close: Recent Paintings* (1991). Exhibition catalogue, with essay by Peter Schjeldahl.

Smith, Roberta. "In Portraits on a Grand Scale, Chuck Close Moves On." *The New York Times*, November 8, 1991, p. C24.

Whitney Museum of American Art, New York. *1991 Biennial Exhibition* (New York and London: W.W. Norton, 1991). Exhibition catalogue by Richard Armstrong, John G. Hanhardt, Richard Marshall, and Lisa Phillips.

Butler Institute of American Art, Youngstown, Ohio. *Chuck Close: Editions, A Catalogue Raisonné and Exhibition* (1989). Exhibition catalogue, with introduction by Louis A. Zona and essay by Jim Pernotto.

Art Institute of Chicago. *Chuck Close* (1989). Exhibition catalogue by Colin Westerbeck.

Finch, Christopher. "Color Close-ups." *Art in America* 77 (March 1989), pp. 113–118, 161.

Walker Art Center, Minneapolis, Minnesota. *First Impressions: Early Prints by Forty-six Contemporary Artists* (New York: Hudson Hills Press, 1989). Exhibition catalogue by Elizabeth Armstrong and Sheila McGuire.

Whitney Museum of American Art, New York. *Image World: Art and Media Culture* (1989). Exhibition catalogue by Marvin Heiferman and Lisa Phillips, with essay by John G. Hanhardt.

Pace Gallery, New York. *Chuck Close: New Paintings* (1988). Exhibition catalogue, with essay by Klaus Kertess.

Johnson, Ken. "Photographs by Chuck Close." *Arts Magazine* 61 (April 1987), pp. 20–23.

Lyons, Lisa, and Robert Storr. *Chuck Close* (New York: Rizzoli International Publications, 1987).

Pace Gallery, New York. *Chuck Close: Recent Work* (1986). Exhibition catalogue, with interview by Arnold Glimcher.

Close, Chuck. "A Progression by Chuck Close: Who's Afraid of Photography?" *Artforum* 22 (May 1984), pp. 50–55.

Museum of Contemporary Art, Los Angeles. *The First Show: Painting and Sculpture from Eight Collections, 1940–1980* (1983). Exhibition catalogue edited by Julia Brown and Bridget Johnson, with essay by Pontus Hulten.

Walker Art Center, Minneapolis, Minnesota. *Close Portraits* (1980). Exhibition catalogue by Martin Friedman and Lisa Lyons, with texts by Chuck Close, Leslie Close, Mark Greenwold, Robert Israel, and Joe Zucker.

Kunstraum München. *Chuck Close* (1979). Exhibition catalogue by Hermann Kern.

Pace Gallery, New York. *Chuck Close: Recent Work* (1979). Exhibition catalogue, with essay by Kim Levin.

Australian National Gallery, Canberra. *Illusion and Reality* (1977). Exhibition catalogue, with introduction by John Stringer.

Musée national d'art moderne, Centre Georges Pompidou, Paris. *Paris-New York* (1977). Exhibition catalogue by Pontus Hulten, with essays by Daniel Abadie, Robert Bordaz, Gabrielle Buffet-Picabia, Alfred Pacquement, Hélène Seckel, et al.

Centre National d'Art Contemporain, Paris. *Hyperréalistes américains, réalistes européens* (1974). Exhibition catalogue by Daniel Abadie, with essays by Wolfgang Becker, Jean Clair, and Pierre Restany.

Wallraf-Richartz-Museum and Kunsthalle Köln. *Projekt '74: Kunst bleibt Kunst, Aspekte internationaler Kunst am Anfang der 70er Jahre* (1974). Exhibition catalogue, with foreword by Dieter Ronte and essays by Marlis Grüterich, Birgit Hein, Wulf Herzogenrath, David A. Ross, Manfred Schneckenburger, et al.

Museum of Contemporary Art, Chicago. *Chuck Close* (1972). Exhibition brochure by Dennis Adrian.

Würtembergischer Kunstverein, Stuttgart. *Amerikanischer Fotorealismus* (1972). Exhibition catalogue by Uwe M. Schneede.

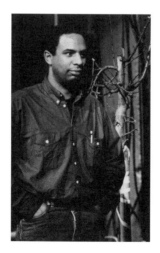

Stan Douglas

b. 1960, Vancouver, British Columbia, Canada
lives in Vancouver, British Columbia, Canada

Selected One-Person Exhibitions

Renaissance Society at the University of Chicago, 1995, *Stan Douglas: Evening; Hors-champs.*

David Zwirner Gallery, New York, 1995, *Stan Douglas.*

Milwaukee Art Museum, Wisconsin, 1994, *Currents 24: Stan Douglas* (brochure).

Institute of Contemporary Arts, London, 1994, *Stan Douglas.*

Wadsworth Atheneum, Hartford, Connecticut, 1994, *Stan Douglas: Matrix 123* (brochure).

Art Gallery of York University, Toronto, and Macdonald Stewart Art Centre at the University of Guelph, Ontario, 1994, *Stan Douglas* (brochure).

Musée national d'art moderne, Centre Georges Pompidou, Paris, 1994, *Stan Douglas* (catalogue).

UBC Fine Arts Gallery, Vancouver, 1992, *Stan Douglas: Monodramas and Loops* (catalogue).

Galerie national du Jeu de Paume, Paris, 1991, *Stan Douglas.*

Contemporary Art Gallery, Vancouver, 1988, *Stan Douglas: Television Spots* (catalogue).

Art Gallery of Ontario, Toronto, 1987, *Perspective '87: Stan Douglas* (catalogue).

Western Front, Vancouver, 1986, *Onomatopoeia.*

Or Gallery, Vancouver, 1985, *Panoramic Rotunda.*

Ridge Theater, Vancouver, 1984, *Sideworks.*

Selected Group Exhibitions

Museum of Modern Art, New York, 1995, *Video Spaces: Eight Installations* (catalogue).

Whitney Museum of American Art, New York, 1995, *1995 Biennial Exhibition* (catalogue).

Setagaya Art Museum, Tokyo, 1995, *Spirits on the Crossing: Travellers to/from Nowhere. Contemporary Art in Canada, 1980–94* (catalogue).

San Francisco Museum of Modern Art, 1995, *Public Information: Desire, Disaster, Document* (catalogue).

Canadian Artist's Network: Black Artists in Action, Toronto, 1994, *First Light: Celebrating African Canadian Cinema.*

Vancouver Art Gallery, 1993, *Out of Place* (catalogue).

Power Plant, Toronto, 1992, *The Creation … of the African-Canadian Odyssey* (catalogue).

Kassel, 1992, *Documenta IX* (catalogue).

Musée national d'art moderne, Centre Georges Pompidou, Paris, 1990, *Passages de l'Image* (catalogue).

Venice, 1990, *XLIV Esposizione Internazionale d'Arte: La Biennale di Venezia* (catalogue).

Biennale of Sydney, 1990, *The Readymade Boomerang: Certain Relations in 20th Century Art* (catalogue).

Graphische Sammlung, Staatsgalerie Stuttgart, 1989, *Photo-Kunst: Arbeiten aus 150 Jahren / du XXème au XIXème siècle, aller et retour* (catalogue).

Vancouver Art Gallery, 1986, *Broken Muse* (catalogue).

National Gallery of Canada, Ottawa, 1986, *Songs of Experience / Chants d'expérience* (catalogue).

Vancouver Art Gallery, 1983, *Vancouver: Art and Artists, 1931–1983* (catalogue).

Selected Bibliography

Museum of Modern Art, New York. *Video Spaces: Eight Installations* (1995). Exhibition catalogue, with introduction by Samuel Delany and essay by Barbara London.

San Francisco Museum of Modern Art. *Public Information: Desire, Disaster, Document* (1995). Exhibition catalogue, with introduction by Gary Garrels and essays by Jim Lewis, Christopher Phillips, Sandra S. Phillips, Robert R. Riley, Abigail Solomon Godeau, and John S. Weber.

Setagaya Art Museum, Tokyo. *Spirits on the Crossing: Travellers to / from Nowhere. Contemporary Art in Canada, 1980–94* (1995). Exhibition catalogue, with essays by Yuko Hasegawa, Shinji Kohmoto, and Diana Nemiroff.

Vogel, Sabine B. "Stan Douglas: Kunsthalle." *Artforum* 33 (January 1995), p. 95.

Whitney Museum of American Art, New York. *1995 Biennial Exhibition* (New York: Harry N. Abrams, 1995). Exhibition catalogue by Klaus Kertess, with essays by Gerald M. Edelman, John G. Hanhardt, and Lynne Tillman and poem by John Ashbery.

Elwes, Catherine. "Stan Douglas: ICA, London." *Art Monthly*, no. 180 (October 1994), pp. 28–29.

Lebrero Stals, José. "Stan Douglas." *Flash Art*, no. 177 (Summer 1994), p. 111.

Milwaukee Art Museum, Wisconsin. *Currents 24: Stan Douglas* (1994). Exhibition brochure, with essay by Dean Sobel and text by Stan Douglas.

Musée national d'art moderne, Centre Georges Pompidou, Paris. *Stan Douglas* (1994). Exhibition catalogue, with introduction by Christine van Assche, essays by Peter Culley and Jean-Christophe Royoux, and text by Stan Douglas.

Watson, Scott. "Making History." *Canadian Art* 11 (Winter 1994), pp. 30–37.

Cooke, Lynne. "Broadcast Views: Stan Douglas Interviewed by Lynne Cooke." *Frieze*, no. 12 (September–October 1993), pp. 41–45.

Vancouver Art Gallery. *Out of Place* (1993). Exhibition catalogue by Gary Dufour, with essays by Peter Culley, Agnaldo Farias, Charlotte Townsend-Gault, Robin Laurence, Roberto Merino, et al., and text by Stan Douglas.

Documenta IX (Stuttgart: Edition Cantz; New York: Harry N. Abrams, 1992). 3 vols. Exhibition catalogue, with introduction by Jan Hoet and essays by Bart De Baere, Cornelius Castoriadis, Hilde Daem, Claudia Herstatt, Heiner Müller, et al.

Power Plant, Toronto. *The Creation … of the African-Canadian Odyssey* (1992). Exhibition catalogue by Nkiru Nzegwu, with foreword by Richard Rhodes.

UBC Fine Arts Gallery, Vancouver. *Stan Douglas: Monodramas and Loops* (1992). Exhibition catalogue, with essays by John Fiske and Scott Watson.

Centre Cultural de la Fundació Caixa de Pensions, Barcelona. *Passages de l'Image* (1991). Exhibition catalogue, with introduction by Raymond Bellour, Catherine David, and Christine van Assche, and essays by Jacques Aumont, Alain Bergala, Pascal Bonitzer, Christine Buci-Glucksmann, Jean François Chevrier, et al. (catalogue accompanying the 1990 exhibition organized by Musée national d'art moderne, Centre Georges Pompidou).

Joselit, David. "Projected Identities." *Art in America* 79 (November 1991), pp. 116–123.

Biennale of Sydney. *The Readymade Boomerang: Certain Relations in 20th Century Art* (1990). Exhibition catalogue by René Block, with essays by Lynne Cooke, Anne Marie Freybourg, Dick Higgins, Bernice Murphy, and Emmett Williams, and text by Stan Douglas.

Graphische Sammlung, Staatsgalerie Stuttgart. *Photo-Kunst: Arbeiten aus 150 Jahren / du XXème au XIXème siècle, aller et retour* (Stuttgart: Edition Cantz, 1989). Exhibition catalogue by Jean-François Chevrier, with essays by Ursula Zeller.

Henry, Karen. "Stan Douglas: Artspeak Gallery, Vancouver." *Parachute*, no. 51 (June–August 1988), pp. 35–36.

Contemporary Art Gallery, Vancouver. *Stan Douglas: Television Spots* (1988). Exhibition catalogue, with essay by Miriam Nichols.

Art Gallery of Ontario, Toronto. *Perspective '87: Stan Douglas* (1987). Exhibition catalogue by Barbara Fischer.

National Gallery of Canada, Ottawa. *Songs of Experience / Chants d'expérience* (1986). Exhibition catalogue, with essays by Jessica Bradley and Diana Nemiroff, and text by Stan Douglas.

Vancouver Art Gallery. *Broken Muse* (1986).
Exhibition catalogue by Helga Pakasaar and
Keith Wallace, with text by Stan Douglas.

Vancouver Art Gallery. *Vancouver: Art and
Artists, 1931–1983* (1983). Exhibition
catalogue, with foreword by Luke Rombout
and essays by Alvin Balkind, Claudia Beck,
Jo-Anne Birnie Danzker, Karen Duffek,
Lorna Farrell-Ward, et al.

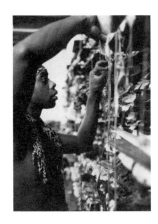

Leonardo Drew

b. 1961, Tallahassee, Florida, USA
lives in Brooklyn, New York, USA

Selected One-Person Exhibitions

Walter/McBean Gallery, San Francisco Art
Institute, 1994, *Leonardo Drew.*

Thread Waxing Space, New York, 1994,
Leonardo Drew (catalogue).

Barbara Toll Fine Arts, New York, 1994,
Leonardo Drew.

Herbert F. Johnson Museum of Art,
Cornell University, Ithaca, New York, 1994,
Leonardo Drew.

Thread Waxing Space, New York, 1992,
Leonardo Drew (catalogue).

Unique Gallery, Westport, Connecticut, 1983,
Leonardo Drew.

Burroughs Building, Bridgeport Public
Library, Connecticut, 1980, *Leonardo Drew.*

Inn at Longshore, Westport, Connecticut,
1978, *Leonardo Drew.*

Burroughs Building, Bridgeport Public
Library, Connecticut, 1978, *Leonardo Drew.*

State National Bank, Bridgeport,
Connecticut, 1978, *Leonardo Drew.*

Selected Group Exhibitions

Art Institute of Chicago, 1995, *About Place:
Recent Art of the Americas* (catalogue).

Aldrich Museum of Contemporary Art,
Ridgefield, Connecticut, 1994, *Promising
Suspects* (catalogue).

White Columns, New York, 1994,
Markets of Resistance.

PaineWebber, New York, 1993, *The Studio
Museum in Harlem: 25 Years of African-American
Art* (brochure).

Biennial Dakar, Senegal, 1992,
*A/Cross Currents: Synthesis in African
American Abstract Painting/Croisements des
Parcours: Synthèse de la Peinture Abstraite
Africaine Américaine* (catalogue).

Thread Waxing Space, New York, 1992,
*Three Sculptors: Leonardo Drew, Lisa Hoke,
Brad Kahlhamer* (catalogue).

Cooper Union School of Art and School
of Architecture, New York, 1992, *Good Stuff:
Alumni Artists.*

Nicole Klagsbrun Gallery, New York, 1992.

Studio Museum in Harlem, New York, 1991,
From the Studio: Artists-in-Residence, 1990–91
(brochure).

Scott Hanson Gallery, New York, 1989,
Outside the Clock: Beyond Good and Elvis.

Kenkeleba House, New York, 1985,
Pillar to Post.

Selected Bibliography

Art Institute of Chicago. *About Place:
Recent Art of the Americas* (1995). Exhibition
catalogue by Madeleine Grynsztejn, with
essay by Dave Hickey.

Aldrich Museum of Contemporary Art,
Ridgefield, Connecticut. *Promising Suspects*
(1994). Exhibition catalogue, with essay
by Barry A. Rosenberg.

Cotter, Holland. "Leonardo Drew."
The New York Times, April 1, 1994, p. C20.

Levin, Kim. "Voice Choices: Leonardo
Drew." *Village Voice*, March 29, 1994, p. 71.

MacAdam, Barbara. "Leonardo Drew:
Thread Waxing Space, Barbara Toll." *Artnews*
93 (Summer 1994), p. 180.

Thread Waxing Space, New York. *Leonardo
Drew* (1994). Exhibition catalogue, with essay
by Hilton Als and text by Leonardo Drew.

Als, Hilton. "Openings: Leonardo Drew."
Artforum 21 (February 1993), p. 94.

Heartney, Eleanor. "Leonardo Drew at
Thread Waxing Space." *Art in America* 81
(March 1993), pp. 112–113.

Lohaus, Stella. "Leonardo Drew."
Forum International, no. 17 (March–April
1993), p. 133.

Naves, Mario. "Leonardo Drew."
New Art Examiner 20 (February 1993), p. 29.

Nesbitt, Lois E. "Leonardo Drew:
Thread Waxing Space." *Artforum* 21
(January 1993), p. 87.

Schwabsky, Barry. "Leonardo Drew:
Thread Waxing Space." *Sculpture* 12 (March–
April 1993), p. 77.

Wood, Carol. "Leonardo Drew." *Tema Celeste*,
no. 39 (Winter 1993), p. 78.

Cotter, Holland. "From the Studio: Artists
in Residence 1990–1991." *The New York Times*,
January 10, 1992, p. C28.

Biennial Dakar, Senegal. *A/Cross Currents:
Synthesis in African American Abstract
Painting/Croisements des Parcours: Synthèse de
la Peinture Abstraite Africaine Américaine*
(1992). Exhibition catalogue, with essay by
Corrine Jennings.

Faust, Gretchen. "Leonardo Drew, Lisa Hoke,
Brad Kahlhamer." *Arts Magazine* 66
(April 1992), pp. 94–95.

Glueck, Grace. "Drew's Expressive Power;
Fischl Belly-Flop." *New York Observer*,
November 30, 1992, p. 23.

Heartney, Eleanor. "Brad Kahlhamer,
Lisa Hoke and Leonardo Drew at the
Thread Waxing Space." *Art in America* 80
(May 1992), p. 137.

Kimmelman, Michael. "Leonardo Drew."
The New York Times, November 27, 1992,
p. C23.

Thread Waxing Space, New York. *Leonardo Drew* (1992). Exhibition catalogue, with essay by Thomas McEvilley and interview with Tim Nye.

Thread Waxing Space, New York. *Three Sculptors: Leonardo Drew, Lisa Hoke, Brad Kahlhamer* (1992). Exhibition catalogue by Christian Leigh.

Brenson, Michael. "Sculptors Using the Wall as Venue and Inspiration." *The New York Times*, February 24, 1989, p. C30.

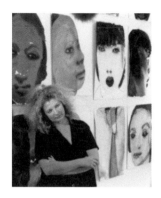

Marlene Dumas

b. 1953, Capetown, South Africa

lives in Amsterdam, Netherlands

Selected One-Person Exhibitions

Galerie Stampa, Basel, 1995, *Marlene Dumas: Love Hurts.*

Malmö Konsthall, Sweden, 1995, *Det unika med att vara en människa / The Particularity of Being Human: Marlene Dumas, Francis Bacon* (catalogue).

Douglas Hyde Gallery, Dublin, 1994, *Marlene Dumas: Chlorosis* (catalogue).

Jack Tilton Gallery, New York, 1994, *Marlene Dumas: Not from Here.*

Goldie Paley Gallery, Moore College of Art and Design, Philadelphia, Pennsylvania, 1993, *Marlene Dumas* (catalogue).

Bonner Kunstverein, 1993, *Marlene Dumas* (catalogue).

Produzentengalerie, Hamburg, 1993, *Marlene Dumas: Land of Milk and Honey* (catalogue).

Zeno X Gallery, Antwerp, 1993, *Give the People What They Want.*

Stedelijk Van Abbemuseum, Eindhoven, Netherlands, 1992, *Marlene Dumas: Miss Interpreted* (catalogue).

Galerie Isabella Kacprzak, Cologne, 1992, *Ask Me No Questions and I'll Tell You No Lies.*

Staatsgalerie Moderner Kunst, Munich, 1990, *The Origin of the Species* (catalogue).

Museum Overholland, Amsterdam, 1990, *Marlene Dumas: Couples* (catalogue).

Kunsthalle Bern, 1989, *Marlene Dumas: The Question of Human Pink* (catalogue).

Kunsthalle zu Kiel, West Germany, 1988, *Waiting (for meaning)* (catalogue).

Galerie Stampa, Basel, 1988, *Marlene Dumas: Arbeiten, 1986–1988* (with Rosemarie Trockel).

Galerie Paul Andriesse, Amsterdam, 1987, *The Private versus the Public.*

Galerie Paul Andriesse, Amsterdam, 1985, *The Eyes of the Night Creatures* (catalogue).

Centraal Museum, Utrecht, 1984, *Ons Land Licht Lager Dan De Zee* (catalogue).

Galerie Paul Andriesse, Amsterdam, 1983, *Unsatisfied Desire.*

Galerie Lambelet, Basel, 1980, *Marlene Dumas.*

Galerie Annemarie de Kruyff, Paris, 1979, *Marlene Dumas.*

Selected Group Exhibitions

Venice, 1995, *XLVI Esposizione Internazionale d'Arte: Identità e Alterità* (catalogue).

Johannesburg, 1995, *Africus: The Johannesburg Biennale* (catalogue).

Nykytaiteen Museo and Valtion Taidemuseo, Helsinki, 1995, *Ars 95: Yksityinen / Julkinen, Private / Public* (catalogue).

Museo Nacional Centro de Arte Reina Sofía, Madrid, 1994, *Cocido y crudo* (catalogue).

Gemäldegalerie Neue Meister, Staatliche Kunstsammlungen Dresden, 1994, *4 x 1 im Albertinum: Marlene Dumas, Günther Fruhtrunk, Louise Lawler, Marcel Odenbach* (catalogue).

Centre d'Art Contemporain, Geneva, 1994, *Miriam Cahn, Marlene Dumas, Kiki Smith, Sue Williams: Dessins.*

Musée d'Art Moderne de la Ville de Paris (ARC), 1994, *Du concept à l'image: Art Pays-Bas, XXᵉ siècle* (catalogue).

Kunsthalle Wien, 1993, *Der zerbrochene Spiegel: Positionen zur Malerei* (catalogue).

Kunsthalle Basel, 1993, *Das 21. Jahrhundert: Mit Parcelsus in die Zukunft / The 21st Century: Into the Future with Paracelsus* (catalogue).

De Pont Stichting, Tilburg, Netherlands, 1992, *De Opening* (catalogue).

Kassel, 1992, *Documenta IX* (catalogue).

New Museum of Contemporary Art, New York, 1991, *The Interrupted Life* (catalogue).

Stichting De Appel, Amsterdam, 1991, *Inscapes* (catalogue).

Jack Tilton Gallery, New York, 1991, *Forbidden Games.*

Museums Ludwig in den Rheinhallen der Kölner Messe, 1989, *Bilderstreit: Widerspruch, Einheit und Fragment in der Kunst seit 1960* (catalogue).

Frankfurter Kunstverein und Schirn Kunsthalle, 1989, *Prospect 89: Eine internationale Ausstellung aktueller Kunst* (catalogue).

Fruitmarket Gallery, Edinburgh, 1989, *6 Dutch Artists* (catalogue).

Stichting De Appel, Amsterdam, 1987, *Nightfire* (catalogue).

Tate Gallery, London, 1987, *Art from Europe: Works by Ulay and Marina Abramovic, René Daniëls, Marlene Dumas, Astrid Klein, Pieter Laurens Mol, Andreas Schulze, Rosemarie Trockel* (catalogue).

São Paulo, 1985, *XVIII Bienal de São Paulo* (catalogue).

Stedelijk Van Abbemuseum, Eindhoven, Netherlands, 1985, *Christa Dichgans, Lili Dujourie, Marlene Dumas, Lesley Fox Croft, Kees de Goede, Frank van Hemert, Cristina Iglesias, Harald Klingelhöller, Mark Luyten, Juan Muñoz, Katherine Porter, Julião Sarmento, Barbara Schmidt Heins, Gabriele Schmidt-Heins, Didier Vermeiren* (catalogue).

Biennale of Sydney, 1984, *The Fifth Biennale of Sydney. Private Symbol: Social Metaphor* (catalogue).

Museum Boymans-van Beuningen, Rotterdam, 1983, *Veertien kunstenaars uit Nederland* (catalogue).

Kassel, 1982, *documenta 7* (catalogue).

Selected Bibliography

Nykytaiteen Museo and Valtion Taidemuseo, Helsinki. *Ars 95: Yksityinen / Julkinen, Private / Public* (1995). Exhibition catalogue edited by Maaretta Jaukkuri and Asko Mäkelä, with essays by Yonah Foncé-Zimmerman, Jonathan Friedman, Michael Glasmeier, and Matti Wuori.

Johannesburg. *Africus: The Johannesburg Biennale Catalogue* (Johannesburg: Greater Johannesburg Transitional Metropolitan Council, 1995). Exhibition catalogue, with essay by Maarten Bertheux.

Malmö Konsthall, Sweden. *Det unika med att vara en människa / The Particularity of Being Human: Marlene Dumas, Francis Bacon* (1995). Exhibition catalogue, with preface by Sune Nordgren, introduction by Marente Bloemheuvel and Jan Mot, essays by Richard Francis and Daniel Kurjakovic, and text by Marlene Dumas.

Museo Nacional Centro de Arte Reina Sofía, Madrid. *Cocido y crudo* (1995). Exhibition catalogue by Dan Cameron, with essays by Jean Fisher, Gerardo Mosquera, Jerry Saltz, and Mar Villaespesa.

Cameron, Dan. "Marlene Dumas: Jack Tilton Gallery, New York." *Frieze*, no. 19 (November–December 1994), pp. 55–56.

Douglas Hyde Gallery, Dublin. *Marlene Dumas: Chlorosis* (1994). Exhibition catalogue, with essay by John Hutchinson and text by Marlene Dumas.

Laing, Carol. "Marlene Dumas: Art Gallery of York University, North York." *Parachute*, no. 76 (October–December 1994), pp. 61–62.

Musée d'Art Moderne de la Ville de Paris (ARC). *Du concept à l'image: Art Pays-Bas, XXe siècle* (1994). Exhibition catalogue, with foreword by Suzanne Pagé and Béatrice Parent, introductions by Alain Cueff and Bert Jansen, and essays by Jan van Adrichem, Saskia Bos, Dominic van den Boogerd, Jean Frémon, Jacinto Lageira, et al.

Schwabsky, Barry. "Marlene Dumas: Jack Tilton Gallery." *Artforum* 33 (October 1994), pp. 103–104.

Bonner Kunstverein and Institute of Contemporary Arts, London. *Marlene Dumas* (1993). Exhibition catalogue, with foreword by Emma Dexter, essay by Annelie Pohlen, and text by Marlene Dumas.

Goldie Paley Gallery, Moore College of Art and Design, Philadelphia, Pennsylvania. *Marlene Dumas* (1993). Exhibition catalogue, with foreword by Elsa Longhauser, essay by Jolie van Leeuwen, and text by Marlene Dumas.

Parkett, no. 38 (December 1993), issue featuring Marlene Dumas, with essays by Ulrich Loock, Ingrid Schaffner, Anna Tilroe, and Marina Warner.

Van den Bergh, Jos. "Marlene Dumas: Zeno X Gallery." *Artforum* 32 (October 1993), p. 110.

Kunsthalle Wien and Deichtorhallen Hamburg. *Der zerbrochene Spiegel: Positionen zur Malerei* (1993). Exhibition catalogue by Kasper König and Hans-Ulrich Obrist, with essays by Klaus Bachler, Zdenek Felix, Ursula Pasterk, and Toni Stooss.

Stedelijk Van Abbemuseum, Eindhoven, Netherlands. *Marlene Dumas: Miss Interpreted* (1992). Exhibition catalogue, with foreword by Jan Debbaut, introduction by Selma Klein Essink, essay by Marcel Vos, and text by Marlene Dumas.

Documenta IX (Stuttgart: Edition Cantz; New York: Harry N. Abrams, 1992). 3 vols. Exhibition catalogue, with introduction by Jan Hoet and essays by Bart De Baere, Cornelius Castoriadis, Hilde Daem, Claudia Herstatt, Heiner Müller, et al.

Koether, Jutta. "Marlene Dumas: Isabella Kacprzak." *Artforum* 30 (April 1992), pp. 110–111.

De Pont Stichting, Tilburg, Netherlands. *De Opening* (1992). Exhibition catalogue, with essays by Wilma van Asseldonk, Dominic van den Boogerd, and Elly Stegeman.

Stichting De Appel, Amsterdam. *Inscapes* (1991). Exhibition catalogue by Saskia Bos, with text by Marlene Dumas.

New Museum of Contemporary Art, New York. *The Interrupted Life* (1991). Exhibition catalogue by France Morin, with essays by Peter Greenaway, bell hooks, Sanford Kwinter, Sylvère Lotringer, Charles Merewether, et al.

Schaffner, Ingrid. "Snow White in the Wrong Story." *Arts Magazine* 65 (March 1991), pp. 59–63.

Staatsgalerie Moderner Kunst, Munich. *The Origin of the Species* (1990). Exhibition catalogue, with essay by Ulrich Bischoff and text by Marlene Dumas.

Kunsthalle Bern. *Marlene Dumas: The Question of Human Pink* (1989). Exhibition catalogue, with essay by Ulrich Loock and text by Marlene Dumas.

Frankfurter Kunstverein und Schirn Kunsthalle. *Prospect 89: Eine internationale Ausstellung aktueller Kunst* (1989). Exhibition catalogue by Peter Weiermair.

Fruitmarket Gallery, Edinburgh, 1989. *Marlene Dumas* (1989). Exhibition catalogue, with essay by Martijn van Nieuwenhuyzen (published in conjunction with the exhibition *6 Dutch Artists*).

Groot, Paul. "Marlene Dumas: Galerie Paul Andriesse." *Artforum* 27 (March 1989), pp. 149–150.

Museums Ludwig in den Rheinhallen der Kölner Messe. *Bilderstreit: Widerspruch, Einheit und Fragment in der Kunst seit 1960* (Cologne: DuMont Buchverlag, 1989). Exhibition catalogue by Siegfried Gohr and Johannes Gachnang, with essays by Hans Belting, André Berne-Joffroy, Emile Cioran, Michael Compton, Piet de Jonge, et al.

Stichting De Appel, Amsterdam. *Nightfire* (1987). Exhibition catalogue, with introductions by Saskia Bos and Edna van Duyn and text by Marlene Dumas.

Tate Gallery, London. *Art from Europe: Works by Ulay and Marina Abramovic, René Daniëls, Marlene Dumas, Astrid Klein, Pieter Laurens Mol, Andreas Schulze, Rosemarie Trockel* (1987). Exhibition catalogue, with introduction by Catherine Lacey and text by Marlene Dumas.

Stedelijk Van Abbemuseum, Eindhoven, Netherlands. *Christa Dichgans, Lili Dujourie, Marlene Dumas, Lesley Fox Croft, Kees de Goede, Frank van Hemert, Cristina Iglesias, Harald Klingelhöller, Mark Luyten, Juan Muñoz, Katherine Porter, Julião Sarmento, Barbara Schmidt Heins, Gabriele Schmidt-Heins, Didier Vermeiren* (1985). Exhibition catalogue, with foreword by Rudi Fuchs and essays by Michel Assenmaker, Jan Debbaut, Lourdes Iglesias, Piet de Jonge, Ulrich Loock, et al.

Galerie Paul Andriesse, Amsterdam. *The Eyes of the Night Creatures* (1985). Exhibition catalogue, with essay by Paul Andriesse and text by Marlene Dumas.

Netherlands Office for the Fine Arts, International Department, Amsterdam. *A participação neerlandesa na Bienal de São Paulo 1985 / The Dutch Contribution to the 1985 São Paulo Biennale* (1985). Exhibition catalogue by Wim Beeren, Piet de Jonge, and Gijs van Tuyl.

Biennale of Sydney. *The Fifth Biennale of Sydney. Private Symbol: Social Metaphor (1984).* Exhibition catalogue, with introduction by Leon Paroissien, essays by Stuart Morgan, Annelie Pohlen, Carter Ratcliff, and Nelly Richard, and text by Marlene Dumas.

Centraal Museum, Utrecht. *Ons Land Licht Lager Dan De Zee* (1984). Exhibition catalogue, with essays by Marja Bosma and Jan Debbaut.

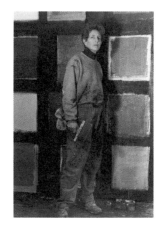

Louise Fishman

b. 1939, Philadelphia, Pennsylvania, USA

lives in New York, New York, USA

Selected One-Person Exhibitions

Robert Miller Gallery, New York, 1995, *Louise Fishman: Small Paintings.*

Robert Miller Gallery, New York, 1993, *Louise Fishman* (catalogue).

Temple Gallery, Tyler School of Art of Temple University, Philadelphia, Pennsylvania, 1992, *Louise Fishman* (catalogue).

Olin Art Gallery, Kenyon College, Gambier, Ohio, 1992, *Louise Fishman: Small Paintings* (brochure).

Lennon, Weinberg Gallery, New York, 1989, *Louise Fishman: Paintings, 1987–1989* (catalogue).

Simon Watson Gallery, New York, 1989, *Remembrance and Renewal: Louise Fishman* (catalogue).

Baskerville + Watson Gallery, New York, 1984, *Louise Fishman.*

Oscarsson Hood Gallery, New York, 1982, *Louise Fishman: Recent Work.*

55 Mercer, New York, 1979, *Louise Fishman: Five Years.*

John Doyle Gallery, Chicago, 1976, *Louise Fishman.*

Nancy Hoffman Gallery, New York, 1974, *Louise Fishman.*

Philadelphia Art Alliance, Pennsylvania, 1964, *Louise Fishman.*

Selected Group Exhibitions

University Art Museum and Pacific Film Archive, University of California, Berkeley, 1995, *In a Different Light* (catalogue).

Sweet Briar College Art Gallery, Virginia, 1994, *Relatively Speaking: Mothers and Daughters in Art* (brochure).

Robert Miller Gallery, New York, 1992, *Paintings by Martha Diamond, Mary Heilmann, Harriet Korman, Louise Fishman, and Bernard Piffaretti.*

Suzanne Lemberg Usdan Gallery, Bennington College, Bennington, Vermont, 1989, *Belief in Paint: Eleven Contemporary Artists.*

Jewish Museum, New York, 1988, *Golem! Danger, Deliverance, and Art* (catalogue).

Whitney Museum of American Art, New York, 1987, *1987 Biennial Exhibition* (catalogue).

Jewish Museum, New York, 1986, *Jewish Themes: Contemporary American Artists II* (catalogue).

Pratt Manhattan Center Gallery, New York, 1986, *Spirit Tracks: Big Abstract Drawing* (catalogue).

Baxter Art Gallery, California Institute of Technology, Pasadena, 1985, *Painting as Landscape: Views of American Modernism, 1920–1984* (catalogue).

Proctor Art Center, Bard College, Annandale-on-Hudson, New York, 1984, *Second Nature: Abstract Drawings and Paintings.*

Hudson River Museum, Yonkers, New York, 1983, *Six Painters* (catalogue).

Hillwood Art Gallery, Long Island University, Greenvale, New York, 1983, *Painting from the Mind's Eye* (catalogue).

Neuberger Museum, State University of New York at Purchase, New York, 1982, *Abstraction.*

Bennington College, Bennington, Vermont, 1982, *Five New York Artists.*

Lowe Gallery, Syracuse University, Ithaca, New York, 1977, *Critic's Choice.*

Marion Koogler McNay Art Institute, San Antonio, Texas, 1976, *American Artist '76: A Celebration* (catalogue).

Whitney Museum of American Art, New York, 1973, *1973 Biennial Exhibition* (catalogue).

Nancy Hoffman Gallery, New York, 1973, *A Woman's Group.*

Selected Bibliography

University Art Museum and Pacific Film Archive, University of California, Berkeley. *In a Different Light* (San Francisco: City Lights Books, 1995). Exhibition catalogue edited by Nayland Blake, Lawrence Rinder, and Amy Scholder, with essays by Dan Cameron, Dennis Cooper and Richard Hawkins, Pam Gregg, Harmony Hammond, et al.

Harris, Bertha. "Louise Fishman: Valles Marineris, 1992." *Artforum* 32 (May 1994), pp. 74–75, 119.

Sweet Briar College Art Gallery, Virginia. *Relatively Speaking: Mothers and Daughters in Art* (1994). Exhibition brochure, with foreword by Judith Swirsky and introduction by Charlotta Kotik.

Robert Miller Gallery, New York. *Louise Fishman* (1993). Exhibition catalogue, with essay by Melissa E. Feldman.

Seiden, Miriam. "Material Imperatives." *Art in America* 81 (September 1993), pp. 94–99.

Olin Art Gallery, Kenyon College, Gambier, Ohio. *Louise Fishman: Small Paintings* (1992). Exhibition brochure, with introduction by Read Baldwin and essay by Simon Watson.

Temple Gallery, Tyler School of Art of Temple University, Philadelphia, Pennsylvania. *Louise Fishman* (1992). Exhibition catalogue, with foreword by Don Desmett, essays by Michael Brenson and Simon Watson, and text by Louise Fishman.

Hagen, Charles. "Louise Fishman: Lennon, Weinberg." *Artforum* 28 (January 1990), p. 135.

Lennon, Weinberg Gallery, New York. *Louise Fishman: Paintings, 1987–1989* (1989). Exhibition catalogue, with foreword by Bernard Lennon and Jill Weinberg.

Simon Watson Gallery, New York. *Remembrance and Renewal: Louise Fishman* (1989). Exhibition catalogue, with essay by Lisa Liebmann.

Jewish Museum, New York. *Golem! Danger, Deliverance, and Art* (1988). Exhibition catalogue, with foreword by Isaac Bashevis Singer and essays by Emily D. Bilski, Moshe Idel, and Elfi Ledig.

Westfall, Stephen. "Louise Fishman at Baskerville + Watson." *Art in America* 75 (January 1987), pp. 131–132.

Whitney Museum of American Art, New York. *1987 Biennial Exhibition* (New York and London: W.W. Norton, 1987). Exhibition catalogue by Richard Armstrong, John G. Hanhardt, Richard Marshall, and Lisa Phillips.

Jewish Museum, New York. *Jewish Themes: Contemporary American Artists II* (1986). Exhibition catalogue, with introduction by Susan Tumarkin Goodman and text by Louise Fishman.

Baxter Art Gallery, California Institute of Technology, Pasadena, and Parrish Art Museum, Southampton, New York. *Painting as Landscape: Views of American Modernism, 1920–1984* (1985). Exhibition catalogue by Klaus Kertess.

Storr, Robert. "Louise Fishman at Baskerville & Watson." *Art in America* 73 (February 1985), pp. 140–141.

Hillwood Art Gallery, Long Island University, Greenvale, New York. *Painting from the Mind's Eye* (1983). Exhibition catalogue, with essay by Judith K. Collischan Van Wagner.

Hudson River Museum, Yonkers, New York. *Six Painters* (1983). Exhibition catalogue, with essay by Peter Langlykke.

Welish, Marjorie. "Louise Fishman at Nancy Hoffman." *Art in America* 68 (February 1980), pp. 131–132.

Feinberg, Jean E. "Louise Fishman: New Paintings." *Arts Magazine* 54 (November 1979), pp. 105–107.

Marion Koogler McNay Art Institute, San Antonio, Texas. *American Artist '76: A Celebration* (1976). Exhibition catalogue, with introduction by Alice C. Simkins and text by Louise Fishman.

Robert Gober

b. 1954, Wallingford, Connecticut, USA

lives in New York, New York, USA

Selected One-Person Exhibitions

Paula Cooper Gallery, New York, 1994, *Robert Gober.*

Serpentine Gallery, London, 1993, *Robert Gober* (catalogue).

Dia Center for the Arts, New York, 1992, *Robert Gober* (catalogue).

Galerie nationale du Jeu de Paume, Paris, 1991, *Robert Gober* (catalogue).

Museum Boymans–van Beuningen, Rotterdam, 1990, *Robert Gober* (catalogue).

Paula Cooper Gallery, New York, 1989, *Robert Gober.*

Galerie Gisela Capitain, Cologne, 1988, *Robert Gober.*

Galerie Max Hetzler, Cologne, 1988, *Robert Gober.*

Art Institute of Chicago, 1988, *Robert Gober* (brochure).

Tyler Gallery, Tyler School of Art of Temple University, Elkins Park, Pennsylvania, 1988, *Robert Gober* (brochure).

Paula Cooper Gallery, New York, 1987, *Robert Gober.*

Galerie Jean Bernier, Athens, 1987, *Robert Gober* (brochure).

Daniel Weinberg Gallery, Los Angeles, 1986, *Robert Gober: Recent Work.*

Paula Cooper Gallery, New York, 1985, *Robert Gober: Recent Sculptures.*

Daniel Weinberg Gallery, Los Angeles, 1985, *Robert Gober: Recent Sculpture.*

Paula Cooper Gallery, New York, 1984, *Robert Gober: Slides of a Changing Painting.*

Selected Group Exhibitions

Museum of Contemporary Art, San Diego, La Jolla, California, 1995, *Sleeper: Katharina Fritsch, Robert Gober, Guillermo Kuitca, Doris Salcedo* (catalogue).

Kunsthaus Zürich, 1995, *Zeichen & Wunder.*

American Center, Paris, 1995, *Micromegas* (catalogue).

University Art Museum and Pacific Film Archive, University of California, Berkeley, 1995, *In a Different Light* (catalogue).

Walker Art Center, Minneapolis, Minnesota, 1994, *Duchamp's Leg* (brochure).

Kunstverein München, 1994, *Oh boy, It's a Girl!: Feminismen in der Kunst* (catalogue).

Museum für Moderne Kunst, Frankfurt, 1994, *Szenenwechsel V / Change of Scene V* (brochure).

Koninklijk Museum voor Schone Kunsten, Antwerp, 1993, *The Sublime Void: On the Memory of the Imagination* (catalogue).

Domaine de Kerguéhennec en Bignan, Locminé, France, 1993, *De la main à la tête: l'objet théorique* (brochure).

Whitney Museum of American Art, 1993, *1993 Biennial Exhibition* (catalogue).

Hochschule für angewandte Kunst, Vienna, 1993, *Live in Your Head / Lebe in deinem Kopf* (catalogue).

MIT-List Visual Arts Center, Cambridge, Massachusetts, 1992, *Corporal Politics* (catalogue).

Kunstmuseum und Kunsthalle Basel, 1992, *Transform: Bild Objekt Skulptur im 20. Jahrhundert* (catalogue).

FAE Musée d'Art Contemporain, Pully / Lausanne, Switzerland, 1992, *Post Human* (catalogue).

Kassel, 1992, *Documenta IX* (catalogue).

Kunstverein Hamburg, 1992, *Gegendarstellung: Ethik und Ästhetik im Zeitalter von Aids* (catalogue).

Hayward Gallery, London, 1992, *Doubletake: Collective Memory and Current Art* (catalogue).

Boymans-van Beuningen Museum, Rotterdam, 1991, *The Physical Self* (catalogue).

Institute of Contemporary Art, University of Pennsylvania, Philadelphia, 1991, *Devil on the Stairs: Looking Back on the Eighties* (catalogue).

Martin-Gropius-Bau, Berlin, 1991, *Metropolis* (catalogue).

Whitney Museum of American Art, New York, 1991, *1991 Biennial Exhibition* (catalogue).

Biennale of Sydney, 1990, *The Readymade Boomerang: Certain Relations in 20th Century Art* (catalogue).

Hirshhorn Museum and Sculpture Garden, Smithsonian Institution, Washington, D.C., 1990, *Culture and Commentary: An Eighties Perspective* (catalogue).

Kunstverein München, 1989, *Gober, Halley, Kessler, Wool: Four Artists from New York* (catalogue).

Wiener Secession, 1989, *Wittgenstein* (catalogue).

John and Mable Ringling Museum of Art, Sarasota, Florida, 1989, *Contemporary Perspectives 1: Abstraction in Question* (catalogue).

Stedelijk Museum, Amsterdam, 1989, *Horn of Plenty: Sixteen Artists from NYC / Hoorn van overloed: Zestien Kunstenaars uit NYC* (catalogue).

Institute of Contemporary Art and Museum of Fine Arts, Boston, 1988, *The BiNATIONAL: American Art of the Late 80s / Amerikanische Kunst der späten 80er Jahre, German Art of the Late 80s / Deutsche Kunst der späten 80er Jahre* (organized with Städtische Kunsthalle, Kunstsammlung Nordrhein-Westfalen and Kunstverein für die Rheinlande und Westfalen, Düsseldorf) (catalogue).

303 Gallery, New York, 1988, *Robert Gober, Christopher Wool* (catalogue).

Institute of Contemporary Art, Boston, 1988, *Utopia Post Utopia: Configuration of Nature and Culture in Recent Sculpture and Photography* (catalogue).

Saatchi Collection, London, 1987, *New York Art Now: The Saatchi Collection* (catalogue).

Fundación Caja de Pensiones, Madrid, 1987, *Art and Its Double: Recent Developments in New York Art / El Arte y su Doble: una perspectiva de Nueva York* (catalogue).

Renaissance Society at the University of Chicago, 1986, *New Sculpture: Robert Gober, Jeff Koons, Haim Steinbach* (catalogue).

Selected Bibliography

University Art Museum and Pacific Film Archive, University of California, Berkeley. *In a Different Light* (San Francisco: City Lights Books, 1995). Exhibition catalogue edited by Nayland Blake, Lawrence Rinder, and Amy Scholder, with essays by Dan Cameron, Dennis Cooper and Richard Hawkins, Pam Gregg, Harmony Hammond, et al.

Kunstverein München. *Oh boy, It's a Girl!: Feminismen in der Kunst* (1994). Exhibition catalogue, with introduction by Hedwig Saxenhuber and Astrid Wege and essays by Marie Luise Agerer, Nicola Bongard, Lukas Duwenhögger, Thomas Eggerer, Valie Export, et al.

Perchuk, Andrew. "Robert Gober: Paula Cooper Gallery." *Artforum* 33 (October 1994), p. 101.

Smith, Roberta. "Robert Gober." *The New York Times*, May 6, 1994, p. C19.

Koninklijk Museum voor Schone Kunsten, Antwerp. *The Sublime Void: On the Memory of the Imagination* (1993). Exhibition catalogue by Bart Cassiman, with essays by Theodor Adorno, Charles Baudelaire, Walter Benjamin, Henri Bergson, Maurice Blanchot, et al.

Dia Center for the Arts, New York. *Robert Gober* (1993). Exhibition catalogue, with introduction by Karen Marta and essay by Dave Hickey.

Domaine de Kerguéhennec en Bignan, Locminé, France. *De la main à la tête: l'objet théorique* (1993). Exhibition brochure, with essay by Denys Zacharopoulos.

Hochschule für angewandte Kunst, Vienna. *Live in Your Head / Lebe in deinem Kopf* (1993). Exhibition catalogue by Robert Nickas.

Martin-Gropius-Bau, Berlin, and Royal Academy of Arts, London. *American Art in the 20th Century: Painting and Sculpture, 1913–1993* (Berlin: Zeitgeist Gesellschaft; Munich: Prestel, 1993). Exhibition catalogue by Christos M. Joachimides and Norman Rosenthal, with essays by Brooks Adams, David Anfam, Richard Armstrong, John Beardsley, Neal Benezra, et al.

Serpentine Gallery, London, and Tate Gallery Liverpool. *Robert Gober* (1993). Exhibition catalogue, with foreword by Lewis Biggs and Julia Peyton-Jones, essay by Lynne Cooke, and interview with Richard Flood.

Whitney Museum of American Art, New York. *1993 Biennial Exhibition* (New York: Harry N. Abrams, 1993). Exhibition catalogue by Thelma Golden, John G. Hanhardt, Lisa Phillips, and Elisabeth Sussman, with essays by Homi K. Bhabha, Coco Fusco, B. Ruby Rich, Avital Ronell, and Jeanette Vuocolo.

Kunstmuseum und Kunsthalle Basel. *Transform: BildObjektSkulptur im 20. Jahrhundert* (1992). Exhibition catalogue, with foreword by Ernst Beyeler, introductions by Gottfried Boehm and Franz Meyer, and essays by Luciano Fabro, Andreas Franzke, Stephan E. Hauser, Julian Heynen, Felix Philipp Ingold, et al.

Criqui, Jean-Pierre. "Robert Gober: Jeu de Paume." *Artforum* 30 (January 1992), pp. 115–116.

FAE Musée d'Art Contemporain, Pully/Lausanne, Switzerland. *Post Human* (1992). Exhibition catalogue by Jeffrey Deitch.

Kunstverein Hamburg. *Gegendarstellung: Ethik und Ästhetik im Zeitalter von Aids* (1992). Exhibition catalogue, with introduction by Stephan Schmidt-Wulffen and Martin Schwander and text by Robert Gober.

Hayward Gallery, London. *Doubletake: Collective Memory and Current Art* (London: South Bank Centre; Zurich: Parkett, 1992). Exhibition catalogue edited by Lynne Cooke, Bice Curiger, and Greg Hilty, with essays by Jacques Attali, J.G. Ballard, Georges Bataille, Pinckney Benedict, Roberto Calasso, et al.

Kimmelman, Michael. "Setting One Visual Trap after Another." *The New York Times*, October 4, 1992, p. H35.

MIT-List Visual Arts Center, Cambridge, Massachusetts. *Corporal Politics* (1992). Exhibition catalogue, with essays by Donald Hall, Thomas Lagueur, and Helaine Posner.

Institute of Contemporary Art, University of Pennsylvania, Philadelphia. *Devil on the Stairs: Looking Back on the Eighties* (1991). Exhibition catalogue by Robert Storr, with foreword by Judith Tannenbaum and essay by Peter Schjeldahl.

Galerie nationale du Jeu de Paume, Paris. *Robert Gober* (1991). Exhibition catalogue by Catherine David, with essay by Joan Simon.

Martin-Gropius-Bau, Berlin. *Metropolis* (New York: Rizzoli, 1991). Exhibition catalogue edited by Christos M. Joachimides and Norman Rosenthal, with essays by Achille Bonito Oliva, Jeffrey Deitch, Wolfgang Max Faust, Vilém Flusser, Boris Groys, et al.

Parkett, no. 27 (March 1991), issue featuring Robert Gober, with essays by Greg Bordowitz, Josef Helfenstein, Nancy Spector, and Harald Szeemann and interview with Teresia Bush and Ned Rifkin.

Whitney Museum of American Art, New York. *1991 Biennial Exhibition* (New York and London: W.W. Norton, 1991). Exhibition catalogue by Richard Armstrong, John G. Hanhardt, Richard Marshall, and Lisa Phillips.

Museum Boymans-van Beuningen, Rotterdam. *Robert Gober* (1990). Exhibition catalogue, with introductions by Ulrich Loock and Karel Schampers and essay by Trevor Fairbrother.

Hirshhorn Museum and Sculpture Garden, Smithsonian Institution, Washington, D.C. *Culture and Commentary: An Eighties Perspective* (1990). Exhibition catalogue by Kathy Halbreich, with essays by Maurice Culot, Vijak Mahdavi, Bernardo Nadal-Ginard, Michael M. Thomas, Sherry Turkle, and Simon Watney.

Johnson, Ken. "Cleaning House." *Art in America* 78 (January 1990), pp. 150–151.

Espace Lyonnais d'Art Contemporain. *Status of Sculpture* (1990). Exhibition catalogue, with essay by Bernard Brunon.

Biennale of Sydney. *The Readymade Boomerang: Certain Relations in 20th Century Art* (1990). Exhibition catalogue by René Block, with essays by Lynne Cooke, Anne Marie Freybourg, Dick Higgins, Bernice Murphy, and Emmett Williams.

Stedelijk Museum, Amsterdam. *Horn of Plenty: Sixteen Artists from NYC / Hoorn van overloed: Zestien Kunstenaars uit NYC* (1989). Exhibition catalogue by Gosse Oosterhof, with essay by Dan Cameron.

Gober, Robert. "Cumulus from America." *Parkett*, no. 19 (March 1989), pp. 69–173.

Deichtorhallen Hamburg. *Einleuchten: Will, Vorstel, and Simul in HH* (1989). Exhibition catalogue by Harald Szeemann, with essays by Heinz Liesbrock, Christoph Schenker, and Stephen Schmidt-Wulffen.

Kunstverein München. *Gober, Halley, Kessler, Wool: Four Artists from New York* (1989). Exhibition catalogue, with introduction by Zdenek Felix, and essays by Kay Heymer, Christoph Schenker, and Noemi Smolik.

John and Mable Ringling Museum of Art, Sarasota, Florida. *Contemporary Perspectives 1: Abstraction in Question* (1989). Exhibition catalogue, with introduction by Joseph Jacobs and essays by Bruce W. Ferguson, Joan Simon, and Roberta Smith.

Smith, Roberta. "The Reinvented Americana of Robert Gober's Mind." *The New York Times*, October 13, 1989, p. C28.

Institute of Contemporary Art, Boston. *Utopia Post Utopia: Configuration of Nature and Culture in Recent Sculpture and Photography* (Cambridge, Mass.: MIT Press, 1988). Exhibition catalogue, with essays by Frederic Jameson, Alice Jardine, David Joselit, Eric Michaud, Abigail Solomon-Godeau, and Elisabeth Sussman.

Saatchi Collection, London. *New York Art Now: The Saatchi Collection* (1988). Exhibition catalogue, with essay by Dan Cameron.

Fundación Caja de Pensiones, Madrid. *Art and Its Double: Recent Developments in New York Art / El Arte y su Doble: una perspectiva de Nueva York* (1987). Exhibition catalogue by Dan Cameron.

Renaissance Society at the University of Chicago. *New Sculpture: Robert Gober, Jeff Koons, Haim Steinbach* (1986). Exhibition catalogue, with introduction by Gary Garrels.

Angela Grauerholz

b. 1952, Hamburg, West Germany
lives in Montreal, Quebec, Canada

Selected One-Person Exhibitions

Musée d'art contemporain de Montréal, 1995, *Angela Grauerholz* (catalogue).

Galerie Franck + Schulte, Berlin, 1994, *Angela Grauerholz: Recent Photographs.*

MIT-List Visual Arts Center, Cambridge, Massachusetts, 1993, *Angela Grauerholz: Recent Photographs* (catalogue).

Domaine de Kerguéhennec en Bignan, Locminé, France, 1993, *Secrets: A Gothic Tale (in progress).*

Galerie nächst St. Stephan, Rosemarie Schwarzwälder, Vienna, 1993, *Angela Grauerholz.*

Galerie Franck + Schulte, Berlin, 1992, *Angela Grauerholz: Die Documenta Arbeiten.*

Galerie Claire Burrus, Paris, 1992, *Angela Grauerholz.*

Presentation House Gallery, Vancouver, 1991, *Timeframe: Angela Grauerholz, Michèle Waquant* (catalogue).

Westfälischer Kunstverein, Münster, Germany, 1991, *Angela Grauerholz: Photographien* (catalogue).

Mercer Union, Toronto, 1990, *Angela Grauerholz* (catalogue).

Art 45, Inc., Montreal, 1989, *Angela Grauerholz.*

Photographers Gallery, Saskatoon, Saskatchewan, Canada, 1988, *Portraits.*

Hall du Pavillon Central, Université de Sherbrooke, Quebec, 1987, *Paysages diagonales / Paysages urbains.*

Art 45, Inc., Montreal, 1987, *Angela Grauerholz: Photographies.*

Art 45, Inc., Montreal, 1985, *Angela Grauerholz.*

Agnes Etherington Art Centre, Queens University, Kingston, Ontario, Canada, 1985, *April / Davey / Grauerholz* (catalogue).

VU, Centre d'animation et de diffusion de la photographie, Quebec, 1984, *Angela Grauerholz.*

Selected Group Exhibitions

Setagaya Art Museum, Tokyo, 1995, *Spirits on the Crossing: Travellers to / from Nowhere. Contemporary Art in Canada, 1980–94* (catalogue).

Mala Galerija, Moderna Galerija Ljubljana, 1994, *Kraji / Places* (catalogue).

Galerie nächst St. Stephan, Rosemarie Schwarzwälder, Vienna, 1994, *Angela Grauerholz, James Welling and Gaylen Gerber.*

FRAC des Pays de la Loire, Gétigné Clisson, France, 1993, *Canada: une nouvelle génération.*

Domaine de Kerguéhennec en Bignan, Locminé, France, 1992, *Une seconde pensée du paysage.*

Kassel, 1992, *Documenta IX* (catalogue).

FRAC de Champagne-Ardenne, Reims, France, 1992, *La Traversée des mirages: photographie du Québec* (catalogue).

Olga Korper Gallery, Toronto, 1991, *Modus Operandi.*

Barbican Art Gallery, London, 1991, *Un-natural Traces: Contemporary Art from Canada* (catalogue).

49e Parallèle, Centre d'art contemporain canadien, New York, 1991, *The Photographic Image: Photo Based Works.*

Biennale of Sydney, 1990, *The Readymade Boomerang: Certain Relations in 20th Century Art* (catalogue).

Galerie du Musée du Québec, 1989, *Territoires d'artistes: paysages verticaux.*

Musée d'art contemporain de Montréal, 1989, *Tenir l'image à distance* (catalogue).

Presentation House Gallery, Vancouver, 1989, *Taking Pictures* (catalogue).

Power Plant, Toronto, 1988, *La ruse historique: L'art à Montréal / The Historical Ruse: Art in Montreal* (catalogue).

Coburg Gallery, Vancouver, 1985, *Lynne Cohen, Angela Grauerholz, Louise Lawler.*

49e Parallèle, Centre d'art contemporain canadien, New York, 1983, *New Image: Contemporary Quebec Photography* (catalogue).

Winnipeg Art Gallery, Manitoba, Canada, 1983, *Latitudes et parallèles / Latitudes and Parallels* (catalogue).

Centre des Arts Saidye Bronfman, Montreal, 1983, *Photographie actuelle au Québec / Quebec Photography: Invitational* (catalogue).

Selected Bibliography

Grande, John. "Angela Grauerholz: Musée d'art contemporain." *Artforum* 33 (April 1995), p. 97.

Musée d'art contemporain de Montréal. *Angela Grauerholz* (1995). Exhibition catalogue by Paulette Gagnon.

Setagaya Art Museum, Tokyo. *Spirits on the Crossing: Travellers to / from Nowhere. Contemporary Art in Canada, 1980–94* (1995). Exhibition catalogue, with essays by Yuko Hasegawa, Shinji Kohmoto, and Diana Nemiroff.

Mala Galerija, Moderna Galerija Ljubljana. *Kraji / Places* (1994). Exhibition catalogue by Lara Štrumej and Igor Zabel.

MIT-List Visual Arts Center, Cambridge, Massachusetts. *Angela Grauerholz: Recent Photographs* (1993). Exhibition catalogue by Helaine Posner.

Unger, Miles. "Angela Grauerholz: M.I.T. List Visual Arts Center." *New Art Examiner* 21 (December 1993), pp. 33–34.

Documenta IX (Stuttgart: Edition Cantz; New York: Harry N. Abrams, 1992). 3 vols. Exhibition catalogue, with introduction by Jan Hoet and essays by Bart De Baere, Cornelius Castoriadis, Hilde Daem, Claudia Herstatt, Heiner Müller, et al.

Art Gallery of Ontario, Toronto. *Urban Inscriptions* (1992). Exhibition catalogue by Michèle Thériault.

Perrin, Frank. "Angela Grauerholz: Claire Burrus." *Flash Art*, no. 167 (November–December 1992), p. 108.

Barbican Art Gallery, London. *Un-natural Traces: Contemporary Art from Canada* (1991). Exhibition catalogue by Carol Brown and Bruce W. Ferguson.

Cheetham, Mark A., and Linda Hutcheon. *Remembering Postmodernism: Trends in Recent Canadian Art* (New York, Oxford, and Toronto: Oxford University Press, 1991).

Pontbriand, Chantal. "Le Regard vertigineux de l'ange: photographies d'Angela Grauerholz." *Parachute*, no. 63 (July–September 1991), pp. 4–11.

Musée du Québec. *Un archipel de désir: les artistes québécois et la scène internationale* (1991). Exhibition catalogue by Louise Dery and Chantal Pontbriand.

Westfälischer Kunstverein, Münster, Germany. *Angela Grauerholz: Photographien* (1991). Exhibition catalogue, with introduction by Friedrich Meschede and essay by Chantal Pontbriand.

Mercer Union, Toronto. *Angela Grauerholz* (1990). Exhibition catalogue by Johanne Lamoureux and Cheryl Simon.

Biennale of Sydney. *The Readymade Boomerang: Certain Relations in 20th Century Art* (1990). Exhibition catalogue by René Block, with essays by Lynne Cooke, Anne Marie Freybourg, Dick Higgins, Bernice Murphy, and Emmett Williams.

Musée d'art contemporain de Montréal. *Ténir l'image à distance* (1989). Exhibition catalogue by Réal Lussier, with foreword by Manon Blanchette and essay by Philippe Dubois.

Presentation House Gallery, Vancouver. *Taking Pictures* (1989). Exhibition catalogue by Keith Wallace.

Seaton, Beth. "Angela Grauerholz: Mundane Re-Membrances. An Interview by Beth Seaton." *Parachute*, no. 56 (October–December 1989), pp. 23–25.

Pontbriand, Chantal. "A Canadian Portfolio: Tunnel of Light." *Canadian Art* 5 (Winter 1988), pp. 66–69.

Power Plant, Toronto. *La ruse historique: L'art à Montréal / The Historical Ruse: Art in Montreal* (1988). Exhibition catalogue by Chantal Pontbriand.

Bérard, Serge. "Angela Grauerholz: Art 45, Montréal." *Parachute*, no. 40 (September–December 1985), pp. 32–33.

Agnes Etherington Art Centre, Queens University, Kingston, Ontario, Canada. *April / Davey / Grauerholz* (1985). Exhibition catalogue by Martha Townsend.

VU, Centre d'animation et de diffusion de la photographie, Quebec. *Fragments: photographie actuelle au Québec* (1985). Exhibition catalogue, with essay by Denis Lessard.

Centre des Arts Saidye Bronfman, Montreal. *Photographie actuelle au Québec / Quebec Photography: Invitational* (1983). Exhibition catalogue, with foreword by Peter Krausz and essays by Jean Tourangeau and Katherine Tweedie.

49e Parallèle, Centre d'art contemporain canadien, New York. *New Image: Contemporary Quebec Photography* (1983). Exhibition catalogue, with essay by Peter Krausz.

Winnipeg Art Gallery, Manitoba, Canada. *Latitudes et parallèles / Latitudes and Parallels* (1983). Exhibition catalogue, with essays by Penny Cousineau, Tom Gore, and Shirley Madill.

Gary Hill

b. 1951, Santa Monica, California, USA
lives in Seattle, Washington, USA

Selected One-Person Exhibitions

Museum für Gegenwartskunst, Öffentliche Kunstsammlung Basel, 1994, *Gary Hill: Imagining the Brain Closer than the Eyes* (catalogue).

Hirshhorn Museum and Sculpture Garden, Smithsonian Institution, Washington, D.C., 1994, *Gary Hill* (organized by Henry Art Gallery, University of Washington, Seattle) (catalogue).

Musée d'Art Contemporain de Lyon, 1994, *Gary Hill*.

Long Beach Museum of Art, California, 1993, *Gary Hill: Sites Recited*.

Museum of Modern Art, Oxford, 1993, *Gary Hill: In Light of the Other* (catalogue).

Donald Young Gallery, Seattle, 1993, *Gary Hill*.

Watari-um Museum of Contemporary Art, Tokyo, 1992, *Gary Hill: I Believe It Is an Image* (catalogue).

Musée national d'art moderne, Centre Georges Pompidou, Paris, 1992, *Gary Hill* (catalogue).

Museum of Modern Art, New York, 1990, *Inasmuch as It Is Always Already Taking Place*.

Video Galleriet, Huset, and Ny Carlsberg Glyptotek, Copenhagen, 1990, *Other Words and Images: Video af Gary Hill* (catalogue).

Musée d'art moderne Villeneuve d'Ascq, France, 1989, *Gary Hill: Disturbance (among the Jars)* (catalogue).

Espace Lyonnais d'Art Contemporain, 1988, *Gary Hill*.

Museum of Contemporary Art, Los Angeles, 1987, *Gary Hill: Crux*.

Kitchen Center for Video and Music, New York, 1979, *Gary Hill: Primarily Speaking, A Video Installation*.

Kitchen Center for Video and Music, New York, 1979, *Gary Hill*.

Selected Group Exhibitions

Museum of Modern Art, New York, 1995, *Video Spaces: Eight Installations* (catalogue).

Venice, 1995, *XLVI Esposizione Internazionale d'Arte: Identità e Alterità* (catalogue).

Zentrum für Medientechnologie, Karlsruhe, 1995, *Mediale*.

Museo Nacional Centro de Arte Reina Sofía, Madrid, 1994, *Cocido y crudo* (catalogue).

Contemporary Arts Center, Cincinnati, Ohio, 1994, *Light into Art* (brochure).

Lannan Foundation, Los Angeles, 1994, *Facts and Figures: Selections from the Lannan Foundation*.

Martin-Gropius-Bau, Berlin, and Royal Academy of Arts, London, 1993, *American Art in the 20th Century: Painting and Sculpture, 1913–1993* (catalogue).

Rooseum Center for Contemporary Art, Malmö, Sweden, 1993, *Passagearbeten / Passageworks* (catalogue).

Whitney Museum of American Art, New York, 1993, *1993 Biennial Exhibition* (catalogue).

Ydessa Hendeles Art Foundation, Toronto, 1993, *Eadweard Muybridge, Bill Viola, Giulio Paolini, Gary Hill, James Coleman*.

Kassel, 1992, *Documenta IX* (catalogue).

Hayward Gallery, London, 1992, *Doubletake: Collective Memory and Current Art* (catalogue).

Renaissance Society at the University of Chicago, 1991, *The Body (2)*.

Institute of Contemporary Art, Boston, 1991, *Currents*.

Musée national d'art moderne, Centre Georges Pompidou, Paris, 1990, *Passages de l'Image* (catalogue).

Kölnischer Kunstverein, 1989, *Video-Skulptur retrospektiv und aktuell, 1963–1989* (catalogue).

Los Angeles Contemporary Exhibitions, 1986, *Resolution: A Critique of Video Art* (catalogue).

Walter Phillips Gallery, Banff Centre School of Fine Arts, Alberta, Canada, 1983, *The Second Link: Viewpoints on Video in the Eighties* (catalogue).

Selected Bibliography

Kandel, Susan. "Gary Hill: Museum of Contemporary Art." *Artforum* 33 (April 1995), pp. 86–87.

Museum of Modern Art, New York. *Video Spaces: Eight Installations* (1995). Exhibition catalogue, with introduction by Samuel Delany and essay by Barbara London.

Museo Nacional Centro de Arte Reina Sofía, Madrid. *Cocido y crudo* (1995). Exhibition catalogue by Dan Cameron, with essays by Jean Fisher, Gerardo Mosquera, Jerry Saltz, and Mar Villaespesa.

Henry Art Gallery, University of Washington, Seattle. *Gary Hill* (1994). Exhibition catalogue, with essays by Chris Bruce, Lynne Cooke, Bruce W. Ferguson, John G. Hanhardt, and Robert Mittenthal.

Stedelijk Museum, Amsterdam. *Gary Hill* (1993). Exhibition catalogue, with introduction by Dorine Mignot, essays by Lynne Cooke, George Quasha, and Willem van Weelden, and text by Gary Hill.

Cornwell, Regina. "Gary Hill: Interview." *Art Monthly*, no. 170 (October 1993), pp. 3–11.

Centre del Carme, IVAM, Valencia. *Gary Hill* (1993). Exhibition catalogue, with essays by Christine van Assche, Lynne Cooke, Jacinto Lageira, and Hippolyte Massardier, and text by Gary Hill.

Museum of Modern Art, Oxford, and Tate Gallery Liverpool. *Gary Hill: In Light of the Other* (1993). Exhibition catalogue, with introduction by Chrissie Iles and essays by Corinne Diserens, Bruce W. Ferguson, Robert Mittenthal, Stuart Morgan, and Lars Nittve.

Rooseum Center for Contemporary Art, Malmö, Sweden. *Passagearbeten / Passageworks* (1993). Exhibition catalogue by Lars Nittve, with essays by Lynne Cooke, Brian Hatton, Johannes Meinhardt, Stuart Morgan, Chantal Pontriand, and Stephen Sarrazin.

Sarrazin, Stephen. "Gary Hill: Mean What You Move." *Flash Art*, no. 173 (November–December 1993), pp. 86–87.

Vogel, Sabine B. "Gary Hill: Stedelijk Van Abbemuseum." *Artforum* 32 (November 1993), pp. 120–121.

Whitney Museum of American Art, New York. *1993 Biennial Exhibition* (New York: Harry N. Abrams, 1993). Exhibition catalogue by Thelma Golden, John G. Hanhardt, Lisa Phillips, and Elisabeth Sussman, with essays by Homi K. Bhabha, Coco Fusco, B. Ruby Rich, Avital Ronell, and Jeanette Vuocolo.

Cooke, Lynne. "Who Am I But a Figure of Speech?" *Parkett*, no. 34 (December 1992), pp. 16–27.

Hayward Gallery, London. *Doubletake: Collective Memory and Current Art* (London: South Bank Centre; Zurich: Parkett, 1992). Exhibition catalogue edited by Lynne Cooke, Bice Curiger, and Greg Hilty, with essays by Jacques Attali, J.G. Ballard, Georges Bataille, Pinckney Benedict, Roberto Calasso, et al.

Centre Cultural de la Fundació Caixa de Pensions, Barcelona. *Passages de l'Image* (1991). Exhibition catalogue, with introduction by Raymond Bellour, Catherine David, and Christine van Assche and essays by Jacques Aumont, Alain Bergala, Pascal Bonitzer, Christine Buci-Glucksmann, Jean-François Chevrier, et al. (catalogue accompanying the 1990 exhibition organized by Musée national d'art moderne, Centre Georges Pompidou).

Hill, Gary. "Site Re:cite." *Camera Obscura* 24 (1991), pp. 125–138.

Martin-Gropius-Bau, Berlin. *Metropolis* (New York: Rizzoli, 1991). Exhibition catalogue edited by Christos M. Joachimides and Norman Rosenthal, with essays by Achille Bonito Oliva, Jeffrey Deitch, Wolfgang Max Faust, Vilém Flusser, Boris Groys, et al.

Stedelijk Museum, Amsterdam. *Energieën* (1990). Exhibition catalogue by Wim Beeren, with text by Gary Hill.

Galerie des Archives, Paris. *Gary Hill: And Sat down beside Her* (1990). Exhibition catalogue, with essay by Robert Mittenthal.

Video Galleriet, Huset, and Ny Carlsberg Glyptotek, Copenhagen. *Other Words and Images: Video af Gary Hill* (1990). Exhibition catalogue, with essays by Raymond Bellour, Poul Borum, and Agnete Dorph Christoffersen, and text by Gary Hill.

Kölnischer Kunstverein. *Video-Skulptur retrospektiv und aktuell, 1963–1989* (Cologne: DuMont Buchverlag, 1989). Exhibition catalogue edited by Edith Decker and Wulf Herzogenrath, with essays by Vittorio Fagone, John G. Hanhardt, and Friedemann Malsch.

Musée d'art moderne Villeneuve d'Ascq, France. *Gary Hill: Disturbance (among the Jars)* (1989). Exhibition catalogue, with essay by Jean-Paul Fargier and text by George Quasha.

Whitney Museum of American Art, New York. *Eye for I: Video Self-Portraits* (1989). Exhibition catalogue, with foreword by John Hanhardt and essay by Raymond Bellour.

Los Angeles Contemporary Exhibitions. *Resolution: A Critique of Video Art* (1986). Exhibition catalogue, with essays by Jean Baudrillard, Dara Birnbaum, Lyn Blumenthal, Chris Dercon, Douglas Hall, et al.

Long Beach Museum of Art, California. *Video: A Retrospective. Long Beach Museum of Art, 1974–1984* (1984). Exhibition catalogue, with essays by Kathy Rae Huffman, Kira Perov, David Ross, and Bill Viola.

Furlong, Lucinda. "A Manner of Speaking: An Interview with Gary Hill." *Afterimage* 10 (March 1983), pp. 9–16.

Craigie Horsfield

b. 1949, Cambridge, England

lives in London, England

Selected One-Person Exhibitions

Frith Street Gallery, London, 1995, *Craigie Horsfield*.

Carnegie Museum of Art, Pittsburgh, Pennsylvania, 1994, *Craigie Horsfield* (brochure).

Galerie Micheline Szwajcer, Antwerp, 1994, *Craigie Horsfield*.

Walker Art Center, Minneapolis, Minnesota, 1993, *Craigie Horsfield*.

Galería Cómicos, Lisbon, 1993, *Craigie Horsfield*.

Barbara Gladstone Gallery, New York, 1993, *Craigie Horsfield*.

Irish Museum of Modern Art, Dublin, 1993, *Craigie Horsfield*.

Frith Street Gallery, London, 1992, *Craigie Horsfield: Photographs*.

Kunsthalle Zürich, 1992, *Craigie Horsfield*.

Musée d'Art Moderne de Saint-Etienne, France, 1992, *Craigie Horsfield*.

Stedelijk Museum, Amsterdam, 1992, *Craigie Horsfield*.

Institute of Contemporary Arts, London, 1991, *Craigie Horsfield* (catalogue).

Barbara Gladstone Gallery, New York, 1991, *Craigie Horsfield*.

Ydessa Hendeles Art Foundation, Toronto, 1990, *Craigie Horsfield*.

Johnen & Schöttle, Cologne, 1990, *Craigie Horsfield*.

Galerie Giovanna Minelli, Paris, 1990, *Craigie Horsfield*.

Frith Street Gallery, London, 1990, *Craigie Horsfield*.

Showroom, London, 1989, *Craigie Horsfield*.

Cambridge Darkroom, England, 1988, *Craigie Horsfield* (catalogue).

Selected Group Exhibitions

Witte de With, Rotterdam, 1995, *Call It Sleep*.

Hayward Gallery, London, 1994, *The Epic and the Everyday* (catalogue).

Museum van Hedendaagse Kunst, Ghent, 1994, *Beeld / Beeld*.

Musée d'Art Moderne de la Ville de Paris (ARC), 1991, *Lieux communs, figures singulières* (catalogue).

Museum of Contemporary Art, Los Angeles, 1991, *A Dialogue about Recent American and European Photography* (catalogue).

Witte de With, Rotterdam, 1990, *De afstand (distance)* (catalogue).

Grafische Sammlung, Staatsgalerie Stuttgart, 1989, *Photo-Kunst: Arbeiten aus 150 Jahren / du XXème au XIXème siècle, aller et retour* (catalogue).

Centre national des arts plastiques, Paris, 1989, *Un'altra obiettività / Another Objectivity* (catalogue).

Institute of Contemporary Arts, London, 1988, *Another Objectivity* (catalogue).

Musée des Beaux-Arts, Nantes, 1988, *Matter of Facts: Photographie Art Contemporain en Grande-Bretagne* (catalogue).

Selected Bibliography

Archer, Michael. "Craigie Horsfield: Frith Street Gallery." *Artforum* 33 (May 1995), p. 109.

Carnegie Museum of Art, Pittsburgh, Pennsylvania. *Craigie Horsfield* (1994). Exhibition brochure by Richard Armstrong.

Hayward Gallery, London. *The Epic and the Everyday* (London: South Bank Centre, 1994). Exhibition catalogue by James Lingwood.

Horsfield, Craigie. "April 4, 1994: A Project for Artforum by Craigie Horsfield." *Artforum* 32 (May 1994), pp. 76–83, 119.

_____. "21.10.1994." *De Witte Raaf*, no. 52 (November 1994), pp. 4–5.

_____. "30.08.92 (on Walker Evans)." *The Lectures* (Rotterdam: Witte de With, 1992), pp. 45–57.

_____. "I shall speak of empirical cosmology …" *The Lectures* (Rotterdam: Witte de With, 1992), pp. 81–98.

Institute of Contemporary Arts, London. *Craigie Horsfield* (1991). Exhibition catalogue, with interview by Jean François Chevrier and James Lingwood.

Museum of Contemporary Art, Los Angeles. *A Dialogue about Recent American and European Photography* (1991). Exhibition catalogue by Jean-François Chevrier and Ann Goldstein.

Musée d'Art Moderne de la Ville de Paris (ARC). *Lieux communs, figures singulières* (1991). Exhibition catalogue by Jean-François Chevrier, with foreword by Suzanne Pagé and text by Craigie Horsfield.

Horsfield, Craigie. "Here in Germany Today." In *Symposium die Photographie in der Zeitgenössischen Kunst: Eine Veranstaltung der Akademie Schloss Solitude* (Stuttgart: Edition Cantz, 1990), pp. 195–218.

Witte de With, Rotterdam. *De afstand (distance)* (Rotterdam: Uitgeverij 010, 1990). Exhibition catalogue, with foreword by Chris Dercon and essay by Jean-François Chevrier.

Centre national des arts plastiques, Paris, and Centro per l'arte contemporanea Luigi Pecci, Prato, Italy. *Un'altra obiettività / Another Objectivity* (Milan: Idea Books, 1989). Exhibition catalogue by Jean-François Chevrier and James Lingwood, with text by Craigie Horsfield.

Grafische Sammlung, Staatsgalerie Stuttgart. *Photo-Kunst: Arbeiten aus 150 Jahren / du XXème au XIXème siècle, aller et retour* (Stuttgart: Edition Cantz, 1989). Exhibition catalogue by Jean-François Chevrier, with essays by Ursula Zeller.

Cambridge Darkroom, England. *Craigie Horsfield* (1988). Exhibition catalogue, with introduction by Mark Lumley, essay by John Goto, and text by Craigie Horsfield.

Institute of Contemporary Arts, London. *Another Objectivity* (1988). Exhibition catalogue by Jean-François Chevrier and James Lingwood.

Musée des Beaux-Arts, Nantes, Musée d'Art Moderne de Saint-Etienne, and Metz pour la Photographie, Cave Sainte-Croix, France. *Matter of Facts: Photographie Art Contemporain en Grande-Bretagne* (1988). Exhibition catalogue by Jean-François Chevrier and James Lingwood.

Cristina Iglesias

b. 1956, San Sebastián, Spain

lives in Madrid, Spain

Selected One-Person Exhibitions

Galerie Konrad Fischer, Düsseldorf, 1994, *Cristina Iglesias*.

Stedelijk Van Abbemuseum, Eindhoven, Netherlands, 1994, *Cristina Iglesias: Una Habitación* (catalogue).

Galerie Ghislaine Hussenot, Paris, 1993, *Cristina Iglesias*.

Mala Galerija, Moderna Galerija Ljubljana, 1993, *Cristina Iglesias* (catalogue).

Art Gallery of York University, Toronto, 1992, *Cristina Iglesias* (catalogue).

Kunsthalle Bern, 1991, *Cristina Iglesias* (catalogue).

Galerie Jean Bernier, Athens, 1991, *Cristina Iglesias*.

Galería Cómicos-Luisserpa, Lisbon, 1990, *Cristina Iglesias*.

Stichting De Appel, Amsterdam, 1990, *Cristina Iglesias* (catalogue).

Galería Marga Paz, Madrid, 1990, *Cristina Iglesias*.

Galerie Ghislaine Hussenot, Paris, 1989, *Cristina Iglesias*.

Galerij Joost Declercq, Ghent, Belgium, 1988, *Cristina Iglesias*.

Kunstverein für die Rheinlande und Westfalen, Düsseldorf, 1988, *Cristina Iglesias* (catalogue).

Galerie Jean Bernier, Athens, 1988, *Cristina Iglesias*.

Galería Marga Paz, Madrid, 1987, *Cristina Iglesias*.

Capc Musée d'art contemporain de Bordeaux, 1987, *Cristina Iglesias: Sculptures de 1984 à 1987* (catalogue).

Galerie Peter Pakesch, Vienna, 1987, *Cristina Iglesias*.

Galería Juana de Aizpuru, Madrid, 1985, *Cristina Iglesias*.

Casa de Bocage, Setúbal, Portugal, 1984, *Cristina Iglesias: Arqueologías* (catalogue).

Selected Group Exhibitions

Moskenes, Norway, 1994, *Artscape Norway*.

Koninklijk Museum voor Schone Kunsten, Antwerp, 1993, *The Sublime Void: On the Memory of the Imagination* (catalogue).

Venice, 1993, *XLV Esposizione Internazionale d'Arte: Punti cardinali dell'arte* (catalogue).

Donald Young Gallery, Seattle, 1992.

Salas del Arenal, Seville, 1992, *The Last Days* (catalogue).

Selected Bibliography

Stedelijk Van Abbemuseum, Eindhoven, Netherlands. *Cristina Iglesias: Una Habitación* (1995). Exhibition catalogue, with essay by Bartomeu Marí.

Mala Galerija, Moderna Galerija Ljubljana. *Cristina Iglesias* (1994). Exhibition catalogue, with essay by Zdenka Badovinac.

Koninklijk Museum voor Schone Kunsten, Antwerp. *The Sublime Void: On the Memory of the Imagination* (1993). Exhibition catalogue by Bart Cassiman, with essays by Theodor Adorno, Charles Baudelaire, Walter Benjamin, Henri Bergson, Maurice Blanchot, et al.

Ministerio de Asuntos Exteriores de España. *Cristina Iglesias* (Barcelona: Àmbit Servicios Editoriales, S.A., 1993). Exhibition catalogue, with essays by Aurora García and José Ángel Valente.

Salas del Arenal, Seville. *The Last Days* (1992). Exhibition catalogue, with introduction by José-Luis Brea and essays by Juan Vicente Aliaga, Massimo Cacciari, Dan Cameron, Manel Clot, and Francisco Jarauta.

Calvo Serraller, Francisco. *Escultura española actual: una generación para un fin de siglo* (Madrid: Ed. Fundación Lugar, 1992).

Centre Julio Gonzalez, IVAM, Valencia. *La Colección del IVAM: Adquisiciones, 1985–1992* (1992). Exhibition catalogue, with introduction by Carmen Alborch, Tomàs Llorens, Vicente Todolí, and J.F. Yvars.

Art Gallery of York University, Toronto. *Cristina Iglesias* (1992). Exhibition catalogue, with introduction by Loretta Yarlow and text by Pepe Espaliú.

Kunsthalle Bern. *Cristina Iglesias* (1991). Exhibition catalogue, with essays by Ulrich Loock and José Ángel Valente.

Centre del Carme, IVAM, Valencia. *Espacio mental* (1991). Exhibition catalogue by Bart Cassiman.

Martin-Gropius-Bau, Berlin. *Metropolis* (New York: Rizzoli, 1991). Exhibition catalogue edited by Christos M. Joachimides and Norman Rosenthal, with essays by Achille Bonito Oliva, Jeffrey Deitch, Wolfgang Max Faust, Vilém Flusser, Boris Groys, et al.

Centre Julio Gonzalez, IVAM, Valencia, 1992, *La Colección del IVAM: Adquisiciones, 1985–1992* (catalogue).

Centre del Carme, IVAM, Valencia, 1991, *Espacio mental* (catalogue).

Martin-Gropius-Bau, Berlin, 1991, *Metropolis* (catalogue).

Biennale of Sydney, 1990, *The Readymade Boomerang: Certain Relations in 20th Century Art* (catalogue).

Galerie Max Hetzler, Cologne, 1989, *Förg, Iglesias, Spalletti, Vercruysse, West, Wool* (catalogue).

Donald Young Gallery, Chicago, 1988, *Three Spanish Artists: Cristina Iglesias, Pello Irazu, Fernando Sinaga.*

Royal Hospital Kilmainham, Dublin, 1988, *ROSC '88 Exhibition of Contemporary Art* (catalogue).

Stichting De Appel, Amsterdam, 1987, *Nightfire* (catalogue).

Musée d'Art Moderne de la Ville de Paris (ARC), 1987, *Espagne '87: Dynamiques et Interrogations* (catalogue).

Venice, 1986, *XLII Esposizione Internazionale d'Arte: La Biennale di Venezia* (catalogue).

Fundación Caja de Pensiones, Madrid, 1986, *1981–1986: Pintores y escultores españoles* (catalogue).

Stedelijk Van Abbemuseum, Eindhoven, Netherlands, 1985, *Christa Dichgans, Lili Dujourie, Marlene Dumas, Lesley Fox Croft, Kees de Goede, Frank van Hemert, Cristina Iglesias, Harald Klingelhöller, Mark Luyten, Juan Muñoz, Katherine Porter, Julião Sarmento, Barbara Schmidt Heins, Gabriele Schmidt-Heins, Didier Vermeiren* (catalogue).

Melo, Alexandre. "Cristina Iglesias: Galeria Comicos." *Artforum* 29 (May 1991), p. 157.

Stichting De Appel, Amsterdam. *Cristina Iglesias* (1990). Exhibition catalogue by Bart Cassiman.

Centro Atlántico de Arte Moderno (CAAM), Las Palmas, Spain. *Towards Landscape / Hacia El Paisaje* (1990). Exhibition catalogue, with introduction by Aurora García and essay by Denys Zacharopoulos.

Biennale of Sydney. *The Readymade Boomerang: Certain Relations in 20th Century Art* (1990). Exhibition catalogue by René Block, with essays by Lynne Cooke, Anne Marie Freybourg, Dick Higgins, Bernice Murphy, and Emmett Williams, and text by Cristina Iglesias.

García, Aurora. "Cristina Iglesias: Galeria Marga Paz." *Artforum* 26 (February 1988), pp. 155–156.

Royal Hospital Kilmainham, Dublin. *ROSC '88 Exhibition of Contemporary Art* (1988). Exhibition catalogue, with foreword by Patrick J. Murphy, introduction by Rosemarie Mulcahy, and essay by Fred Gaysek.

Melo, Alexandre. "Cristina Iglesias: A Free Exercise of Intelligence." *Flash Art*, no. 138 (January–February 1988), pp. 91–92.

Kunstverein für die Rheinlande und Westfalen, Düsseldorf. *Cristina Iglesias* (1988). Exhibition catalogue, with essays by Aurora García and Jiri Svestka and text by Cristina Iglesias.

Stichting De Appel, Amsterdam. *Nightfire* (1987). Exhibition catalogue, with introductions by Saskia Bos and Edna van Duyn.

Capc Musée d'art contemporain de Bordeaux. *Cristina Iglesias: Sculptures de 1984 à 1987* (1987). Exhibition catalogue, with foreword by Jean-Louis Froment and essay by Alexandre Melo.

Donald Judd

b. 1928, Excelsior Springs, Missouri, USA

d. 1994, New York, New York, USA

Selected One-Person Exhibitions

Paula Cooper Gallery, New York, 1995, *Donald Judd*.

PaceWildenstein, New York, 1994, *Donald Judd: Sculpture* (catalogue).

Galerie Gmurzynska, Cologne, 1994, *Donald Judd: The Moscow Installation* (catalogue).

Museum Wiesbaden, 1993, *Kunst + Design: Donald Judd, Preisträger der Stankowski-Stiftung 1993 / Art + Design: Donald Judd, Recipient of the Stankowski Prize 1993* (catalogue).

Museum Boymans–van Beuningen, Rotterdam, 1993, *Donald Judd Furniture: Retrospective* (catalogue).

Österreichisches Museum für angewandte Kunst, Vienna, 1991, *Donald Judd: Architektur* (catalogue).

Whitney Museum of American Art, New York, 1988, *Donald Judd* (catalogue).

Stedelijk Van Abbemuseum, Eindhoven, Netherlands, 1987, *Donald Judd* (catalogue).

Moderne Galerie Bottrop, West Germany, 1977, *Donald Judd: Skulpturen und Zeichnungen* (catalogue).

Kunstmuseum Basel, 1976, *Donald Judd: Zeichnungen / Drawings, 1956–1976* (catalogue).

National Gallery of Canada, Ottawa, 1975, *Donald Judd* (catalogue).

Pasadena Art Museum, California, 1971, *Don Judd* (catalogue).

Stedelijk Van Abbemuseum, Eindhoven, Netherlands, 1970, *Don Judd* (catalogue).

Whitney Museum of American Art, New York, 1968, *Don Judd* (catalogue).

Leo Castelli Gallery, New York, 1966, *Don Judd*.

Green Gallery, New York, 1963, *Don Judd*.

Selected Group Exhibitions

Martin-Gropius-Bau, Berlin, and Royal Academy of Arts, London, 1993, *American Art in the 20th Century: Painting and Sculpture, 1913–1993* (catalogue).

Kunstmuseum und Kunsthalle Basel, 1992, *Transform: BildObjektSkulptur im 20. Jahrhundert* (catalogue).

Museums Ludwig in den Rheinhallen der Kölner Messe, 1989, *Bilderstreit: Widerspruch, Einheit und Fragment in der Kunst seit 1960* (catalogue).

Westfälischen Landesmuseums für Kunst und Kulturgeschichte in der Stadt Münster, West Germany, 1987, *Skulptur Projekte in Münster, 1987* (catalogue).

Musée national d'art moderne, Centre Georges Pompidou, Paris, 1987, *L'époque, la mode, la morale, la passion: Aspects de l'art d'aujourd'hui, 1977–1987* (catalogue).

Museum Ludwig, Cologne, 1986, *Europa / Amerika: Die Geschichte einer künstlerischen Faszination seit 1940* (catalogue).

Kassel, 1982, *documenta 7* (catalogue).

Venice, 1976, *XXXVII Biennale di Venezia* (catalogue).

Park Sonsbeek, Arnhem, Netherlands, 1971, *Sonsbeek 71* (catalogue).

Museum of Modern Art, New York, 1968, *The Art of the Real: An Aspect of American Painting and Sculpture, 1948–1968* (catalogue).

Kassel, 1968, *4. documenta* (catalogue).

Los Angeles County Museum of Art, 1967, *American Sculpture of the Sixties* (catalogue).

Jewish Museum, New York, 1966, *Primary Structures: Younger American and British Sculptors* (catalogue).

Saõ Paulo, 1965, *VIII Bienal de Saõ Paulo* (catalogue).

Selected Bibliography

Myers, Terry R. "Donald Judd. Pace." *Flash Art*, no. 171 (Summer 1993), p. 114.

Pace Gallery, New York. *Donald Judd: Large-Scale Works* (1993). Exhibition catalogue, with essay by Rudi Fuchs and text by Donald Judd.

Gambrell, Jamey. "Five from Spain." *Art in America* 79 (September 1987), pp. 160–171.

Musée d'Art Moderne de la Ville de Paris (ARC). *Espagne '87: Dynamiques et Interrogations* (1987). Exhibition catalogue, with essays by Jean Jacques Aillagon, Guadalupe Echeverria, Carmen Giménez, Jean Musy, Suzanne Pagé, and Miguel Satrustegui.

Galería Cómicos-Luisserpa, Lisbon. *Cristina Iglesias* (1986). Exhibition catalogue, with text by Cristina Iglesias.

Biennale di Venezia. *XLII Esposizione Internazionale d'Arte La Biennale di Venezia: Arte e Scienza* (Milan: Electa, 1986). Exhibition catalogue, with introduction by Maurizio Calvesi and essays by Roy Ascott, Margherita Asso, Umberto Baldini, Luigina Bortolatto, Dario Del Bufalo, et al.

Stedelijk Van Abbemuseum, Eindhoven, Netherlands. *Christa Dichgans, Lili Dujourie, Marlene Dumas, Lesley Fox Croft, Kees de Goede, Frank van Hemert, Cristina Iglesias, Harald Klingelhöller, Mark Luyten, Juan Muñoz, Katherine Porter, Julião Sarmento, Barbara Schmidt Heins, Gabriele Schmidt-Heins, Didier Vermeiren* (1985). Exhibition catalogue, with foreword by Rudi Fuchs and essays by Michel Assenmaker, Jan Debbaut, Lourdes Iglesias, Piet de Jonge, Ulrich Loock, et al.

Fundación Caja de Pensiones, Madrid. *1981–1986: Pintores y escultores españoles* (1985). Exhibition catalogue, with essay by Kevin Power.

Casa de Bocage, Setúbal, Portugal. *Cristina Iglesias: Arqueologías* (1984). Exhibition catalogue, with essay by Antonio Cerveira Pinto.

Schellmann, Jörg, and Mariette Josephus Jitta, eds. *Donald Judd: Prints and Works in Editions* (Cologne and New York: Edition Schellmann, 1993). Catalogue raisonné, with essays by Rudi Fuchs and Mariette Josephus Jitta (published in conjunction with exhibition at the Haags Gemeentemuseum, The Hague).

Museum Wiesbaden. *Kunst + Design: Donald Judd, Preisträger der Stankowski-Stiftung 1993 / Art + Design: Donald Judd, Recipient of the Stankowski Prize 1993* (Stuttgart: Cantz Verlag, 1993). Exhibition catalogue by Renate Petzinger and Volker Rattemeyer, with essays by Rudi Fuchs and Franz Meyer and text by Donald Judd.

Kunstmuseum und Kunsthalle Basel. *Transform: BildObjektSkulptur im 20. Jahrhundert* (1992). Exhibition catalogue, with foreword by Ernst Beyeler, introductions by Gottfried Boehm and Franz Meyer, and essays by Luciano Fabro, Andreas Franzke, Stephan E. Hauser, Julian Heynen, Felix Philipp Ingold, et al.

Pace Gallery, New York. *Donald Judd: New Sculpture* (1991). Exhibition catalogue, with essay by Yve-Alain Bois.

Russell, John. "Majesty Made out of Plywood, Aluminum and Plexiglass." *The New York Times*, September 29, 1991, p. C22.

Pagel, David. "Donald Judd." *Arts Magazine* 64 (March 1990), p. 100.

Staatliche Kunsthalle Baden-Baden. *Donald Judd* (Stuttgart: Edition Cantz, 1989). Exhibition catalogue, with introduction by Jochen Poetter, essay by Franz Meyer, and interview by Jochen Poetter and Rosemarie E. Pahlke.

Museums Ludwig in den Rheinhallen der Kölner Messe. *Bilderstreit: Widerspruch, Einheit und Fragment in der Kunst seit 1960* (Cologne: DuMont Buchverlag, 1989). Exhibition catalogue by Johannes Gachnang and Siegfried Gohr, with essays by Hans Belting, André Berne-Joffroy, Emile Cioran, Michael Compton, Piet de Jonge, et al.

Westfälischer Kunstverein Münster, West Germany. *Donald Judd: Architektur* (1989). Exhibition catalogue edited by Marianne Stockebrand, with text by Donald Judd.

Whitney Museum of American Art, New York. *Donald Judd* (New York and London: W.W. Norton, 1988). Exhibition catalogue by Barbara Haskell.

Judd, Donald. *Donald Judd: Complete Writings, 1975–1986* (Eindhoven: Stedelijk Van Abbemuseum, 1987).

Musée national d'art moderne, Centre Georges Pompidou, Paris. *L'époque, la mode, la morale, la passion: Aspects de l'art d'aujourd'hui, 1977–1987* (1987). Exhibition catalogue by Bernard Blistène, Catherine David, and Alfred Pacquement, with essays by Jean-François Chevrier, Serge Daney, Philippe Dubois, Thierry de Duve, Johannes Gachnang, et al.

Westfälischen Landesmuseums für Kunst und Kulturgeschichte in der Stadt Münster, West Germany. *Skulptur Projekte in Münster, 1987* (Cologne: DuMont Buchverlag, 1987). Exhibition catalogue edited by Klaus Bußmann and Kasper König, with essays by Marianne Brouwer, Benjamin H.D. Buchloh, Antje von Graevenitz, Thomas Kellein, Hannelore Kersting, et al.

Solomon R. Guggenheim Museum, New York. *Transformations in Sculpture: Four Decades of American and European Art* (1985). Exhibition catalogue by Diane Waldman.

Kunstmuseum Basel. *Donald Judd: Zeichnungen / Drawings, 1956–1976* (1976). Exhibition catalogue, with introduction by Dieter Koepplin.

Judd, Donald. *Donald Judd: Complete Writings, 1959–1975* (Halifax: Press of Nova Scotia College of Art and Design; New York: New York University Press, 1975).

National Gallery of Canada, Ottawa. *Donald Judd* (1975). Exhibition catalogue by Brydon Smith, with essay by Roberta Smith and text by Dan Flavin; catalogue raisonné of paintings, objects, and woodblocks 1960–1974, compiled by Dudley Del Balso, Brydon Smith, and Roberta Smith.

Pasadena Art Museum, California. *Don Judd* (1971). Exhibition catalogue, with essay and interview by John Coplans.

Whitney Museum of American Art, New York. *Don Judd* (1968). Exhibition catalogue by William C. Agee.

Los Angeles County Museum of Art. *American Sculpture of the Sixties* (1967). Exhibition catalogue edited by Maurice Tuchman, with essays by Lawrence Alloway, Wayne V. Andersen, Dore Ashton, John Coplans, Clement Greenberg, et al.

Jewish Museum, New York. *Primary Structures: Younger American and British Sculptors* (1966). Exhibition catalogue by Kynaston McShine.

Per Kirkeby

b. 1938, Copenhagen, Denmark

lives in Copenhagen and Læsø, Denmark, and Arnasco, Savona, Italy

Selected One-Person Exhibitions

Musée des Beaux-Arts, Nantes, 1995, *Per Kirkeby* (catalogue).

Michael Werner Gallery, New York, 1995, *Per Kirkeby: Early Works* (catalogue).

Recklinghausen Kunsthalle, Germany, 1994, *Per Kirkeby* (catalogue).

Kestner-Gesellschaft, Hannover, 1991, *Per Kirkeby: Bilder* (catalogue).

MIT-List Visual Arts Center, Cambridge, Massachusetts, 1991, *Per Kirkeby: Paintings and Drawings* (catalogue).

Moderna Museet, Stockholm, 1990, *Per Kirkeby: Måleri / Paintings, Skulptur / Sculptures, Teckningar / Drawings, Böcker / Books, Film / Films, 1964–1990* (catalogue).

Galerie Lelong, Zurich, 1990, *Per Kirkeby* (catalogue).

Neue Galerie am Landesmuseum Joanneum, Graz, Austria, 1990, *Per Kirkeby* (catalogue).

Städtische Galerie im Städelsches Kunstinstitut, Frankfurt, 1990, *Per Kirkeby: Gemälde, Arbeiten auf Papier, Skulpturen, 1977–1990* (catalogue).

Centre del Carme, IVAM, Valencia, 1989, *Per Kirkeby: Pinturas, esculturas, grabados y escritos* (catalogue).

Galerie Kaj Forsblom, Helsinki, 1989, *Per Kirkeby*.

Galleri Malmgran, Göteborg, Sweden, 1989, *Per Kirkeby: Monotypes*.

Kunstmuseum Winterthur, Switzerland, 1989, *Per Kirkeby: Werke, 1983–1988* (catalogue).

Galerie Lelong, Zurich, 1989, *Per Kirkeby: Bilder und Skulpturen* (catalogue).

Galerie Thaddaeus Ropac, Salzburg, 1988, *Per Kirkeby: Bilder, Aquarelle*.

Mary Boone Gallery, New York, 1988, *Per Kirkeby*.

Palais des Beaux Arts, Brussels, 1988, *Per Kirkeby: Schilderijen, Sculpturen en modellen in brons / Peintures, sculptures et modèles en bronze*.

Museum Ludwig, Cologne, 1987, *Per Kirkeby: Retrospektive* (catalogue).

Museum Boymans-van Beuningen, Rotterdam, 1987, *Per Kirkeby: Bäksteensculptuur / Backstein-Skulptur* (catalogue).

Mary Boone Michael Werner Gallery, New York, 1986, *Per Kirkeby* (catalogue).

Städtisches Museum Abteiberg, Mönchengladbach, West Germany, 1986, *Per Kirkeby: Skulptur und Druckgrafik* (catalogue).

Galerie Thaddaeus Ropac, Salzburg, 1986, *Per Kirkeby: Salzburg-Bilder und sieben Skulpturen* (catalogue).

Whitechapel Art Gallery, London, 1985, *Per Kirkeby: Recent Painting and Sculpture* (catalogue).

Galerie Knödler, Zurich, 1985, *Per Kirkeby: Skulpturen und Bilder* (catalogue).

Fruitmarket Gallery, Edinburgh, 1985, *Per Kirkeby* (catalogue).

Kunstverein Braunschweig, West Germany, 1984, *Per Kirkeby* (catalogue).

Galerie Michael Werner, Cologne, 1984, *Per Kirkeby: Sechs Bilder* (catalogue).

Galerie Thaddaeus Ropac, Salzburg, 1984, *Per Kirkeby* (catalogue).

Musée d'Art Moderne de Strasbourg, France, 1984, *Per Kirkeby* (catalogue).

Samenslutingen af Danske Kunstforeninger, Copenhagen, 1983, *Per Kirkeby* (catalogue).

Galerie Michael Werner, Cologne, 1983, *Per Kirkeby*.

Galerie Gillespie-Laage-Salomon, Paris, 1983, *Per Kirkeby*.

Galerie Susanne Ottesen, Copenhagen, 1983, *Per Kirkeby: 6 Kobbertryk* (catalogue).

Galerie Springer, West Berlin, 1983, *Per Kirkeby: Bilder aus der Berliner Zeit 1982* (catalogue).

daad-galerie, West Berlin, 1983, *Per Kirkeby: Zeichnungen, 1964–1982* (catalogue).

Stedelijk Van Abbemuseum, Eindhoven, Netherlands, 1982, *Per Kirkeby* (catalogue).

Galerie Crone, Hamburg, 1982, *Per Kirkeby: Neue Bilder und Atlas Series* (catalogue).

Galerie Springer, West Berlin, 1982, *Per Kirkeby*.

Galerie Michael Werner, Cologne, 1982, *Per Kirkeby: Semele Serie* (catalogue).

Ordrupgaardsamlingen, Charlottenlund, Copenhagen, 1981, *Per Kirkeby* (catalogue).

Galerie Michael Werner, Cologne, 1980, *Per Kirkeby* (catalogue).

Galerie Helen van der Meij, Amsterdam, 1980, *Per Kirkeby*.

Galerie Fred Jahn, Munich, 1980, *Per Kirkeby*.

Kunsthalle Bern, 1979, *Per Kirkeby* (catalogue).

Kunstraum München, 1978, *Per Kirkeby* (catalogue).

Museum Folkwang, Essen, West Germany, 1977, *Per Kirkeby: Fliegende Blätter* (catalogue).

Daner Galleriet, Karlsons Klister 2, Kopenhagen Statens Museum for Kunst, Kuperstichkabinett, 1975.

Galerie Michael Werner, Cologne, 1974.

Tranegården, Gentofte Kunstbibliotek, Copenhagen, 1972.

Jysk Kunstgalerie, Copenhagen, 1968.

Den Frie Udstillings bygning, Copenhagen, 1965.

Selected Group Exhibitions

São Paulo, 1994, *22 Bienal Internacional de São Paulo* (catalogue).

Museum Moderner Kunst, Stiftung Ludwig, Vienna, 1994, *Malfiguren: Francesco Clemente, Jörg Immendorff, Per Kirkeby, Malcom Morley, Hermann Nitsch, Cy Twombly* (catalogue).

Kassel, 1992, *Documenta IX* (catalogue).

Musée national d'art moderne, Centre Georges Pompidou, and La Grande Halle, La Villette, Paris, 1989, *Magiciens de la Terre* (catalogue).

Museums Ludwig in den Rheinhallen der Kölner Messe, 1989, *Bilderstreit: Widerspruch, Einheit und Fragment in der Kunst seit 1960* (catalogue).

Carnegie Museum of Art, Pittsburgh, Pennsylvania, 1988, *Carnegie International* (catalogue).

Hamburger Bahnhof, West Berlin, 1988, *Zeitlos: Kunst von heute im Hamburger Bahnhof, Berlin* (catalogue).

Castello di Rivoli, Turin, Italy, 1987, *Standing Sculpture* (catalogue).

Westfälischen Landesmuseums für Kunst und Kulturgeschichte in der Stadt Münster, West Germany, 1987, *Skulptur Projekte in Münster, 1987* (catalogue).

Museum Ludwig, Cologne, 1986, *Europa / Amerika: Die Geschichte einer künstlerischen Faszination seit 1940* (catalogue).

Museum of Art, Carnegie Institute, Pittsburgh, Pennsylvania, 1985, *Carnegie International* (catalogue).

Wilhelm-Lehmbruck-Museum, Duisburg, West Germany, 1985, *Dänische Skulptur im 20. Jahrhundert* (catalogue).

Museum of Modern Art, New York, 1984, *An International Survey of Recent Painting and Sculpture* (catalogue).

Fundació Caixa de Pensions, Barcelona, 1984, *Ursprung und Vision: Neue Deutsche Malerei* (catalogue).

Merianpark, Basel, 1984, *Skulptur im 20. Jahrhundert* (catalogue).

Stedelijk Van Abbemuseum, Eindhoven, Netherlands, 1984, *Uit het Noorden: Edvard Munch, Asger Jorn, Per Kirkeby* (catalogue).

Staatliche Kunsthalle Baden-Baden, 1983, *Kosmische Bilder in der Kunst des 20. Jahrhunderts* (catalogue).

Martin-Gropius-Bau, West Berlin, 1982, *Zeitgeist: International Art Exhibition, Berlin 1982* (catalogue).

Kassel, 1982, *documenta 7* (catalogue).

Royal Academy of Arts, London, 1981, *A New Spirit in Painting* (catalogue).

Venice, 1980, *XXXIX Biennale di Venezia* (catalogue).

Venice, 1976, *XXXVII Biennale di Venezia* (catalogue).

Louisiana Museum of Modern Art, Humlebaek, Denmark, 1970, *Tabernakel*.

Selected Bibliography

Edelman, Robert. "Per Kirkeby at Michael Werner." *Art in America* 83 (May 1995), pp. 115–116.

Michael Werner Gallery, New York. *Per Kirkeby: Early Works* (1995). Exhibition catalogue, with essay by Lasse B. Antonsen.

Museum Moderner Kunst, Stiftung Ludwig, Vienna. *Malfiguren: Francesco Clemente, Jörg Immendorff, Per Kirkeby, Malcom Morley, Hermann Nitsch, Cy Twombly* (1994). Exhibition catalogue, with introduction by Lóránd Hegy and essays by Achille Bonito Oliva, Otto Breicha, Rainer Fuchs, and Edwin Lachnit.

Recklinghausen Kunsthalle, Germany. *Per Kirkeby* (1994). Exhibition catalogue, with foreword by Ferdinand Ulrich, essays by Ane Hejlskov Larsen and Hans-Jürgen Schwalm, and text by Per Kirkeby.

Kunsthalle Wien, and Deichtorhallen Hamburg. *Der zerbrochene Spiegel: Positionen zur Malerei* (1993). Exhibition catalogue by Kasper König and Hans-Ulrich Obrist, with essays by Klaus Bachler, Zdenek Felix, Ursula Pasterk, and Toni Stooss.

Documenta IX (Stuttgart: Edition Cantz; Harry N. Abrams, New York, 1992). 3 vols. Exhibition catalogue, with introduction by Jan Hoet, essays by Bart De Baere, Cornelius Castoriadis, Hilde Daem, Claudia Herstatt, Heiner Müller, et al., and text by Per Kirkeby.

Kuspit, Donald. "Per Kirkeby: Michael Werner." *Artforum* 30 (April 1992), p. 93.

Schjeldahl, Peter. "Northern Light." *Village Voice*, February 4, 1992, p. 89.

Kestner-Gesellschaft, Hannover. *Per Kirkeby* (1991). Exhibition catalogue edited by Carl Haenlein, with essays by Carsten Ahrens and Siegfried Gohr.

Städtische Galerie im Städelsches Kunstinstitut, Frankfurt. *Per Kirkeby: Gemälde, Arbeiten auf Papier, Skulpturen, 1977–1990* (1990). Exhibition catalogue, with foreword by Klaus Gallwitz and essays by Beatrice von Bismarck, Ursula Grzechca Mohr, and Ulrich Wilmes.

Neue Galerie am Landesmuseum Joanneum, Graz, Austria. *Per Kirkeby* (1990). Exhibition catalogue, with foreword by Kurt Jungwirth and essay by Wilfried Skreiner.

Moderna Museet, Stockholm. *Per Kirkeby: Måleri/Paintings, Skulptur/Sculptures, Teckningar/Drawings, Böcker/Books, Film/Films, 1964–1990* (1990). Exhibition catalogue, with essays by Siegfried Gohr, Ane Hejlskov Larsen, Lars Morell, Carl Nørrested, Peter Schjeldahl, and Asger Schnack.

Centre del Carme, IVAM, Valencia. *Per Kirkeby: Pinturas, esculturas, grabados y escritos* (1989). Exhibition catalogue by Piet de Jonge and Vicente Todolí, with essays by Troels Andersen and Denys Zacharopoulos and text by Per Kirkeby.

Galerie Lelong, Zurich. *Per Kirkeby: Bilder und Skulpturen* (1989). Exhibition catalogue, with essay by Friedrich Meschede.

Museums Ludwig in den Rheinhallen der Kölner Messe. *Bilderstreit: Widerspruch, Einheit und Fragment in der Kunst seit 1960* (Cologne: DuMont Buchverlag, 1989). Exhibition catalogue by Siegfried Gohr and Johannes Gachnang, with essays by Hans Belting, André Berne-Joffroy, Emile Cioran, Michael Compton, Piet de Jonge, et al.

Musée national d'art moderne, Centre Georges Pompidou, and La Grande Halle, La Villette, Paris. *Magiciens de la Terre* (1989). Exhibition catalogue, with foreword by Jean-Hubert Martin and essays by Homi Bhabha, Mark Francis, Pierre Gaudibert, Aline Luque, André Marcadé, et al.

Kunstmuseum Winterthur, Switzerland. *Per Kirkeby: Werke, 1983–1988* (1989). Exhibition catalogue, with foreword by Rudolf Koella, essay by Max Wechsler, and text by Per Kirkeby.

Zacharopoulos, Denys. "The Desperation of the Nebulae." *Artforum* 27 (February 1989), pp. 107–113.

Carnegie Museum of Art, Pittsburgh, Pennsylvania. *Carnegie International* (Munich: Prestel, 1988). Exhibition catalogue, with essays by John Caldwell, Vicky Clark, Lynne Cooke, Milena Kalinovska, and Thomas McEvilley.

Hamburger Bahnhof, West Berlin. *Zeitlos: Kunst von heute im Hamburger Bahnhof, Berlin* (Munich: Prestel-Verlag, 1988). Exhibition catalogue by Harald Szeemann, with essays by Markus Brüderlin and Roman Kurzmeyer and text by Per Kirkeby.

Museum Boymans-van Beuningen, Rotterdam. *Per Kirkeby: Bäksteensculptuur/Backstein-Skulptur* (1987). Exhibition catalogue, with foreword by Wim Crouwel, essay by Karel Schampers, and text by Per Kirkeby.

Museum Ludwig, Cologne. *Per Kirkeby: Retrospektive* (1987). Exhibition catalogue, with foreword by Siegfried Gohr and essays by Troels Andersen, Andreas Franzke, and Peter Schjeldahl.

Castello di Rivoli, Turin, Italy. *Standing Sculpture* (1987). Exhibition catalogue by Rudi Fuchs, Johannes Gachnang, and Francesco Poli, with introduction by Cristina Mundici.

Städtisches Museum Abteiberg, Mönchengladbach, West Germany. *Per Kirkeby: Skulptur und Druckgrafik* (1986). Exhibition catalogue, with foreword by Dierk Stemmler, essays by Troels Andersen, Johannes Gachnang, and Hannelore Kersting, and text by Per Kirkeby.

Mary Boone Michael Werner Gallery, New York. *Per Kirkeby* (1986). Exhibition catalogue, with essay by Peter Schjeldahl.

Museum Ludwig, Cologne. *Europa / Amerika: Die Geschichte einer künstlerischen Faszination seit 1940* (1986). Exhibition catalogue, with introduction by Siegfried Gohr and essays by Craig Adcock, Dore Ashton, Alberto Boatto, John Cage, Rainer Crone, et al.

Galerie Thaddaeus Ropac, Salzburg. *Per Kirkeby: Salzburg-Bilder und sieben Skulpturen* (1986). Exhibition catalogue, with text by Per Kirkeby.

Westfälischen Landesmuseums Münster, West Germany. *Per Kirkeby Skulptur: Projekt für Münster* (1986). Exhibition catalogue, with essay by Friedrich Meschede and text by Per Kirkeby.

Museum of Art, Carnegie Institute, Pittsburgh, Pennsylvania. *Carnegie International* (Munich: Prestel-Verlag, 1985). Exhibition catalogue edited by Saskia Bos and John Lane, with introduction by John Lane and John Caldwell and essays by Achille Bonito Oliva, Benjamin H.D. Buchloh, Bazon Brock, Germano Celant, Rudi Fuchs, et al.

Fruitmarket Gallery, Edinburgh, and Douglas Hyde Gallery, Dublin. *Per Kirkeby* (1985). Exhibition catalogue, with foreword by Mark Francis, essay by Troels Andersen, and text by Per Kirkeby.

Galerie Knödler, Zurich. *Per Kirkeby: Skulpturen und Bilder* (1985). Exhibition catalogue, with essay by Agnes von der Borch.

Whitechapel Art Gallery, London. *Per Kirkeby: Recent Painting and Sculpture* (1985). Exhibition catalogue, with foreword by Nicholas Serota, essay by Tony Godfrey, and text by Per Kirkeby.

Stedelijk Van Abbemuseum, Eindhoven, Netherlands. *Uit het Noorden: Edvard Munch, Asger Jorn, Per Kirkeby* (1984). Exhibition catalogue, with essays by R.H. Fuchs and Johannes Gachnang and text by Per Kirkeby.

Fundació Caixa de Pensions, Barcelona, and Palacio Velázquez, Parque del Retiro, Madrid. *Ursprung und Vision: Neue Deutsche Malerei* (Berlin: Frölich and Kaufmann, 1984). Exhibition catalogue by Christos M. Joachimides, with foreword by Carmen Giménez and interview with Walter Grasskamp.

Kunstverein Braunschweig, West Germany. *Per Kirkeby* (1984). Exhibition catalogue, with essays by Dieter Blume, Wilhelm Bojescul, Andreas Franzke, and Jürgen Klein.

Merianpark, Basel. *Skulptur im 20. Jahrhundert* (1984). Exhibition catalogue, with foreword by Ernst Beyeler, Reinhold Hohl, and Martin Schwander, and essays by Zdenek Felix, Andreas Franzke, Laszlo Glozer, Sarah Gossa, Antje von Graevenitz, et al.

Museum of Modern Art, New York. *An International Survey of Recent Painting and Sculpture* (1984). Exhibition catalogue by Kynaston McShine.

Galerie Thaddaeus Ropac, Salzburg. *Per Kirkeby* (1984). Exhibition catalogue, with text by Per Kirkeby.

Musée d'Art Moderne de Strasbourg, France. *Per Kirkeby* (1984). Exhibition catalogue, with foreword by Nadine Lehni and text by Per Kirkeby.

Galerie Michael Werner, Cologne. *Per Kirkeby: Sechs Bilder* (1984). Exhibition catalogue, with text by Per Kirkeby.

Staatliche Kunsthalle Baden-Baden. *Kosmische Bilder in der Kunst des 20. Jahrhunderts* (1983). Exhibition catalogue, with foreword by Katharina Schmidt and essays by Henning Genz, Siegmar Holsten, and Marianne Kersting.

daad-galerie, West Berlin. *Per Kirkeby: Zeichnungen, 1964–1982* (1983). Exhibition catalogue, with foreword by René Block, essay by Johannes Gachnang, and text by Per Kirkeby.

Samenslutingen af Danske Kunstforeninger, Copenhagen. *Per Kirkeby* (1983). Exhibition catalogue, with text by Per Kirkeby.

Martin-Gropius-Bau, West Berlin. *Zeitgeist: International Art Exhibition, Berlin 1982* (New York: George Braziller, 1983). Exhibition catalogue edited by Christos M. Joachimides and Norman Rosenthal, with essays by Walter Bachauer, Thomas Bernhard, Karl-Heinz Bonrer, Paul Feyerabend, Hilton Kramer, et al.

Galerie Susanne Ottesen, Copenhagen. *Per Kirkeby: 6 Kobbertryk* (1983). Exhibition catalogue, with essay by Eric Fischer.

Galerie Springer, West Berlin. *Per Kirkeby: Bilder aus der Berliner Zeit 1982* (1983). Exhibition catalogue, with text by Per Kirkeby.

Stedelijk Van Abbemuseum, Eindhoven, Netherlands. *Per Kirkeby* (1982). Exhibition catalogue, with essay by Johannes Gachnang and text by Per Kirkeby.

Galerie Crone, Hamburg. *Per Kirkeby: Neue Bilder und Atlas Series* (1982). Exhibition catalogue, with essay by Martin Warnke and text by Per Kirkeby.

Kirkeby, Per. *Selected Essays from Bravura* (Amsterdam: Stedelijk Van Abbemuseum, 1982).

Galerie Michael Werner, Cologne. *Per Kirkeby: Semele Serie* (1982). Exhibition catalogue, with essay by A.R. Penck.

Ordrupgaardsamlingen, Charlottenlund, Copenhagen. *Per Kirkeby* (1981). Exhibition catalogue, with foreword by Hanne Finsen, essay by R.H. Fuchs, and text by Per Kirkeby.

Royal Academy of Arts, London. *A New Spirit in Painting* (1981). Exhibition catalogue by Christos M. Joachimides, Norman Rosenthal, and Nicholas Serota.

Galerie Michael Werner, Cologne. *Per Kirkeby* (1980). Exhibition catalogue, with essays by Rudi H. Fuchs and Johannes Gachnang.

Kunsthalle Bern. *Per Kirkeby* (1979). Exhibition catalogue, with foreword by Johannes Gachnang, essay by Theo Kneubühler, and text by Per Kirkeby.

Kunstraum München. *Per Kirkeby* (1978). Exhibition catalogue, with essay by Hermann Kern and text by Per Kirkeby.

Museum Folkwang, Essen, West Germany. *Per Kirkeby: Fliegende Blätter* (1977). Exhibition catalogue, with essays by Troels Andersen and Zdenek Felix and text by Per Kirkeby.

Guillermo Kuitca

b. 1961, Buenos Aires, Argentina

lives in Buenos Aires, Argentina

Selected One-Person Exhibitions

Wexner Center for the Arts, Columbus, Ohio, 1994, *Guillermo Kuitca: Burning Beds. A Survey, 1982–1994* (catalogue).

Thomas Cohn Arte Contemporânea, Rio de Janeiro, 1994, *Guillermo Kuitca: Obras Recentes* (catalogue).

Sperone Westwater, New York, 1994, *Guillermo Kuitca: The Tablada Suite (1991–1993) and New Paintings* (catalogue).

Sperone Westwater, New York, 1993, *Guillermo Kuitca*.

Musée d'art contemporain de Montréal, 1993, *Guillermo Kuitca: Les Lieux de l'errance* (brochure).

Centre del Carme, IVAM, Valencia, 1993, *Guillermo Kuitca* (catalogue).

Museum of Modern Art, New York, 1991, *Projects 30: Guillermo Kuitca* (brochure).

Annina Nosei Gallery, New York, 1991, *Kuitca* (catalogue).

Galleria Gian Enzo Sperone, Rome, 1990, *Guillermo Kuitca* (catalogue).

Thomas Solomon's Garage, Los Angeles, 1990, *Guillermo Kuitca*.

Witte de With, Rotterdam, 1990, *Guillermo Kuitca* (catalogue).

Kunsthalle Basel, 1990, *Guillermo Kuitca*.

Galeria Atma, San José, Costa Rica, 1989, *Guillermo Kuitca*.

Galeria Paulo Figuerado, São Paulo, 1987, *Guillermo Kuitca*.

Thomas Cohn Arte Contemporânea, Rio de Janeiro, 1986, *Guillermo Kuitca*.

Elizabeth Franck Gallery, Knokke-Le-Zoute, Belgium, 1985, *Guillermo Kuitca* (catalogue).

Centro de Arte y Comunicación, Buenos Aires, 1982, *Guillermo Kuitca*.

Fundación San Telmo, Buenos Aires, 1980, *Guillermo Kuitca*.

Selected Group Exhibitions

Museum of Contemporary Art, San Diego, La Jolla, California, 1995, *Sleeper: Katharina Fritsch, Robert Gober, Guillermo Kuitca, Doris Salcedo* (catalogue).

Art Institute of Chicago, 1995, *About Place: Recent Art of the Americas* (catalogue).

Museum of Modern Art, New York, 1994, *Mapping* (catalogue).

Museum of Modern Art, Oxford, 1994, *Art from Argentina, 1920–1994* (catalogue).

Winnipeg Art Gallery, Manitoba, Canada, 1993, *Cartographies* (catalogue).

Estación Plaza de Armas, Seville, 1992, *Latin American Artists of the Twentieth Century* (catalogue).

Kassel, 1992, *Documenta IX* (catalogue).

Institute of Contemporary Art, Boston, 1992, *Currents: The Absent Body* (brochure).

Museo de Arte Contemporáneo de Monterrey, Mexico, 1991, *Mito y Magia en América: Los Ochenta* (catalogue).

Martin-Gropius-Bau, Berlin, 1991, *Metropolis* (catalogue).

São Paulo, 1989, *XX Bienal de São Paulo* (catalogue).

Stedelijk Museum, Amsterdam, 1989, *U-ABC: Schilderijen, beelden, fotografie uit Uruguay, Argentinië, Brazilië, Chili / Paintings, Sculptures, Photography from Uruguay, Argentina, Brazil, Chile* (catalogue).

Galeria Arte Actual, Santiago de Chile, 1987, *Argentina: Pintura Joven*.

Istituto Italo-Latinoamericano, Rome, 1987, *Arte Argentina, 1810–1987* (catalogue).

Galería Ruth Benzacar, Buenos Aires, and Museo Nacional de Artes Plásticas, Montevideo, 1985, *Del Pop Art a la Nueva Imagen*.

São Paulo, 1985, *XVIII Bienal de São Paulo* (catalogue).

Museo de América, Madrid, 1983, *Realismo, Tres Vertientes*.

Centro de Arte y Comunicación, Buenos Aires, 1982, *Grupo IIIII* (catalogue).

Selected Bibliography

Art Institute of Chicago. *About Place: Recent Art of the Americas* (1995). Exhibition catalogue by Madeleine Grynsztejn, with essay by Dave Hickey.

Contemporary Art Foundation, Amsterdam, 1994. *Guillermo Kuitca: Burning Beds. A Survey, 1982–1994* (1994). Exhibition catalogue by Eduardo Lipschutz-Villa, with essays by Josefina Ayerza, Donald Baechler, Douglas Blau, John Coffey, Robert Rosenblum, et al., and text by Guillermo Kuitca (published in conjunction with exhibition at Wexner Center for the Arts, Columbus, Ohio).

Thomas Cohn Arte Contemporânea, Rio de Janeiro. *Guillermo Kuitca: Obras Recentes* (1994). Exhibition catalogue.

Filler, Martin. "Slightly Stateless, but at Home with Himself." *The New York Times*, May 8, 1994, p. H34.

Museum of Modern Art, New York. *Mapping* (New York: Harry N. Abrams, 1994). Exhibition catalogue by Robert Storr.

Museum of Modern Art, Oxford. *Art from Argentina, 1920–1994* (1994). Exhibition catalogue edited by David Elliott, with essays by Carlos Basualdo, Miguel Briante, Dan Cameron, Mercedes Casanegra, Jorge Glusberg, et al.

Sperone Westwater, New York. *Guillermo Kuitca: The Tablada Suite, 1991–1993* (1994). Exhibition catalogue.

Contemporary Art Foundation, Amsterdam. *A Book Based on Guillermo Kuitca* (1993). Exhibition catalogue, with essays by Marcelo E. Pacheco, Martin Rejtman, and Jerry Saltz (published in conjunction with exhibition at Centre del Carme, IVAM, Valencia).

Kimmelman, Michael. "Guillermo Kuitca." *The New York Times*, May 14, 1993, p. C26.

Musée d'art contemporain de Montréal. *Guillermo Kuitca: Les Lieux de l'errance* (1993). Exhibition brochure, with essay by Réal Lussier.

Museum of Modern Art, New York. *Latin American Artists of the Twentieth Century* (New York: Harry N. Abrams, 1993). Exhibition catalogue by Waldo Rasmussen, with essays by Aracy Amaral, Dore Ashton, Jacqueline Barnitz, Florencia Bazzano Nelson, Guy Brett, et al. (published in conjunction with 1992 exhibition at Estación Plaza de Armas, Seville).

Sperone Westwater, New York. *Guillermo Kuitca* (1993). Exhibition catalogue, with anonymous text.

Winnipeg Art Gallery, Manitoba, Canada. *Cartographies* (1993). Exhibition catalogue by Ivo Mesquita, with essays by Paulo Herkenhoff and Justo Pastor Mellado.

Zabalbeascoa, Anatxu. "Guillermo Kuitca: IVAM." *Artforum* 32 (November 1993), p. 117.

Documenta IX (Stuttgart: Edition Cantz; New York: Harry N. Abrams, 1992). 3 vols. Exhibition catalogue, with introduction by Jan Hoet and essays by Bart De Baere, Cornelius Castoriadis, Hilde Daem, Claudia Herstatt, Heiner Müller, et al.

Newport Harbor Art Museum, Newport Beach, California. *Guillermo Kuitca* (1992). Exhibition catalogue, with essay by Lynn Zelevansky.

Greenlees, Don. "Three from Latin America. Guillermo Kuitca: How to Map the Universe." *Artnews* 90 (October 1991), pp. 94–95.

Martin-Gropius-Bau, Berlin. *Metropolis* (New York: Rizzoli, 1991). Exhibition catalogue edited by Christos M. Joachimides and Norman Rosenthal, with essays by Achille Bonito Oliva, Jeffrey Deitch, Wolfgang Max Faust, Vilém Flusser, Boris Groys, et al.

Museo de Arte Contemporáneo de Monterrey, Mexico. *Mito y Magia en América: Los Ochenta* (1991). Exhibition catalogue by Miguel Cervantes and Charles Merewether, with essays by Francesco Pellizzi, Alberto Ruy Sanchéz, Peter Schjeldahl, and Edward J. Sullivan.

Annina Nosei Gallery, New York. *Kuitca* (1991). Exhibition catalogue, with essay by Achille Bonito Oliva.

Borum, Jenifer B. "Guillermo Kuitca: Annina Nosei Gallery." *Artforum* 28 (May 1990), p. 189.

Galerie Barbara Farber, Amsterdam. *Guillermo Kuitca* (1990). Exhibition catalogue, with essays by Wim Beeren and Edward L. Smith.

Feintuch, Robert. "Guillermo Kuitca at Annina Nosei." *Art in America* 78 (September 1990), pp. 198–199.

Galleria Gian Enzo Sperone, Rome. *Guillermo Kuitca* (1990). Exhibition catalogue, with essay by Charles Merewether.

Witte de With, Rotterdam. *Guillermo Kuitca* (1990). Exhibition catalogue, with introduction by Chris Dercon and essay by Rina Carvajal.

Stedelijk Museum, Amsterdam. *U-ABC: Schilderijen, beelden, fotografie uit Uruguay, Argentinië, Brazilië, Chili / Paintings, Sculptures, Photography from Uruguay, Argentina, Brazil, Chile* (1989). Exhibition catalogue edited by Wim Beeren and Dorine Mignot, with essays by Aracy Amaral, Els Barents,

Angel Kalenberg, Guillermo Whitelow, and Raúl Zurita.

Galería del Retiro, Buenos Aires. *Guillermo Kuitca* (1982). Exhibition catalogue, with essay by Jorge Glusberg.

Moshe Kupferman

b. 1926, Jaroslav, Poland
lives on Kibbutz Lochamei Hagetaot, Israel

Selected One-Person Exhibitions

Studio Bocchi, Rome, 1994, *Moshe Kupferman* (catalogue).

Muzeum Sztuki, Łódź, and Centrum Sztuki Współczesnej, Warsaw, 1993, *Moshe Kupferman: Prace na papierze / Works on Paper, Malarstwo / Painting* (organized in collaboration with the Tel Aviv Museum of Art) (catalogue).

Noemi Givon Gallery, Tel Aviv, 1992, *Moshe Kupferman*.

Shigeru Yokota Gallery, Tokyo, 1992, *Moshe Kupferman*.

North Carolina Museum of Art, Raleigh, 1991, *Moshe Kupferman. Between Oblivion and Remembrance: Paintings and Works on Paper, 1972–1991* (catalogue).

Musée d'Art Contemporain, Dunkerque, France, 1991, *Moshe Kupferman* (catalogue).

Musée national d'art moderne, Centre Georges Pompidou, Paris, 1987, *Moshe Kupferman: Peintures et œuvres sur papier* (catalogue).

Israel Museum, Jerusalem, and Tel Aviv Museum of Art, 1984, *Moshe Kupferman: Paintings, Works on Paper, 1963–1984* (catalogue).

Stedelijk Museum, Amsterdam, 1981, *Kupferman: Werk op papier* (catalogue).

Wadsworth Atheneum, Hartford, Connecticut, 1980, *Moshe Kupferman: Matrix 61* (brochure).

Tel Aviv Museum of Art, 1978, *Kupferman* (catalogue).

Bertha Urdang Gallery, New York, 1977, *Moshe Kupferman: Five Paintings, Nine Drawings* (catalogue).

Israel Museum, Jerusalem, 1969, *Moshe Kupferman* (catalogue).

Ghetto Fighters' House, Kibbutz Lochamei Hagetaot, 1962, *Moshe Kupferman*.

Chemerinsky Gallery, Tel Aviv, 1960, *Moshe Kupferman*.

Selected Group Exhibitions

Galeria Zachęta, Warsaw, 1995, *Where Is Abel, Thy Brother?* (catalogue).

Israel Museum, Jerusalem, 1994, *Along New Lines: Israeli Drawing Today* (catalogue).

Centre des Arts Saidye Bronfman, Montreal, 1993, *Jacob El Hanani and Moshe Kupferman: Drawings.*

Israel Museum, Jerusalem, 1991, *Routes of Wandering: Nomadism, Voyages and Transitions in Contemporary Israeli Art* (catalogue).

Detroit Institute of Arts, 1991, *Art in Israel Today* (catalogue).

Albright-Knox Art Gallery, Buffalo, New York, 1989, *Transformations in Landscape: Postwar Works from the Collection.*

Jewish Museum, New York, 1989, *In the Shadow of Conflict: Israeli Art, 1980–1989* (catalogue).

Venice, 1986, *XLII Esposizione Internazionale d'Arte: La Biennale di Venezia* (catalogue).

Tel Aviv Museum of Art, 1986, *The Want of Matter: A Quality in Israeli Art* (catalogue).

Koninklijk Museum voor Schone Kunsten, Antwerp, 1985, *Kunst in Israel, 1960–1985* (catalogue).

Hirshhorn Museum and Sculpture Garden, Smithsonian Institution, Washington, D.C., 1984, *Drawings, 1974–1984* (catalogue).

Jewish Museum, New York, 1981, *Artists of Israel: 1920–1980* (catalogue).

Los Angeles County Museum of Art, 1978, *Seven Artists in Israel: 1948–1978* (catalogue).

Louisiana Museum of Modern Art, Humlebaek, Denmark, 1977, *10 kunstere fra Israel* (catalogue).

Worcester Art Museum, Massachusetts, 1975, *Three Israeli Artists: Gross, Neustein, Kupferman* (catalogue).

Israel Museum, Jerusalem, 1974, *Beyond Drawing.*

Museum of Art, Ein Harod, Israel, 1963, *New Horizons.*

Selected Bibliography

Galeria Zachęta, Warsaw. *Where Is Abel, Thy Brother?* (1995). Exhibition catalogue by Anda Rottenberg, with essays by Wiesław Borowski, Michael Brenson, Nella Cassouto, Jean-François Chevrier, E.M. Cioran, et al.

5-55, Primo Piano, Sala 1, Studio Bocchi, Rome. *Halal: arte contemporanea da Israele* (1994). Exhibition catalogue, with introductions by Mary Angela Schroth and Yali Zalmona and essays by Amnon Barzel, Achille Bonito Oliva, Nella Cassouto, Arturo Schwarz, Sarit Shapira, and Adachiara Zevi (published in conjunction with one-person exhibition at Studio Bocchi).

Israel Museum, Jerusalem. *Along New Lines: Israeli Drawing Today* (1994). Exhibition catalogue, with essays by Menashe Kadishman, Joshua Neustein, and Meira Perry-Lehmann.

Muzeum Sztuki, Łódź, and Centrum Sztuki Współczesnej, Warsaw. *Moshe Kupferman: Prace na papierze / Works on Paper, Malarstwo / Painting* (1993). Exhibition catalogue by Yona Fischer, with text by Moshe Kupferman.

Cotter, Holland. "Moshe Kupferman." *The New York Times*, February 28, 1992, p. C18.

Halperen, Max. "Moshe Kupferman: North Carolina Museum of Art." *Artnews* 91 (February 1992), p. 137.

Detroit Institute of Arts. *Art in Israel Today* (1991). Exhibition catalogue by Jan van der Marck.

Israel Museum, Jerusalem. *Routes of Wandering: Nomadism, Voyages and Transitions in Contemporary Israeli Art* (1991). Exhibition catalogue, with foreword by Yigal Zalmona, essay by Sarit Shapira, and interview with Edmond Jabès by Bracha Lichtenberg Ettinger.

North Carolina Museum of Art, Raleigh. *Moshe Kupferman. Between Oblivion and Remembrance: Paintings and Works on Paper, 1972–1991* (1991). Exhibition catalogue, with essays by John W. Coffey II and Yona Fischer.

Jewish Museum, New York. *In the Shadow of Conflict: Israeli Art, 1980–1989* (1989). Exhibition catalogue by Susan Tumarkin Goodman, with essays by Eugene and Anita Weiner, A.B. Yehoshua, and Yigal Zalmona.

Musée national d'art moderne, Centre Georges Pompidou, Paris. *Moshe Kupferman: Peintures et œuvres sur papier* (1987). Exhibition catalogue, with essays by Yona Fischer, Alfred Pacquement, Ad Petersen, and Marcelin Pleynet.

Israel Pavilion, 42nd International Art Exhibition at the Venice Biennale. *Color Territories* (1986). Exhibition catalogue by Yona Fischer.

Tel Aviv Museum of Art. *The Want of Matter: A Quality in Israeli Art* (1986). Exhibition catalogue by Sara Breitberg-Semel.

Hirshhorn Museum and Sculpture Garden, Smithsonian Institution, Washington, D.C. *Drawings, 1974–1984* (1984). Exhibition catalogue by Frank Gettings, with essay by Yona Fischer.

Israel Museum, Jerusalem, and Tel Aviv Museum of Art. *Moshe Kupferman: Paintings, Works on Paper, 1963–1984* (1984). Exhibition catalogue, with introduction by Yona Fischer and essays by Sarah Breitberg-Semel and Ad Petersen.

Jewish Museum, New York. *Artists of Israel: 1920–1980* (1981). Exhibition catalogue, with foreword by Susan Tumarkin Goodman and essays by Moshe Barasch, Yona Fischer, and Yigal Zalmona.

Stedelijk Museum, Amsterdam. *Kupferman: Werk op papier* (1981). Exhibition catalogue by Ad Petersen, with essay by Yona Fischer.

Burnside, Madeleine. "Moshe Kupferman at Bertha Urdang." *New York Arts Journal,* no. 18 (June 1980), pp. 24–26.

Pincus-Witten, Robert. "Seven Artists of Israel." *Artforum* 17 (Summer 1979), pp. 50–54.

Lopez Cardozo, Judith. "Moshe Kupferman: Bertha Urdang Gallery." *Artforum* 16 (January 1978), pp. 71–72.

Los Angeles County Museum of Art. *Seven Artists in Israel: 1948–1978* (1978). Exhibition catalogue by Stephanie Barron and Maurice Tuchman.

Tel Aviv Museum of Art. *Kupferman* (1978). Exhibition catalogue by Sarah Breitberg.

Pincus-Witten, Robert. "The Neustein Papers." *Arts Magazine* 52 (October 1977), pp. 102–115.

Bertha Urdang Gallery, New York. *Moshe Kupferman: Five Paintings, Nine Drawings* (1977). Exhibition catalogue, with essay by Robert Pincus-Witten.

Pincus-Witten, Robert. "Six Propositions on Jewish Art." *Arts Magazine* 50 (December 1975), pp. 66–69.

Israel Museum, Jerusalem. *Moshe Kupferman* (1969). Exhibition catalogue, with essay by Yona Fischer.

Thomas Locher

b. 1956, Munderkingen, West Germany

lives in Cologne, Germany

Selected One-Person Exhibitions

Kunstverein München, 1995, *Diskurs Zwei: Präambel und Grundrechte im Grundgesetz für die BRD-Ein Kommentar* (catalogue).

Galerie Metropol, Vienna, 1994, *Diskurs Ein: Europäische Menschenrechtskonvention.*

Galerie Michael Fuchs, Berlin, 1994, *Begriffe.*

Salzburger Kunstverein, 1993, *Thomas Locher* (with Hans Weigand) (catalogue).

Kunsthalle Zürich, 1993, *Thomas Locher* (catalogue).

Kölnischer Kunstverein, 1992, *Wer sagt was und warum* (catalogue).

Galería Antoni Estrany, Barcelona, 1992, *Thomas Locher* (brochure).

Stichting De Appel, Amsterdam, 1992, *Thomas Locher* (catalogue).

Kunsthalle Bielefeld, Germany, 1992, *Doppelzimmer.*

Galerie Anne de Villepoix, Paris, 1991, *Thomas Locher.*

Jay Gorney Modern Art, New York, 1991, *Marking and Labeling* (brochure).

Karsten Schubert Gallery, London, 1990, *Thomas Locher* (with Thomas Grünfeld).

Galleria Lia Rumma, Naples, 1990, *Thomas Locher.*

Galerie Tanja Grunert, Cologne, 1989, *Markierung und Etikettierung.*

Galerie Tanja Grunert, Cologne, 1988, *Thomas Locher.*

Karsten Schubert Gallery and Interim Art, London, 1987, *Thomas Locher.*

Galerie Tanja Grunert, Cologne, 1987, *Thomas Locher.*

Selected Group Exhibitions

Kunsthalle Wien, 1994, *Jetztzeit.*

Galleria Lia Rumma, Naples, 1994, *Le costanti nell'arte* (catalogue).

Neuberger Museum of Art, State University of New York at Purchase, New York, 1994, *Translucent Writings* (catalogue).

Neuen Galerie am Landesmuseum Joanneum, Graz, Austria, 1993, *Kontext Kunst* (catalogue).

Städtische Kunsthalle Düsseldorf, 1993, *Karl Schmidt-Rottluff Stipendium* (catalogue).

Architekturmuseum Frankfurt, 1993, *Deutsche Kunst mit Photographie: Die 90er Jahre* (catalogue).

Unité d'Habitation, Firminy, France, 1993, *Project Unité* (catalogue).

Kunsthalle Bielefeld, Germany, 1993, *Kunst um Kunst* (catalogue).

Museum of Contemporary Art, Sydney, 1992, *Humpty Dumpty's Kaleidoscope: A New Generation of German Artists* (catalogue).

Westfälisches Landesmuseum für Kunst und Kulturgeschichte, Münster, Germany, 1992, *Das offene Bild: Aspekte der Moderne in Europa nach 1945* (catalogue).

Musée d'Art Moderne de la Ville de Paris (ARC), 1992, *Qui, Quoi, Où?: Un regard sur l'art en Allemagne en 1992* (catalogue).

Städtische Kunsthalle Düsseldorf, 1992, *Avantgarde und Kampagne* (catalogue).

Stichting De Appel, Amsterdam, 1991, *Inscapes* (catalogue).

Galleria Comunale, Bologna, Musei Comunali, Rimini, and ex-colonia "Le Navi," Cattolica, Italy, 1991, *Anni Novanta* (catalogue).

Museum des 20. Jahrhunderts, Vienna, 1991, *Bildlicht: Malerei zwischen Material und Immaterialität* (catalogue).

Bonner Kunstverein, 1991, *Kunstfonds: Zen Jahre* (catalogue).

Venice, 1990, *XLIV Esposizione Internazionale d'Arte: La Biennale di Venezia* (catalogue).

Wiener Secession, 1989, *Wittgenstein* (catalogue).

Tate Gallery Liverpool, 1989, *Art from Köln* (catalogue).

Kunstverein Hamburg, 1989, *'Das Medium der Fotografie ist berechtigt, Denkanstösse zu geben': Sammlung F.C. Gundlach* (catalogue).

Frankfurter Kunstverein und Schirn Kunsthalle, 1989, *Prospect 89: Eine internationale Ausstellung aktueller Kunst* (catalogue).

Magazin, Centre National d'Art Contemporain de Grenoble, 1988, *19&&* (brochure).

Karsten Schubert Gallery and Interim Art, London, 1987, *Denkpause: Günther Förg, Thomas Grünfeld, Thomas Locher, Rosemarie Trockel, Peter Zimmermann* (catalogue).

Selected Bibliography

Neuberger Museum of Art, State University of New York at Purchase, New York. *Translucent Writings* (1994). Exhibition catalogue, with foreword by Lucinda H. Gedeon, afterword by Grita Insam, and essays by Robert Adrian, Friedrich Kittler, Wolfgang Kos, Ferdinand Schmatz, and Peter Weibel.

Neuen Galerie am Landesmuseum Joanneum, Graz, Austria. *Kontext Kunst* (Cologne: DuMont Buchverlag, 1994). Exhibition catalogue edited by Peter Weibel, with essays by Jan Avgikos, Christoph Blase, Benjamin H.D. Buchloh, Joshua Decter, Helmut Draxler, et al., and text by Thomas Locher.

Kunsthalle Bielefeld, Germany. *Kunst um Kunst* (1993). Exhibition catalogue, with introduction by Hans-Michael Herzog and essays by Jean-Pierre Dubost, Johannes Meinhardt, and Tilman Osterwold.

Kravagna, Christian. "Thomas Locher, Hans Weigand." *Artforum* 32 (December 1993), p. 91.

Salzburger Kunstverein. *Thomas Locher, Hans Weigand* (1993). Exhibition catalogue, with essays by Silvia Eiblmayr and Peter Weibel and text by Thomas Locher.

Unité d'Habitation, Firminy, France. *Project Unité* (1993). Exhibition catalogue, with essay by Yves Aupetitallot and text by Thomas Locher.

Kunsthalle Zürich. *Wörter Sätze Zahle Dinge — Tableaus, Fotografien, Bilder* (1993). Exhibition catalogue, with essays by Bernhard Bürgi and Boris Groys (published in conjunction with the exhibition *Thomas Locher*).

Stichting De Appel, Amsterdam. *Thomas Locher* (1992). Exhibition catalogue, with text by Thomas Locher.

Städtische Kunsthalle Düsseldorf. *Avantgarde und Kampagne* (1992). Exhibition catalogue, with essays by Jürgen Harten and Michael Schirner.

Kölnischer Kunstverein. *Wer sagt was und warum — vier imaginäre Räume* (1992). Exhibition catalogue, with essay by Peter Weibel and text by Thomas Locher.

Lebrero Stals, José. "Bielefeld: Thomas Locher, Kunsthalle." *Flash Art*, no. 164 (May–June 1992), p. 124.

Museum of Contemporary Art, Sydney. *Humpty Dumpty's Kaleidoscope: A New Generation of German Artists* (1992). Exhibition catalogue, with foreword by Leon Paroissien and essay by Bernice Murphy.

Musée d'Art Moderne de la Ville de Paris (ARC). *Qui, Quoi, Où?: Un regard sur l'art en Allemagne en 1992* (1992). Exhibition catalogue by Laurence Bossé and Hans-Ulrich Obrist, with Peter Sloterdijk interview by Hans-Ulrich Obrist and essays by Durs Grünbein and John Miller.

Westfälisches Landesmuseum für Kunst und Kulturgeschichte, Münster, Germany. *Das offene Bild: Aspekte der Moderne in Europa nach 1945* (Stuttgart: Edition Cantz, 1992). Exhibition catalogue by Erich Franz, with essays by Eva Schmidt.

Galleria Comunale, Bologna, Musei Comunali, Rimini, and ex-colonia "Le Navi," Cattolica, Italy. *Anni Novanta* (Milan: Arnoldo Mondadori Editore, 1991). Exhibition catalogue, with introduction by Ranato Barilli and essays by Dede Auregli, Jan Avgikos, Roberto Daoglio, José Lebrero Stals, and Françoise-Claire Prodhon.

Brüderlin, Markus. "Thomas Locher: Galerie Metropol." *Artforum* 29 (April 1991), p. 138.

Fleck, Robert. "Thomas Locher: Anne de Villepoix." *Flash Art*, no. 161 (November–December 1991), pp. 142–143.

Thomas Locher: Doppelzimmer (Cologne: Galerie Tanja Grunert and Michael Janssen; Vienna: Galerie Metropol; Paris: Galerie Anne de Villepoix, 1991).

Carpenter, Merlin. "Thomas Locher: Tanja Grunert." *Artscribe*, no. 81 (May 1990), pp. 84–85.

Graw, Isabelle. "Thomas Locher: Learn for Life." *Flash Art*, no. 153 (Summer 1990), pp. 116–117.

Magnani, Vittorio. "Ordering Procedures." *Arts Magazine* 64 (March 1990), pp. 78–83.

Smolik, Noemi. "Thomas Locher: Galerie Tanja Grunert." *Artforum* 28 (April 1990), p. 187.

Frankfurter Kunstverein und Schirn Kunsthalle. *Prospect 89: Eine internationale Ausstellung aktueller Kunst* (1989). Exhibition catalogue by Peter Weiermair.

Tate Gallery Liverpool. *Art from Köln* (1989). Exhibition catalogue, with introduction by Lewis Biggs and essays by Lucie Beyer, Karen Marta, and Hein Stünke.

Wiener Secession, and Palais de Beaux Arts, Brussels. *Wittgenstein: Le Jeu de l'indicible / The Play of the Unsayable* (1989). Exhibition catalogue, with introduction by Marcel Huys.

Cameron, Dan. *Thomas Locher* (Cologne: Galerie Tanja Grunert; London: Interim Art and Karsten Schubert Gallery, 1987).

Locher, Thomas. *Das Eine — das Selbe — das Gleiche* (Cologne: Galerie Tanja Grunert; Munich: Galerie Christoph Dürr, 1987).

Morgan, Stuart. "The World in Pieces." *Artscribe*, no. 65 (September–October 1987), pp. 65–66.

Karsten Schubert Gallery and Interim Art, London. *Denkpause: Günther Förg, Thomas Grünfeld, Thomas Locher, Rosemarie Trockel, Peter Zimmermann* (1987). Exhibition catalogue, with essay by Stuart Morgan.

Agnes Martin

b. 1912, Macklin, Saskatchewan, Canada

lives in Taos, New Mexico, USA

Selected One-Person Exhibitions

PaceWildenstein, New York, 1995,
Agnes Martin: Recent Paintings.

Magasin 3 Stockholm, 1994, *Agnes Martin: Målningar* (brochure).

Santa Fe Museum of Fine Arts, New Mexico, 1994, *Agnes Martin.*

Galerie Michael Werner, Cologne, 1994, *Agnes Martin: Bilder.*

Wildenstein Gallery, Tokyo, 1993, *Agnes Martin.*

Whitney Museum of American Art, New York, 1992, *Agnes Martin* (catalogue).

Galerie Yvon Lambert, Paris, 1992, *Agnes Martin.*

Pace Gallery, New York, 1991, *Agnes Martin: Recent Paintings.*

Chinati Foundation, Marfa, Texas, 1991, *Agnes Martin: On a Clear Day.*

Stedelijk Museum, Amsterdam, 1991, *Agnes Martin: Paintings and Drawings / Peintures et Dessins / Schilderijen en Tekeningen / Gemälde und Zeichnungen, 1974–1990* (catalogue).

Mary Boone Gallery, New York, 1991, *Agnes Martin: Paintings 1959 to 1969.*

Cleveland Museum of Art, Ohio, 1989, *Agnes Martin: Recent Works* (brochure).

Akira Ikeda Gallery, Tokyo, 1989, *Agnes Martin* (catalogue).

Galerie Yvon Lambert, Paris, 1987, *Agnes Martin: Peintures, 1975–1986.*

Waddington Galleries, London, 1986, *Agnes Martin: Recent Paintings* (catalogue).

Mayor Gallery, London, 1984, *Agnes Martin: Recent Paintings* (brochure).

Wichita State University, Kansas, 1980, *Agnes Martin.*

Mayor Gallery, London, 1978, *Agnes Martin: Six New Paintings.*

Hayward Gallery, London, 1977, *Agnes Martin: Paintings and Drawings, 1957–75* (catalogue).

Pace Gallery, New York, 1975, *Agnes Martin: New Paintings.*

Kunstraum München, 1973, *Agnes Martin* (catalogue).

Institute of Contemporary Art, University of Pennsylvania, Philadelphia, 1973, *Agnes Martin* (catalogue).

Robert Elkon Gallery, New York, 1972, *Agnes Martin: Eight Paintings, 1961–1967.*

Nicholas Wilder Gallery, Los Angeles, 1967, *October — Agnes Martin.*

Nicholas Wilder Gallery, Los Angeles, 1965, *Agnes Martin.*

Robert Elkon Gallery, New York, 1962, *Agnes Martin Paintings.*

Betty Parsons Gallery, New York, 1958, *Agnes Martin.*

Selected Group Exhibitions

Whitney Museum of American Art, New York, 1995, *1995 Biennial Exhibition* (catalogue).

Kunsthalle Wien, 1993, *Der zerbrochene Spiegel: Positionen zur Malerei* (catalogue).

Martin-Gropius-Bau, Berlin, and Royal Academy of Arts, London, 1993, *American Art in the 20th Century: Painting and Sculpture, 1913–1993* (catalogue).

Lingotto, Turin, Italy, 1992, *Arte Americana, 1930–1970* (catalogue).

Albright-Knox Art Gallery, Buffalo, New York, 1989, *Abstraction, Geometry, Painting: Selected Geometric Abstract Painting in America since 1945* (catalogue).

Museums Ludwig in den Rheinhallen der Kölner Messe, 1989, *Bilderstreit: Widerspruch, Einheit und Fragment in der Kunst seit 1960* (catalogue).

Carnegie Museum of Art, Pittsburgh, Pennsylvania, 1988, *Carnegie International* (catalogue).

Museum of Contemporary Art, Los Angeles, 1986, *Individuals: A Selected History of Contemporary Art, 1945–1986* (catalogue).

Museum of Modern Art, New York, 1985, *Contrasts of Form: Geometric Abstract Art, 1910–1980* (catalogue).

Stedelijk Museum, Amsterdam, 1982, *'60 '80: attitudes / concepts / images* (catalogue).

Messegelände, Cologne, 1981, *Westkunst: Zeitgenössische Kunst seit 1939* (catalogue).

San Francisco Museum of Modern Art, 1980, *Twenty American Artists* (catalogue).

Venice, 1980, *XXXIX Biennale di Venezia* (catalogue).

Hirshhorn Museum and Sculpture Garden, Smithsonian Institution, Washington, D.C., 1980, *The Fifties: Aspects of Painting in New York* (catalogue).

Art Institute of Chicago, 1979, *73rd American Exhibition* (catalogue).

Pace Gallery, New York, 1978, *Grids: Format and Image in 20th-Century Art* (catalogue).

Fine Arts Center Gallery, University of Massachusetts, Amherst, 1976, *Critical Perspectives in American Art* (catalogue).

Stedelijk Museum, Amsterdam, 1975, *Fundamentele Schilderkunst / Fundamental Painting* (catalogue).

Kassel, 1972, *documenta 5* (catalogue).

Institute of Contemporary Art, University of Pennsylvania, Philadelphia, 1972, *Grids* (catalogue).

Philadelphia Museum of Art, Pennsylvania, 1968, *The Pure and Clear: American Innovations* (catalogue).

Museum of Modern Art, New York, 1968, *Art of the Real: USA, 1948–1968* (catalogue).

Institute of Contemporary Art, University of Pennsylvania, Philadelphia, 1967, *A Romantic Minimalism* (catalogue).

Solomon R. Guggenheim Museum, New York, 1966, *Systemic Painting* (catalogue).

Museum of Modern Art, New York, 1965, *The Responsive Eye* (catalogue).

Solomon R. Guggenheim Museum, New York, 1964, *American Drawings* (catalogue).

Wadsworth Atheneum, Hartford, Connecticut, 1964, *Black, White, and Grey*.

Whitney Museum of American Art, New York, 1962, *Geometric Abstraction in America* (catalogue).

Department of Fine Arts of Carnegie Institute, Pittsburgh, Pennsylvania, 1961, *The 1961 Pittsburgh International Exhibition of Contemporary Painting and Sculpture* (catalogue).

Helmhaus, Zürich, 1960, *Konkrete Kunst: Fünfzig Jahre Entwicklung* (catalogue).

Selected Bibliography

Whitney Museum of American Art, New York. *1995 Biennial Exhibition* (New York: Harry N. Abrams, 1995). Exhibition catalogue by Klaus Kertess, with essays by Gerald M. Edelman, John G. Hanhardt, and Lynne Tillman and poem by John Ashbery.

Cotter, Holland. "Agnes Martin: All the Way to Heaven." *Art in America* 81 (April 1993), pp. 88–97, 149.

Martin-Gropius-Bau, Berlin, and Royal Academy of Arts, London. *American Art in the 20th Century: Painting and Sculpture, 1913–1993* (Berlin: Zeitgeist-Gesellschaft; Munich: Prestel, 1993). Exhibition catalogue by Christos M. Joachimides and Norman Rosenthal, with essays by Brooks Adams, David Anfam, Richard Armstrong, John Beardsley, Neal Benezra, et al.

Serpentine Gallery, London. *Agnes Martin* (1993). Exhibition catalogue, with foreword by Julia Peyton-Jones, essay by Germano Celant, interview by Irving Sandler, and text by Agnes Martin.

Kunsthalle Wien and Deichtorhallen Hamburg. *Der zerbrochene Spiegel: Positionen zur Malerei* (1993). Exhibition catalogue by Kasper König and Hans-Ulrich Obrist, with essays by Klaus Bachler, Zdenek Felix, Ursula Pasterk, and Toni Stooss.

Kimmelman, Michael. "Nature's Mystical Poetry, Written in Paint." *The New York Times*, November 15, 1992, p. H35.

Schjeldahl, Peter. "Martin Eyes." *Village Voice*, November 24, 1992, p. 100.

Schwarz, Dieter, ed. *Agnes Martin: Writings / Schriften* (Winterthur: Kunstmuseum Winterthur; Stuttgart: Edition Cantz, 1992).

Whitney Museum of American Art, New York. *Agnes Martin* (New York: Harry N. Abrams, 1992). Exhibition catalogue by Barbara Haskell, with essays by Anna C. Chave and Rosalind Krauss and text by Agnes Martin.

Stedelijk Museum, Amsterdam. *Agnes Martin: Paintings and Drawings / Peintures et Dessins / Schilderijen en Tekeningen / Gemälde und Zeichnungen, 1974–1990* (1991). Exhibition catalogue by Marja Bloem, with essays by Mark Stevens and Erich Franz and text by Agnes Martin and Ann Wilson.

Albright-Knox Art Gallery, Buffalo, New York. *Abstraction, Geometry, Painting: Selected Geometric Abstract Painting in America since 1945* (1989). Exhibition catalogue, with essay by Michael Auping.

Cleveland Museum of Art, Ohio. *Agnes Martin: Recent Works* (1989). Exhibition brochure, with essay by Tom E. Hinson.

Museums Ludwig in den Rheinhallen der Kölner Messe. *Bilderstreit: Widerspruch, Einheit und Fragment in der Kunst seit 1960* (Cologne: DuMont Buchverlag, 1989). Exhibition catalogue by Siegfried Gohr and Johannes Gachnang, with essays by Hans Belting, André Berne-Joffroy, Emile Cioran, Michael Compton, Piet de Jonge, et al.

Carnegie Museum of Art, Pittsburgh, Pennsylvania. *Carnegie International* (Munich: Prestel, 1988). Exhibition catalogue, with essays by John Caldwell, Vicky Clark, Lynne Cooke, Milena Kalinovska, and Thomas McEvilley.

McEvilley, Thomas. "'Grey Geese Descending': The Art of Agnes Martin." *Artforum* 25 (Summer 1987), pp. 94–99.

Museum of Contemporary Art, Los Angeles. *Individuals: A Selected History of Contemporary Art, 1945–1986* (New York: Abbeville Press, 1986). Exhibition catalogue edited by Howard Singerman, with introduction by Julia Brown Turrell and essays by Germano Celant, Hal Foster, Donald Kuspit, Kate Linker, Ronald J. Onorato, et al.

Museum of Modern Art, New York. *Contrasts of Form: Geometric Abstract Art, 1910–1980* (1985). Exhibition catalogue, with essays by Magdalena Dabrowski and John Elderfield.

Stedelijk Museum, Amsterdam. *'60 '80: attitudes / concepts / images* (Amsterdam: Van Gennep, 1982). Exhibition catalogue, with foreword by Edy de Wilde, introduction by Ad Petersen, essays by Wim Beeren, Cor Blok, Antje von Graevenitz, and Gijs von Tuyl, and text by Agnes Martin.

Messegelände, Cologne. *Westkunst: Zeitgenössische Kunst seit 1939* (Cologne: Du Mont Buchverlag, 1981). Exhibition catalogue by Lazlo Glozer, with introduction by Kasper König.

Hirshhorn Museum and Sculpture Garden, Smithsonian Institution, Washington, D.C. *The Fifties: Aspects of Painting in New York* (1980). Exhibition catalogue by Phyllis Rosenzweig.

Pace Gallery, New York. *Grids: Format and Image in 20th-Century Art* (1978). Exhibition catalogue, with essay by Rosalind Krauss.

Hayward Gallery, London. *Agnes Martin: Paintings and Drawings, 1957–75* (London: Arts Council of Great Britain, 1977). Exhibition catalogue, with essay by Dore Ashton and text by Agnes Martin.

Fine Arts Center Gallery, University of Massachusetts, Amherst. *Critical Perspectives in American Art* (1976). Exhibition catalogue, with essays by Sam Hunter, Rosalind Krauss, and Marcia Tucker.

Stedelijk Museum, Amsterdam. *Fundamentele Schilderkunst / Fundamental Painting* (1975). Exhibition catalogue, with introduction by de Wilde, essay by Rini Dippel, and text by Agnes Martin.

Alloway, Lawrence. "Formlessness Breaking down Form: The Paintings of Agnes Martin." *Studio International* 185 (February 1973), pp. 61–63.

Kunstraum München. *Agnes Martin* (1973). Exhibition catalogue, with essay by Hermann Kern.

Institute of Contemporary Art, University of Pennsylvania, Philadelphia. *Agnes Martin* (1973). Exhibition catalogue, with foreword by Suzanne Delehanty, essay by Lawrence Alloway, and text by Agnes Martin and Anne Wilson.

Institute of Contemporary Art, University of Pennsylvania, Philadelphia. *Grids* (1972). Exhibition catalogue, with essay by Lucy R. Lippard.

Museum of Modern Art, New York. *Art of the Real: USA, 1948–1968* (1968). Exhibition catalogue, with essay by E.C. Goossen.

Philadelphia Museum of Art, Pennsylvania. *The Pure and Clear: American Innovations* (1968). Exhibition catalogue, with foreword by Evan H. Turner and introduction by Eleanor B. Lloyd.

Institute of Contemporary Art, University of Pennsylvania, Philadelphia. *A Romantic Minimalism* (1967). Exhibition catalogue, with essay by Stephen S. Prokopoff.

Solomon R. Guggenheim Museum, New York. *Systemic Painting* (1966). Exhibition catalogue, with essay by Lawrence Alloway.

Museum of Modern Art, New York. *The Responsive Eye* (1965). Exhibition catalogue, with essay by William C. Seitz.

Solomon R. Guggenheim Museum, New York. *American Drawings* (1964). Exhibition catalogue, with essay by Lawrence Alloway.

Whitney Museum of American Art, New York. *Geometric Abstraction in America* (1962). Exhibition catalogue, with essay by John Gordon.

Beatriz Milhazes

b. 1960, Rio de Janeiro, Brazil

lives in Rio de Janeiro, Brazil

Selected One-Person Exhibitions

Dorothy Goldeen Gallery, Los Angeles, 1995, *Beatriz Milhazes*.

Paço Imperial, Rio de Janeiro, 1995, *Projeto FINEP* (catalogue).

Galeria Anna Maria Niemeyer, Rio de Janeiro, 1994, *Beatriz Milhazes: Pinturas*.

Paço Imperial, Rio de Janeiro, 1994, *Beatriz Milhazes*.

Galería Ramis Barquet, Monterrey, Mexico, 1994, *Beatriz Milhazes* (catalogue).

Galeria Camargo Vilaça, São Paulo, 1993, *Beatriz Milhazes: Pinturas Recentes* (catalogue).

Subdistrito Comercial de Arte, São Paulo, 1991, *Beatriz Milhazes* (catalogue).

Galeria Saramenha, Rio de Janeiro, 1990, *Beatriz Milhazes*.

Pasárgada Arte Contemporânea, Recife, Brazil, 1989, *Beatriz Milhazes*.

Galeria Suzana Sassoun, São Paulo, Brazil, 1988, *Beatriz Milhazes*.

Galeria Cesar Aché, Rio de Janeiro, 1987, *Beatriz Milhazes* (catalogue).

Galeria Cesar Aché, Rio de Janeiro, 1985, *Beatriz Milhazes*.

Selected Group Exhibitions

Galeria Camargo Vilaça, São Paulo, 1995 (catalogue).

Galerie Regard, Geneva, 1995.

Museu de Arte Moderna, Rio de Janeiro, 1995, *Anos 80* (catalogue).

Center for the Arts, Yerba Buena Gardens, San Francisco, 1994, *The Exchange Show: Twelve Painters from San Francisco and Rio de Janeiro* (catalogue).

Luigi Marrozzini Gallery, San Juan, Puerto Rico, 1994, *Pequeño Formato Latinoamericano* (catalogue).

Museo de Guadalajara, Mexico, 1994, *Encuentro Interamericano de Artes Plásticas: Dialogo Sobre Siete Puntos*.

National Museum of Women in the Arts, Washington, D.C., 1993, *UltraModern: The Art of Contemporary Brazil* (catalogue).

Sala Alternativa Artes Visuales, Caracas, 1992, *América*.

Museu de Arte Moderna do Rio de Janeiro, 1992, *Eco / Arte* (catalogue).

Museo de Bellas Artes, Caracas, 1991, *Brasil: La nueva generación* (catalogue).

Casa França-Brasil, Rio de Janeiro, 1991, *BR / 80, A Pintura dos anos 80* (catalogue).

Museu de Arte Moderna do Rio de Janeiro, 1989, *Rio hoje*.

Museu de Arte Contemporânea da Universidade de São Paulo, 1989, *Canale, Fonseca, Milhazes, Pizarro, Zerbini* (catalogue).

Cuenca, Ecuador, 1989, *II Bienal Internacional de Cuenca* (catalogue).

Funarte, Rio de Janeiro, 1988, *Salão Nacional de Artes Plásticas* (catalogue).

Parque Lage, Rio de Janeiro, 1986, *Território ocupado* (catalogue).

Parque Lage, Rio de Janeiro, 1984, *Como vai você, Geração 80?* (catalogue).

Museu de Arte Moderna do Rio de Janeiro, 1983, *Salão Nacional de Artes Plásticas* (catalogue).

Selected Bibliography

Galería Ramis Barquet, Monterrey, Mexico. *Beatriz Milhazes* (1994). Exhibition catalogue, with essay by Paulo Herkenhoff.

Reis, Paulo. "A Sofisticação do Popular." *Jornal do Brasil*, May 4, 1994, p. B6.

Sada, Paola. "Beatriz Milhazes: Galería Ramis Barquet." *Art Nexus*, no. 14 (October 1994), p. 121.

Center for the Arts, Yerba Buena Gardens, San Francisco. *The Exchange Show: Twelve Painters from San Francisco and Rio de Janeiro* (San Francisco: Society for Art Publications of the Americas, 1994). Exhibition catalogue by Anne Trueblood Brodzky and Marcus de Lontra Costa.

Sala Alternativa Artes Visuales, Caracas, and Galeria Camargo Vilaça, São Paulo. *Beatriz Milhazes: Pinturas Recentes* (1993). Exhibition catalogue, with essay by Stella Teixeira de Barros.

Caula, Sandra. "Superficies Profundas de Beatriz Milhazes." *Arte Internacional* 17 (October 1993), p. 35.

Comodo, Roberto. "Explosão de Cores e Arabescos." *Jornal do Brasil*, October 11, 1993, p. B4.

Davila, Sergio. "Essa Moça É do Babado." *Revista da Folha* (November 1993), p. 14.

National Museum of Women in the Arts, Washington, D.C. *UltraModern: The Art of Contemporary Brazil* (1993). Exhibition catalogue, with introduction by Susan Fisher Sterling and essays by Aracy A. Amaral and Paulo Herkenhoff.

Andrade, Geraldo Edson. "Eco/Art." *Revista Galeria*, no. 27 (1992), p. 83.

Andrade, Geraldo Edson. "Eco/Art." *Revista Ventura*, no. 21 (1992), pp. 48–61.

Mesquita, Ivo. "Arte y ecologia—Eco/Art." *Art Nexus*, no. 6 (October 1992), pp. 156–157.

Museu de Arte Moderna do Rio de Janeiro. *Eco/Arte* (1992). Exhibition catalogue, with essay by Charles Merewether.

Casa França-Brasil, Rio de Janeiro. *BR 80: Pintura Brasil década de 80* (Rio de Janeiro: Prazer e Reflexão, 1991). Exhibition catalogue, with essays by Aracy A. Amaral and Frederico Morais.

Morais, Frederico. "Beatriz Milhazes: Decor não é crime." *Revista Galeria*, no. 25 (1991), pp. 56–59.

Subdistrito Comercial de Arte, São Paulo. *Beatriz Milhazes* (1991). Exhibition catalogue, with essay by Luiz Ernesto.

Basbaum, Ricardo. "Planos Múltiplos." *Guia das Artes* 20 (September 1990), pp. 96–98.

Cuenca, Ecuador. *II Bienal Internacional de Cuenca* (1989). Exhibition catalogue.

Museu de Arte Contemporânea da Universidade de São Paulo. *Canale, Fonseca, Milhazes, Pizarro, Zerbini* (1989). Exhibition catalogue, with essay by Fernando Cochiaralle.

Basbaum, Ricardo. "Pintura dos anos 80." *Revista Gávea*, no. 6 (1988), pp. 39–57.

Joan Mitchell

b. 1926, Chicago, Illinois, USA
d. 1992, Paris, France

Selected One-Person Exhibitions

Galerie nationale du Jeu de Paume, Paris, 1994, *Joan Mitchell: les dernières années (1983–1992)*, and Musée des Beaux-Arts, Nantes, 1994, *Joan Mitchell: œuvres de 1951 à 1982* (catalogue).

Whitney Museum of American Art, New York, 1992, *Joan Mitchell: Pastels* (catalogue).

Laura Carpenter Fine Art, Santa Fe, New Mexico, 1992, *Joan Mitchell: Trees and Other Paintings, 1960 to 1990* (catalogue).

Robert Miller Gallery, New York, 1989, *Joan Mitchell* (catalogue).

Herbert F. Johnson Museum of Art, Cornell University, Ithaca, New York, 1988, *Joan Mitchell* (catalogue).

Musée d'Art Moderne de la Ville de Paris (ARC), 1982, *Joan Mitchell: choix de peintures, 1970–1982* (catalogue).

Whitney Museum of American Art, New York, 1974, *Joan Mitchell* (catalogue).

Everson Museum of Art, Syracuse, New York, 1972, *Joan Mitchell: My Five Years in the Country* (catalogue), and Martha Jackson Gallery, New York, 1972, *Blue Series, 1970–1971; The Field Series, 1971–1972*.

Martha Jackson Gallery, New York, 1968, *Joan Mitchell: Recent Paintings*.

Galerie Jean Fournier, Paris, 1967, *Joan Mitchell* (brochure).

Galerie Jacques Dubourg and Galerie Lawrence, Paris, 1962, *Joan Mitchell* (brochure).

Stable Gallery, New York, 1953, *Joan Mitchell*.

Selected Group Exhibitions

Fondation Cartier, Jouy-en-Josas, France, 1993, *Azur* (catalogue).

Newport Harbor Art Museum, Newport Beach, California, 1984, *Action / Precision: The New Direction in New York, 1955–60* (catalogue).

Hirshhorn Museum and Sculpture Garden, Smithsonian Institution, Washington, D.C., 1980, *The Fifties: Aspects of Painting in New York* (catalogue).

Musée national d'art moderne, Centre Georges Pompidou, Paris, 1977, *Paris–New York* (catalogue).

Museum of Art, Carnegie Institute, Pittsburgh, Pennsylvania, 1972, *Fresh Air School. Exhibition of Paintings: Sam Francis, Joan Mitchell, Walasse Ting* (catalogue).

Museum of Modern Art International Council, New York, 1966, *Two Decades of American Painting* (organized to travel to Japan and India) (catalogue).

Solomon R. Guggenheim Museum, New York, 1961, *American Abstract Expressionists and Imagists* (catalogue).

Stable Gallery, New York, 1959, *School of New York: Some Younger Artists* (organized by Stable Gallery and American Federation of Arts).

Jewish Museum, New York, 1957, *The New York School: Second Generation. Paintings by Twenty-three Artists* (catalogue).

60 East Street, New York, 1951, *Ninth Street Exhibition of Paintings and Sculpture.*

Selected Bibliography

Galerie nationale du Jeu de Paume, Paris, and Musée des Beaux-Arts, Nantes. *Joan Mitchell* (1994). Exhibition catalogue, with introduction by Daniel Abadie and Henry-Claude Cousseau, essay by Robert Storr and two interviews by Yves Michaud.

Fondation Cartier, Jouy-en-Josas, France. *Azur* (1993). Exhibition catalogue, with introduction by Hervé Chandés and essays by Manlio Brusatin, Michel Cassé, Paolo Fabbri, Michael Jakob, Jacqueline Lichtenstein, et al.

Kimmelman, Michael. "Joan Mitchell." *The New York Times*, April 9, 1993, p. C26.

Kuspit, Donald. "Joan Mitchell: Robert Miller and Susan Sheehan." *Artforum* 32 (October 1993), p. 88.

Robert Miller Gallery, New York. *Joan Mitchell 1992* (1993). Exhibition catalogue, with foreword by John Ashbery.

Schjeldahl, Peter. "Different Strokes." *Village Voice*, April 27, 1993, p. 95.

Laura Carpenter Fine Art, Santa Fe, New Mexico. *Joan Mitchell: Trees and Other Paintings, 1960 to 1990* (1992). Exhibition catalogue, with essay and poem by John Yau.

Kertess, Klaus. "Joan Mitchell: The Last Decade." *Art in America* 80 (December 1992), pp. 94–100.

Robert Miller Gallery, New York. *Joan Mitchell: Pastel* (1992). Exhibition catalogue, with essay by Klaus Kertess (published in conjunction with exhibition at Whitney Museum of American Art).

Johnson, Ken. "Joan Mitchell at Robert Miller." *Art in America* 79 (October 1991), pp. 146–147.

Russell, John. "Paintings that Liberate the Viewer's Imagination." *The New York Times*, April 12, 1991, p. C22.

Solomon, Deborah. "In Monet's Light." *The New York Times Magazine*, November 24, 1991, pp. 44–50, 62–64.

Berkson, Bill. "In Living Chaos: Joan Mitchell." *Artforum* 27 (September 1988), pp. 96–99.

Herbert F. Johnson Museum of Art, Cornell University, Ithaca, New York. *Joan Mitchell* (New York: Hudson Hills Press, 1988). Exhibition catalogue by Judith E. Bernstock.

Newport Harbor Art Museum, Newport Beach, California. *Action / Precision: The New Direction in New York, 1955–60* (1984). Exhibition catalogue by Paul Schimmel, with essays by B.H. Friedman, John Bernard Myers, and Robert Rosenblum.

Musée d'Art Moderne de la Ville de Paris (ARC). *Joan Mitchell: choix de peintures 1970–1982* (1982). Exhibition catalogue, with introduction by Suzanne Pagé, essays by Marcelin Pleynet and Barbara Rose, and text by Joan Mitchell.

Hirshhorn Museum and Sculpture Garden, Smithsonian Institution, Washington, D.C. *The Fifties: Aspects of Painting in New York* (1980). Exhibition catalogue by Phyllis Rosenzweig.

Sandler, Irving. *The New York School: The Painters and Sculptors of the Fifties* (New York: Harper and Row, 1978).

Musée national d'art moderne, Centre Georges Pompidou, Paris. *Paris-New York* (1977). Exhibition catalogue by Pontus Hulten, with essays by Daniel Abadie, Robert Bordaz, Gabrielle Buffet-Picabia, Alfred Pacquement, Hélène Seckel, et al.

Ratcliff, Carter. "Joan Mitchell's Envisionments." *Art in America* 62 (July–August 1974), pp. 34–37.

Whitney Museum of American Art, New York. *Joan Mitchell* (1974). Exhibition catalogue by Marcia Tucker.

Museum of Modern Art International Council, New York. *Two Decades of American Painting* (1966). Exhibition catalogue, with introduction by Waldo Rasmussen and essays by Lucy R. Lippard, Irving Sandler, and G.R. Swenson.

Rose, Barbara. "The Second Generation: Academy and Breakthrough." *Artforum* 4 (September 1965), pp. 53–63.

Solomon R. Guggenheim Museum, New York. *American Abstract Expressionists and Imagists* (1961). Exhibition catalogue, with introduction by H. Harvard Arnason.

B.H. Friedman, ed. *School of New York: Some Younger Artists* (New York: Grove Press; London: Evergreen Books, 1959).

Jewish Museum, New York. *The New York School: Second Generation. Paintings by Twenty-three Artists* (1957). Exhibition catalogue, with essay by Leo Steinberg.

Tomoharu Murakami

b. 1938, Tokyo, Japan
lives in Tokyo, Japan

Selected One-Person Exhibitions

Gallery Shimada, Tokyo, 1993, *Tomoharu Murakami: The Latter Term.*

Gallery Shimada, Tokyo, 1993, *Tomoharu Murakami: The First Term.*

Gallery Ando, Tokyo, 1993, *Tomoharu Murakami.*

Galerie Katrin Rabus, Bremen, 1992, *Tomoharu Murakami.*

Gallery Shimada, Tokyo, 1992,
Tomoharu Murakami (catalogue).

James Corcoran Gallery, Los Angeles, 1992,
Tomoharu Murakami.

Gallery Shimada, Yamaguchi, Japan, 1991,
Tomoharu Murakami.

Kasahara Gallery, Osaka, 1991,
Tomoharu Murakami.

Richard Gray Gallery, Chicago, 1991,
Tomoharu Murakami: Paintings.

Shigeru Yokota Gallery, Tokyo, 1990,
Tomoharu Murakami (catalogue).

Gallery Shimada, Yamaguchi, Japan, 1989,
Tomoharu Murakami.

Shigeru Yokota Gallery, Tokyo, 1989,
Tomoharu Murakami (catalogue).

Galerie Elke Dröscher, Hamburg, 1989,
Tomoharu Murakami.

Gatodo Gallery, Tokyo, 1988,
Tomoharu Murakami (catalogue).

Galerie Zellermeyer, Berlin, 1988,
Tomoharu Murakami (catalogue).

Galerie Loehr, Frankfurt, 1988,
Tomoharu Murakami.

Gallery Shimada, Yamaguchi, Japan, 1988,
Tomoharu Murakami.

Kommunale Galerie in der Weserburg,
Bremen, 1987, *Tomoharu Murakami*.

Galerie Katrin Rabus, Bremen, 1987,
Tomoharu Murakami.

James Corcoran Gallery, Los Angeles, 1987,
Tomoharu Murakami.

Gatodo Gallery, Tokyo, 1985,
Tomoharu Murakami (catalogue).

Laboratory Gallery, Sapporo, Japan, 1985,
Tomoharu Murakami (catalogue).

Gatodo Gallery, Tokyo, 1984,
Tomoharu Murakami (catalogue).

Jiyūgaoka Gallery, Tokyo, 1983,
Tomoharu Murakami (catalogue).

Los Angeles Institute of Contemporary Art,
1981, *Tomoharu Murakami* (catalogue).

Gatodo Gallery, Tokyo, 1978,
Tomoharu Murakami (catalogue).

Minami Gallery, Tokyo, 1975,
Tomoharu Murakami (catalogue).

Yoseido Gallery, Tokyo, 1974,
Tomoharu Murakami (catalogue).

Yoseido Gallery, Tokyo, 1963,
Tomoharu Murakami (catalogue).

Yoseido Gallery, Tokyo, 1961,
Tomoharu Murakami (catalogue).

Selected Group Exhibitions

Meguro Museum of Art, Japan, 1994,
Explore the Mystery of the Color Red
(catalogue).

Shiseidō Gallery, Tokyo, 1994,
Tsubaki-kai Exhibition '94 (catalogue).

Frederick R. Weisman Museum of Art,
Pepperdine University, Malibu, California,
1994, *Conversations on the Rim: Joe Goode
and Tomoharu Murakami* (catalogue).

Neues Museum Weserburg, Bremen,
1992, *Von Aufang au...*

Fukuyama Museum of Art, Japan,
1991, *Japanese Paintings in the 20th Century:
Modernism and Beyond* (catalogue).

Miyagi Museum of Art, Japan, 1991,
Painting from the Showa Era (1926–1989)
(catalogue).

New Museum of Contemporary Art,
New York, 1991, *Cadences: Icon and Abstraction
in Context* (catalogue).

Frankfurter Kunstverein, 1990, *Japanische
Kunst der Achtziger Jahre* (catalogue).

Royal Hospital Kilmainham, Dublin, 1988,
ROSC '88 Exhibition of Contemporary Art
(catalogue).

Tokyo Metropolitan Art Museum, 1984,
*Trends of Contemporary Japanese Art,
1970–1984: Universality/Individuality*
(catalogue).

Museum of Modern Art, Seoul, 1981,
*Contemporary Japanese Art Exhibition:
Trends of Japanese Art, 1970s* (catalogue).

São Paulo, 1981, *XVI Bienal de São Paulo*
(catalogue).

Kyoto National Museum of Modern Art,
1964, *Contemporary Trends of Japanese Paintings
and Sculptures* (catalogue).

Selected Bibliography

Frederick R. Weisman Museum of Art,
Pepperdine University, Malibu, California.
*Conversations on the Rim: Joe Goode
and Tomoharu Murakami* (1994). Exhibition
catalogue, with essay by Dana Friis-Hansen.

Koplos, Janet. "Rockets and Refrigerators."
Art in America 81 (July 1993), pp. 67–72.

Monos (Tokyo: Tokyo Publishing House,
1993). Exhibition catalogue.

Gallery Shimada, Tokyo, and Galerie Katrin
Rabus, Bremen. *Tomoharu Murakami*
(1992). Exhibition catalogue, with essays by
Thomas Deecke and Mikio Takata.

New Museum of Contemporary Art,
New York. *Cadences: Icon and Abstraction in
Context* (1991). Exhibition catalogue, with
introduction by Gary Sangster, essays by
Elizabeth Grosz and Yve-Alain Bois, and
text by Tomoharu Murakami.

Shigeru Yokota Gallery, Tokyo. *Tomoharu
Murakami: The Stations of the Cross* (1989).
Exhibition catalogue, with essay by
Eberhard Kuhn.

Mollenkof, Peter. "Tomoharu Murakami:
Gatodo." *Artnews* 87 (April 1988), p. 177.

Royal Hospital Kilmainham, Dublin.
ROSC '88 Exhibition of Contemporary Art
(1988). Exhibition catalogue, with foreword
by Patrick J. Murphy, introduction by
Rosemarie Mulcahy, and essay by
Fred Gaysek.

Colpitt, Frances. "Tomoharu Murakami
at James Corcoran." *Art in America* 75
(November 1987), pp. 186, 189.

Gatodo Gallery, Tokyo. *Murakami Tomoharu*
(1985). Exhibition catalogue, with essay by
Shigeo Chiba.

Laboratory Gallery, Sapporo, Japan.
Paintings of Murakami Tomoharu: Towards Depth
(1985). Exhibition catalogue, with essay by
Shigeo Chiba.

Los Angeles Institute of Contemporary Art. *Tomoharu Murakami* (1981). Exhibition catalogue by Noriko Fujinami, with essays by Tamon Miki and Hideki Nakamura.

Minami Gallery, Tokyo. *Tomoharu Murakami* (1975). Exhibition catalogue, with essay by Yusuke Nakahara.

Yoseido Gallery, Tokyo. *Murakami Tomoharu* (1974). Exhibition brochure, with essay by Tamon Miki.

Tony Oursler

b. 1957, New York, New York, USA

lives in New York, New York, USA

Selected One-Person Exhibitions

Wiener Secession, 1995, *Tony Oursler.*

Stedelijk Van Abbemuseum, Eindhoven, Netherlands, 1995, *Tony Oursler.*

Galerie Ghislaine Hussenot, Paris, 1995, *Tony Oursler.*

Les Musées de la Ville de Strasbourg, 1995, *Tony Oursler: Installations vidéo, objets, aquarelles.*

Centre d'Art Contemporain, Geneva, 1995, *Tony Oursler.*

rum, Malmö, Sweden, 1995, *Tony Oursler: Hysterical.*

Metro Pictures, New York, 1994, *Tony Oursler: Dummies, Flowers, Alters, Clouds, and Organs.*

Portikus, Frankfurt, 1994, *Systems for Dramatic Feedback* (catalogue).

Jean Bernier Gallery, Athens, 1994, *Tony Oursler.*

Lisson Gallery, London, 1994, *Tony Oursler.*

Ikon Gallery, Birmingham, *Tony Oursler: Dummies, Dolls, and Poison Candies...,* and Bluecoat Gallery, London, 1993, *Tony Oursler:...Cigarettes, Flowers, and Videotapes.*

Centre d'Art Contemporain, Geneva, 1993, *Tony Oursler: White Trash and Phobic* (catalogue).

Kortrijk Railway Station, Netherlands, 1992, *Station Project* (with James Casebere).

Diane Brown Gallery, New York, 1991, *Tony Oursler.*

Hallwalls Contemporary Arts Center, Buffalo, New York, 1990, *Tony Oursler.*

Kitchen Center for Video and Music, New York, 1989, *Relatives* (with Constance DeJong).

Kijkhuis, The Hague, 1985, *Tony Oursler.*

Los Angeles Contemporary Exhibitions — Panic House, 1983, *The Tony Oursler Show.*

Walker Art Center, Minneapolis, Minnesota, 1982, *Tony Oursler.*

Selected Group Exhibitions

Museum of Modern Art, New York, 1995, *Video Spaces: Eight Installations* (catalogue).

Centro Civico per l'Arte La Grancia, Serre di Rapolano, Siena, Italy, 1995, *Invito a Serre: XIV Grancia. Immagini in prospettive.*

Dia Center for the Arts, New York, 1995, *Fantastic Prayers.*

Kunsthaus Zürich, 1995, *Zeichen & Wunder.*

Laura Carpenter Fine Art, Santa Fe, New Mexico, 1994, *Tony Oursler, Jim Shaw.*

Salzburger Kunstverein, 1994, *Tony Oursler and Jon Kessler* (catalogue).

Kassel, 1992, *Documenta IX* (catalogue).

Whitney Museum of American Art, New York, 1989, *1989 Biennial Exhibition* (catalogue).

Kölnischer Kunstverein, 1989, *Video-Skulptur retrospektiv und aktuell, 1963–1989* (catalogue).

Institute of Contemporary Art and Museum of Fine Arts, Boston, 1988, *The BiNATIONAL: American Art of the Late 80s / Amerikanische Kunst der späten 80er Jahre, German Art of the Late 80s / Deutsche Kunst der späten 80er Jahre* (organized with Städtische Kunsthalle, Kunstsammlung Nordrhein-Westfalen and Kunstverein für die Rheinlande und Westfalen, Düsseldorf) (catalogue).

Kassel, 1987, *documenta 8* (catalogue).

Musée national d'art moderne, Centre Georges Pompidou, Paris, 1987, *L'époque, la mode, la morale, la passion: Aspects de l'art d'aujourd'hui, 1977–1987* (catalogue).

Hirshhorn Museum and Sculpture Garden, Smithsonian Institution, Washington, D.C., 1984, *Content: A Contemporary Focus, 1974–1984* (catalogue).

Stedelijk Museum, Amsterdam, 1984, *Het Lumineuze Beeld / The Luminous Image* (catalogue).

Long Beach Museum of Art, California, 1984, *Video: A Retrospective. Long Beach Museum of Art, 1974–1984* (catalogue).

New Museum, New York, 1981, *Not Just for Laughs: The Art of Subversion* (catalogue).

Selected Bibliography

Decter, Joshua. "Tony Oursler: Metro Pictures." *Artforum* 33 (February 1995), p. 89.

Duncan, Michael. "Tony Oursler at Metro Pictures." *Art in America* 83 (January 1995), p. 105.

Museum of Modern Art, New York. *Video Spaces: Eight Installations* (1995). Exhibition catalogue, with introduction by Samuel Delany and essay by Barbara London.

Portikus, Frankfurt, Les Musées de la Ville de Strasbourg, France, Centre d'Art Contemporain, Geneva, and Stedelijk Van Abbemuseum, Eindhoven, Netherlands. *Tony Oursler* (1995). Exhibition catalogue edited by Friedemann Malsch, with essays by Paolo Colombo and Elizabeth Janus, Tony Conrad and Constance DeJong, Friedemann Malsch, et al., and text by Tony Oursler.

Volk, Gregory. "Tony Oursler: Metro Pictures." *Artnews* 94 (February 1995), p. 127.

Salzburger Kunstverein. *Tony Oursler and Jon Kessler* (1994). Exhibition catalogue, with foreword by Silvia Eiblmayr, essays by Carsten Ahrens and Stella Rolling, and interview with Elizabeth Janus.

Smith, Roberta. "Tony Oursler." *The New York Times*, November 25, 1994, p. C24.

Archer, Michael. "Tony Oursler: Ikon Gallery, Birmingham." *Frieze*, no. 13 (November–December 1993), p. 63.

Centre d'Art Contemporain, Geneva. *Tony Oursler: White Trash and Phobic* (1993). Exhibition catalogue, with introduction by Elizabeth Janus and texts by Mike Kelley and Tony Oursler.

Documenta IX (Stuttgart: Edition Cantz; New York: Harry N. Abrams, 1992). 3 vols. Exhibition catalogue, with introduction by Jan Hoet and essays by Bart De Baere, Cornelius Castoriadis, Hilde Daem, Claudia Herstatt, Heiner Müller, et al.

Hall, Doug, and Sally Jo Fifer, eds. *Illuminating Video* (New York: Aperture Press; San Francisco: Bay Area Video Coalition, 1990).

Miller, John. "Tony Oursler: Diane Brown Gallery." *Artforum* 29 (October 1990), p. 164.

Carr, C. "Constance DeJong and Tony Oursler, *Relatives*: The Kitchen." *Artforum* 27 (May 1989), p. 157.

Kölnischer Kunstverein. *Video-Skulptur retrospektiv und aktuell, 1963–1989* (Cologne: DuMont Buchverlag, 1989). Exhibition catalogue edited by Edith Decker and Wulf Herzogenrath, with essays by Vittorio Fagone, John G. Hanhardt, and Friedemann Malsch.

Whitney Museum of American Art, New York. *1989 Biennial Exhibition* (New York and London: W.W. Norton, 1989). Exhibition catalogue by Richard Armstrong, John G. Hanhardt, Richard Marshall, and Lisa Phillips.

Institute of Contemporary Art and Museum of Fine Arts, Boston. *The BiNATIONAL: American Art of the Late 80s / Amerikanische Kunst der späten 80er Jahre, German Art of the Late 80s / Deutsche Kunst der späten 80er Jahre* (Cologne: DuMont Buchverlag, 1988). Exhibition catalogue by Trevor Fairbrother, David Joselit, and Elisabeth Sussman, with essays by Thomas Crow and Lynne Tillman and interview with Tony Oursler.

Musée national d'art moderne, Centre Georges Pompidou, Paris. *L'époque, la mode, la morale, la passion: Aspects de l'art d'aujourd'hui, 1977–1987* (1987). Exhibition catalogue by Bernard Blistène, Catherine David, and Alfred Pacquement, with essays by Jean-François Chevrier, Serge Daney, Philippe Dubois, Thierry de Duve, Johannes Gachnang, et al.

Stedelijk Museum, Amsterdam. *Het Lumineuze Beeld / The Luminous Image* (1984). Exhibition catalogue edited by Dorine Mignot, with essays by Vito Acconci, Wim Beeren, Constance DeJong, Jean-Paul Fargier, David Hall, et al.

Hirshhorn Museum and Sculpture Garden, Smithsonian Institution, Washington, D.C. *Content: A Contemporary Focus, 1974–1984* (1984). Exhibition catalogue by Howard N. Fox, Miranda McClintic, and Phyllis Rosenzweig.

Long Beach Museum of Art, California. *Video: A Retrospective. Long Beach Museum of Art, 1974–1984* (1984). Exhibition catalogue, with essays by Kathy Rae Huffman, Kira Perov, David Ross, and Bill Viola.

New Museum, New York. *Not Just for Laughs: The Art of Subversion* (1981). Exhibition catalogue by Marcia Tucker.

Sigmar Polke

b. 1941, Oels, Germany
(now Olesnica, Poland)
lives in Cologne, Germany

Selected One-Person Exhibitions

Walker Art Center, Minneapolis, Minnesota, 1995, *Sigmar Polke: Illumination* (catalogue).

Tate Gallery Liverpool, 1995, *Sigmar Polke: Join the Dots* (catalogue).

Carré d'Art, Musée d'Art contemporain, Nîmes, 1994, *Sigmar Polke* (catalogue).

Portikus, Frankfurt, 1994, *Sigmar Polke*.

Fundació Espai Poblenou, Barcelona, 1993, *Sigmar Polke* (catalogue).

Städtisches Museum Abteiberg, Mönchengladbach, Germany, 1992, *Sigmar Polke: Neue Bilder* (catalogue).

Stedelijk Museum, Amsterdam, 1992, *Sigmar Polke* (catalogue).

San Francisco Museum of Modern Art, 1990, *Sigmar Polke* (catalogue).

Galerie Crousel-Robelin / Bama, Paris, 1990, *Sigmar Polke: Peintures récentes*.

Mary Boone Michael Werner Gallery, New York, 1988, *Sigmar Polke: Drawings, 1963–1969.*

Musée d'Art Moderne de la Ville de Paris (ARC), 1988, *Sigmar Polke* (catalogue).

Kunstmuseum Bonn, 1988, *Sigmar Polke: Zeichnungen, Aquarelle, Skizzenbücher, 1962–1988* (catalogue).

Kunsthalle Hamburg, 1986, *Sigmar Polke: Neue Bilder.*

Galerie Toni Gerber, Bern, 1985, *Sigmar Polke: Neue Bilder.*

Anthony d'Offay Gallery, London, 1985, *Sigmar Polke: Recent Paintings.*

Marian Goodman Gallery, New York, 1984, *Sigmar Polke: Paintings.*

Josef-Haubrich-Kunsthalle, Cologne, 1984, *Sigmar Polke* (catalogue).

Museum Boymans-van Beuningen, Rotterdam, 1983, *Sigmar Polke* (catalogue).

Städtisches Museum Abteiberg, Mönchengladbach, West Germany, 1983, *Skizzenbuch aus der Jahre 1968–1969* (catalogue).

Holly Solomon Gallery, New York, 1982, *Sigmar Polke: Works, 1972–1981.*

InK, Halle für internationale neue Kunst, Zurich, 1978, *Sigmar Polke* (catalogue).

Kasseler Kunstverein, 1977, *Sigmar Polke: Fotos / Achim Duchow: Projektionen* (catalogue).

Galerie Helen van der Meij, Amsterdam, 1976, *Seriaal.*

Kunsthalle Tübingen, West Germany, 1976, *Sigmar Polke: Bilder, Tücher, Objekte. Werkauswahl, 1962–1971* (catalogue).

Galerie Klein, Bonn, 1974, *Sigmar Polke*.

Städtisches Kunstmuseum, Bonn, 1974, *Sigmar Polke: Original + Fälschung* (with Achim Duchow) (catalogue).

Westfälischer Kunstverein, Münster, West Germany, 1973, *Franz Liszt kommt gern zu mir zum Fernsehen* (with Achim Duchow) (catalogue).

Galerie Konrad Fischer, Düsseldorf, 1970, *Sigmar Polke*.

Galerie René Block, West Berlin, 1966, *Sigmar Polke* (brochure).

Selected Group Exhibitions

Anthony d'Offay Gallery, London, 1994, *Painting, Drawings, and Sculpture*.

Museum Ludwig, Cologne, 1993, *Photographie in der Deutschen Gegenwartskunst* (catalogue).

Venice, 1993, *XLV Esposizione Internazionale d'Arte: Punti cardinali dell'arte* (catalogue).

Fondation Cartier, Jouy-en-Josas, France, 1993, *Azur* (catalogue).

Walker Art Center, Minneapolis, Minnesota, 1992, *Photography in Contemporary German Art, 1960 to the Present* (catalogue).

Watari-um Museum of Contemporary Art, Tokyo, 1992, *I Love Art II: In Quest of the Concept of Contemporary Art* (catalogue).

Museum des 20. Jahrhunderts, Vienna, 1991, *Bildlicht: Malerei zwischen Material und Immaterialität* (catalogue).

Stedelijk Museum, Amsterdam, 1990, *Energiëen* (catalogue).

Museum van Hedendaagse Kunst, Ghent, Belgium, 1989, *Open Mind (Gesloten Circuits, Circuiti Chiusi)* (catalogue).

Musée national d'art moderne, Centre Georges Pompidou, and La Grande Halle, La Villette, Paris, 1989, *Magiciens de la Terre* (catalogue).

Museums Ludwig in den Rheinhallen der Kölner Messe, 1989, *Bilderstreit: Widerspruch, Einheit und Fragment in der Kunst seit 1960* (catalogue).

Tate Gallery Liverpool, 1989, *Art from Köln* (catalogue).

Saatchi Collection, London, 1988, *The Saatchi Collection* (catalogue).

Kunsthalle Bremen, and Wissenschaftszentrum, Bonn, 1988, *Mythos Europa: Europa und der Stier im Zeitalter der industriellen Zivilisation* (catalogue).

Carnegie Museum of Art, Pittsburgh, Pennsylvania, 1988, *Carnegie International* (catalogue).

Milwaukee Art Museum, Wisconsin, 1987, *Warhol / Beuys / Polke* (catalogue).

Musée national d'art moderne, Centre Georges Pompidou, Paris, 1987, *L'époque, la mode, la morale, la passion: Aspects de l'art d'aujourd'hui, 1977–1987* (catalogue).

Los Angeles County Museum of Art, 1987, *Avant-Garde in the Eighties* (catalogue).

Museum Ludwig, Cologne, 1986, *Europa / Amerika: Die Geschichte einer künstlerischen Faszination seit 1940* (catalogue).

Venice, 1986, *XLII Esposizione Internazionale d'Arte: La Biennale di Venezia* (catalogue).

Royal Academy of Arts, London, 1985, *German Art in the 20th Century: Painting and Sculpture, 1905–1985* (catalogue).

Art Gallery of Ontario, Toronto, 1985, *The European Iceberg: Creativity in Germany and Italy Today* (catalogue).

Museum of Art, Carnegie Institute, Pittsburgh, Pennsylvania, 1985, *Carnegie International* (catalogue).

Stedelijk Museum, Amsterdam, 1984, *La Grande Parade: Hoogtepunten van de schilderkunst na 1940 / Highlights in Painting after 1940* (catalogue).

Martin-Gropius-Bau, West Berlin, 1982, *Zeitgeist: International Art Exhibition, Berlin 1982* (catalogue).

Kassel, 1982, *documenta 7* (catalogue).

Messegelände, Cologne, 1981, *Westkunst: Zeitgenössische Kunst seit 1939* (catalogue).

Royal Academy of Arts, London, 1981, *A New Spirit in Painting* (catalogue).

Kassel, 1977, *documenta 6* (catalogue).

Wallraf-Richartz-Museum and Kunsthalle Köln, 1974, *Projekt '74: Kunst bleibt Kunst, Aspekte internationaler Kunst am Anfang der 70er Jahre* (catalogue).

Kassel, 1972, *documenta 5* (catalogue).

Kunsthalle Köln, 1970, *Jetzt: Künste in Deutschland heute* (catalogue).

Stedelijk Van Abbemuseum, Eindhoven, Netherlands, 1967, *Artypo: Kunst, gemaakt met behulp van graphische technieken / Art, made with the help of graphic techniques* (catalogue).

Akademie der Künste, West Berlin, 1966, *Junge Generation: Maler und Bilder in Deutschland* (catalogue).

Galerie René Block, West Berlin, 1964, *Neodada Pop Decollage Kapitalistischer Realismus*.

Düsseldorf, 1963, *Demonstrative Ausstellung in Düsseldorf, Kaiserstrasse*.

Selected Bibliography

Tate Gallery Liverpool. *Sigmar Polke: Join the Dots* (1995). Exhibition catalogue by Judith Nesbitt, with essays by Thomas McEvilley and Sean Rainbird.

Walker Art Center, Minneapolis, Minnesota. *Sigmar Polke: Illumination* (1995). Exhibition catalogue by Richard Flood.

Centre del Carme, IVAM, Valencia. *Sigmar Polke* (1994). Exhibition catalogue, with essays by Bernard Marcadé, Kevin Power, and Guy Tosatto (expanded version of catalogue published in conjunction with exhibition coorganized by Centre del Carme, IVAM, and Carré d'Art, Musée d'Art contemporain, Nîmes).

Criqui, Jean-Pierre. "Clothes Make the Canvas." *Artforum* 33 (November 1994), pp. 58–61.

Fondation Cartier, Jouy-en-Josas, France. *Azur* (1993). Exhibition catalogue, with introduction by Hervé Chandés and essays by Manlio Brusatin, Michel Cassé, Paolo Fabbri, Michael Jakob, Jacqueline Lichtenstein, et al.

Stedelijk Museum, Amsterdam. *Sigmar Polke* (1992). Exhibition catalogue, with foreword by Wim A.L. Beeren and essays by Bice Curiger, Gary Garrels, Ursula Pia Jauch, and Peter Sloterdijk.

Städtisches Museum Abteiberg, Mönchengladbach, Germany. *Sigmar Polke: Neue Bilder* (1992). Exhibition catalogue, with essay by Dierk Stemmler.

Power, Kevin. "Sigmar Polke." *Frieze*, no. 4 (April–May 1992), pp. 24–33.

Walker Art Center, Minneapolis, Minnesota. *Photography in Contemporary German Art, 1960 to the Present* (1992). Exhibition catalogue by Gary Garrels.

Baker, Kenneth. "Addition + Abundance: Sigmar Polke." *Artforum* 29 (April 1991), pp. 82–88.

Parkett, no. 30 (December 1991), issue featuring Sigmar Polke, with essays by G. Roger Denson, Gary Garrels, Laszlo Glozer, Dave Hickey, Thomas McEvilley, and Gabriele Wix.

Smith, Roberta. "Brooklyn Retrospective of the Mercurial Sigmar Polke." *The New York Times*, October 11, 1991, p. C26.

Stedelijk Museum, Amsterdam. *Energiëen* (1990). Exhibition catalogue by Wim Beeren.

Staatliche Kunsthalle Baden-Baden. *Sigmar Polke: Fotografien* (Stuttgart: Edition Cantz, 1990). Exhibition catalogue by Jochen Poetter, with essay by Bice Curiger.

San Francisco Museum of Modern Art. *Sigmar Polke* (1990). Exhibition catalogue, with essays by John Baldessari, John Caldwell, Michael Oppitz, Peter Schjeldahl, Katharina Schmidt, and Reiner Speck.

Museums Ludwig in den Rheinhallen der Kölner Messe. *Bilderstreit: Widerspruch, Einheit und Fragment in der Kunst seit 1960* (Cologne: DuMont Buchverlag, 1989). Exhibition catalogue by Siegfried Gohr and Johannes Gachnang, with essays by Hans Belting, André Berne-Joffroy, Emile Cioran, Michael Compton, Piet de Jonge, et al.

Musée national d'art moderne, Centre Georges Pompidou, and La Grande Halle, La Villette, Paris. *Magiciens de la Terre* (1989). Exhibition catalogue, with foreword by Jean-Hubert Martin and essays by Homi Bhabha, Mark Francis, Pierre Gaudibert, Aline Luque, André Marcadé, et al.

Graphische Sammlung, Staatsgalerie Stuttgart. *Photo-Kunst: Arbeiten aus 150 Jahren / du XXème au XIXème siècle, aller et retour* (Stuttgart: Edition Cantz, 1989). Exhibition catalogue by Jean-François Chevrier, with essays by Ursula Zeller.

Tate Gallery Liverpool. *Art from Köln* (1989). Exhibition catalogue, with introduction by Lewis Biggs and essays by Lucie Beyer, Karen Marta, and Hein Stünke.

Kunstmuseum Bonn. *Sigmar Polke: Zeichnungen, Aquarelle, Skizzenbücher, 1962–1988* (1988). Exhibition catalogue by Katharina Schmidt, with essay by Gunter Schweikhart.

Carnegie Museum of Art, Pittsburgh, Pennsylvania. *Carnegie International* (Munich: Prestel, 1988). Exhibition catalogue, with essays by John Caldwell, Vicky Clark, Lynne Cooke, Milena Kalinovska, and Thomas McEvilley.

Musée d'Art Moderne de la Ville de Paris (ARC). *Sigmar Polke* (1988). Exhibition catalogue, with introduction by Suzanne Pagé and essays by Bice Curiger, Demosthenes Davvetas, Feelman and Dietman, Bernard Lamarche-Vadel, Hagen Lieberknecht, et al.

Storr, Robert. "Beuys's Boys." *Art in America* 76 (March 1988), pp. 96–103, 167.

Los Angeles County Museum of Art. *Avant-Garde in the Eighties* (1987). Exhibition catalogue by Howard N. Fox.

Milwaukee Art Museum, Wisconsin. *Warhol / Beuys / Polke* (1987). Exhibition catalogue by Russell Bowman, with essays by Linda C. Cathcart, Donald Kuspit, and Lisa Liebmann.

Musée national d'art moderne, Centre Georges Pompidou, Paris. *L'époque, la mode, la morale, la passion: Aspects de l'art d'aujourd'hui, 1977–1987* (1987). Exhibition catalogue by Bernard Blistène, Catherine David, and Alfred Pacquement, with essays by Jean-François Chevrier, Serge Daney, Philippe Dubois, Thierry de Duve, Johannes Gachnang, et al.

Pavillon der Bundesrepublik Deutschland, Venice. *Sigmar Polke: Athanor. Il Padiglione. XLII Biennale di Venezia, 1986* (1986). Exhibition catalogue by Dierk Stemmler.

Museum Ludwig, Cologne. *Europa / Amerika: Die Geschichte einer künstlerischen Faszination seit 1940* (1986). Exhibition catalogue, with introduction by Siegfried Gohr and essays by Craig Adcock, Dore Ashton, Alberto Boatto, John Cage, Rainer Crone, et al.

Museum of Art, Carnegie Institute, Pittsburgh, Pennsylvania. *Carnegie International* (Munich: Prestel-Verlag, 1985). Exhibition catalogue edited by Saskia Bos and John Lane, with introduction by John Lane and John Caldwell and essays by Achille Bonito Oliva, Benjamin H.D. Buchloh, Bazon Brock, Germano Celant, Rudi Fuchs, et al.

Gintz, Claude. "Polke's Slow Dissolve." *Art in America* 73 (December 1985), pp. 102–109.

Royal Academy of Arts, London. *German Art in the 20th Century: Painting and Sculpture, 1905–1985* (1985). Exhibition catalogue edited by Christos M. Joachimides, Norman Rosenthal and Wieland Schmied, with essays by Werner Becker, Hanne Bergius, Georg Bussmann, Matthias Eberle, Ivo Frenzel, et al.

Art Gallery of Ontario, Toronto. *The European Iceberg: Creativity in Germany and Italy Today* (1985). Exhibition catalogue by Germano Celant, with foreword by Roald Nasgaard and essays by Giovanni Anceschi, Giuseppe Bartolucci, Vittorio Boarini, Nicoletta and Andrea Branzi, Tilmann Buddensieg, et al.

Stedelijk Museum, Amsterdam. *La Grande Parade: Hoogtepunten van de schilderkunst na 1940 / Highlights in Painting after 1940* (1984). Exhibition catalogue with foreword and introduction by Edy de Wilde.

Curiger, Bice. "Sigmar Polke: Theorie der Röhrenden Teilchen / Theory of Pulsating Particles." *Parkett*, no. 2 (July 1984), pp. 36–56.

Josef-Haubrich-Kunsthalle, Cologne. *Sigmar Polke* (1984). Exhibition catalogue by Harald Szeemann and Toni Stooss, with essays by Siegfried Gohr, Dietrich Helms, Jürgen Hohmeyer, Barbara Reise, and Reiner Speck, and text by Sigmar Polke.

Museum Boymans-van Beuningen, Rotterdam. *Sigmar Polke* (1983). Exhibition catalogue, with foreword by Wim Beeren and essays by Hagen Lieberknecht and Dierk Stemmler.

Martin-Gropius-Bau, West Berlin. *Zeitgeist: International Art Exhibition, Berlin 1982* (New York: George Braziller, 1983). Exhibition catalogue edited by Christos M. Joachimides and Norman Rosenthal, with essays by Walter Bachauer, Thomas Bernhard, Karl-Heinz Bonrer, Paul Feyerabend, Hilton Kramer, et al.

Buchloh, Benjamin. "Parody and Appropriation in Francis Picabia, Pop and Sigmar Polke." *Artforum* 20 (March 1982), pp. 28–34.

Messegelände, Cologne. *Westkunst: Zeitgenössische Kunst seit 1939* (Cologne: Du Mont Buchverlag, 1981). Exhibition catalogue by L. Glozer, with introduction by Kasper König.

Royal Academy of Arts, London. *A New Spirit in Painting* (1981). Exhibition catalogue by Christos M. Joachimides, Norman Rosenthal, and Nicholas Serota.

InK, Halle für internationale neue Kunst, Zurich. *Sigmar Polke* (1978). Exhibition catalogue by Christel Saur.

Reise, Barbara M. "Who, What Is 'Sigmar Polke'? Parts I and II, Part III, Part IV" *Studio International* 92 (July–August 1976), pp. 83–86; 92 (September–October 1976), pp. 207–210; and 93 (January–February 1977), pp. 38–40.

Kunsthalle Tübingen, Kunsthalle Düsseldorf, West Germany, and Stedelijk Van Abbemuseum, Eindhoven, Netherlands. *Sigmar Polke: Bilder, Tücher, Objekte. Werkauswahl, 1962–1971* (1976). Exhibition catalogue by B.H.D. Buchloh, with essays by Friedrich W. Heubach and Schuldt and text by Sigmar Polke and Gerhard Richter.

Wallraf-Richartz-Museum and Kunsthalle Köln. *Projekt '74: Kunst bleibt Kunst, Aspekte internationaler Kunst am Anfang der 70er Jahre* (1974). Exhibition catalogue, with foreword by Dieter Ronte and essays by Marlis Grüterich, Birgit Hein, Wulf Herzogenrath, David A. Ross, Manfred Schneckenburger, et al.

Westfälischer Kunstverein, Münster, West Germany. *Franz Liszt kommt gern zu mir zum Fernsehen* (1973). Exhibition catalogue, with essays by Jean-Christophe Ammann, Fritz Heubach, and Klaus Honnef.

Kunsthalle Köln. *Jetzt: Künste in Deutschland heute* (1970). Exhibition catalogue by Birgit Hein and Helmut R. and Petra Leppien.

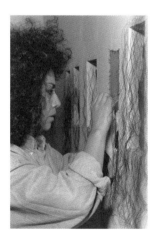

Doris Salcedo

b. 1958, Bogotá, Colombia
lives in Bogotá, Colombia

Selected One-Person Exhibitions

Brooke Alexander Gallery, New York, 1994, *La Casa Viuda*.

Garcés Velásquez Galería, Bogotá, 1990, *Doris Salcedo* (brochure).

Casa de la Moneda, Bogotá, 1985, *Nuevos Nombres*.

Selected Group Exhibitions

Museum of Contemporary Art, San Diego, La Jolla, California, 1995, *Sleeper: Katharina Fritsch, Robert Gober, Guillermo Kuitca, Doris Salcedo* (catalogue).

Art Institute of Chicago, 1995, *About Place: Recent Art of the Americas* (catalogue).

Museo Nacional Centro de Arte Reina Sofía, Madrid, 1994, *Cocido y crudo* (catalogue).

Brooke Alexander Gallery, New York, 1994, *Willie Doherty / Mona Hatoum / Doris Salcedo*.

John Berggruen Gallery, San Francisco, 1994, *Points of Interest, Points of Departure*.

Rhona Hoffman Gallery, Chicago, 1994, *Sculpture*.

Stichting De Appel, Amsterdam, 1994, *The Spine* (catalogue).

Venice, 1993, *XLV Esposizione Internazionale d'Arte: Punti cardinali dell'arte* (catalogue).

Shedhalle, Zurich, 1992, *Ulf Rollof, Doris Salcedo, Cecile Huber, Liliana Moro, Marianna Uutinen* (catalogue).

Biblioteca Luis-Ángel Arango, Bogotá, 1992, *Ante América* (catalogue).

Biennale of Sydney, 1992, *The Boundary Rider: The 9th Biennale of Sydney* (catalogue).

Institute of Contemporary Art, Boston, 1992, *Currents: The Absent Body* (brochure).

Biblioteca Luis-Ángel Arango, Bogotá, 1991, *Nuevas adquisiciones*.

Garcés Velásquez Galería, Bogotá, 1989, *Hierro*.

Selected Bibliography

Art Institute of Chicago. *About Place: Recent Art of the Americas* (1995). Exhibition catalogue by Madeleine Grynsztejn, with essay by Dave Hickey.

Museo Nacional Centro de Arte Reina Sofía, Madrid. *Cocido y crudo* (1995). Exhibition catalogue by Dan Cameron, with essays by Jean Fisher, Gerardo Mosquera, Jerry Saltz, and Mar Villaespesa.

Amor, Monica. "Doris Salcedo." *Art Nexus*, no. 59 (July–September 1994), pp. 102–103, 166–167.

Stichting De Appel, Amsterdam. *The Spine* (1994). Exhibition catalogue, with essays by Saskia Bos and Edna van Duyn.

Aukeman, Anastasia. "Doris Salcedo: Privileged Position." *Artnews* 93 (March 1994), p. 157.

Cameron, Dan. "Absence Makes the Art." *Artforum* 33 (October 1994), pp. 88–91.

Harris, Susan. "Doris Salcedo: Brooke Alexander Gallery." *Art Press*, no. 193 (July–August 1994), p. I.

Hirsch, Faye. "Doris Salcedo at Brooke Alexander." *Art in America* 82 (October 1994), p. 136.

Morgan, Stuart. "The Spine: de Appel, Amsterdam." *Frieze*, no. 16 (May 1994), pp. 52–53.

Garcés Velásquez Galería, Bogotá. *Doris Salcedo* (1993). Exhibition brochure, with essay by Charles Merewether.

Merewether, Charles. "Naming Violence in the Work of Doris Salcedo." *Third Text*, no. 24 (Fall 1993), pp. 35–44.

Parias Durán, María Claudia. "Doris Salcedo." *Poliester* 2 (Fall 1993), pp. 28–31.

Salcedo, Doris. "Aperto: Doris Salcedo." *Flash Art*, no. 171 (Summer 1993), p. 97.

Biblioteca Luis-Ángel Arango, Bogotá. *Ante América* (1992). Exhibition catalogue by Gerardo Mosquera, Carolina Ponce de Leon, and Rachel Weiss, with essays by José Hermán Aguilar, David Boxer, Gérman Rubiano Caballero, Dan Cameron, Luis Camnitzer, et al.

Biennale of Sydney. *The Boundary Rider: The 9th Biennale of Sydney* (1992). Exhibition catalogue, with essays by Stephen Bann, Anthony Bond, Ian Burn, Charles Merewether, Juan Muñoz, and John Welchman.

Shedhalle, Zurich. *Ulf Rollof, Doris Salcedo, Cecile Huber, Liliana Moro, Marianna Uutinen* (1992). Exhibition catalogue, with essays by Edith Krebs and Harm Lux.

Garcés Velásquez Galería, Bogotá. *Doris Salcedo* (1990). Exhibition brochure, with essay by Carolina Ponce de Leon.

Cindy Sherman

b. 1954, Glen Ridge, New Jersey, USA

lives in New York, New York, USA

Selected One-Person Exhibitions

Hirshhorn Museum and Sculpture Garden, Smithsonian Institution, Washington, D.C., 1995, *Directions: Cindy Sherman, Film Stills* (brochure).

Metro Pictures, New York, 1995, *Cindy Sherman*.

Irish Museum of Modern Art, Dublin, 1994, *From Beyond the Pale: Cindy Sherman* (with Julião Sarmento) (catalogue).

Galerie Borgmann Capitain, Cologne, 1994, *Cindy Sherman: Untitled, 1987–1991*.

Tel Aviv Museum of Art, 1993, *Cindy Sherman*.

Galerie Ghislaine Hussenot, Paris, 1993, *Cindy Sherman*.

Linda Cathcart Gallery, Santa Monica, California, 1992, *Cindy Sherman: New Photographs*.

Galerie Monika Sprüth, Cologne, 1992, *Cindy Sherman*.

Kunsthalle Basel, 1991, *Cindy Sherman* (catalogue).

National Art Gallery, Wellington, New Zealand, 1989, *Cindy Sherman* (catalogue).

Whitney Museum of American Art, New York, 1987, *Cindy Sherman* (catalogue).

Metro Pictures, New York, 1987, *Cindy Sherman*.

Westfälischer Kunstverein, Münster, West Germany, 1985, *Cindy Sherman* (catalogue).

Laforet Museum, Tokyo, 1984, *Cindy Sherman* (catalogue).

Akron Art Museum, Ohio, 1984, *Cindy Sherman* (catalogue).

Stedelijk Museum, Amsterdam, 1982, *Cindy Sherman* (catalogue).

Texas Gallery, Houston, 1982, *Cindy Sherman*.

Metro Pictures, New York, 1980, *Cindy Sherman*.

Contemporary Arts Museum, Houston, 1980, *Cindy Sherman: Photographs* (brochure).

Hallwalls Contemporary Arts Center, Buffalo, New York, 1979, *Cindy Sherman*.

Selected Group Exhibitions

Whitney Museum of American Art, New York, 1995, *1995 Biennial Exhibition* (catalogue).

Lannan Foundation, Los Angeles, 1994, *Facts and Figures: Selections from the Lannan Foundation*.

Ueno Royal Museum, Tokyo, and Hakone Open-Air Museum, Hakone, Japan, 1994, *Against All Odds: The Healing Powers of Art* (catalogue).

Martin-Gropius-Bau, Berlin, and Royal Academy of Arts, London, 1993, *American Art in the 20th Century: Painting and Sculpture, 1913–1993* (catalogue).

Kunstnernes Hus, Oslo, 1993, *Louise Lawler, Cindy Sherman, Laurie Simmons* (catalogue).

Capc Musée d'art contemporain de Bordeaux, 1992, *Périls et Colères* (catalogue).

Museum of Modern Art, New York, 1991, *Pleasures and Terrors of Domestic Comfort* (catalogue).

Institute of Contemporary Art, University of Pennsylvania, Philadelphia, 1991, *Devil on the Stairs: Looking Back on the Eighties* (catalogue).

Spoleto Festival, Charleston, South Carolina, 1991, *Places with a Past: New Site-Specific Art at Charleston's Spoleto Festival* (catalogue).

Martin-Gropius-Bau, Berlin, 1991, *Metropolis* (catalogue).

Biennale of Sydney, 1990, *The Readymade Boomerang: Certain Relations in 20th Century Art* (catalogue).

Whitney Museum of American Art, New York, 1989, *Image World: Art and Media Culture* (catalogue).

Museums Ludwig in den Rheinhallen der Kölner Messe, 1989, *Bilderstreit: Widerspruch, Einheit und Fragment in der Kunst seit 1960* (catalogue).

Musée national d'art moderne, Centre Georges Pompidou, Paris, 1987, *L'époque, la mode, la morale, la passion: Aspects de l'art d'aujourd'hui, 1977–1987* (catalogue).

Fundación Caja de Pensiones, Madrid, 1987, *Art and Its Double: Recent Developments in New York Art / El Arte y su Doble: una perspectiva de Nueva York* (catalogue).

Museum of Contemporary Art, Los Angeles, 1986, *Individuals: A Selected History of Contemporary Art, 1945–1986* (catalogue).

Frankfurter Kunstverein und Schirn Kunsthalle, 1986, *Prospect 86: Eine internationale Ausstellung aktueller Kunst* (catalogue).

Museum of Art, Carnegie Institute, Pittsburgh, Pennsylvania, 1985, *Carnegie International* (catalogue).

Contemporary Arts Museum, Houston, 1984, *The Heroic Figure* (catalogue).

Biennale of Sydney, 1984, *The Fifth Biennale of Sydney. Private Symbol: Social Metaphor* (catalogue).

Tate Gallery, London, 1983, *New Art* (catalogue).

Whitney Museum of American Art, New York, 1983, *1983 Biennial Exhibition* (catalogue).

Hirshhorn Museum and Sculpture Garden, Smithsonian Institution, Washington, D.C., 1983, *Directions, 1983* (catalogue).

Museum of Modern Art, New York, 1983, *Big Pictures by Contemporary Photographers*.

Institute of Contemporary Art, University of Pennsylvania, Philadelphia, 1982, *Image Scavengers: Photography* (catalogue).

Kassel, 1982, *documenta 7* (catalogue).

Venice, 1982, *XL Biennale di Venezia* (catalogue).

Walker Art Center, Minneapolis, Minnesota, 1982, *Eight Artists: The Anxious Edge* (catalogue).

Hayden Gallery, Massachusetts Institute of Technology, Cambridge, 1981, *Body Language: Figurative Aspects of Recent Art* (catalogue).

Musée national d'art moderne, Centre Georges Pompidou, Paris, 1981, *Autoportraits* (catalogue).

Musée d'Art Moderne de la Ville de Paris (ARC), 1980, *Ils se disent peintres, ils se disent photographes* (catalogue).

Artists Space, New York, 1978, *Four Artists* (brochure).

Selected Bibliography

Hirshhorn Museum and Sculpture Garden, Smithsonian Institution, Washington, D.C. *Directions: Cindy Sherman, Film Stills* (1995). Exhibition brochure by Phyllis Rosenzweig.

Kimmelman, Michael. "Portraitist in the Halls of Her Artistic Ancestors: At the Met with Cindy Sherman." *The New York Times*, May 19, 1995, pp. B1, B16.

Schjeldahl, Peter. "Master Class." *Village Voice*, February 7, 1995, p. 77.

Wakefield, Neville. "Cindy Sherman: Metro Pictures." *Artforum* 33 (April 1995), p. 89.

Whitney Museum of American Art, New York. *1995 Biennial Exhibition* (New York: Harry N. Abrams, 1995). Exhibition catalogue by Klaus Kertess, with essays by Gerald M. Edelman, John G. Hanhardt, and Lynne Tillman and poem by John Ashbery.

Irish Museum of Modern Art, Dublin. *From Beyond the Pale: Julião Sarmento and Cindy Sherman* (1994). Exhibition catalogue by Michael Tarantino.

Avgikos, Jan. "Cindy Sherman: Burning down the House." *Artforum* 31 (January 1993), pp. 74–79.

Krauss, Rosalind, and Norman Bryson. *Cindy Sherman, 1975–1993* (New York: Rizzoli, 1993).

Krauss, Rosalind. "Cindy Sherman's Gravity: A Critical Fable." *Artforum* 32 (September 1993), pp. 163–164, 203.

Martin-Gropius-Bau, Berlin, and Royal Academy of Arts, London. *American Art in the 20th Century: Painting and Sculpture, 1913–1993* (Berlin: Zeitgeist-Gesellschaft; Munich: Prestel, 1993). Exhibition catalogue by Christos M. Joachimides and Norman Rosenthal, with essays by Brooks Adams, David Anfam, Richard Armstrong, John Beardsley, Neal Benezra, et al.

Whitney Museum of American Art, New York. *1993 Biennial Exhibition* (New York: Harry N. Abrams, 1993). Exhibition catalogue by Thelma Golden, John G. Hanhardt, Lisa Phillips, and Elisabeth Sussman, with essays by Homi K. Bhabha, Coco Fusco, B. Ruby Rich, Avital Ronell, and Jeanette Vuocolo.

Capc Musée d'art contemporain de Bordeaux. *Périls et Colères* (1992). Exhibition catalogue, with foreword by Jean-Louis Froment and essays by Dan Cameron, Régis Durand, Hanna Humeltenberg, Donald Kuspit, Lucy Lippard, et al.

Heartney, Eleanor. "Cindy Sherman at Metro Pictures." *Art in America* 80 (September 1992), pp. 127–128.

Kunsthalle Basel. *Cindy Sherman* (Stuttgart: Edition Cantz, 1991). Exhibition catalogue edited by Thomas Kellein, with essay by Carla Schulz-Hoffmann.

Danto, Arthur C. *Cindy Sherman: History Portraits* (New York: Rizzoli, 1991).

Martin-Gropius-Bau, Berlin. *Metropolis* (New York: Rizzoli, 1991). Exhibition catalogue edited by Christos M. Joachimides and Norman Rosenthal, with essays by Achille Bonito Oliva, Jeffrey Deitch, Wolfgang Max Faust, Vilém Flusser, Boris Groys, et al.

Museum of Modern Art, New York. *Pleasures and Terrors of Domestic Comfort* (New York: Harry N. Abrams, 1991). Exhibition catalogue by Peter Galassi.

Parkett, no. 29 (September 1991), issue featuring Cindy Sherman, with essays by Norman Bryson, Wilfried Dickhoff, Ursula Pia Jauch, Elfriede Jelinek, and Abigail Solomon-Godeau.

Institute of Contemporary Art, University of Pennsylvania, Philadelphia. *Devil on the Stairs: Looking Back on the Eighties* (1991). Exhibition catalogue by Robert Storr, with foreword by Judith Tannenbaum and essay by Peter Schjeldahl.

Spoleto Festival, Charleston, South Carolina. *Places with a Past: New Site-Specific Art at Charleston's Spoleto Festival* (New York: Rizzoli, 1991). Exhibition catalogue by Mary Jane Jacob, with essay by Theodore Rosengarten.

Danto, Arthur C. *Cindy Sherman: Untitled Film Stills* (New York: Rizzoli, 1990).

Biennale of Sydney. *The Readymade Boomerang: Certain Relations in 20th Century Art* (1990). Exhibition catalogue by René Block, with essays by Lynne Cooke, Anne Marie Freybourg, Dick Higgins, Bernice Murphy, and Emmett Williams.

Museums Ludwig in den Rheinhallen der Kölner Messe. *Bilderstreit: Widerspruch, Einheit und Fragment in der Kunst seit 1960* (Cologne: DuMont Buchverlag, 1989). Exhibition catalogue by Siegfried Gohr and Johannes Gachnang, with essays by Hans Belting, André Berne-Joffroy, Emile Cioran, Michael Compton, Piet de Jonge, et al.

National Art Gallery, Wellington, New Zealand. *Cindy Sherman* (1989). Exhibition catalogue, with essays by Robert Leonard and Priscilla Pitts.

Whitney Museum of American Art, New York. *Image World: Art and Media Culture* (1989). Exhibition catalogue by Marvin Heiferman and Lisa Phillips, with essay by John G. Hanhardt.

Fundación Caja de Pensiones, Madrid. *Art and Its Double: Recent Developments in New York Art / El Arte y su Doble: una perspectiva de Nueva York* (1987). Exhibition catalogue by Dan Cameron.

Musée national d'art moderne, Centre Georges Pompidou, Paris. *L'époque, la mode, la morale, la passion: Aspects de l'art d'aujourd'hui, 1977–1987* (1987). Exhibition catalogue by Bernard Blistène, Catherine David, and Alfred Pacquement, with essays by Jean-François Chevrier, Serge Daney, Philippe Dubois, Thierry de Duve, Johannes Gachnang, et al.

Whitney Museum of American Art, New York. *Cindy Sherman* (1987). Exhibition catalogue, with essays by Lisa Phillips and Peter Schjeldahl.

Frankfurter Kunstverein und Schirn Kunsthalle. *Prospect 86: Eine internationale Ausstellung aktueller Kunst* (1986). Exhibition catalogue by Peter Weiermair.

Museum of Contemporary Art, Los Angeles. *Individuals: A Selected History of Contemporary Art, 1945–1986* (New York: Abbeville Press, 1986). Exhibition catalogue edited by Howard Singerman, with introduction by Julia Brown Turrell and essays by Germano Celant, Hal Foster, Donald Kuspit, Kate Linker, Ronald J. Onorato, et al.

Museum of Art, Carnegie Institute, Pittsburgh, Pennsylvania. *Carnegie International* (Munich: Prestel-Verlag, 1985). Exhibition catalogue edited by Saskia Bos and John Lane, with introduction by John Lane and John Caldwell and essays by Achille Bonito Oliva, Benjamin H.D. Buchloh, Bazon Brock, Germano Celant, Rudi Fuchs, et al.

Westfälischer Kunstverein, Münster, West Germany. *Cindy Sherman* (1985). Exhibition catalogue by Marianne Stockebrand, with text by Cindy Sherman.

Contemporary Arts Museum, Houston. *The Heroic Figure* (1984). Exhibition catalogue by Linda Cathcart, with essay by Craig Owens.

Biennale of Sydney. *The Fifth Biennale of Sydney. Private Symbol: Social Metaphor* (1984). Exhibition catalogue, with introduction by Leon Paroissien and essays by Stuart Morgan, Annelie Pohlen, Carter Ratcliff, and Nelly Richard.

Schjeldahl, Peter, and Michael Danoff. *Cindy Sherman* (New York: Pantheon, 1984) (published in conjunction with exhibition at Akron Art Museum).

Stedelijk Museum, Amsterdam. *Cindy Sherman* (1982). Exhibition catalogue, with introduction by Els Barents.

Hayden Gallery, Massachusetts Institute of Technology, Cambridge. *Body Language: Figurative Aspects of Recent Art* (1982). Exhibition catalogue by Roberta Smith.

Institute of Contemporary Art, University of Pennsylvania, Philadelphia. *Image Scavengers: Photography* (1982). Exhibition catalogue by Paula Marincola, with essay by Douglas Crimp.

Contemporary Arts Museum, Houston. *Cindy Sherman: Photographs* (1980). Exhibition brochure, with essay by Linda L. Cathcart.

Musée d'Art Moderne de la Ville de Paris (ARC). *Ils se disent peintres, ils se disent photographes* (1980). Exhibition catalogue, with introduction by Suzanne Pagé and essay by Michel Nuridsany.

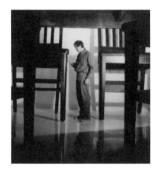

Robert Therrien

b. 1947, Chicago, Illinois, USA
lives in Los Angeles, California, USA

Selected One-Person Exhibitions

Galerie Micheline Szwajcer, Antwerp, 1995, *Robert Therrien*.

Eli Broad Foundation, Santa Monica, California, 1994, *Robert Therrien*.

Leo Castelli Gallery, New York, 1993, *Robert Therrien*.

Angles Gallery, Santa Monica, California, 1992, *Robert Therrien*.

Museo Nacional Centro de Arte Reina Sofía, Madrid, 1991, *Robert Therrien* (catalogue).

Leo Castelli Gallery at 65 Thompson Street, New York, 1991, *Robert Therrien*.

San Diego Museum of Art, California, 1980, *Sculpture in California, 1975–80* (catalogue).

La Jolla Museum of Contemporary Art, California, 1977, *Four Californians* (catalogue).

Galerie Konrad Fischer, Düsseldorf, 1987, *Robert Therrien*.

Hoshour Gallery, Albuquerque, New Mexico, 1987, *Robert Therrien*.

Leo Castelli Gallery, New York, 1986, *Robert Therrien: A Series of Installations*.

Museum of Contemporary Art, Los Angeles, 1984, *Robert Therrien* (catalogue).

Otis Art Institute of the Parsons School of Design, Los Angeles, 1980, *Robert Therrien*.

Holly Solomon Gallery, New York, 1978, *Robert Therrien*.

Ruth S. Schaffner Gallery, Los Angeles, 1977, *Robert Therrien*.

Selected Group Exhibitions

American Center, Paris, 1995, *Micromegas* (catalogue).

San Diego, California, and Tijuana, Mexico, 1994, *inSITE94* (catalogue).

Domaine de Kerguéhennec en Bignan, Locminé, France, 1993, *De la main à la tête: l'objet théorique* (brochure).

Kassel, 1992, *Documenta IX* (catalogue).

Neues Museum Weserburg, Bremen, 1991, *Lafrenz Collection, Hamburg* (catalogue).

Aargauer Kunsthaus, Aarau, Switzerland, 1988, *Skulptur/Sculpture: Material und Abstraktion: 2 x 5 Positionen* (catalogue).

Walker Art Center, Minneapolis, 1988, *Sculpture Inside Outside* (catalogue).

Magasin 3 Stockholm, 1988, *Lynda Benglis, John Chamberlain, Joel Fisher, Mel Kendrick, Robert Therrien* (catalogue).

Albright-Knox Art Gallery, Buffalo, New York, 1987, *Structure to Resemblance: Work by Eight American Sculptors* (catalogue).

Museum of Contemporary Art, Los Angeles, 1986, *Individuals: A Selected History of Contemporary Art, 1945–1986* (catalogue).

Whitney Museum of American Art, New York, 1985, *1985 Biennial Exhibition* (catalogue).

Selected Bibliography

Knight, Christopher. "New Border Customs." *Los Angeles Times*, October 1, 1994, pp. F1, F8.

Upshaw, Reagan. "Robert Therrien at Leo Castelli." *Art in America* 82 (May 1994), p. 108.

Domaine de Kerguéhennec en Bignan, Locminé, France. *De la main à la tête: l'objet théorique* (1993). Exhibition brochure, with essay by Denys Zacharopoulos.

Johnson, Ken. "Robert Therrien at Angles." *Art in America* 81 (January 1993), pp. 108–109.

Documenta IX (Stuttgart: Edition Cantz; New York: Harry N. Abrams, 1992). 3 vols. Exhibition catalogue, with introduction by Jan Hoet and essays by Bart De Baere, Cornelius Castoriadis, Hilde Daem, Claudia Herstatt, Heiner Müller, et al.

Museo Cantonale d'Arte, Cantone Ticino, Lugano, Switzerland. *Panza di Biumo: Gli anni ottanta e novanta dalla collezione / The Eighties and Nineties from the Collection* (1992). Exhibition catalogue, with introductions by Marco Franciolli and Manuela Kahn-Rossi and essays by Jean-Michel Foray and Giuseppe Panza di Biumo.

Pagel, David. "Looking at Ourselves." *Los Angeles Times*, October 22, 1992, pp. F9–F10.

Museo Nacional Centro de Arte Reina Sofía, Madrid. *Robert Therrien* (1991). Exhibition catalogue, with essay and interview by Margit Rowell.

Smith, Roberta. "Robert Therrien." *The New York Times*, June 21, 1991, p. C20.

Peterson, William. "Robert Therrien with Responses by Robert Creeley." *Artspace* 13 (May–June 1989), pp. 58–63.

Aargauer Kunsthaus, Aarau, Switzerland. *Skulptur/Sculpture: Material und Abstraktion: 2 x 5 Positionen* (1988). Exhibition catalogue, with introduction by Corinne Diserens and essays by Steven Henry Madoff and Beat Wismer.

Kimmelman, Michael. "Robert Therrien." *The New York Times*, May 20, 1988, p. C24.

Walker Art Center, Minneapolis. *Sculpture Inside Outside* (New York: Rizzoli, 1988). Exhibition catalogue, with essays by Peter W. Boswell, Douglas Dreishpoon, Martin Friedman, Donna Harkavy, Nancy Princenthal, et al.

Magasin 3 Stockholm. *Lynda Benglis, John Chamberlain, Joel Fisher, Mel Kendrick, Robert Therrien* (1988). Exhibition catalogue, with foreword by David Neuman and essay by Carter Ratcliff.

Albright-Knox Art Gallery, Buffalo, New York. *Structure to Resemblance: Work by Eight American Sculptors* (1987). Exhibition catalogue, with essays by Michael Auping, Cheryl A. Brutvan, Susan Krane, and Helen Raye.

Morgan, Robert C. "American Sculpture and the Search for a Referent." *Arts Magazine* 62 (November 1987), pp. 20–23.

Saunders, Wade. "Talking Objects: Interviews with Ten Younger Sculptors." *Art in America* 73 (November 1985), pp. 110–137.

Museum of Contemporary Art, Los Angeles. *Robert Therrien* (1984). Exhibition catalogue, with essay by Julia Brown.

Mallinson, Constance. "Robert Therrien at the Museum of Contemporary Art." *Art in America* 72 (October 1984), p. 213.

San Diego Museum of Art, California. *Sculpture in California, 1975–80* (1980). Exhibition catalogue by Richard Armstrong.

Keefe, Jeffrey. "Robert Therrien at Ruth S. Schaffner Gallery." *Artforum* 16 (January 1978), pp. 75–76.

Olejarz, Harold. "Robert Therrien." *Arts Magazine* 53 (December 1978), pp. 32–33.

La Jolla Museum of Contemporary Art, California. *Four Californians* (1977). Exhibition catalogue by Richard Armstrong.

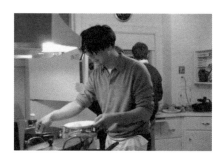

Rirkrit Tiravanija

b. 1961, Buenos Aires, Argentina
lives in New York, New York, USA

Selected One-Person Exhibitions

303 Gallery, New York, 1995,
Untitled, 1995 (Still).

neugerriemschneider, Berlin, 1994,
Untitled, 1994 (meet tim and burkhard).

303 Gallery, New York, 1994,
Untitled, 1993 (1271).

Galerie Schipper & Krome, Cologne,
1994, *Untitled, 1994 (Fear Eats the Soul / Angst essen Seele auf)*.

Jack Hanley Gallery, San Francisco, 1994,
Untitled, 1994 (Beauty).

Randolph Street Gallery, Chicago, 1993,
Untitled, 1993 (Live and Eat, Eat and Die).

303 Gallery, New York, 1992,
Untitled, 1992 (Free).

Randy Alexander Gallery, New York,
1991, *Untitled, 1990 (Blind)*.

Project Room, Paula Allen Gallery,
New York, 1990, *Pad Thai*.

Selected Group Exhibitions

Whitney Museum of American Art,
New York, 1995, *1995 Biennial Exhibition*
(catalogue).

Walker Art Center, Minneapolis, Minnesota,
1995, *Economies: Hans Accola and Rirkrit Tiravanija* (brochure).

Kunsthalle Basel, 1995, *Balloon Frame*.

Basilico Fine Arts, New York, 1995,
Möbius Strip (brochure).

Museo Nacional Centro de Arte Reina Sofía,
Madrid, 1994, *Cocido y crudo* (catalogue).

Kölnischer Kunstverein, 1994,
Der Stand Der Dinge (catalogue).

Gavin Brown's enterprise, New York, 1994,
Rirkrit Tiravanija, Andy Warhol.

Grazer Kunstverein, Graz, Austria, 1994,
Esprit d'Amusement.

Cleveland Center for Contemporary Art,
Ohio, 1994, *Outside the Frame: Performance and the Object* (catalogue).

Musée d'Art Moderne de la Ville de Paris
(ARC), 1994, *L'Hiver de l'Amour* (catalogue).

Le Consortium, Centre d'art contemporain,
Dijon, France, 1994, *Surface de Réparations*
(catalogue).

Thread Waxing Space, New York, 1994,
Don't Look Now (catalogue).

Kunstverein Hamburg, 1993, *Backstage: Topologie Zeitgenössischer Kunst* (catalogue).

Musée d'Art Moderne de la Ville de Paris
(ARC), 1993, *Migrateurs* (brochure).

Institute of Contemporary Arts, London,
1993, *Real Time* (catalogue).

Venice, 1993, *XLV Esposizione Internazionale d'Arte: Punti cardinali dell'arte* (catalogue).

Institute for Contemporary Art, P.S. 1
Museum, Long Island City, New York, 1993,
Sleepless Nights.

Aldrich Museum of Contemporary Art,
Ridgefield, Connecticut, 1993,
Simply Made in America (catalogue).

Suzanne Lemberg Usdan Gallery,
Bennington College, Bennington, Vermont,
1992, *Transgressions in the White Cube: Territorial Mappings* (catalogue).

303 Gallery, New York, 1992,
One Leading to Another.

Centrum Sztuki Współczesnej, Warsaw,
1991, *The Wealth of Nations* (catalogue).

AC Project Room, New York, 1991,
Shooter's Hill.

303 Gallery, New York, 1991, *True to Life*.

Hallwalls Contemporary Arts Center, Buffalo,
New York, 1991, *FluxAttitudes* (catalogue).

Selected Bibliography

Basilico Fine Arts, New York. *Möbius Strip* (1995). Exhibition brochure, with essays by Liam Gillick and Matthew Ritchie and afterword by Stefano Basilico.

Hinley, Bruce. "Rirkrit Tiravanija: Gavin Brown's enterprise." *Artforum* 95 (January 1995), pp. 86–87.

Jones, Ronald. "Rirkrit Tiravanija and Andy Warhol." *Frieze*, no. 20 (January–February 1995), p. 60.

Museo Nacional Centro de Arte Reina Sofía, Madrid. *Cocido y crudo* (1995). Exhibition catalogue by Dan Cameron, with essays by Jean Fisher, Gerardo Mosquera, Jerry Saltz, and Mar Villaespesa.

Whitney Museum of American Art, New York. *1995 Biennial Exhibition* (New York: Harry N. Abrams, 1995). Exhibition catalogue by Klaus Kertess, with essays by Gerald M. Edelman, John G. Hanhardt, and Lynne Tillman, and poem by John Ashbery.

Brown, Gavin. "Rirkrit Tiravanija: Other Things, Elsewhere." *Flash Art*, no. 177 (Summer 1994), pp. 102–104.

Galeria Camargo Vilaça, São Paulo, *SPNY* (1994). Exhibition catalogue, with essays by Marcia Fortes and Anthony Haden-Guest.

Cameron, Dan. "Food for Thought." *Frieze*, no. 17 (June–August 1994), pp. 50–52.

Cleveland Center for Contemporary Art. *Outside the Frame: Performance and the Object* (1994). Exhibition catalogue by Robyn Brentano and Olivia Georgia.

Thread Waxing Space, New York. *Don't Look Now* (1994). Exhibition catalogue by Joshua Decter.

Musée d'Art Moderne de la Ville de Paris (ARC). *L'Hiver de l'Amour* (1994). Exhibition catalogue, with introduction by Suzanne Pagé.

Aldrich Museum of Contemporary Art, Ridgefield, Connecticut. *Simply Made in America* (1993). Exhibition catalogue by Barry A. Rosenberg, with text by Rirkrit Tiravanija.

Kunstverein Hamburg. *Backstage: Topologie Zeitgenössischer Kunst* (1993). Exhibition catalogue by Stephan Schmidt-Wulffen and Barbara Steiner and text by Rirkrit Tiravanija.

Institute of Contemporary Arts, London. *Real Time* (1993). Exhibition catalogue by Gavin Brown, with text by Rirkrit Tiravanija.

Salzburger Kunstverein, Wiener Secession, and Grazer Kunstverein, Austria. *Real Sex, Real Real, Real AIDS, Real Text* (1993). Exhibition catalogue, with essays by Hildegund Amanshauser, Louise Bourgeois, Larry Clark, Elke Krystufek, Eleonora Louis, et al.

Centrum Sztuki Współczesnej, Warsaw. *The Wealth of Nations* (1993). Exhibition catalogue by Cornelia Lauf, with essays by Alice Jarrard and Pierre Piotrowski.

Weil, Benjamin. "Ouverture: Rirkrit Tiravanija." *Flash Art*, no. 175 (January–February 1993), p. 79.

Wiener Secession. *Viennese Story* (1993). Exhibition catalogue, with introduction by Jérôme Sans and essay by Robert Fleck and Jérôme Sans.

Nesbitt, Lois. "Rirkrit Tiravanija: 303 Gallery." *Artforum* 31 (December 1992), p. 95.

New Museum of Contemporary Art and French Cultural Services, New York. *The Big Nothing, or Le Presque Rien* (1992). Exhibition catalogue by Kerri Scharlin.

Smith, Roberta. "The Gallery Is the Message." *The New York Times*, October 4, 1992, p. B35.

Suzanne Lemberg Usdan Gallery, Bennington College, Bennington, Vermont. *Transgressions in the White Cube: Territorial Mappings* (1992). Exhibition catalogue by Joshua Decter.

Faust, Gretchen. "Rirkrit Tiravanija." *Arts Magazine* 65 (April 1991), p. 97.

Richard Tuttle

b. 1941, Rahway, New Jersey, USA

lives in Santa Fe, New Mexico, USA

Selected One-Person Exhibitions

Museum of Fine Arts, Santa Fe, New Mexico, 1995, *North-South Axis.*

Mary Boone Gallery, New York, 1995, *Richard Tuttle.*

Texas Gallery, Houston, 1994, *Richard Tuttle.*

Annemarie Verna Galerie, Zurich, 1994, *Richard Tuttle.*

Galerie Meert Rihoux, Brussels, 1994, *Richard Tuttle.*

Galerie Jürgen Becker, Hamburg, 1994, *Richard Tuttle.*

Brooke Alexander Editions, New York, 1993, *Richard Tuttle: Prints and Related Works.*

Staatliche Kunsthalle Baden-Baden, 1993, *Richard Tuttle: Chaos, die/the Form* (catalogue).

Laura Carpenter Fine Art, Santa Fe, New Mexico, 1992, *Richard Tuttle.*

Instituto Valenciano de Arte Moderno, Valencia, 1992, *The Poetry of Form: Richard Tuttle. Drawings from the Vogel Collection* (coorganized by Indianapolis Museum of Art, Indiana) (catalogue).

Victoria Miro Gallery, London, 1991, *New Works by Richard Tuttle.*

Galería Weber, Alexander, y Cobo, Madrid, 1991, *Richard Tuttle.*

Institute of Contemporary Art, Amsterdam, 1991, *Richard Tuttle: Twenty Floor Drawings* (catalogue).

Sala Montcada de la Fundació "La Caixa," Barcelona, 1991, *Richard Tuttle: Crickets* (catalogue).

Rona Hoffman Gallery, Chicago, 1991, *Richard Tuttle.*

Blum Helman Gallery, New York, 1990, *Inside: the Still Pure Form.*

Sprengel Museum, Hannover, 1990, *Richard Tuttle: In Memory of Writing* (catalogue).

Galerie Yvon Lambert, Paris, 1990, *Richard Tuttle: Paris Pieces.*

Galerie Schmela, Düsseldorf, 1990, *Richard Tuttle.*

Galleria Alessandra Bonomo, Rome, 1989, *Vienna Gotico.*

Galerie Karsten Greve, Cologne, 1988, *Richard Tuttle* (catalogue).

Galerie Hubert Winter, Vienna, 1987, *Locus solus IV / Richard Tuttle.*

Neue Galerie am Landesmuseum Joanneum, Graz, Austria, 1987, *Richard Tuttle: The Baroque and Color* (catalogue).

Musée d'Art Moderne de la Ville de Paris (ARC), 1986, *Richard Tuttle* (catalogue).

Capc Musée d'art contemporain de Bordeaux, 1986, *Richard Tuttle: Wire Pieces* (catalogue).

Reinhard Onnasch Galerie, Berlin, 1986, *Richard Tuttle: Spirals.*

Institute of Contemporary Arts, London, 1985, *Richard Tuttle. Triangle's: Works 1964–1985, Two Pinwheels: Works 1964–1985* (catalogue).

Städtisches Museum Abteiberg, Mönchengladbach, West Germany, 1985, *Richard Tuttle* (catalogue).

Portland Center for the Visual Arts, Oregon, 1984, *Richard Tuttle: Engineer* (catalogue).

Galleria Ugo Ferranti, Rome, 1983, *Richard Tuttle.*

Musée de Calais, France, 1982, *Richard Tuttle: Pairs* (catalogue).

Baxter Art Gallery, California Institute of Technology, 1980, *Richard Tuttle: From 210 Collage-Drawings* (catalogue).

Museum Haus Lange, Krefeld, 1980, *Richard Tuttle: 12 Drahtoktogonale, 1971, 25 Wasserfarbenblätter, 1980* (catalogue).

Centre d'Arts Plastiques Contemporains de Bordeaux, 1979, *Richard Tuttle* (catalogue).

Stedelijk Museum, Amsterdam, 1979, *Richard Tuttle: Title 1–6, Title I–VI, Title A–N, Title 11–16, Titre 1–8, Titolo 1–8* (catalogue).

Bell Gallery, Brown University, Providence, Rhode Island, 1978, *Richard Tuttle* (catalogue).

Betty Parsons Gallery, New York, 1978, *Richard Tuttle: New Work at Betty Parsons.*

Kunsthalle Basel, 1977, *Richard Tuttle New York: 100 Zeichnungen und Aquarelle 1968–1976* (catalogue).

Whitney Museum of American Art, New York, 1975, *Richard Tuttle* (catalogue).

Wadsworth Atheneum, Hartford, Connecticut, 1975, *Richard Tuttle: Matrix 10* (brochure).

Kunstraum München, 1973, *Richard Tuttle: Das 11. Papierachteck und Wandmalereien / The 11th Paper Octagonal and Paintings for the Wall* (catalogue).

Museum of Modern Art, New York, 1972, *Projects: Richard Tuttle.*

Dallas Museum of Fine Arts, 1971, *Richard Tuttle* (catalogue).

Betty Parsons Gallery, New York, 1965, *Richard Tuttle: Constructed Paintings* (brochure).

Selected Group Exhibitions

Galerie Yvon Lambert, Paris, 1992, *Agnes Martin, Richard Tuttle.*

Galerie Gisèle Linder, Basel, 1992, *Une forme, une surface, un volume.*

Lingotto, Turin, Italy, 1992, *Arte Americana, 1930–1970* (catalogue).

Kunstmuseum Basel and Berowergut Rienhen, 1991, *Karl August Burckhardt-Koechlin-Fonds: Zeichnungen des 20. Jahrhunderts* (catalogue).

Brooke Alexander Editions, New York, 1991, *Poets / Painters Collaborations.*

Whitney Museum of American Art, New York, 1990, *The New Sculpture, 1965–1975: Between Geometry and Gesture* (catalogue).

Andrea Rosen Gallery, New York, 1990, *Stendhal Syndrome* (brochure).

Holly Solomon Gallery, New York, 1989, *Alain Kirili, Richard Tuttle, William Wegman.*

Sheldon Memorial Art Gallery and Sculpture Garden, University of Nebraska-Lincoln, 1989, *Sculptors on Paper: New Work* (catalogue).

Michael Klein Gallery, New York, 1989, *Jackie Ferrara, Jene Highstein, Richard Tuttle, Jackie Windsor.*

P.S. 1, Institute for Art and Urban Resources, Long Island City, New York, 1988, *(C)overt: A Series of Exhibitions at P.S. 1* (catalogue).

Westfälischen Landesmuseums für Kunst und Kulturgeschichte in der Stadt Münster, West Germany, 1987, *Skulptur Projekte in Münster, 1987* (catalogue).

Whitney Museum of American Art, New York, 1987, *1987 Biennial Exhibition* (catalogue).

Wiener Secession, 1986, *Wien Fluss, 1986* (catalogue).

Palacio de Velázquez, Parque del Retiro, Madrid, 1986, *Entre la Geometría y el Gesto: Escultura Norteamericana, 1965–1975* (catalogue).

Frankfurter Kunstverein und Schirn Kunsthalle, 1986, *Prospect 86: Eine internationale Ausstellung aktueller Kunst* (catalogue).

Westfälischer Kunstverein, Münster, West Germany, 1985, *Wasserfarbenblätter* (catalogue).

Museum of Contemporary Art, Los Angeles, 1983, *The First Show: Painting and Sculpture from Eight Collections, 1940–1980* (catalogue).

P.S. 1, Institute for Art and Urban Resources, New York, 1983, *Abstract Painting: 1960–69* (catalogue).

Kassel, 1982, *documenta 7* (catalogue).

Art Institute of Chicago, 1982, *74th American Exhibition* (catalogue).

Fruitmarket Gallery, Edinburgh, 1982, *New Works of Contemporary Art and Music* (catalogue).

Stedelijk Museum, Amsterdam, 1982, *'60 '80: attitudes / concepts / images* (catalogue).

Messegelände, Cologne, 1981, *Westkunst: Zeitgenössische Kunst seit 1939* (catalogue).

Hayward Gallery, London, 1980, *Pier + Ocean: Construction in the Art of the Seventies* (catalogue).

Stedelijk Museum, Amsterdam, 1978, *Door beeldhouwers gemaakt / Made by Sculptors* (catalogue).

Philadelphia College of Art, Pennsylvania, 1976, *Private Notations: Artists' Sketchbooks II* (catalogue).

Venice, 1976, *XXXVII Biennale di Venezia* (catalogue).

Museum of Modern Art, New York, 1976, *Drawing Now* (catalogue).

Städtisches Museum Schloss Morsbroich, Leverkusen, 1975, *USA: Zeichnungen 3* (catalogue).

Contemporary Arts Center, Cincinnati, Ohio, 1975, *Mel Bochner, Barry Le Va, Dorothea Rockburne, Richard Tuttle* (catalogue).

Art Museum, Princeton University, New Jersey, 1974, *Line as Language: Six Artists Draw* (catalogue).

Kassel, 1972, *documenta 5* (catalogue).

Detroit Institute of Arts, 1969, *Other Ideas* (catalogue).

Whitney Museum of American Art, New York, 1969, *Anti-Illusion: Procedures / Materials* (catalogue).

Kunsthalle Bern, 1969, *Live in Your Head: When Attitudes Become Form: Works — Concepts — Processes — Situations — Information* (catalogue).

Washington University Art Gallery, St. Louis, Missouri, 1969, *Here and Now* (catalogue).

Pittsburgh Plan for the Arts, Pennsylvania, 1968, *Pittsburgh Plan for the Arts.*

Selected Bibliography

Staatliche Kunsthalle Baden-Baden. *Richard Tuttle: Chaos, die / the Form* (Stuttgart: Edition Cantz, 1993). Exhibition catalogue, with essay by Margrit Franziska Brehm and interview by Jochen Poetter.

Liebmann, Lisa. "Richard Tuttle: Mary Boone Gallery." *Artforum* 31 (January 1993), p. 82.

Institute of Contemporary Art, Amsterdam, and Instituto Valenciano de Arte Moderno, Valencia. *The Poetry of Form: Richard Tuttle. Drawings from the Vogel Collection* (1992). Exhibition catalogue, with essays by Jack Cowart, Holliday T. Day, Susan Harris, and Bret Waller.

Cotter, Holland. "Richard Tuttle." *The New York Times,* October 30, 1992, p. C29.

Institute of Contemporary Art, Amsterdam. *Richard Tuttle: Twenty Floor Drawings* (1991). Exhibition catalogue, with foreword by Eduardo Lipschutz-Villa and essay by Susan Harris.

Sprengel Museum, Hannover. *Richard Tuttle: In Memory of Writing* (1990). Exhibition catalogue by Dietmar Elger, with essays by Jürgen Partenheimer, Marcia Tucker, and Marjorie Welsh, and text by Richard Tuttle.

Whitney Museum of American Art, New York. *The New Sculpture, 1965–1975: Between Geometry and Gesture* (1990). Exhibition catalogue by Richard Armstrong and Richard Marshall, with essays by John G. Hanhardt and Robert Pincus-Witten.

Galerie Karsten Greve, Cologne, and Thomas Segal Gallery, Boston. *Richard Tuttle: Portland Works, 1976* (1988). Exhibition catalogue, with text by Richard Tuttle.

Neue Galerie am Landesmuseum Joanneum, Graz, Austria. *The Baroque and Color / Das Barocke und die Farbe: Richard Tuttle* (1987). Exhibition catalogue, with forewords by Kurt Jungwirth and Wilfried Skreiner and text by Richard Tuttle.

Westfälischen Landesmuseums für Kunst und Kulturgeschichte in der Stadt Münster, West Germany. *Skulptur Projekte in Münster, 1987* (Cologne: DuMont Buchverlag, 1987). Exhibition catalogue edited by Klaus Bußmann and Kasper König, with essays by Marianne Brouwer, Benjamin H.D. Buchloh, Antje von Graevenitz, Thomas Kellein, Hannelore Kersting, et al.

Whitney Museum of American Art, New York. *1987 Biennial Exhibition* (New York and London: W.W. Norton, 1987). Exhibition catalogue by Richard Armstrong, John G. Hanhardt, Richard Marshall, and Lisa Phillips.

Capc Musée d'art contemporain de Bordeaux. *Richard Tuttle: Wire Pieces* (1986). Exhibition catalogue, with foreword by Jean-Louis Froment, introduction by François Pluchart, essays by Germano Celant, Jürgen Glaesemer, Hermann Kern, Ellen Lubell, and Marcia Tucker, interview by Sylvie Couderc, and text by Richard Tuttle.

Frankfurter Kunstverein und Schirn Kunsthalle. *Prospect 86: Eine internationale Ausstellung aktueller Kunst* (1986). Exhibition catalogue by Peter Weiermair, with text by Richard Tuttle.

Palacio de Velázquez, Parque del Retiro, Madrid. *Entre la Geometría y el Gesto: Escultura Norteamericana, 1965–1975* (1986). Exhibition catalogue by Richard Armstrong and Richard Marshall.

Städtisches Museum Abteiberg, Mönchengladbach, West Germany. *Richard Tuttle* (1985). Exhibition catalogue edited by Dierk Stemmler, with text by Richard Tuttle.

Institute of Contemporary Arts, London, and Fruitmarket Gallery, Edinburgh. *Richard Tuttle. Triangle's: Works 1964–1985, Two Pinwheels: Works 1964–1985* (1985). Exhibition catalogue, with introductions by Declan McGonagle and Mark Francis.

Westfälischer Kunstverein, Münster, West Germany. *Wasserfarbenblätter* (1985). Exhibition catalogue by Marianne Stockebrand.

Schjeldahl, Peter. *Art of Our Time: The Saatchi Collection,* vol. 1 (London: Lund Humphries and Rizzoli, 1984).

Messegelände, Cologne. *Westkunst: Zeitgenössische Kunst seit 1939* (Cologne: Du Mont Buchverlag, 1981). Exhibition catalogue by Lazlo Glozer, with introduction by Kasper König.

Baxter Art Gallery, California Institute of Technology. *Richard Tuttle: From 210 Collage-Drawings* (1980). Exhibition catalogue, with foreword by Michael H. Smith and essay by Susan C. Larsen.

Rijksmuseum Kröller-Müller, Otterlo, Netherlands, and Hayward Gallery, London. *Pier + Ocean: Construction in the Art of the Seventies* (1980). Exhibition catalogue by Gerhard von Graevenitz.

Centre d'Arts Plastiques Contemporains de Bordeaux. *Richard Tuttle* (1979). Exhibition catalogue, with text by Richard Tuttle.

Stedelijk Museum, Amsterdam. *Richard Tuttle: Title 1–6, Title I–VI, Title A–N, Title 11–16, Titre 1–8, Titolo 1–8* (1979). Exhibition catalogue, with text by Richard Tuttle.

Pincus-Witten, Robert. *Postminimalism* (New York: Out of London Press, 1977).

Institute for Art and Urban Resources, Long Island City, New York. *Rooms (P.S. 1)* (1976). Exhibition catalogue, with foreword by Alanna Heiss and text by Richard Tuttle.

Contemporary Arts Center, Cincinnati, Ohio. *Mel Bochner, Barry Le Va, Dorothea Rockburne, Richard Tuttle* (1975). Exhibition catalogue, with introduction by Ragland Watkins and essays by Dorothy Alexander, Carroll Dunham, and Naomi Spector.

Whitney Museum of American Art, New York. *Richard Tuttle* (1975). Exhibition catalogue by Marcia Tucker.

Art Museum, Princeton University, New Jersey. *Line as Language: Six Artists Draw* (1974). Exhibition catalogue by Marcia Tucker.

Lubell, Ellen. "Wire / Pencil / Shadow: Elements of Richard Tuttle." *Arts Magazine* 47 (November 1972), pp. 50–52.

Dallas Museum of Fine Arts. *Richard Tuttle* (1971). Exhibition catalogue by Robert M. Murdock.

Pincus-Witten, Robert. "The Art of Richard Tuttle." *Artforum* 8 (February 1970), pp. 62–67.

Detroit Institute of Arts. *Other Ideas* (1969). Exhibition catalogue, with introduction by Samuel J. Wagstaff and text by Richard Tuttle.

Whitney Museum of American Art, New York. *Anti-Illusion: Procedures / Materials* (1969). Exhibition catalogue, with essays by James Monte and Marcia Tucker.

Betty Parsons Gallery, New York. *Richard Tuttle: Constructed Paintings* (1965). Exhibition brochure, with essay by Gordon B. Washburn and text by Richard Tuttle.

Franz West

b. 1947, Vienna, Austria

lives in Vienna, Austria

Selected One-Person Exhibitions

Galerie Walcheturm, Zurich, 1995, *Franz West.*

Bij Annick en Anton Herbert, Ghent, Belgium, 1995, *Ordinary Language.*

Lisson Gallery, London, 1994, *Konversation.*

David Zwirner, New York, 1994, *Home Elements (A Retrospective).*

Dia Center for the Arts, New York, 1994, *Franz West: Rest.*

Museum of Contemporary Art, Los Angeles, 1994, *Franz West: Test.*

Mala Galerija, Moderna Galerija Ljubljana, 1993, *Franz West* (catalogue).

Galerie Foksal, Warsaw, 1992, *Untersuchungen zur Amerikanischen Kunst* (catalogue).

Salzburger Kunstverein, 1991, *Franz West (Brückenköpfe).*

Galerie Max Hetzler, Cologne, 1991, *Franz West.*

Jänner Galerie, Vienna, 1990, *Defunctus. Franz West.*

Kunsthistorisches Museum, Vienna, 1989, *Franz West.*

Institute of Contemporary Art, P.S. 1 Museum, Long Island City, New York, 1989, *Possibilities: Franz West* (catalogue).

Museum Haus Lange, Krefeld, West Germany, 1989, *Franz West* (catalogue).

Galerie Peter Pakesch, Vienna, 1988, *Wegener Räume 2/6 – 5/6.*

Portikus, Frankfurt, 1988, *Franz West: Schöne Aussicht* (catalogue).

Kunsthalle Bern, 1988, *Franz West* (catalogue).

Wiener Secession, 1987, *Franz West: Ansicht* (catalogue).

Neue Galerie am Landesmuseum Joanneum, Graz, Austria, 1986, *Franz West: Legitime Skulptur* (catalogue).

Galerie nächst St. Stephan, Vienna, 1980, *Franz West.*

Selected Group Exhibitions

Fundación "la Caixa," Madrid, 1994, *La Visión Austriaca: Tres generaciones de artistas. The Austrian Vision: Three Generations of Austrian Artists* (catalogue).

Musée national d'art moderne, Centre Georges Pompidou, Paris, 1994, *Hors limites: l'art et la vie, 1952–1994* (catalogue).

Kunsthalle Wien, 1994, *Jetztzeit.*

Koninklijk Museum voor Schone Kunsten, Antwerp, 1993, *The Sublime Void: On the Memory of the Imagination* (catalogue).

Kassel, 1992, *Documenta IX* (catalogue).

Martin-Gropius-Bau, Berlin, 1991, *Metropolis* (catalogue).

Institute of Contemporary Arts and Serpentine Gallery, London, 1990, *Possible Worlds: Sculpture from Europe* (catalogue).

Venice, 1990, *XLIV Esposizione Internazionale d'Arte: La Biennale di Venezia* (catalogue).

Musée d'Art Moderne de la Ville de Paris (ARC), 1990, *Herbert Brandl, Ernst Caramelle, Franz West* (catalogue).

Wiener Secession, 1989, *Wittgenstein* (catalogue).

Westfälischen Landesmuseums für Kunst und Kulturgeschichte in der Stadt Münster, West Germany, 1987, *Skulptur Projekte in Münster, 1987* (catalogue).

Städtische Kunsthalle Düsseldorf, 1986, *SkulpturSein* (catalogue).

Messegelände, Cologne, 1981, *Westkunst: Zeitgenössische Kunst seit 1939* (catalogue).

Selected Bibliography

Freedman, Carl. "Franz West: Lisson Gallery, London." *Frieze*, no. 20 (January–February 1995), pp. 55–56.

Auerbach, Lisa Anne. "Franz West: Museum of Contemporary Art." *Artforum* 32 (Summer 1994), pp. 98–99.

Schjeldahl, Peter. "Westway." *Village Voice*, October 18, 1994, p. 90.

Decter, Joshua. "Franz West: David Zwirner." *Artforum* 31 (May 1993), pp. 105–106.

Koninklijk Museum voor Schone Kunsten, Antwerp. *The Sublime Void: On the Memory of the Imagination* (1993). Exhibition catalogue by Bart Cassiman, with essays by Theodor Adorno, Charles Baudelaire, Walter Benjamin, Henri Bergson, Maurice Blanchot, et al.

Mala Galerija, Moderna Galerija Ljubljana. *Franz West* (1993). Exhibition catalogue, with essay by Bart De Baere.

Parkett, no. 37 (September 1993), issue featuring Franz West, with essays by Jan Avgikos, Martin Prinzhorn, Elisabeth Schlebrügge, Harald Szeemann, and Denys Zacharopoulos, interview by Martin Gutman and Jürgen Walter, and text by Franz West.

Galerie Foksal, Warsaw, and David Zwirner, New York. *Franz West: Investigations of American Art* (1992). Exhibition catalogue, with interview by Kasper König.

Felderer, Brigitte, and Herbert Lachmayer. "Potentially Inaccessible — Factually Accessible," *Parkett*, no. 25 (June 1990), pp. 88–96 (with text by Franz West).

Institute of Contemporary Arts and Serpentine Gallery, London. *Possible Worlds: Sculpture from Europe* (1990). Exhibition catalogue by Iwona Blazwick, James Lingwood, and Andrea Schlieker, with curators' interviews.

Musée d'Art Moderne de la Ville de Paris (ARC), *Herbert Brandl, Ernst Caramelle, Franz West* (1990). Exhibition catalogue, with introduction by Suzanne Pagé and essays by Laurence Bossé, Annie Merie, and Denys Zacharopoulos.

Draxler, Helmut. "Franz West: The Antibody to Anti-Body." *Artforum* 27 (March 1989), pp. 94–101.

Museum Haus Lange, Krefeld, West Germany. *Franz West* (1989). Exhibition catalogue, with essay by Julian Heynen, poem by Vittorio Martini, and text by Franz West.

Institute of Contemporary Art, P.S. 1 Museum, Long Island City, New York. *Possibilities: Franz West* (1989). Exhibition catalogue, with foreword by Chris Dercon and Alanna Heiss and essay by Jeffrey Rian.

Kunsthalle Bern. *Franz West* (1988). Exhibition catalogue, with essay by Ulrich Loock and texts by Martin Prinzhorn, Ferdinand Schmatz, and Franz West.

Portikus, Frankfurt. *Franz West: Schöne Aussicht* (1988). Exhibition catalogue, with introduction by Kasper König, and texts by Mathis Esterhazy, Ulrich Loock, and Franz West.

Westfälischen Landesmuseums für Kunst und Kulturgeschichte in der Stadt Münster, West Germany. *Skulptur Projekte in Münster, 1987* (Cologne: DuMont Buchverlag, 1987). Exhibition catalogue edited by Klaus Bußmann and Kasper König, with essays by Marianne Brouwer, Benjamin H.D. Buchloh, Antje von Graevenitz, Thomas Kellein, Hannelore Kersting, et al.

Wiener Secession. *Franz West: Ansicht* (1987). Exhibition catalogue, with foreword by Ulrich Loock, essays by Hildegund Amanshauser, Edelbert Köb, August Ruhs, Ferdinand Schmatz, and Georg Schöllhammer, and texts by Albert Béguin and Franz West, Herbert Brandl, Mathis Esterhazy, Peter Pakesch, Herman Nitsch Schule, et al.

Städtische Kunsthalle Düsseldorf. *SkulpturSein* (1986). Exhibition catalogue by Harald Szeemann, with introduction by Jürgen Harten, essay by Johann Gottfried Herder, and texts by Ferdinand Schmatz and Franz West.

Neue Galerie am Landesmuseum Joanneum, Graz, Austria. *Franz West: Legitime Skulptur* (1986). Exhibition catalogue, with foreword by Kurt Jungwirth, essay by Wilfried Skreiner, and text by Franz West.

Rachel Whiteread

b. 1963, London, England
lives in London, England

Selected One-Person Exhibitions

Karsten Schubert Gallery, London, 1995, *Rachel Whiteread: Sculptures.*

Kunsthalle Basel, 1994, *Rachel Whiteread* (catalogue).

Galerie Aurel Scheibler, Cologne, 1994, *Rachel Whiteread: Works on Paper* (in collaboration with Karsten Schubert Gallery, London).

daad-galerie, Berlin, 1993, *Rachel Whiteread: Gouachen / Gouaches* (catalogue).

193 Grove Road, London, 1993, *House* (a project commissioned by Artangel Trust and Beck's, London) (brochure).

Museum of Contemporary Art, Chicago, 1993, *Options 46: Rachel Whiteread* (brochure).

Stedelijk Van Abbemuseum, Eindhoven, Netherlands, 1992, *Rachel Whiteread* (catalogue).

Sala Montcada de la Fundació "La Caixa," Barcelona, 1992, *Rachel Whiteread: escultures* (catalogue).

Luhring Augustine Gallery, New York, 1992, *Rachel Whiteread: Recent Sculpture.*

Karsten Schubert Gallery, London, 1991, *Rachel Whiteread.*

Arnolfini Gallery, Bristol, 1991, *Rachel Whiteread.*

Chisenhale Gallery, London, 1990, *Ghost* (catalogue).

Carlile Gallery, London, 1988, *Rachel Whiteread.*

Selected Group Exhibitions

Anthony d'Offay Gallery, London, 1995, *Rooms: Richard Hamilton, Reinhard Mucha, Bruce Nauman, Bill Viola, Rachel Whiteread.*

Galerie nationale du Jeu de Paume, Paris, 1995, *Double Mixte: Générique 2* (catalogue).

Luhring Augustine Gallery, New York, 1994, *Sculpture.*

Museum of Modern Art, New York, 1994, *Sense and Sensibility: Women Artists and Minimalism in the Nineties* (catalogue).

Tate Gallery, London, 1993, *The Turner Prize, 1993* (brochure).

Power Plant, Toronto, 1993, *Whiteness and Wounds* (brochure).

Koninklijk Museum voor Schone Kunsten, Antwerp, 1993, *The Sublime Void: On the Memory of the Imagination* (catalogue).

Rooseum Center for Contemporary Art, Malmö, Sweden, 1993, *Passagearbeten / Passageworks* (catalogue).

Biennale of Sydney, 1992, *The Boundary Rider: The 9th Biennale of Sydney* (catalogue).

Barbara Gladstone Gallery and SteinGladstone Gallery, New York, 1992, *Lea Andrews, Keith Coventry, Anya Gallaccio, Damien Hirst, Gary Hume, Abigail Lane, Sarah Lucas, Steven Pippin, Marc Quinn, Marcus Taylor, Rachel Whiteread, and a Book by Liam Gillick.*

Christine Burgin, New York, 1992, *Lili Dujourie, Jeanne Silverthorne, Pia Stadtbäumer, Rachel Whiteread.*

Kassel, 1992, *Documenta IX* (catalogue).

Saatchi Collection, London, 1992, *Young British Artists: John Greenwood, Damien Hirst, Alex Landrum, Langlands and Bell, Rachel Whiteread* (catalogue).

Hayward Gallery, London, 1992, *Doubletake: Collective Memory and Current Art* (catalogue).

Tate Gallery, London, 1991, *The Turner Prize, 1991* (brochure).

Serpentine Gallery, London, 1991, *Broken English: Angela Bulloch, Ian Davenport, Anya Gallaccio, Damien Hirst, Gary Hume, Michael Landy, Sarah Staton, and Rachel Whiteread* (brochure).

Martin-Gropius-Bau, Berlin, 1991, *Metropolis* (catalogue).

Selected Bibliography

Kimmelman, Michael. "Turning Things Inside Out." *The New York Times*, February 5, 1995, pp. H1, H35.

Kunsthalle Basel. *Rachel Whiteread* (1994). Exhibition catalogue, with foreword by Milena Kalinovska, Thomas Kellein, and Thomas Murphy, and essay by Christoph Grunenberg.

Criqui, Jean-Pierre. "Focus: Rachel Whiteread, Kunsthalle Basel." *Artforum* 33 (November 1994), pp. 82–83.

Museum of Modern Art, New York. *Sense and Sensibility: Women Artists and Minimalism in the Nineties* (1994). Exhibition catalogue by Lynn Zelevansky.

Parkett, no. 42 (December 1994), issue featuring Rachel Whiteread, with essays by Trevor Fairbrother, Rudolf Schmitz, Neville Wakefield, and Simon Watney.

Searle, Adrian. "Rachel Doesn't Live Here Any More." *Frieze*, no. 14 (January–February 1994), pp. 26–29.

Yood, James. "Chicago: Rachel Whiteread, Museum of Contemporary Art." *Artforum* 32 (January 1994), p. 94.

daad-galerie, Berlin. *Rachel Whiteread: Gouachen / Gouaches* (Stuttgart: Cantz, 1993). Exhibition catalogue, with essay by Friedrich Meschede.

Von Drathen, Doris. "Rachel Whiteread: Found Form." *Parkett*, no. 38 (December 1993), pp. 22–31.

Karsten Schubert Gallery, London, and Luhring Augustine Gallery, New York. *Rachel Whiteread: Plaster Sculptures* (1993). Exhibition catalogue, with essay by David Batchelor.

Koninklijk Museum voor Schone Kunsten, Antwerp. *The Sublime Void: On the Memory of the Imagination* (1993). Exhibition catalogue by Bart Cassiman, with essays by Theodor Adorno, Charles Baudelaire, Walter Benjamin, Henri Bergson, Maurice Blanchot, et al.

Rooseum Center for Contemporary Art, Malmö, Sweden. *Passagearbeten / Passageworks* (1993). Exhibition catalogue by Lars Nittve, with essays by Lynne Cooke, Brian Hatton, Stuart Morgan, Johannes Meinhardt, Chantal Pontriand, and Stephen Sarrazin.

Smith, Roberta. "The Best of Artists, the Worst of Artists." *The New York Times*, November 30, 1993, pp. B1–B2.

Documenta IX (Stuttgart: Edition Cantz; New York: Harry N. Abrams, 1992). 3 vols. Exhibition catalogue, with introduction by Jan Hoet and essays by Bart De Baere, Cornelius Castoriadis, Hilde Daem, Claudia Herstatt, Heiner Müller, et al.

Hayward Gallery, London. *Doubletake: Collective Memory and Current Art* (London: South Bank Centre; Zurich: Parkett, 1992). Exhibition catalogue edited by Lynne Cooke, Bice Curiger, and Greg Hilty, with essays by Jacques Attali, J.G. Ballard, Georges Bataille, Pinckney Benedict, Roberto Calasso, et al.

Hirsch, Faye. "Rachel Whiteread." *Arts Magazine* 66 (April 1992), p. 71.

Sala Montcada de la Fundació "La Caixa," Barcelona. *Rachel Whiteread: escultures* (1992). Exhibition catalogue, with essay by Jorge Luis Marzo.

Saatchi Collection, London. *Young British Artists: John Greenwood, Damien Hirst, Alex Landrum, Langlands and Bell, Rachel Whiteread* (1992). Exhibition catalogue, with essay by Sarah Kent.

Smith, Roberta. "Rachel Whiteread." *The New York Times*, January 17, 1992, p. C28.

Spector, Nancy. "Art and Objecthood." *Tema Celeste*, nos. 37–38 (Fall 1992), pp. 74–79.

Stedelijk Van Abbemuseum, Eindhoven, Netherlands. *Rachel Whiteread* (1992). Exhibition catalogue, with foreword by Jan Debbaut and Selma Klein Essink, introduction by Stuart Morgan, and interview by Iwona Blazwick.

Taplin, Robert. "Rachel Whiteread at Luhring Augustine." *Art in America* 80 (September 1992), p. 124.

Martin-Gropius-Bau, Berlin. *Metropolis* (New York: Rizzoli, 1991). Exhibition catalogue edited by Christos M. Joachimides and Norman Rosenthal, with essays by Achille Bonito Oliva, Jeffrey Deitch, Wolfgang Max Faust, Vilém Flusser, Boris Groys, et al.

Renton, Andrew, and Liam Gillick, eds. *Technique Anglaise: Current Trends in British Art* (London: Thames and Hudson, One-Off Press, 1991).

Brooks, Liz. "Rachel Whiteread: Chisenhale." *Artscribe*, no. 84 (November–December 1990), p. 80.

Chisenhale Gallery, London. *Ghost* (1990). Exhibition catalogue, with introduction by Emma Dexter and essay by Liam Gillick.

Hayward Gallery, London. *The British Art Show, 1990* (London: South Bank Centre, 1990). Exhibition catalogue by Caroline Collier, Andrew Narine, and David Ward, and text by Rachel Whiteread.

Rémy Zaugg

b. 1943, Courgenay, Jura, Switzerland

lives in Basel, Switzerland

Selected One-Person Exhibitions

Musée national d'art moderne, Centre Georges Pompidou, 1995, *Herzog et de Meuron: Une exposition conçue par Rémy Zaugg.*

Módulo, Lisbon, 1994, *Rémy Zaugg: Pintura.*

Barbara Gross Galerie, Munich, 1994, *Rémy Zaugg: Aber ich, die Welt, ich sehe Dich.*

Brooke Alexander Gallery, New York, 1994, *Rémy Zaugg: Imagine.*

Ronny van de Velde, Antwerp, 1993, *Rémy Zaugg: Tableaux Aveugles, 1986–1991.*

Mai 36 Galerie, Zurich, 1993, *Rémy Zaugg: Fussnoten zu "Réflexions sur et d'une feuille de papier, 1970–1989."*

Museum für Gegenwartskunst, Basel, 1993, *Rémy Zaugg: Ein Blatt Papier, Die Stadt.*

Gesellschaft für aktuelle Kunst, Bremen, 1993, *Draußen.*

Westfälisches Landesmuseum für Kunst und Kulturgeschichte, Münster, Germany, 1993, *Jemand.*

Musée Rath, Musée d'art et d'histoire, Geneva, 1992, *Rémy Zaugg: Une feuille de papier.*

Brooke Alexander Gallery, New York, 1991, *A Sheet of Paper II, 23 Paintings*; and Brooke Alexander Editions, New York, 1991, *Reflections on and onto a Sheet of Paper, 34 Screenprints.*

Kunstmuseum Luzern, Switzerland, 1991, *Rémy Zaugg.*

Galerie Pierre Huber, Geneva, 1991, *Rémy Zaugg: Notes, études, 1985–1988.*

Renaissance Society at the University of Chicago, 1991, *Rémy Zaugg.*

Zwinger Galerie, Berlin, 1991, *Rémy Zaugg: Réflexions sur et d'une feuille de papier.*

Musée d'Art Contemporain de Lyon, 1990, *Une feuille de papier.*

Museum Folkwang Essen, West Germany, 1989, *Ein Blatt Papier, Perzeptive Skizzen, oder die Entstehung eines Bildwerks, Werke von 1973 bis 1989.*

Mai 36 Galerie, Lucerne, Switzerland, 1989, *Voir Mort: 28 tableaux.*

Le Consortium, Centre d'art contemporain, Dijon, 1989, *Rémy Zaugg: Personne.*

Musée d'Art Moderne de la Ville de Paris (ARC), 1988, *Rémy Zaugg: A propos d'un tableau.*

Kunsthalle Basel, 1988, *Rémy Zaugg: Für ein Bild.*

Stedelijk Van Abbemuseum, Eindhoven, Netherlands, 1984, *Une feuille de papier… pourquoi?*

Kunsthalle Bern, 1979, *Rémy Zaugg: Réflexion 1977.*

Galerie Rolf Preisig, Basel, 1977, *Rémy Zaugg: L.B. Alberti.*

Galerie nächst St. Stephan, Vienna, 1977, *Rémy Zaugg: 143 mises en scène d'une peinture autour du cube.*

Kunstmuseum Basel, 1972, *Rémy Zaugg: Dedans-dehors, dehors-dedans, 1968–1972.*

Selected Group Exhibitions

Mai 36 Galerie, Zurich, 1994, *On Kawara, Rémy Zaugg.*

Arnhem, Netherlands, 1993, *Sonsbeek 93* (catalogue).

Museo Nacional Centro de Arte Reina Sofía, Madrid, 1992, *Repetición / Transformación* (catalogue).

Westfälischen Landesmuseums für Kunst und Kulturgeschichte, Münster, Germany, 1992, *Das offene Bild: Aspekte der Moderne in Europa nach 1945* (catalogue).

Akademie der bildenden Künste, Vienna, 1992, *Über Malerei: Begegnung mit der Geschichte* (catalogue).

Museum für Gegenwartskunst, Basel, 1991, *Emanuel Hoffmann-Stiftung, Basel* (catalogue).

Musée des Beaux-Arts, La Chaux-de-Fonds, Musée Cantonal des Beaux-Arts, Lausanne, and Musée d'Art et d'Histoire, Neuchâtel, Switzerland, 1991, *Extra Muros: Art suisse contemporain* (catalogue).

Stichting De Appel, Amsterdam, 1991, *Inscapes* (catalogue).

Brooke Alexander, New York, 1991, *Ulrich Rückriem, Richard Tuttle, Rémy Zaugg.*

Witte de With, Rotterdam, 1991, *Cézanne (Enquête).*

Castello di Rivara, Turin, Italy, 1990, *65–74: Aspetti e Pratiche dell'Arte Europea* (catalogue).

Biennale of Sydney, 1990, *The Readymade Boomerang: Certain Relations in 20th Century Art* (catalogue).

Stichting De Appel, Amsterdam, 1987, *Nightfire* (catalogue).

Westfälischen Landesmuseums für Kunst und Kulturgeschichte in der Stadt Münster, West Germany, 1987, *Skulptur Projekte in Münster, 1987* (catalogue).

Stedelijk Van Abbemuseum, Eindhoven, Netherlands, 1986, *Ooghoogte, eye level, Augenhöhe, ligne d'horizon, Stedelijk Van Abbemuseum, 1936–1986* (catalogue).

Castello di Rivoli, Turin, Italy, 1986, *Ouverture II.*

Kassel, 1982, *documenta 7* (catalogue).

Paris, 1977, *Biennale de Paris* (catalogue).

Selected Bibliography

Zaugg, Rémy. *Le Musée des Beaux-Arts auquel je rêve ou le lieu de l'œuvre et de l'homme* (Dijon and Paris: Les presses du réel, 1995).

_____. *Aber ich, die Welt, ich sehe Dich* (Munich: Barbara Gross Galerie, 1994).

Arnhem, Netherlands. *Sonsbeek 93* (Ghent: Snoeck-Ducaju and Zoon, 1993). Exhibition catalogue by Valerie Smith, coedited with Jan Brand and Catelijne de Muynck.

Zaugg, Rémy. *Réflexions sur et d'une feuille de papier / Reflexionen auf und über ein Blatt Papier* (Stuttgart: Edition Cantz, 1993). Book edited by Theodora Vischer, with essays by Rainer Borgemeister, Rainer Michael Mason, and Claude Ritschard; published in conjunction with the exhibition *Rémy Zaugg: Ein Blatt Papier, Die Stadt* at the Museum für Gegenwartskunst, Basel.

_____. *Von Bild zur Welt* (Cologne: Verlag der Buchandlung, 1993). Book edited by Eva Schmidt, with foreword by Klaus Bußmann and essays by Xavier Douroux, Doris von Drathen, Bernhard Fibicher, Erich Franz, Franz Meyer, et al.; published in conjunction with the exhibitions *Jemand* at Westfälisches Landesmuseum für Kunst und Kulturgeschichte, Münster, and *Draußen* at the Gesellschaft für aktuelle Kunst, Bremen, Germany.

Statens Museum for Kunst, Copenhagen. *Samling, Sammlung, Collection Block* (1992). Exhibition catalogue, with foreword by Villads Villadsen and essays by Klaus Ebbeke, Elisabeth Delin Hansen, Bjørn Nøgaard, Uwe M. Scheede, and Wieland Schmied.

Museo Nacional Centro de Arte Reina Sofía, Madrid. *Repetición / Transformación* (1992). Exhibition catalogue, with essays by Francisco Calvo Serraller, Aurora García, and Michael Tarantino and text by Rémy Zaugg.

Ritschard, Claude. "Rémy Zaugg: Three or Four French Windows (The Lake, Boats, the Shore, the Hotels, the Alps…), A Self-Portrait." *Parkett*, no. 31 (March 1992), pp. 113–117.

Wulffen, Thomas. "Rémy Zaugg: Kunstverein Hamburg." *Forum International*, no. 15 (November–December 1992), p. 105.

Zaugg, Rémy. *Ein Blatt Papier II / A Sheet of Paper II* (Paris, Dijon, and Brussels: Art et art, Les presses du réel, 1992). Book with essays by Jean-Christophe Ammann, Erich Franz, Rudi H. Fuchs, Luk Lambrecht, Christoph Schenker, and Michael Tarantino.

Stadtraum, Biel, Switzerland. *Tabula Rasa* (1991). Exhibition catalogue, with introduction by Benhard Fibicher and essays by Marion Erdheim, Hervé Gauville, and Andreas Meier.

Musée des Beaux-Arts, La Chaux-de-Fonds, Musée Cantonal des Beaux-Arts, Lausanne, and Musée d'Art et d'Histoire, Neuchâtel, Switzerland. *Extra Muros: Art suisse contemporain* (1991). Exhibition catalogue, with foreword by Edmond Charrière, Catherine Quéloz, and Dieter Schwarz, essays by Yve-Alain Bois, Peter Bürger, Thomas Crow, Thierry de Duve, Johannes Gachnang, et al., and text by Rémy Zaugg.

Criqui, Jean-Pierre. *Cézanne (Enquête)* (Rotterdam: Witte de With, 1991). Book published in conjunction with exhibition at Witte de With.

Tarantino, Michael. "Rémy Zaugg: Ronny van de Velde." *Artforum* 29 (May 1991), p. 160.

Zaugg, Rémy. *Le tableau te constitue et tu constitues le tableau. Projets* (Lucerne: Kunstmuseum Luzern, 1991). Book published in conjunction with one-person exhibitions at Kunstmuseum Luzern, Le Consortium, Centre d'art contemporain, Dijon, Hamburger Kunstverein, and Wiener Secession.

Castello di Rivara, Turin, Italy. *65–74: Aspetti e Pratiche dell'Arte Europea* (1990). Exhibition catalogue by Gregorio Magnani.

Zaugg, Rémy. *Conversations avec Jean-Christophe Ammann: Portrait* (Dijon: Art et art, Ecrits d'artistes, 1990).

_____. *Personne* (Dijon: Le Consortium, Centre d'art contemporain; Paris: Galerie Anne de Villepoix, 1990). Book with essays by Alain Coulange, Xavier Douroux, and Franck Gautherot; published in conjunction with exhibitions at Le Consortium, Centre d'art contemporain, Dijon, and Galerie Anne de Villepoix, Paris.

_____. *Réflexions sur et d'une feuille de papier / Reflexionen auf und über ein Blatt Papier / Reflections on and onto a Sheet of Paper / Reflecties op en over een blad papier* (Berlin: Reinhard Onnasch Kunsthandel; Antwerp: Ronny van de Velde Galerie, 1990). Book with introduction by Rainer Borgemeister.

_____. *Voir Mort* (Basel: Wiese Verlag, 1989). Book published in conjunction with exhibition at Mai 36 Galerie, Lucerne, Switzerland.

Wechsler, Max. "Rémy Zaugg: Kunsthalle Basel." *Artforum* 26 (Summer 1988), pp. 151–152.

Zaugg, Rémy. *Für ein Bild* (Basel: Kunsthalle Basel, 1988). Book with introduction by Jean-Christophe Ammann and essays by Felix Philipp Ingold and Theodora Vischer; published in conjunction with exhibition at Kunsthalle Basel.

Westfälischen Landesmuseums für Kunst und Kulturgeschichte in der Stadt Münster, West Germany. *Skulptur Projekte in Münster, 1987* (Cologne: DuMont Buchvurlag, 1987). Exhibition catalogue edited by Klaus Bußmann and Kasper König, with essays by Marianne Brouwer, Benjamin H.D. Buchloh, Antje von Graevenitz, Thomas Kellein, Hannelore Kersting, et al., and text by Rémy Zaugg.

Zaugg, Rémy. *A Sheet of Paper* (Eindhoven, Netherlands: Stedelijk Van Abbemuseum, 1987).

_____. *Een vel papier. Gids / A Sheet of Paper. Guide* (Eindhoven, Netherlands: Stedelijk Van Abbemuseum, 1984). Book with essay by Rudi Fuchs; published in conjunction with the exhibition *Une feuille de papier… pourquoi?* at Stedelijk Van Abbemuseum, Eindhoven, Netherlands.

_____. *Réflexion 1977* (Bern: Kunsthalle Bern, 1979). Book with introduction by Johannes Gachnang and essay by René Denizot; published in conjunction with exhibition at Kunsthalle Bern.

_____. *Dedans-dehors, dehors-dedans, 1968–1972* (Basel: Kunstmuseum Basel, 1972). Book with essay by Dieter Koepplin; published in conjunction with exhibition at Kunstmuseum Basel.

Dimensions are in inches and centimeters. Except where noted, height precedes width precedes depth. Ø signifies diameter.

Chantal Akerman

Bordering on Fiction: Chantal Akerman's *D'Est*
1994
25 video laser disc players, 25 video laser discs, 25 video monitors, projection screen, 2 16mm film projectors, and a full-length feature film
Courtesy of Walker Art Center, Minneapolis

Nobuyoshi Araki

Sentimental Journey, Winter Journey
with **Equinox Flowers** 1995
113 black-and-white photographs, each 9 x 11 in. (22.9 x 27.9 cm); 20 color photographs, each 23⅝ x 35⁷⁄₁₆ in. (60 x 90 cm)
Installation dimensions variable
Collection of the artist

Richard Artschwager

Table Prepared in the Presence of Enemies 1993
Aluminum, Formica, and wood
59 x 60 x 75 in. (149.9 x 152.4 x 190.5 cm)
Collection of the artist

D. W. VI 1994
Plywood, pine, and metal screws
20¼ x 22½ x 22½ in. (51.4 x 57.1 x 57.1 cm)
Collection of Mary Jo and James L. Winokur, Pittsburgh

D. W. VII 1994
Plywood, pine, and metal screws
37 x 26 x 17¼ in. (94 x 66 x 43.8 cm)
Collection of Mary Jo and James L. Winokur, Pittsburgh

D. W. VIII 1994
Plywood, pine, and metal screws
17½ x 25 x 58¾ in. (44.4 x 63.5 x 149.2 cm)
Collection of The Carnegie Museum of Art
Mr. and Mrs. James Rich Fund and Second Century Acquisition Fund, 95.53

Untitled 1995
Plywood, pine, and metal screws
47 x 30 x 36 in. (119.4 x 76.2 x 91.4 cm)
Collection of the artist

Untitled 1995
Plywood, pine, and metal screws
29 x 30 x 26½ in. (73.7 x 76.2 x 67.3 cm)
Collection of the artist

Untitled 1995
Plywood, pine, and metal screws
72 x 72 x 22 in. (182.9 x 182.9 x 55.9 cm)
Collection of the artist

Untitled 1995
Plywood, pine, and metal screws
28 x 35 x 28 in. (71.1 x 88.9 x 71.1 cm)
Collection of the artist

Untitled 1995
Plywood, pine, and metal screws
48 x 24 x 15 in. (121.9 x 61 x 38.1 cm)
Collection of the artist

Untitled 1995
Plywood, pine, and metal screws
96 x 12 x 12 in. (243.8 x 30.5 x 30.5 cm)
Collection of the artist

Untitled 1995
Plywood, pine, and metal screws
37 x 48 x 66 in. (94 x 121.9 x 167.6 cm)
Collection of the artist

Untitled 1995
Plywood, pine, and metal screws
32 x 28 x 28 in. (81.3 x 71.1 x 71.1 cm)
Collection of the artist

Untitled 1995
Plywood, pine, and metal screws
21 x 65 x 16 in. (53.3 x 165.1 x 40.6 cm)
Collection of the artist

Untitled 1995
Plywood, pine, and metal screws
36 x 36 x 16 in. (91.4 x 91.4 x 40.6 cm)
Collection of the artist

Untitled 1995
Plywood, pine, and metal screws
36 x 36 x 16 in. (91.4 x 91.4 x 40.6 cm)
Collection of the artist

Untitled 1995
Plywood, pine, and metal screws
36 x 68 x 16 in. (91.4 x 172.7 x 40.6 cm)
Collection of the artist

Untitled 1995
Plywood, pine, and metal screws
85 x 45 x 25 in. (215.9 x 114.3 x 63.5 cm)
Collection of the artist

Untitled 1995
Plywood, pine, and metal screws
36 x 32 x 24 in. (91.4 x 81.3 x 61 cm)
Collection of the artist

Untitled 1995
Plywood, pine, and metal screws
61 x 16 x 40 in. (154.9 x 40.6 x 101.6 cm)
Collection of the artist

Untitled 1995

Plywood, pine, and metal screws

25 x 96 x 19 in. (63.5 x 243.8 x 48.3 cm)

Collection of the artist

Untitled 1995

Plywood, pine, and metal screws

19 x 34 x 90 in. (48.3 x 86.4 x 228.6 cm)

Collection of the artist

Untitled 1995

Plywood, pine, and metal screws

45 x 33 x 30 in. (114.3 x 83.8 x 76.2 cm)

Collection of the artist

Untitled 1995

Plywood, pine, and metal screws

76 x 44 x 24 in. (193 x 111.8 x 61 cm)

Collection of the artist

Untitled 1995

Plywood, pine, and metal screws

48 x 60 x 24 in. (121.9 x 152.4 x 61 cm)

Collection of the artist

Untitled 1995

Plywood, pine, and metal screws

31 x 42 x 33 in. (78.7 x 106.7 x 83.8 cm)

Collection of the artist

Untitled 1995

Plywood, pine, and metal screws

44 x 21 x 44 in. (111.8 x 53.3 x 111.8 cm)

Collection of the artist

Untitled 1995

Plywood, pine, and metal screws

18 x 18 x 18 in. (45.7 x 45.7 x 45.7 cm)

Collection of the artist

Untitled 1995

Plywood, pine, and metal screws

35 x 60 x 60 in. (88.9 x 152.4 x 152.4 cm)

Collection of the artist

Untitled 1995

Plywood, pine, and metal screws

27 x 48 x 42 in. (68.6 x 121.9 x 106.7 cm)

Collection of the artist

Untitled 1995

Plywood, pine, and metal screws

98 x 48 x 25 in. (248.9 x 121.9 x 63.5 cm)

Collection of the artist

Untitled 1995

Plywood, pine, and metal screws

57 x 65 x 21 in. (144.8 x 165.1 x 53.3 cm)

Collection of the artist

Untitled 1995

Plywood, pine, and metal screws

72 x 48 x 22 in. (182.9 x 121.9 x 55.9 cm)

Collection of the artist

Untitled 1995

Plywood, pine, and metal screws

35 x 48 x 19 in. (88.9 x 121.9 x 48.3 cm)

Collection of the artist

Untitled 1995

Plywood, pine, and metal screws

14 x 52 x 20 in. (35.6 x 132.1 x 50.8 cm)

Collection of the artist

Untitled 1995

Plywood, pine, and metal screws

30 x 36 x 25 in. (76.2 x 91.4 x 63.5 cm)

Collection of the artist

Untitled 1995

Plywood, pine, and metal screws

76 x 68 x 21 in. (193 x 172.7 x 53.3 cm)

Collection of the artist

Untitled 1995

Plywood, pine, and metal screws

74 x 42 x 26 in. (188 x 106.7 x 66 cm)

Collection of the artist

Mirosław Bałka

14 x 3 x 7, 14 x 3 x 7, 300 x 170 x 8, 280 x 190 x 8, Ø0.8 x 1100, Ø25 x 27, Ø25 x 27, 60 x 20 x 15, 60 x 20 x 15, 242 x 170 x 15, 242 x 170 x 15, 50 x 30 x 40, 50 x 30 x 39, Ø20 x 2 1994

Steel, linoleum, terrazzo, paper, salt, ash, felt, and heating cables

5 $\frac{1}{2}$ x 1 $\frac{3}{16}$ x 2 $\frac{3}{4}$, 5 $\frac{1}{2}$ x 1 $\frac{3}{16}$ x 2 $\frac{3}{4}$, 118 $\frac{1}{8}$ x 66 $\frac{15}{16}$ x 3 $\frac{1}{8}$, 110 $\frac{1}{4}$ x 74 $\frac{13}{16}$ x 3 $\frac{1}{8}$, Ø5 $\frac{5}{16}$ x 433 $\frac{3}{8}$, Ø9 $\frac{13}{16}$ x 10 $\frac{5}{8}$, Ø9 $\frac{13}{16}$ x 10 $\frac{5}{8}$, 23 $\frac{5}{8}$ x 7 $\frac{7}{8}$ x 5 $\frac{7}{8}$, 23 $\frac{5}{8}$ x 7 $\frac{7}{8}$ x 5 $\frac{7}{8}$, 95 $\frac{5}{16}$ x 66 $\frac{15}{16}$ x 5 $\frac{15}{16}$, 95 $\frac{5}{16}$ x 66 $\frac{15}{16}$ x 5 $\frac{15}{16}$, 19 $\frac{11}{16}$ x 11 $\frac{13}{16}$ x 15 $\frac{3}{8}$, 19 $\frac{11}{16}$ x 11 $\frac{13}{16}$ x 15 $\frac{3}{8}$, Ø7 $\frac{7}{8}$ x $\frac{13}{16}$ in.

(title of work refers to its components' dimensions in centimeters)

Collection of the artist

Courtesy of LondonProjects

Stephan Balkenhol

Large Man's Head 1993

Cedar and stain

47 x 38 $\frac{1}{2}$ x 4 in. (119.4 x 97.8 x 10.2 cm)

Regen Projects, Los Angeles

Large Woman's Head 1993

Cedar and stain

47 x 38 $\frac{1}{8}$ x 4 in. (119.4 x 97.8 x 10.2 cm)

Regen Projects, Los Angeles

Engel, Teufel, Welt 1994

Painted wawa-wood

Engel: 112 $\frac{3}{16}$ x 15 $\frac{3}{4}$ x 31 $\frac{1}{2}$ in.

(285 x 40 x 80 cm)

Teufel: 108 $\frac{1}{4}$ x 14 $\frac{3}{16}$ x 23 $\frac{5}{8}$ in.

(275 x 36 x 60 cm)

Welt: 59 $\frac{1}{16}$ x 11 $\frac{13}{16}$ x 10 $\frac{13}{16}$ in.

(150 x 30 x 27.5 cm)

Galerie Löhrl, Mönchengladbach

Grosser Mann 1994
Painted cedar
88 x 39 x 22 in. (223.5 x 99.1 x 55.9 cm)
Collection of Ellen and Jerome Stern
Courtesy of Barbara Gladstone Gallery,
New York

Kleiner Mann 1994
Painted wawa-wood
63 x 12½ x 11 in. (160 x 31.7 x 27.9 cm)
Collection of Sophie van Moerkerke
Courtesy of Barbara Gladstone Gallery,
New York

Small Man in Black Pants 1994
Sugar pine and stain
62 x 15 x 10 in. (157.5 x 38.1 x 25.4 cm)
Collection of Mr. and Mrs. Milton Fine,
Pittsburgh

Georg Baselitz

Abilgards Kirche 4.II.91–9.II.91 1991
Oil on canvas
118⅛ x 98⁷⁄₁₆ in. (300 x 250 cm)
Collection of Lynn and Allen Turner, Chicago

Bildzehn 27.X.91–8.XI.91 1991
Oil on canvas
113⅜ x 180⁵⁄₁₆ in. (288 x 458 cm)
PaceWildenstein, New York

Zwei Steine 12.I.91–13.II.91 1991
Oil on canvas
118⅛ x 98⁷⁄₁₆ in. (300 x 250 cm)
Galerie Michael Werner, Cologne
and New York

Bildelf 21.V.92–23.V.92 1992
Oil on canvas
113¾ x 181½ in. (289 x 461 cm)
Anthony d'Offay Gallery, London

Bildeinunddreißig 6.XI–1.XII.1994 1994
Oil on canvas
114³⁄₁₆ x 177³⁄₁₆ in. (290 x 450 cm)
Galerie Michael Werner, Cologne
and New York

Rob Birza

Frost and Frowzy 1994
Ceramic, wood, paint, and electric lights
80¹¹⁄₁₆ x 90⁹⁄₁₆ in. (205 x 230 cm)
Collection of the artist

Fresh Air Grid 1995
Metal, wood, and paint
96⁷⁄₁₆ x 177³⁄₁₆ in. (245 x 450 cm)
Collection of the artist

From Soap to Soap 1995
Ceramic, wood, and tempera on canvas
with two cloth-covered tables
55⅛ x 129¹⁵⁄₁₆ in. (140 x 330 cm)
Collection of the artist

Sleeping Mary 1995
Lacquer on canvas, ceramic, and chairs
118⅛ x 157½ x 60 in.
(300 x 400 x 152.4 cm) (overall)
Collection of the artist

Chuck Close

Alex 1991
Oil on canvas
100 x 84 in. (254 x 213.4 cm)
Collection of Lannan Foundation, Los Angeles

Janet 1992
Oil on canvas
100 x 84 in. (254 x 213.4 cm)
Collection of Albright-Knox Art Gallery,
Buffalo, New York
George B. and Jenny R. Mathews Fund, 1992

John 1992
Oil on canvas
100 x 84 in. (254 x 213.4 cm)
Collection of Michael and Judy Ovitz

John II 1993
Oil on canvas
72 x 60 in. (182.9 x 152.4 cm)
Private collection
Courtesy of PaceWildenstein, New York

Self-Portrait 1993
Oil on canvas
72 x 60 in. (182.9 x 152.4 cm)
Private collection

Stan Douglas

Der Sandmann 1994
Projection booth, 2 16mm film loops, color,
sound, 2 modified 16mm film
projectors, projection screen, mirrors,
sound amplifier, and 6 speakers
Collection of The Bohen Foundation

Abandoned Gartenbauamt Greenhouses,
Am Schlaatz 1994
From Potsdam Schrebergarten portfolio
(ed. of 5)
C-print
18½ x 36½ in. (47 x 92.7 cm)
David Zwirner, New York

Abandoned *Laube, Berlinerstrasse 105*,
Berliner Vorstadt 1994
From Potsdam Schrebergarten portfolio
(ed. of 5)
C-print
18 x 21 in. (45.7 x 53.3 cm)
David Zwirner, New York

Compost beside the Wall,
***Halbinsel Meederhorn*, Sacrow** 1994
From Potsdam Schrebergarten portfolio
(ed. of 5)
C-print
18 x 21 in. (45.7 x 53.3 cm)
David Zwirner, New York

Garden Designed by Lenné,
***Halbinsel Meederhorn*, Sacrow** 1994
From Potsdam Schrebergarten portfolio
(ed. of 5)
C-print
18 x 21 in. (45.7 x 53.3 cm)
David Zwirner, New York

"Geschwister-Scholl-Sparte,"
***Potsdam-West*, Am Wildpark** 1994
From Potsdam Schrebergarten portfolio
(ed. of 5)
C-print
18 x 21 in. (45.7 x 53.3 cm)
David Zwirner, New York

Greenhouse beside Kaserne Pappelalle at
***Bornsteder Feld*, Jägervorstadt** 1994
From Potsdam Schrebergarten portfolio
(ed. of 5)
C-print
18 x 21 in. (45.7 x 53.3 cm)
David Zwirner, New York

Path through "Berg Auf," *Am Pfingstberg*,
Pfingstberg 1994
From Potsdam Schrebergarten portfolio
(ed. of 5)
C-print
18 x 21 in. (45.7 x 53.3 cm)
David Zwirner, New York

Private Homes under Renovation beside
***Postdam-West*, Am Wildpark** 1994
From Potsdam Schrebergarten portfolio
(ed. of 5)
C-print
18 x 21 in. (45.7 x 53.3 cm)
David Zwirner, New York

Sanssouci Gardener's *Kleingarten, Am Teehaus*,
Brandenberger Vorstadt 1994
From Potsdam Schrebergarten portfolio
(ed. of 5)
C-print
18 x 21½ in. (45.7 x 54.6 cm)
David Zwirner, New York

Trabant beside "Im Grund," *Am Pfingstberg*,
Pfingstberg 1994
From Potsdam Schrebergarten portfolio
(ed. of 5)
C-print
18 x 21 in. (45.7 x 53.3 cm)
David Zwirner, New York

Two *Lauben* and Transmission Tower,
"Uns genügt's," *Nuthe Strand I*, Babelsberg 1994
From Potsdam Schrebergarten portfolio
(ed. of 5)
C-print
18 x 21 in. (45.7 x 53.3 cm)
David Zwirner, New York

View from below Ruine Belvede of
***Am Pfingstberg* and Rote Kaserne Nedlitz,**
Pfingstberg 1994
From Potsdam Schrebergarten portfolio
(ed. of 5)
C-print
18 x 21 in. (45.7 x 53.3 cm)
David Zwirner, New York

View of "Im Grund," *Am Pfingstberg*
and Rote Kaserne Nedlitz, Pfingstberg 1994
From Potsdam Schrebergarten portfolio
(ed. of 5)
C-print
18½ x 36½ in. (47 x 92.7 cm)
David Zwirner, New York

View of "Uns genügt's" from the
Nuthe-Schnellstrasse, *Nuthe Strand I*,
Babelsberg 1994
From Potsdam Schrebergarten portfolio
(ed. of 5)
C-print
18 x 21 in. (45.7 x 53.3 cm)
David Zwirner, New York

View of *Zu alten Zauche* with *Plattenbauten*,
***Hochhäuser* and the Twin Smokestacks of**
Kohleheizwerke Rehbrüke, Am Schaatz 1994
From Potsdam Schrebergarten portfolio
(ed. of 5)
C-print
18½ x 36½ in. (47 x 92.7 cm)
David Zwirner, New York

Leonardo Drew
Number 45 1995
Mixed media
132 x 312 x 4 in. (335.3 x 792.5 x 10.2 cm)
Collection of the artist
Courtesy of Tim Nye Productions, New York

Marlene Dumas
Betrayal 1994
Ink on paper
29 sheets, each 24 x 19¾ in. (61 x 50.2 cm)
Jack Tilton Gallery, New York

(In Search of) the Perfect Lover 1994
Ink and crayon on paper
58 sheets, each 11⅛ x 9⅝ in.
(28.2 x 24.5 cm)
2 sheets, each 13¾ x 12³⁄₁₆ in. (35 x 31 cm)
1 sheet, 8¹¹⁄₁₆ x 8¼ in. (22 x 21 cm)
Oil on canvas
2 pieces, each 9⁷⁄₁₆ x 7¹⁄₁₆ in. (24 x 18 cm)
Collection of the artist

Louise Fishman

Mars 1992
Oil on canvas
110 x 80 in. (279.4 x 203.2 cm)
Robert Miller Gallery, New York

Olympus Mons 1992
Oil on linen
55 x 45 in. (139.7 x 114.3 cm)
Robert Miller Gallery, New York

Blonde Ambition 1995
Oil on linen
90 x 65 in. (228.6 x 165.1 cm)
Robert Miller Gallery, New York

Burnt Bridges 1995
Oil on linen
84 x 61 in. (213.4 x 154.9 cm)
Robert Miller Gallery, New York

Stork Spreads Wings 1995
Oil on canvas
47 x 40 in. (119.3 x 101.6 cm)
Private collection, Switzerland
Courtesy of Robert Miller Gallery, New York

Vis a Tergo 1995
Oil on linen
30 x 26 in. (76.2 x 66 cm)
Robert Miller Gallery, New York

Robert Gober

Untitled (Man in Drain) 1993–1994
Bronze, wood, brick, aluminum, beeswax,
human hair, chrome, pump, and water
(second edition)
56 x 37½ x 34 in. (142.2 x 95.2 x 86.4 cm)
Collection of the artist

Untitled 1994–1995
Wood, wax, brick, plaster, plastic,
leather, iron, charcoal, cotton socks, electric
light, and motor
31 x 31 x 30½ in. (78.7 x 78.7 x 77.5 cm)
Collection of Emanuel Hoffmann-Stiftung,
on permanent loan at the
Museum für Gegenwartskunst, Basel

Angela Grauerholz

Eclogue or Filling the Landscape 1994
Installation
6-drawer acrylic cabinet with
27 portfolios containing 216 silver prints
of various dimensions
59¹⁄₁₆ x 59¹⁄₁₆ x 34¼ in.
(150 x 150 x 87 cm)
Art 45, Inc., Montreal

The Glare 1995
Gelatin silver print
72 x 48 in. (182.9 x 121.9 cm)
Art 45, Inc., Montreal

Gary Hill

Dervish 1993–1995
Video and sound installation:
2 video projectors, motor, speakers, computer
electronics, mirrors, strobe light, and aluminum
and wood structure
Commissioned by The Bohen Foundation
Courtesy of Donald Young Gallery, Seattle

Craigie Horsfield

Andrzej Klimowski. Crouch Hall Rd, North London.
October 1969 1995
Black-and-white unique photograph
73⅝ x 55⅛ in. (187 x 140 cm)
Collection of Tate Gallery, London
Purchased 1995

Catriona Maclean and Ian Horsfield.
Haysefield Park, Bath. July 1987 1995
Black-and-white unique photograph
59⅞ x 42⅛ in. (152.1 x 107 cm)
Frith Street Gallery, London

C. Horsfield. Well Street, East London.
May 1985 1995
Black-and-white unique photograph
78¾ x 55⅛ in. (200 x 140 cm)
Private collection, London

Kraków. May 1994 1995
Black-and-white unique photograph
110¼ x 94½ in. (280 x 240 cm)
Frith Street Gallery, London

Sumner Street, South London.
December 1994 1995
Black-and-white unique photograph
54⁵⁄₁₆ x 69⁵⁄₁₆ in. (138 x 176 cm)
Frith Street Gallery, London

Well Street, East London. January 1982 1995
Black-and-white unique photograph
82¹¹⁄₁₆ x 51³⁄₁₆ in. (210 x 130 cm)
Private collection, London

Zoo, Oxford. January 1990 1995
Black-and-white unique photograph
48 x 60 in. (121.9 x 152.4 cm)
Collection of Modern Art Museum of Fort
Worth, The Marion Collection

Cristina Iglesias

Untitled (Bamboo Forest I) 1995
Aluminum
94½ x 90⁹⁄₁₆ x 74¹⁄₁₆ in.
(240 x 230 x 188 cm)
Collection of the artist
Courtesy of Donald Young Gallery, Seattle

Untitled (Bamboo Forest II) 1995
Aluminum
94½ x 86⅝ x 33½ in.
(240 x 220 x 85 cm)
Collection of the artist
Courtesy of Donald Young Gallery, Seattle

Untitled (Bamboo Forest III) 1995
Aluminum
94½ x 98⁷⁄₁₆ x 19¹¹⁄₁₆ in.
(240 x 250 x 50 cm)
Collection of the artist
Courtesy of Donald Young Gallery, Seattle

Donald Judd

Untitled 1991
Mill aluminum
5 units, each 59 x 59 x 59 in.
(149.9 x 149.9 x 149.9 cm); 59 x 59 x 331 in.
(149.9 x 149.9 x 840.7 cm) (overall)
Collection of The Donald Judd Estate
Courtesy of PaceWildenstein, New York

Untitled 1991
Douglas fir plywood with aluminum tube
19½ x 45 x 30½ in. (49.5 x 114.3 x 77.5 cm)
Collection of The Donald Judd Estate
Courtesy of PaceWildenstein, New York

Untitled 1993
Douglas fir plywood with transparent
yellow Plexiglas
39⅜ x 39⅜ x 19⅝ in.
(100 x 100 x 49.8 cm)
PaceWildenstein, New York

Untitled 1993
Douglas fir plywood with transparent
amber-orange Plexiglas
39⅝ x 39⅝ x 19⅝ in.
(100.6 x 100.6 x 49.8 cm)
PaceWildenstein, New York

Per Kirkeby

Untitled (Cliff Dwelling under the Hanging Rock)
1995
Brick and mortar
165⅜ x 287⅜ x 177³⁄₁₆ in.
(420 x 730 x 450 cm)
Collection of the artist
Courtesy of Galerie Michael Werner,
Cologne and New York

Guillermo Kuitca

The Tablada Suite I 1991
Acrylic and graphite on canvas
94⅛ x 74¹³⁄₁₆ in. (239 x 190 cm)
Collection of Milwaukee Art Museum
Gift of Contemporary Art Society

The Tablada Suite II 1991
Acrylic and graphite on canvas
74¹³⁄₁₆ x 63 in. (190 x 160 cm)
Collection of Rosa and
Carlos de la Cruz, Miami

The Tablada Suite III 1991
Acrylic and graphite on canvas
57 x 77⅝ in. (144.8 x 197 cm)
Credit Suisse London Art Collection

The Tablada Suite IV 1992
Acrylic and graphite on canvas
76½ x 49¼ in. (194 x 125 cm)
Sperone Westwater, New York

The Tablada Suite V 1992
Acrylic and graphite on canvas
71¼ x 49⅝ in. (181 x 126 cm)
Private collection, Miami

The Tablada Suite VI 1992
Acrylic and graphite on canvas
78¾ x 78¾ in. (200 x 200 cm)
Collection of Albright-Knox Art Gallery,
Buffalo, New York
Edmund Hayes Fund, 1994

The Tablada Suite VII 1992
Acrylic and graphite on canvas
78¾ x 63 in. (200 x 160 cm)
Collection of David Meitus, New York

Moshe Kupferman

Untitled 1994
Oil on canvas
51³⁄₁₆ x 76¾ in. (130 x 195 cm)
Collection of the artist
Courtesy of Marge Goldwater, Inc., New York

Untitled 1994
Oil on canvas
51³⁄₁₆ x 76¾ in. (130 x 195 cm)
Collection of the artist
Courtesy of Marge Goldwater, Inc., New York

Untitled 1994
Oil on canvas
51³⁄₁₆ x 76¾ in. (130 x 195 cm)
Collection of the artist
Courtesy of Marge Goldwater, Inc., New York

Untitled 1994
Oil on canvas
76¾ x 51³⁄₁₆ in. (195 x 130 cm)
Collection of the artist
Courtesy of Marge Goldwater, Inc., New York

Untitled 1994
Oil on canvas
51 3/16 x 76 3/4 in. (130 x 195 cm)
Collection of Joseph Hackmey
The Israel Phoenix Assurance Company,
Tel Aviv

Untitled 1994
Oil on canvas
51 3/16 x 76 3/4 in. (130 x 195 cm)
Collection of Joseph Hackmey
The Israel Phoenix Assurance Company,
Tel Aviv

Thomas Locher

a–f 1991
Cibachrome print
205 x 105 in. (520.7 x 266.7 cm)
Collection of The Carnegie Museum of Art
A.W. Mellon Acquisition Endowment Fund,
93.151.2

x1–z5 1991
Cibachrome print
205 x 105 in. (520.7 x 266.7 cm)
Collection of The Carnegie Museum of Art
A.W. Mellon Acquisition Endowment Fund,
93.151.1

Untitled 1991
Cibachrome print, glass, and frame
80 11/16 x 41 3/8 x 3 1/8 in. (205 x 105 x 8 cm)
Galerie Tanja Grunert and
Michael Janssen, Cologne

Untitled 1991
Cibachrome print, glass, and frame
80 11/16 x 41 3/8 x 3 1/8 in. (205 x 105 x 8 cm)
Galerie Tanja Grunert and
Michael Janssen, Cologne

Grammar 1994
Silkscreen, glass, and aluminum
70 7/8 x 70 7/8 x 3 1/8 in. (180 x 180 x 8 cm)
Galerie Tanja Grunert and
Michael Janssen, Cologne

Die Politik 1994
Silkscreen, glass, and aluminum
70 7/8 x 70 7/8 x 3 1/8 in. (180 x 180 x 8 cm)
Galerie Tanja Grunert and
Michael Janssen, Cologne

Die Soziologie 1994
Silkscreen, glass, and aluminum
70 7/8 x 70 7/8 x 3 1/8 in. (180 x 180 x 8 cm)
Galerie Tanja Grunert and
Michael Janssen, Cologne

A Small Hermeneutics of Conversation 1994
Aluminum and wood engraved
with English text
28 3/4 x 47 1/4 x 27 9/16 in.
(73 x 120 x 70 cm) (table)
30 11/16 x 16 9/16 x 20 7/8 in.
(78 x 42 x 53 cm) (chairs)
Collection of Museum Boymans-van
Beuningen, Rotterdam

A Small Hermeneutics of Silence 1994
Aluminum and wood engraved
with English text
28 3/4 x 78 3/4 x 27 9/16 in.
(73 x 200 x 70 cm) (table)
30 11/16 x 16 9/16 x 20 7/8 in.
(78 x 42 x 53 cm) (chairs)
Collection of Südwest LB, Stuttgart

Untitled 1994
Cibachrome print, glass, and frame
57 1/16 x 41 3/8 x 3 1/8 in. (145 x 105 x 8 cm)
Galerie Tanja Grunert and
Michael Janssen, Cologne

Untitled 1994
Cibachrome print, glass, and frame
57 1/16 x 41 3/8 x 3 1/8 in. (145 x 105 x 8 cm)
Galerie Tanja Grunert and
Michael Janssen, Cologne

Arrows(or +) 1995
Aluminum, glass, and frame
86 5/8 x 86 5/8 x 1 9/16 in. (220 x 220 x 4 cm)
Galerie Tanja Grunert and
Michael Janssen, Cologne

Arrows(or +) 1995
Aluminum, glass, and frame
86 5/8 x 86 5/8 x 1 9/16 in. (220 x 220 x 4 cm)
Galerie Tanja Grunert and
Michael Janssen, Cologne

Arrows(or +) 1995
Aluminum, glass, and frame
86 5/8 x 86 5/8 x 1 9/16 in. (220 x 220 x 4 cm)
Galerie Tanja Grunert and
Michael Janssen, Cologne

Arrows(or +) 1995
Aluminum, glass, and frame
86 5/8 x 86 5/8 x 1 9/16 in. (220 x 220 x 4 cm)
Galerie Tanja Grunert and
Michael Janssen, Cologne

Grammar/construction 1995
Door, window, aluminum, glass, and frame
78 3/4 x 157 1/2 x 3 1/8 in. (200 x 400 x 8 cm)
Galerie Tanja Grunert and
Michael Janssen, Cologne

Grammar/construction 1995
Door, window, aluminum, glass, and frame
78 3/4 x 118 1/8 x 3 1/8 in. (200 x 300 x 8 cm)
Galerie Tanja Grunert and
Michael Janssen, Cologne

The Logic 1995
Silkscreen, glass, and aluminum
70⅞ x 70⅞ x 3⅛ in. (180 x 180 x 8 cm)
Galerie Tanja Grunert and
Michael Janssen, Cologne

The Philosophy 1995
Silkscreen, glass, and aluminum
70⅞ x 70⅞ x 3⅛ in. (180 x 180 x 8 cm)
Galerie Tanja Grunert and
Michael Janssen, Cologne

16 Chairs 1995
Wood engraved with English text
30¹¹⁄₁₆ x 16⁹⁄₁₆ x 20⅞ in.
(78 x 42 x 53 cm)
Galerie Tanja Grunert and
Michael Janssen, Cologne

Untitled 1995
Astralon on wood
59¹⁄₁₆ x 59¹⁄₁₆ x 3⅛ in. (150 x 150 x 8 cm)
Galerie Tanja Grunert and
Michael Janssen, Cologne

Untitled 1995
Astralon on wood
59¹⁄₁₆ x 59¹⁄₁₆ x 3⅛ in. (150 x 150 x 8 cm)
Galerie Tanja Grunert and
Michael Janssen, Cologne

Untitled 1995
Astralon on wood
59¹⁄₁₆ x 59¹⁄₁₆ x 3⅛ in. (150 x 150 x 8 cm)
Galerie Tanja Grunert and
Michael Janssen, Cologne

Untitled 1995
Cibachrome print, glass, and frame
63 x 63 x 3⅛ in. (160 x 160 x 8 cm)
Galerie Tanja Grunert and
Michael Janssen, Cologne

Untitled 1995
Cibachrome print, glass, and frame
63 x 63 x 3⅛ in. (160 x 160 x 8 cm)
Galerie Tanja Grunert and
Michael Janssen, Cologne

Untitled 1995
Cibachrome print, glass, and frame
63 x 63 x 3⅛ in. (160 x 160 x 8 cm)
Galerie Tanja Grunert and
Michael Janssen, Cologne

Untitled 1995
Cibachrome print, glass, and frame
63 x 63 x 3⅛ in. (160 x 160 x 8 cm)
Galerie Tanja Grunert and
Michael Janssen, Cologne

Agnes Martin

Untitled 1994
Acrylic and graphite on linen
60 x 60 in. (152.4 x 152.4 cm)
Collection of The Harwood Museum of the
University of New Mexico, Taos
Gift of the artist

Untitled 1994
Acrylic and graphite on linen
60 x 60 in. (152.4 x 152.4 cm)
Collection of The Harwood Museum of the
University of New Mexico, Taos
Gift of the artist

Untitled 1994
Acrylic and graphite on linen
60 x 60 in. (152.4 x 152.4 cm)
Collection of The Harwood Museum of the
University of New Mexico, Taos
Gift of the artist

Untitled 1994
Acrylic and graphite on linen
60 x 60 in. (152.4 x 152.4 cm)
Collection of The Harwood Museum of the
University of New Mexico, Taos
Gift of the artist

Untitled 1994
Acrylic and graphite on linen
60 x 60 in. (152.4 x 152.4 cm)
Collection of The Harwood Museum of the
University of New Mexico, Taos
Gift of the artist

Untitled 1994
Acrylic and graphite on linen
60 x 60 in. (152.4 x 152.4 cm)
Collection of The Harwood Museum of the
University of New Mexico, Taos
Gift of the artist

Untitled 1994
Acrylic and graphite on linen
60 x 60 in. (152.4 x 152.4 cm)
Collection of The Harwood Museum of the
University of New Mexico, Taos
Gift of the artist

Beatriz Milhazes

Senhorita com seus bichinhos de estimação 1993
Acrylic on canvas
76 x 82¹¹⁄₁₆ in. (193 x 210 cm)
Collection of Ricard Akagawa
Courtesy of Galeria Camargo Vilaça, São Paulo

Tonga II 1994
Acrylic on canvas
63 x 63 in. (160 x 160 cm)
Collection of João Leão Satamini,
Rio de Janeiro
Courtesy of Galeria Camargo Vilaça, São Paulo

Agro B. 1994–1995

Mixed media on canvas

70⅞ x 98⅜ in. (180 x 249.9 cm)

Galeria Camargo Vilaça, São Paulo

Paraora 1994–1995

Mixed media on canvas

78¹¹⁄₁₆ x 118⅞ in. (199.9 x 301.9 cm)

Edward Thorp Gallery, New York

Beijo 1995

Acrylic on canvas

75⁹⁄₁₆ x 118⅛ in. (192 x 300 cm)

Dorothy Goldeen Gallery, Santa Monica

Joan Mitchell

Tondo 1991

Oil on canvas

Ø59 in. (Ø149.9 cm)

Collection of Tony Podesta, Washington, D.C.

Yves 1991

Oil on canvas

110¼ x 78¾ in. (280 x 200 cm)

Estate of Joan Mitchell

Ici 1992

Oil on canvas

2 parts, 102⅜ x 157½ in. (260 x 400 cm)

(overall)

Collection of The Saint Louis Art Museum

Purchase: The Shoenberg Foundation, Inc.

Tilleul 1992

Oil on canvas

2 parts, 110¼ x 157½ in. (280 x 400 cm)

(overall)

Collection of Musée national d'art moderne,

Centre Georges Pompidou, Paris

Tomoharu Murakami

Untitled 1993–1995

Oil on canvas

63¹³⁄₁₆ x 51³⁄₁₆ in. (162 x 130 cm)

Gallery Shimada, Tokyo

Untitled I 1994–1995

Oil on canvas

35¹³⁄₁₆ x 28¾ in. (91 x 73 cm)

Gallery Shimada, Tokyo

Untitled II 1994–1995

Oil on canvas

35¹³⁄₁₆ x 28¾ in. (91 x 73 cm)

Gallery Shimada, Tokyo

Tony Oursler

MMPI (I Like Dramatics) 1994

Video projector, videocassette recorder,

videotape, tripod, light stand, and cloth

Dimensions variable (Tracy Leipold, performer)

Metro Pictures, New York

Telling Vision No. 4 1994

Video projector, videocassette recorder,

videotape, tripod, light stand, and cloth

Dimensions variable (Tony Oursler, performer)

Collection of The Carnegie Museum of Art

Second Century Acquisition Fund,

Oxford Development Acquisition Fund, and

Carnegie Mellon Art Gallery Fund, 95.5

Cow's Heart 1995

Video projector, videocassette recorder,

videotape, glass, formaldehyde, and animal

organ on steel table

57 x 36 x 36 in. (144.8 x 91.4 x 91.4 cm) (overall)

Metro Pictures, New York

Guilty 1995

Video projector, videocassette recorder,

videotape, mattress, and cloth

Dimensions variable (Tracy Leipold, performer)

Metro Pictures, New York

Sigmar Polke

Untitled 1995

Acrylic on canvas

78¾ x 63 in. (200 x 160 cm)

Courtesy of Helen van der Meij, London

Untitled 1995

Acrylic on canvas

118⅛ x 157½ in. (300 x 400 cm)

Courtesy of Helen van der Meij, London

Untitled 1995

Acrylic on canvas

118⅛ x 157½ in. (300 x 400 cm)

Courtesy of Helen van der Meij, London

Untitled 1995

Acrylic on canvas

118⅛ x 157½ in. (300 x 400 cm)

Courtesy of Helen van der Meij, London

Doris Salcedo

Untitled 1989–1992

Wood, cement, and steel

29½ x 18⅞ x 15⅜ in. (75 x 48 x 39 cm)

Collection of the artist

Untitled 1989–1992

Cement, steel, and cloth

4¾ x 12¾ x 6 in. (12 x 32.4 x 15.2 cm)

Collection of the artist

Untitled 1989–1992

Wood, cement, and steel

20 x 14 x 19¼ in. (50.8 x 35.5 x 48.9 cm)

Collection of Carolyn Alexander, New York

Untitled (Armoire) 1992
Wood, cement, and steel
45 x 73½ x 20 in. (114.3 x 186.7 x 50.8 cm)
Collection of The Carnegie Museum of Art
Carnegie Mellon Art Gallery Fund, 93.153

Untitled 1992
Wood, cement, and steel
35 x 54½ x 21 in. (88.9 x 138.4 x 53.3 cm)
Collection of Susan and Michael Hort,
Scarsdale, New York

Untitled 1992
Wood, cement, steel, cloth, and leather
38¼ x 17 x 17 in. (97.1 x 43.2 x 43.2 cm)
Collection of Penny and David McCall,
New York

Untitled 1992
Wood, cement, and steel
37½ x 16 x 16 in. (95.2 x 40.6 x 40.6 cm)
Jedermann Collection, N.A.

Untitled 1992
Wood, cement, steel, and glass
51 x 84¼ x 23 in. (129.5 x 214 x 58.4 cm)
Collection of The Art Institute of Chicago
Gift of the Society for Contemporary Art

Untitled 1992
Wood, cement, and steel
60¼ x 36½ x 16 in. (153 x 92.7 x 40.6 cm)
Collection of Marvin and Elayne Mordes,
Baltimore, Maryland

Untitled 1992
Wood, cement, steel, and cloth
39 x 17 x 17 in. (99.1 x 43.2 x 43.2 cm)
The Carol and Arthur Goldberg Collection

Untitled 1995
Wood, cement, steel, cloth, and glass
110 x 47 x 14½ in. (279.4 x 119.4 x 36.8 cm)
Alexander and Bonin, New York, and
Galeria Camargo Vilaça, São Paulo

Untitled 1995
Wood, cement, and steel
85½ x 45 x 15½ in. (217.2 x 114.3 x 39.4 cm)
Alexander and Bonin, New York, and
Galeria Camargo Vilaça, São Paulo

Untitled 1995
Wood, cement, and steel
68 x 45 x 25 in. (172.7 x 114.3 x 63.5 cm)
Alexander and Bonin, New York, and
Galeria Camargo Vilaça, São Paulo

Untitled 1995
Wood, cement, steel, cloth, and leather
95 x 41 x 18 in. (241.3 x 104.1 x 45.7 cm)
Alexander and Bonin, New York, and
Galeria Camargo Vilaça, São Paulo

Untitled 1995
Wood, cement, and steel
57⁵⁄₁₆ x 40⅛ x 18⅛ in. (145.5 x 102 x 46 cm)
Alexander and Bonin, New York, and
Galeria Camargo Vilaça, São Paulo

Untitled 1995
Wood, cement, and steel
32¼ x 17¹¹⁄₁₆ x 14⁹⁄₁₆ in. (82 x 45 x 37 cm)
Alexander and Bonin, New York, and
Galeria Camargo Vilaça, São Paulo

Untitled 1995
Wood, cement, steel, cloth, and glass
35⁷⁄₁₆ x 13⁹⁄₁₆ x 13⅜ in. (90 x 34.5 x 34 cm)
Alexander and Bonin, New York, and
Galeria Camargo Vilaça, São Paulo

Untitled 1995
Wood, cement, steel, and cloth
62¹⁵⁄₁₆ x 41 x 18⅛ in. (159.8 x 104 x 46 cm)
Alexander and Bonin, New York, and
Galeria Camargo Vilaça, São Paulo

Untitled 1995
Wood, cement, steel, and cloth
47¼ x 40⁹⁄₁₆ x 13¾ in. (120 x 103 x 35 cm)
Alexander and Bonin, New York, and
Galeria Camargo Vilaça, São Paulo

Untitled 1995
Wood, cement, steel, cloth, and glass
38 x 46⁷⁄₁₆ x 16⁹⁄₁₆ in. (96.5 x 118 x 42 cm)
Alexander and Bonin, New York, and
Galeria Camargo Vilaça, São Paulo

Untitled 1995
Wood, cement, steel, and cloth
33⁷⁄₁₆ x 41⁵⁄₁₆ x 37¹³⁄₁₆ in. (85 x 105 x 96 cm)
Alexander and Bonin, New York, and
Galeria Camargo Vilaça, São Paulo

Untitled 1995
Wood, cement, steel, cloth, and glass
36⁷⁄₁₆ x 59¹⁄₁₆ x 19⁵⁄₁₆ in. (92.5 x 150 x 49 cm)
Alexander and Bonin, New York, and
Galeria Camargo Vilaça, São Paulo

Untitled 1995
Wood, cement, steel, and leather
36¼ x 16⁹⁄₁₆ x 16⁹⁄₁₆ in. (92 x 42 x 42 cm)
Alexander and Bonin, New York, and
Galeria Camargo Vilaça, São Paulo

Untitled 1995
Wood, cement, steel, and cloth
37⅜ x 16⁹⁄₁₆ x 37³⁄₁₆ in. (95 x 42 x 96 cm)
Alexander and Bonin, New York, and
Galeria Camargo Vilaça, São Paulo

Untitled 1995

Wood, cement, steel, and vinyl

38 3/16 x 11 13/16 x 17 11/16 in. (97 x 30 x 45 cm)

Alexander and Bonin, New York, and

Galeria Camargo Vilaça, São Paulo

Untitled 1995

Wood, cement, and steel

36 5/8 x 17 1/8 x 17 11/16 in. (93 x 43.5 x 45 cm)

Alexander and Bonin, New York, and

Galeria Camargo Vilaça, São Paulo

Untitled 1995

Wood, cement, and steel

36 5/8 x 17 x 16 1/8 in. (93 x 43 x 41 cm)

Alexander and Bonin, New York, and

Galeria Camargo Vilaça, São Paulo

Untitled 1995

Wood, cement, and steel

68 x 45 x 70 in. (172.7 x 114.3 x 177.8 cm)

Alexander and Bonin, New York, and

Galeria Camargo Vilaça, São Paulo

Cindy Sherman

Untitled (313) 1993

Cibachrome print

74 x 39 1/2 in. (188 x 100.3 cm)

Collection of Linda and Ronald F. Daitz,

New York

Untitled (305) 1994

Cibachrome print

49 3/4 x 73 1/2 in. (126.4 x 186.7 cm)

Collection of Charles Heilbronn, New York

Untitled (306) 1994

Cibachrome print

76 x 51 in. (193 x 129.5 cm)

Metro Pictures, New York

Untitled (307) 1994

Cibachrome print

79 x 42 1/2 in. (200.7 x 108 cm)

Collection of David and Carol Appel, Toronto

Untitled (308) 1994

Cibachrome print

61 1/2 x 47 in. (156.2 x 119.4 cm)

Metro Pictures, New York

Untitled (309) 1994

Cibachrome print

71 x 37 in. (180.3 x 94 cm)

Metro Pictures, New York

Untitled (310) 1994

Cibachrome print

44 x 63 1/2 in. (111.8 x 161.3 cm)

Metro Pictures, New York

Untitled (311) 1994

Cibachrome print

76 x 51 in. (193 x 129.5 cm)

Collection of The Eli Broad Family Foundation,

Santa Monica

Untitled (315) 1995

Cibachrome print

60 x 40 in. (152.4 x 101.6 cm)

Collection of Sandra Simpson, Toronto

Untitled (316) 1995

Cibachrome print

48 x 32 in. (121.9 x 81.3 cm)

Metro Pictures, New York

Robert Therrien

Under the Table 1994

Wood and mixed media

116 x 312 x 216 in. (294.6 x 792.5 x 548.6 cm)

Collection of The Eli Broad Family Foundation,

Santa Monica

Rirkrit Tiravanija

Untitled (Still) 1995

Cooking utensils, refrigerator, tables and chairs,

curry and rice, and various architectural

elements from 303 Gallery

appx. 864 x 240 x 480 in.

(appx. 2194.6 x 609.6 x 1219.2 cm)

303 Gallery, New York

Richard Tuttle

Untitled 1991

Acrylic, electric lights, vinyl/cardboard, and

wood

55 x 20 in. (139.7 x 50.8 cm)

Sperone Westwater, New York

Whiteness 19 (Memory of Alan Houser) 1994

Wood, paint, Styrofoam, cloth, and nails

74 13/16 x 27 9/16 in. (190 x 70 cm)

Private collection, Switzerland

Courtesy of Annemarie Verna Galerie, Zurich

Whiteness 3 1994–1995

Paint on Masonite, latex/fabric, and Styrofoam

39 x 64 in. (99.1 x 162.6 cm)

Mary Boone Gallery, New York

Source of Imagery: V 1995

Wood and acrylic on wooden block

26 x 27 in. (66 x 68.6 cm)

Sperone Westwater, New York

Franz West

Papille 1995

Papier-mâché, stucco, and paint on metal

armature

59 1/16 x 34 5/8 x 19 11/16 in.

(150 x 88 x 50 cm)

David Zwirner, New York

Rondell 1995

Papier-mâché, stucco, and paint on metal

armature

78⅜ x 66⅛ x 30⁵/₁₆ in.

(199 x 168 x 77 cm)

David Zwirner, New York

Telephonesculpture 1995

Papier-mâché, stucco, paint, and table

18½ x 18⅞ x 11¹³/₁₆ in.

(47 x 48 x 30 cm); 27¹⁵/₁₆ x 31⅞ x 28⅜ in.

(71 x 81 x 72 cm) (table)

David Zwirner, New York

Telephonesculpture 1995

Papier-mâché, stucco, paint, and table

19¹¹/₁₆ x 18⅛ x 9⁷/₁₆ in.

(50 x 46 x 24 cm); 28⅜ x 32¹¹/₁₆ x 23⅝ in.

(72 x 83 x 60 cm) (table)

David Zwirner, New York

Telephonesculpture 1995

Papier-mâché, stucco, paint, and table

18½ x 20⅞ x 8¼ in. (47 x 53 x 21 cm);

28⅜ x 51⁹/₁₆ x 33⁷/₁₆ in.

(72 x 131 x 85 cm) (table)

David Zwirner, New York

Telephonesculpture 1995

Papier-mâché, stucco, paint, and couch

21⅝ x 13 x 9⅞ in. (55 x 33 x 25 cm);

41⁵/₁₆ x 94½ x 31½ in.

(105 x 240 x 80 cm) (couch)

David Zwirner, New York

Telephonesculpture 1995

Papier-mâché, stucco, and paint

23⅝ x 15¾ x 12⅝ in. (60 x 40 x 32 cm)

David Zwirner, New York

Telephonesculpture 1995

Papier-mâché, stucco, and paint

19¹¹/₁₆ x 18⅛ x 13¾ in. (50 x 46 x 35 cm)

David Zwirner, New York

Telephonesculpture 1995

Papier-mâché, stucco, and paint

21⅝ x 13⅜ x 6⁵/₁₆ in. (55 x 34 x 16 cm)

David Zwirner, New York

Telephonesculpture 1995

Papier-mâché, stucco, and paint

21⅝ x 19¹¹/₁₆ x 10¼ in. (55 x 50 x 26 cm)

David Zwirner, New York

Untitled 1995

Aluminum, gauze, and paint

32¼ x 82¹¹/₁₆ x 3⅛ in. (82 x 210 x 8 cm)

David Zwirner, New York

Rachel Whiteread

Untitled (One Hundred Spaces) 1995

Resin

100 units of 9 sizes:

17¹⁵/₁₆ x 11¼ x 11¼ in. (44 x 28.6 x 28.5 cm);

18⅞ x 11¹³/₁₆ x 11¹³/₁₆ in. (48 x 30 x 30 cm);

16⁹/₁₆ x 13⁹/₁₆ x 14⁹/₁₆ in. (42 x 34.5 x 37 cm);

15¹⁵/₁₆ x 20¹/₁₆ x 18⁵/₁₆ in. (40.5 x 51 x 46.5 cm);

17½ x 18½ x 15⁹/₁₆ in. (44.4 x 47 x 39.5 cm);

16⅛ x 19⁵/₁₆ x 16⅛ in. (41 x 49 x 41 cm);

16¹⁵/₁₆ x 15⁹/₁₆ x 12³/₁₆ in. (43 x 39.5 x 31 cm);

17⁵/₁₆ x 16⁹/₁₆ x 15¾ in. (44 x 42 x 40 cm);

17½ x 18½ x 16⅛ in. (44.4 x 47 x 41 cm)

Karsten Schubert Contemporary Art, London

and Luhring Augustine Gallery, New York

Rémy Zaugg

Untitled 1990–1995

Acrylic and silkscreen on canvas

110⅝ x 100⅜ in. (281 x 255 cm)

Collection of the artist

Courtesy of Brooke Alexander Gallery,

New York

Untitled 1990–1995

Acrylic and silkscreen on canvas

110⅝ x 100⅜ in. (281 x 255 cm)

Collection of the artist

Courtesy of Brooke Alexander Gallery,

New York

Untitled 1990–1995

Acrylic and silkscreen on canvas

110⅝ x 100⅜ in. (281 x 255 cm)

Collection of the artist

Courtesy of Brooke Alexander Gallery,

New York

This / Here / See / You 1993–1995

Acrylic on canvas

41 x 26⅞ in. (104.1 x 68.2 cm)

Collection of the artist

Courtesy of Brooke Alexander Gallery,

New York

Perhaps / Me / Myself / I / Here 1993–1995

Acrylic on canvas

51¾ x 46¹/₁₆ in. (131.4 x 117 cm)

Collection of the artist

Courtesy of Brooke Alexander Gallery,

New York

That / To Be / You 1994–1995

Acrylic on canvas

30³/₁₆ x 26⅞ in. (76.7 x 68.2 cm)

Collection of the artist

Courtesy of Brooke Alexander Gallery,

New York

This / Here / Now 1994–1995

Acrylic on canvas

30³/₁₆ x 27⅞ in. (76.7 x 70.8 cm)

Collection of the artist

Courtesy of Brooke Alexander Gallery,

New York

Support Organizations

The Andy Warhol Museum

John Smith, Interim Manager

Adrienne Webster, Executive Secretary

Nicol Smith, Administrative Assistant

DeDe Acer, Special Projects, Development

Melissa McSwigan, Special Projects Assistant,
Development

Timothy Boyd, Building Manager

Porter Hanks, Security Supervisor

Archives

John Smith, Archivist

Matt Wrbican, Assistant Archivist

Curatorial

Mark Francis, Curator

Margery King, Assistant Curator

Lisa Miriello, Curatorial Secretary

Education

Ellen Broderick, Curator of Education

Raina Lampkins-Fielder, Education Programs
Coordinator

Victoria Smalls, Clerical Assistant

Jennifer Boughner, Museum Educator

Sarah O'Connel, Museum Educator

Maritza Mosquera, Museum Teacher

Amy Novelli, Museum Teacher

Carolyn Speranza, Museum Teacher

Tresa Varner, Museum Educator

Film and Video

Geralyn Huxley, Assistant Curator of Film
and Video

Greg Pierce, Film and Video Technician

Registrar

Cheryl Saunders, Registrar

Roger Laib, Art Handler

Jim Leddy, Art Handler

Visitor Services

Greg Burchard, Admissions Manager

Jennifer Bossman, Admissions Assistant

Allison Rupert, Admissions Attendant

Maurice Thomas, Admissions Attendant

Women's Committee Executive Committee

Janet Krieger, President

Lowrie Ebbert, First Vice-President

Karen A. Muse, Second Vice-President

Jane Flucker, Recording Secretary

Sue Barnes, Corresponding Secretary

Carol Heppner, Treasurer

Stephanie Flannery, Assistant Treasurer

Lu Damianos

Betty Dickey

Nina Humphrey

Officers of the Fellows of the Museum of Art

James A. Fisher, Co-Chair

Milton Porter, Co-Chair

Teresa Heinz, Co-Chair

Docent Steering Committee

Karen DiPasquale, Co-Chair

Linda Becker, Co-Chair

Martha Bell

Tessie Binstock

Mildred Cassini

Kim D. Dingess

Gaby Dinman

Lora Lee Duncan

Gail Jenkins

Marjorie Ladley

Ellaine Rosen

Credits

Excerpts

The Carnegie Museum of Art gratefully acknowledges the following publishers and authors for permission to reprint excerpts from their works: Walker Art Center, Minneapolis, and Michael Tarantino, © 1995 Walker Art Center. All rights reserved, p. 36; Artforum, Nan Goldin, and Nobuyoshi Araki, © 1995 Artforum International Magazine, pp. 40–41; Portikus, Frankfurt, and Ingrid Schaffner, © 1993 Portikus, Frankfurt, Ingrid Schaffner, and Martin Hentschel, p. 46; Mala Galerija, Moderna Galerija Ljubljana and Zdenka Badovinac, © 1995 Moderna Galerija Ljubljana, p. 50; Witte de With, Rotterdam, and James Lingwood, © 1992 Edition Cantz, Stuttgart, Witte de With, Rotterdam, and James Lingwood, pp. 54–55; The Solomon R. Guggenheim Museum, New York, and Georg Baselitz, © 1995 The Solomon R. Guggenheim Foundation and translation © 1995 by Joachim Neugroschel, pp. 58–59; Stedelijk Museum, Amsterdam, and Marjolein Schaap, © 1991 Marjolein Schaap, p. 64; Staatliche Kunsthalle Baden-Baden and Robert Storr, © 1995 Staatliche Kunsthalle Baden-Baden and Robert Storr, p. 68; Stan Douglas, p. 72; The Art Institute of Chicago and Madeleine Grynsztejn, © 1995 The Art Institute of Chicago, pp. 76–77; The Douglas Hyde Gallery, Dublin, and John Hutchinson, © 1994 The Douglas Hyde Gallery, p. 80; Robert Miller Gallery, New York, and Melissa E. Feldman, p. 82; Galerie nationale du Jeu de Paume, Paris, and Joan Simon, © 1991 éditions du Jeu de Paume, p. 86; Parachute, Beth Seaton, and Angela Grauerholz, © 1989 Parachute, revue d'art contemporain, inc., p. 90; Centre del Carme, IVAM, Valencia, and Jacinto Lageira, © 1993 IVAM Institut Valencià d'Art Modern and Jacinto Lageira, p. 94;

Artforum and Craigie Horsfield, © 1994 Artforum International Magazine, p. 96; Ministerio de Asuntos Exteriores and Aurora García, © 1993 Ministerio de Asuntos Exteriores, Àmbit Servicios Editoriales, S.A., and Aurora García, p. 100; PaceWildenstein, New York, © 1993 Donald Judd / The Pace Gallery of New York, Inc., p. 104; Arti and Per Kirkeby, p. 108; Contemporary Art Foundation, Amsterdam, and Robert Rosenblum, © 1994 Contemporary Art Foundation, p. 110; Verlag Dr. Rainer Höcherl, Munich, W. Asperger Gallery AG, Zug, and Sara Breitberg-Semel, p. 114; Kunsthalle Zürich and Bernhard Bürgi, © 1993 Kunsthalle Zürich, p. 118; Art Monthly, Irving Sandler, and Agnes Martin, © 1993 Irving Sandler, Art Monthly *Agnes Martin Interview*, pp. 122–123; Sala Alternativa Artes Visuales, Caracas, Galeria Camargo Vilaça, São Paulo, and Stella Teixeira de Barros, p. 126; Robert Miller Gallery, New York, and John Ashbery, © 1993 John Ashbery, p. 130; Galerie Katrin Rabus, Bremen, Gallery Shimada, Tokyo, and Mikio Takata, p. 134; Portikus, Frankfurt, Les Musées de la Ville de Strasbourg, Centre d'Art Contemporain, Geneva, Stedelijk Van Abbemuseum, Eindhoven, and Friedemann Malsch, © 1995 Portikus, Frankfurt, Les Musées de la Ville de Strasbourg, Centre d'Art Contemporain, Geneva, and Stedelijk Van Abbemuseum, Eindhoven, pp. 136–137; Centre del Carme, IVAM, Valencia, and Kevin Power, © 1994 IVAM Institut Valencià d'Art Modern, p. 140; Third Text and Charles Merewether, © 1993 Third Text and Charles Merewether, p. 144; Artforum and Neville Wakefield, © 1995 Artforum International Magazine, p. 148; Museo Nacional Centro de Arte Reina Sofía, Madrid, and Margit Rowell, © 1991 Ministerio de Cultura, Museo Nacional Centro de Arte Reina Sofía, and Margit Rowell, p. 154; Parkett, Richard Flood, Rochelle Steiner, and Rirkrit Tiravanija, © July 1995 Parkett-Verlag AG, Zurich, Richard Flood, Rochelle Steiner, and Rirkrit

Tiravanija, p. 158; Sezon Museum of Art, Tokyo, and Gerhard Mack, © 1995 Sezon Museum of Art, p. 162; Mala Galerija, Moderna Galerija Ljubljana and Bart De Baere, © 1993 Moderna Galerija Ljubljana, p. 166; Parkett and Rudolf Schmitz, © December 1994 Parkett-Verlag AG, Zurich, and Rudolf Schmitz, p. 170; Mai 36 Galerie, Lucerne, and Rémy Zaugg, © 1989 Mai 36 Galerie, p. 174.

Photography

Introduction: Richard Stoner, Pittsburgh, pp. 19, 25. Chantal Akerman: courtesy of Walker Art Center, Minneapolis, pp. 37–39. Nobuyoshi Araki: courtesy of the artist, pp. 40, 42–45. Richard Artschwager: © Katrin Schilling, Frankfurt, courtesy of Portikus, Frankfurt, p. 47; © 1993 Dorothy Zeidman, pp. 48–49. Mirosław Bałka: courtesy of Muzeum Sztuki, Łódź, pp. 51–53. Stephan Balkenhol: Joshua White, courtesy of Regen Projects, Los Angeles, p. 55; Larry Lame, courtesy of Barbara Gladstone Gallery, New York, pp. 56–57. Georg Baselitz: courtesy of Galerie Michael Werner, Cologne and New York, pp. 60–63. Rob Birza: © R. v. Gageldonk, pp. 65–67. Chuck Close: Bill Jacobson, courtesy of PaceWildenstein, New York, pp. 69–71. Stan Douglas: courtesy of David Zwirner, New York, pp. 73–75. Leonardo Drew: James Prinz, courtesy of the artist and Tim Nye Productions, New York, pp. 77–79. Marlene Dumas: courtesy of Jack Tilton Gallery, New York, p. 81. Louise Fishman: Beth Phillips, courtesy of Robert Miller Gallery, New York, pp. 83–85. Robert Gober: Bill Jacobson, courtesy of Paula Cooper Gallery, New York, p. 87; Russell Kaye, courtesy of Paula Cooper Gallery, New York, p. 88; James Dee, courtesy of Paula Cooper Gallery, New York, p. 89.

Angela Grauerholz: Courtesy of Art 45, Inc., Montreal, pp. 91–93. Gary Hill: courtesy of Donald Young Gallery, Seattle, p. 95. Craigie Horsfield: Stephen White, courtesy of Frith Street Gallery, London, pp. 97–99. Cristina Iglesias: Dorothee Fischer, courtesy of Galerie Konrad Fischer, Düsseldorf, pp. 101–103. Donald Judd: Bill Jacobson, courtesy of PaceWildenstein, New York, p. 105; courtesy of PaceWildenstein, New York, pp. 106–107. Per Kirkeby: courtesy of Galerie Michael Werner, Cologne and New York, p. 109. Guillermo Kuitca: courtesy of Sperone Westwater, New York, pp. 110–113. Moshe Kupferman: Richard Stoner, Pittsburgh, pp. 115–117. Thomas Locher: Alistair Overbruck, Cologne, courtesy of Galerie Tanja Grunert and Michael Janssen, Cologne, p. 119; Alex Troehler, Zurich, courtesy of Galerie Tanja Grunert and Michael Janssen, Cologne, pp. 120–121. Agnes Martin: Ellen Page Wilson, courtesy of PaceWildenstein, New York, pp. 124–125. Beatriz Milhazes: courtesy of Edward Thorp Gallery, New York, p. 127; courtesy of Galeria Camargo Vilaça, São Paulo, pp. 128–129. Joan Mitchell: Beth Phillips, courtesy of Robert Miller Gallery, New York, pp. 131–133. Tomoharu Murakami: courtesy of Gallery Shimada, Tokyo, p. 135. Tony Oursler: courtesy of Metro Pictures, New York, pp. 137–139. Sigmar Polke: courtesy of Walker Art Center, Minneapolis, p. 141; courtesy of Helen van der Meij, London, pp. 142–143. Doris Salcedo: © 1993 D. James Dee, p. 145; © 1993 D. James Dee, courtesy of Alexander and Bonin, New York, p. 146; courtesy of Alexander and Bonin, New York, p. 147. Cindy Sherman: courtesy of Metro Pictures, New York, pp. 149–153. Robert Therrien: courtesy of the artist, p. 155; © 1994 Douglas M. Parker, Los Angeles, pp. 156–157. Rirkrit Tiravanija: © Gary F. Graves, courtesy of 303 Gallery, New York, pp. 159–161. Richard Tuttle: courtesy of Mary Boone Gallery, New York, p. 163; J.P. Kuhn, Zurich, courtesy of Annemarie Verna Galerie, Zurich, p. 164; © Dorothy Zeidman, courtesy of Mary Boone Gallery, New York, p. 165. Franz West: Friedl Bondy, courtesy of David Zwirner, New York, p. 166; Friedl Kubelka, courtesy of David Zwirner, New York, pp. 167–169. Rachel Whiteread: Sue Ormerod, courtesy of Karsten Schubert Contemporary Art, London, p. 171; Prudence Cuming Associates Limited, London, courtesy of Karsten Schubert Contemporary Art, London, pp. 172–173. Rémy Zaugg: courtesy of Brooke Alexander Gallery, New York, pp. 175–177. Back endleaf: Richard Stoner, Pittsburgh.

Portraits

Chantal Akerman: courtesy of Walker Art Center, Minneapolis, p. 178. Nobuyoshi Araki: Sakiko Nomura, p. 179. Richard Artschwager: Neefus Photographers, Hudson, New York, p. 180. Mirosław Bałka: courtesy of the artist, p. 182. Stephan Balkenhol: courtesy of Johnen & Schöttle, Cologne, p. 184. Georg Baselitz: © 1987 Daniel Blau, Munich, courtesy of Galerie Michael Werner, Cologne and New York, p. 186. Rob Birza: courtesy of the artist, p. 188. Chuck Close: © 1993 David Seidner, courtesy of PaceWildenstein, New York, p. 189. Stan Douglas: Ollertz & Stauss Fotografie, Berlin, courtesy of David Zwirner, New York, p. 190. Leonardo Drew: Jason Schmidt, courtesy of Tim Nye Productions, New York, p. 192. Marlene Dumas: courtesy of Galerie Paul Andriesse, Amsterdam, p. 193. Louise Fishman: © Betsy Crowell, courtesy of Robert Miller Gallery, New York, p. 195. Robert Gober: Donald Moffett, courtesy of Paula Cooper Gallery, New York, p. 196. Angela Grauerholz: courtesy of Art 45, Inc., Montreal, p. 199. Gary Hill: Marine Hugonnier, courtesy of Donald Young Gallery, Seattle, p. 200. Craigie Horsfield: © Craigie Horsfield, London, p. 202. Cristina Iglesias: courtesy of Donald Young Gallery, Seattle, p. 203. Donald Judd: © 1991 Todd Eberle, courtesy of PaceWildenstein, New York, p. 205. Per Kirkeby: © 1987 Daniel Blau, Munich, courtesy of Galerie Michael Werner, Cologne and New York, p. 206. Guillermo Kuitca: Alejandro Kuropatwa, courtesy of Sperone Westwater, New York, p. 210. Moshe Kupferman: Yair Peleg, Kibbutz Lochamei Hagetaot, Israel, p. 211. Thomas Locher: Rolf Walz, p. 212. Agnes Martin: Dorothy Alexander, courtesy of PaceWildenstein, New York, p. 215. Beatriz Milhazes: courtesy of Galeria Camargo Vilaça, São Paulo, p. 217. Joan Mitchell: © 1991 David Seidner, courtesy of Robert Miller Gallery, New York, p. 218. Tomoharu Murakami: Masatomo Murakami, courtesy of Gallery Shimada, Tokyo, p. 219. Tony Oursler: Brad Wilson, courtesy of Metro Pictures, New York, p. 221. Sigmar Polke: courtesy of Walker Art Center, Minneapolis, p. 222. Doris Salcedo: © 1995 The Art Institute of Chicago, p. 225. Cindy Sherman: © 1990 David Seidner, courtesy of Metro Pictures, New York, p. 226. Robert Therrien: courtesy of the artist, p. 228. Rirkrit Tiravanija: Rochelle Steiner, courtesy of Walker Art Center, Minneapolis, p. 230. Richard Tuttle: © Vera Isler, Bottmingen, Switzerland, p. 231. Franz West: C. Alessandri, courtesy of Galerie Walcheturm, Zurich, p. 234. Rachel Whiteread: courtesy of Karsten Schubert Contemporary Art, London, p. 235. Rémy Zaugg: © 1995 Jack Schlechter, Pittsburgh, p. 237.

Cover: Armillary sphere atop Carnegie Institute. Alden and Harlow, architects, 1907. Front endleaf: First *Annual Exhibition*, Carnegie Institute, 1896. Back endleaf: Scaife Galleries, exterior with *Carnegie* (1985) by Richard Serra. Page 239, portrait of Andrew Carnegie.

This publication was organized at The Carnegie Museum
of Art by Gillian Belnap, Head of Publications;
Elissa M. Curcio, Publications Assistant;
and Marcia T. Whitehead, Production Coordinator.

The catalogue was designed by
Anita Meyer and Dina Zaccagnini, plus design inc., Boston
production managed by Pinpoint Incorporated, Boston
typeset in Bembo, Franklin Gothic, and Garage Gothic
by Moveable Type Inc., Toronto
edited by Phil Freshman, Minneapolis
and copy edited by Bob Brunning, Moveable Type Inc.
4,000 copies were printed on Champion Pageantry 80 lb text
in Boston by W.E. Andrews Company and bound
with binding board covers by Acme Bookbinding, Boston.

The paper used in this publication meets the minimum
requirements of the American National Standard for
Information Sciences—Permanence of Paper for Printed
Library Materials, ANSI Z39.48–1984.